Live Coding

Software Studies

Lev Manovich and Noah Wardrip-Fruin, editors

Expressive Processing: Digital Fictions, Computer Games, and Software Studies, Noah Wardrip-Fruin, 2009

Code/Space: Software and Everyday Life, Rob Kitchin and Martin Dodge, 2011

Programmed Visions: Software and Memory, Wendy Hui Kyong Chun, 2011

Speaking Code: Coding as Aesthetic and Political Expression, Geoff Cox and Alex McLean, 2012

10 PRINT CHR$(205.5+RND(1)); : GOTO 10, Nick Montfort, Patsy Baudoin, John Bell, Ian Bogost, Jeremy Douglass, Mark Marino, Michael Mateas, Casey Reas, Mark Sample, and Noah Vawter, 2012

The Imaginary App, Paul D. Miller and Svitlana Matviyenko, 2014

The Stack: On Software and Sovereignty, Benjamin H. Bratton, 2015

Coding Literacy: How Computer Programming Is Changing Writing, Annette Vee, 2017

The Software Arts, Warren Sack, 2019

Critical Code Studies, Mark C. Marino, 2020

How Pac-Man Eats, Noah Wardrip-Fruin, 2020

Live Coding: A User's Manual, Alan F. Blackwell, Emma Cocker, Geoff Cox, Alex McLean, and Thor Magnusson, 2022

Live Coding

A User's Manual

Alan F. Blackwell, Emma Cocker, Geoff Cox, Alex McLean, and Thor Magnusson

The MIT Press
Cambridge, Massachusetts
London, England

© 2022 Massachusetts Institute of Technology

This work is subject to a Creative Commons CC-BY-SA license.
Subject to such license, all rights are reserved.

(cc) BY-SA

The MIT Press would like to thank the anonymous peer reviewers who provided comments on drafts of this book. The generous work of academic experts is essential for establishing the authority and quality of our publications. We acknowledge with gratitude the contributions of these otherwise uncredited readers.

This book was set in Stone Serif and Stone Sans by Westchester Publishing Services. Printed and bound in the United States of America.

Library of Congress Cataloging-in-Publication Data

Names: Blackwell, Alan F., author. | Cocker, Emma, author. | Cox, Geoff, author. | McLean, Alex, 1975– author. | Magnusson, Thor, author.
Title: Live coding : a user's manual / Alan F. Blackwell, Emma Cocker, Geoff Cox, Alex McLean, and Thor Magnusson.
Description: Cambridge, Massachusetts : The MIT Press, [2022] | Series: Software studies | Includes bibliographical references and index.
Identifiers: LCCN 2022008717 (print) | LCCN 2022008718 (ebook) | ISBN 9780262544818 (paperback) | ISBN 9780262372626 (epub) | ISBN 9780262372633 (pdf)
Subjects: LCSH: Computer programming—Philosophy. | Agile software development. | Creation (Literary, artistic, etc.) | Algorithms—Psychological aspects.
Classification: LCC QA76.6 .B5794 2022 (print) | LCC QA76.6 (ebook) | DDC 005.1301—dc23/eng/20220527
LC record available at https://lccn.loc.gov/2022008717
LC ebook record available at https://lccn.loc.gov/2022008718

10 9 8 7 6 5 4 3 2 1

Contents

List of Figures vii
Series Foreword xi
Acknowledgments xiii

1 **Introduction to** *Live Coding: A User's Manual* 1
2 **Partial Histories** 13
3 **Expositions** 39
4 **Notation** 125
5 **Live Coding's Liveness(es)** 159
6 **Time Criticality in Live Coding** 181
7 **What Does Live Coding Know?** 205
8 **What Does Live Coding Want?** 229

Notes 245
Bibliography 295
Index 321

List of Figures

2.1 The original handwritten slub "Generative Manifesto" 18

2.2 The TOPLAP logo created by Adrian Ward 21

2.3 Algorave logo designed by David Palmer, a "spirangle" based on the three-armed algorithmic structure of the Brigid's cross 35

3.1a Rangga Aji 40

3.1b Rangga Aji 40

3.2a Alejandro Albornoz, a.k.a. co(n)de Zero, and Christian Oyarzún 42

3.2b Alejandro Albornoz, a.k.a. co(n)de Zero 42

3.3 ALGOBABEZ (Shelly Knotts and Joanne Armitage) 44

3.4a Rafeale Andrade 46

3.4b Rafeale Andrade 46

3.5 Jack Armitage 48

3.6a Computer artwork by Diego Moreira Guimarães 50

3.6b Pietro Bapthysthe (Diego Dukão and Berin) 50

3.7 Lina Bautista performing as Linalab 52

3.8a Renick Bell 54

3.8b Renick Bell 54

3.9 Ashlae Blum(e) 56

3.10 Alexandra Cardenas 58

3.11 Lucy Cheesman 60

3.12a Screenshot of Joana Chicau live coding visuals in a web browser 62

3.12b Joana Chicau 62

3.13 Periodic table sequencer and IBM six qubit frontend in SuperCollider 64

3.14a Malitzin Cortes, "Generative promenade or Nightmare catcher," Modern Art Museum, Mexico City, 2019 66

3.14b ACI Asia Culture Center. Foodhack 2019 ISEA Korea 2019 66

3.15a Mamady Diarra 68

3.15b Mamady Diarra 68

3.16 Live coding performance 70

3.17 Jason Freeman 72

3.18a Flor de Fuego 74

3.18b Flor de Fuego 74

3.18c Flor de Fuego 74

3.19 Sarah Groff Hennigh-Palermo 76

3.20 Haus++ 78

3.21 TidalCycles code 80

3.22a Timo Hoogland 82

3.22b Timo Hoogland 82

3.23 Miri Kaat 84

3.24a Livecoding jam with Abhinay Khoparzi, Akash Sharma, and Joshua Thomas 86

3.24b Workshop on the Marching JS livecoding platform 86

3.25 Four time-lapse examples of live coded graphics 88

3.26a Melody Loveless and Caitlin Cawley 90

3.27 Mynah Marie, a.k.a. Earth to Abigail 92

3.28a MicoRex 94

3.28b MicoRex 94

3.29 Live coding and using charts for computer-aided composition 96

3.30a Livecoded Splatter in Livecodelab 98

3.30b Altered live coded piece 98

3.31 Punctual live coding language 100

3.32a Jonathan Reus 102

3.32b Jonathan Reus 102

3.33a Chemical Algorave 104

3.33b Chemical Algorave 104

List of Figures

3.34 Top image: Annotations in Gibberwocky show waveforms that are periodically sampled to generate musical patterns. Bottom image: Multiple post-processing shaders stacked in Gibber to create an abstract form 106

3.35 Screenshot from live coding performance INVOCACIONES 108

3.36 Screenshot of live coding with TidalCycles and Hydra 110

3.37 Kate Sicchio 112

3.38 th4 114

3.39 Anne Veinberg and Felipe Ignacio Noriega 116

3.40 Rodrigo Velasco (yecto) 118

3.41 Elizabeth Wilson 120

3.42 Anna Xambó 122

4.1 Visualization of the eight-bit registers of a Z80 microchip as it performs simple calculations, demonstrating the relationship between computation and weaving 137

4.2 Melody Loveless performing as part of the New York DigiAna stream, September 12, 2020 146

4.3 Orca live coding environment 147

4.4 "Keep Live Coding Live" sticker 156

Series Foreword

Software is deeply woven into contemporary life—economically, culturally, creatively, politically—in manners both obvious and nearly invisible. Yet while much is written about how software is used and the activities that it supports and shapes, thinking about software itself has remained largely technical for much of its history. Increasingly, however, artists, scientists, engineers, hackers, designers, and scholars in the humanities and social sciences are finding that for the questions they face, and the things they need to build, an expanded understanding of software is necessary. For such understanding they can call upon a strand of texts in the history of computing and new media, they can take part in the rich implicit culture of software, and they can also take part in the development of an emerging, fundamentally transdisciplinary, computational literacy. These provide the foundation for Software Studies.

Software Studies uses and develops cultural, theoretical, and practice-oriented approaches to make critical, historical, and experimental accounts of (and interventions via) the objects and processes of software. The field engages and contributes to the research of computer scientists, the work of software designers and engineers, and the creations of software artists. It tracks how software is substantially integrated into the processes of contemporary culture and society, reformulating processes, ideas, institutions, and cultural objects around their closeness to algorithmic and formal description and action. Software Studies proposes histories of computational cultures and works with the intellectual resources of computing to develop reflexive thinking about its entanglements and possibilities. It does this both in the scholarly modes of the humanities and social sciences and in the software creation/research modes of computer science, the arts, and design.

The Software Studies book series, published by the MIT Press, aims to publish the best new work in a critical and experimental field that is at once culturally and technically literate, reflecting the reality of today's software culture.

Acknowledgments

This book is a product of slow development. The idea was first discussed by the authors at the Dagstuhl seminar "Collaboration and Learning through Live Coding," organized by Alan Blackwell, Alex McLean, James Noble, and Julian Rohrhuber in 2013, and has subsequently been developed over many years with different levels of intensity. The seminar reflected on the emerging practice of live coding at that time to better understand the potential of live coding for informing cross-disciplinary scholarship and practice and connecting the arts, cultural studies, and computing. Importantly, from the outset, discussions and ideas were grounded in practice (including that of the authors), and ongoing dialogues with the live coding community have been crucially important throughout the development of our writing.

Many of the ideas first discussed at the seminar—including the way we think about programming and wider cultural concerns around notation, liveness, and temporality—have made their way into the book and have been further developed through various publications, events, and conferences over the years, including, most notably, the International Conferences on Live Coding held in Leeds, UK (2015), Ontario, Canada (2016), Morelia, México (2017), Madrid, Spain (2019), Limerick, Ireland (2020), and online from Valdivia, Chile (2021). Further early inspiration derived from research projects such as Live Notation: Transforming Matters of Performance (2012), led by Alex McLean and Hester Reeve working in dialogue with an international network of live artists, coders, and theorists. Thanks go to Arnolfini in Bristol for hosting the first Live Notation Unit event in 2012, and the connection to performance research was emphasized in Emma Cocker's essay "Live Notation: Reflections on a Kairotic Practice" (2013). The UK Arts and Humanities Research Council funded the Live Coding Research Network between 2014 and 2016, led by Thor Magnusson and Alex McLean, which ran three symposia on topics such as live coding and embodiment, live coding in the arts, and live coding and education. The network also launched the International

Conference on Live Coding series. We are also grateful to individuals who engaged with the research project Weaving Codes/Coding Weaves (2014–2016). Ellen Harlizius-Klück and Alex McLean led this project, working with Dave Griffiths alongside Emma Cocker as critical interlocutor, through workshops and residencies including the Centre for Textiles Research, Copenhagen (October 2014); Centre for Participatory IT, Aarhus University (October 2014); Museum für Abgüsse Klassischer Bildwerke (Museum for Plaster Casts of Classical Sculptures), Munich (May 2015); FoAM Kernow, Cornwall (October 2015); Institute for Music and Media, Dusseldorf (January 2016); Threads and Codes symposium, Goldsmiths, University of London (March 2015).

These are a few of the many interconnections that have brought the authors of this book together and the range of fields of expertise and practice they embody across diverse fields—which broadly include computer science, critical design, software studies, computer music, performance writing, cultural studies, contemporary art, and artistic research. Yet, of course, this collective effort extends beyond the authors alone to the many conversations with the broader community of live coding, the interviewees who informed chapter 2, and the contributors to the expositions of practice in chapter 3. The TOPLAP blog, wiki, mailing list, and forum, first established in 2004, is key to the wider exchange of ideas, and more on this and the history of live coding are discussed in chapter 2. Undoubtedly, the thoughts expressed in this book would not be possible without this broader exchange of ideas across various international networks, and we hope this is sufficiently acknowledged given the impossibility of tracing their origins as such. In this connection we are especially grateful to the following: Sam Aaron, Robert Biddle, Andrew R. Brown, Maria Chatzichristodoulou, Luke Church, Nick Collins, Alberto de Campo, Giovanni Fanfani, Yuen Fong Ling, Thomas Green, Dave Griffiths, Mark J. Guzdial, Janis Jefferies, Jan Kees van Kampen, Shelly Knotts, Adrian Kuhn, Annapurna Mamidipudi, Brigid McLeer, David Ogborn, Jochen Arne Otto, Roly Perera, Hester Reeve, Julian Rohrhuber, Juan Gabriel Alzate Romero, Uwe Seifert, Kate Sicchio, Andrew Sorensen, Andre Stitt, Giuseppe Torre, Renate Wieser, Matthew Yee-King, and Ellen Harlizius-Klück. We would also like to thank again all the live coders who contributed their expositions to chapter 3.

Many of the chapters are in some parts derived from our previously published papers, reworked and revised as part of the collaborative writing process. We have acknowledged these in the footnotes, and again key texts by the authors can be found in the full bibliography. We also acknowledge funding from the following sources that supported our research toward this book: PENELOPE project, European Research Council (ERC) under the European Union's Horizon 2020 research and innovation programme (grant agreement No. 682711); Arts & Humanities Research Council (AHRC) Live Notation Network

Acknowledgments

grant; AHRC Live Coding Research Network grant (AH/L007266/1); AHRC Weaving Codes, Coding Weaves (AH/M002403/1); INTENT project, European Research Council (ERC) Consolidator Grant (grant agreement No. 101001848); AHRC Sonic Writing Fellowship Grant (AH/N00194X/1); UKRI Future Leaders Fellowship Algorithmic Pattern (MR/V025260/1); Aarhus University Research Foundation travel award (for funding Geoff Cox's research leave at the Computer Laboratory, University of Cambridge, in 2016); The Contemporary Condition research project at Aarhus University, made possible by a grant from the Danish Council for Independent Research (DFF-4180–00199).

Special thanks go to Doug Sery at MIT Press for his initial support of the project and subsequently to Noah Springer, Lillian Dunaj, Christine Marra and Wendy Lawrence, as well as to the anonymous reviewers who helped to sharpen our writing. We are especially grateful to be able to publish our work as an open-access publication under a copyleft CC-BY-SA license that in so many ways reflects the ethos of the live-coding community. Our institutions have been generous in providing financial support to allow this to happen: School of Arts and Creative Industries, London South Bank University; School of Art and Design, Nottingham Trent University; Library of the University of Sussex; Deutsches Museum, Munich. Through this support we offer the various chapters as necessarily works in progress, open to further timely updates, that reflect the subject matter of the book as a dynamic form and practice.

The book is dedicated to the international community of live coders.

1 Introduction to *Live Coding: A User's Manual*

So what do we mean by calling this book "a user's manual"? This is no arbitrary choice of terminology. A manual is a handbook, traditionally small enough to hold in the hand (*manus* being the Latin word for "hand"), a support for action. The manual can be repeatedly referred to—it is a source of information that can be applied or performed. We hope that this book can serve as a source and inspiration for live coders and for wider users of code. When it comes to computing (not least), the term *user* seems at first to be rather limited and functionary, even when describing well-meaning notions such as user-centered or user-friendly, which are both part of a more general shift toward seemingly inclusive and participatory forms. However, as much as it is clear that the user is open to subtle forms of exploitation,[1] we argue that the user might also be a force for reinvention.

If you are expecting a conventional user's manual, then put this book down. As the title suggests, live coding is there to be used, not least to make visible the materiality of the computer and the varied experience of its usage. It is a user's manual of sorts, but not in any conventional technical sense of being a prescribed set of instructions or a how-to recipe book on how to do live coding. Indeed, there can be no conventional user's manual for live coding because there can be no universal way to understand or practice live coding.[2] There is no universal language to code in, to start with. It is this pluriversal capacity of live coding to resist or trouble any easy classification, categorization, or explanation that we take as our provocation for (the impossibility, or at least challenge of) writing this book.

Certainly, there is something perverse in writing a book about live coding. On the one hand, books are not particularly well suited for registering the dynamic processes of how writing and coding operate as distinctive cognitive practices, unfolding in time. Even static code is poorly expressed once printed on the pages of a book—although it is common enough for programming manuals and textbooks to do just this, encouraging

the reader to read and doggedly type out the program in order to execute it. On the other hand, the very constraints of the printed form allow for other critical reflections to take place, while the textual qualities of writing code can be understood in the broader context of linguistic form, both on the syntactic and semantic levels. Perhaps the disjunction allows certain kinds of thinking to emerge that register how writing and coding are particular technologies that generate particular readings and contingencies. Accordingly, this first chapter operates as a broad introduction to live coding alongside speculation on the inherent reflexivity of technological form, in which the process of writing a book on live coding registers its own particular temporality.

What Is Live Coding?

Live coding has been described in terms such as writing software in real time, changing a program while it is running, projecting the screen for the audience to participate in, writing as an improvisatory practice, composing live using textual notation, changing rules while following them, *conversational programming* (conversing with the computer in its own native language), thinking in public, and creating and using bespoke systems tailored for *on-the-fly* or *just-in-time* performance. However, as live coder David Ogborn states, "To define something is to stake a claim to its future, to make a claim about what it should be or become. This makes me hesitate to define live coding."[3] Live coding is a performance practice that operates as an adventure and exploration, deliberately rejecting fixed definitions, remaining heterogeneous in nature, continually challenging its self-understanding through the practice of writing and rewriting—defining and redefining—as a public performance. With no formal definition (or at least only one that includes the possibility of its own redefinition) also comes some resistance to hierarchical control—live coding cannot really become owned by established practitioners or institutions. In asking "What is live coding?," our intention is not to fix or define but rather to explore how live coding *opens up*. Live coding is about people interacting with the world, and each other, in real time, via code.[4] Live coding is about making software *live*.

To make software live is not a brand-new proposition,[5] as over the past two decades a worldwide live coding movement has emerged within a performance context that throws new light on code-as-interface through an explosion of new tools and practices. Live coding asks questions about *liveness*, inviting us to reflect on what it means to be *live*—to have bodies, to communicate, to act. When we write code live, we adapt it to our needs, and it adapts us in return. In this book we consider how the performance practice of live coding has been enabled by an increased capacity for liveness within

computer programming more broadly and in turn how the performance of live coding proposes new ways of operating, posing questions and challenges to some of the underpinning values and ideologies of a wider computational culture.

Live coding involves a critical orientation toward the otherwise conventionalized work of programming and software engineering.[6] For live coder Sarah Groff Hennigh-Palermo, "This way of computing … helps me 'unthink' the engineering I do as my day job. It allows for a relationship with computers where they are more like plants, rewarding cultivation and experimentation."[7] Live coding gives us a way to think otherwise about coding—what it *can be*, rather than what it *is*. We might consider this capacity of live coding as a technique of *making strange* (or defamiliarization), in the sense first intended by the Russian literary theorist Viktor Shklovsky, as presenting familiar things in a strange way in order to enhance apperception.[8] Live coding *makes software strange*,[9] allowing us to see beyond routine practices and interpretations of code. This book explores the wider context within which the performance practice of live coding emerges while inviting reflection on the potential of what it might become.

Toward the end of the twentieth century, computers were becoming omnipresent across many areas of arts practice, and communities of musicians and artists were beginning to form around specific programming languages (notable are audio programming languages such as Max/MSP, SuperCollider, Pure Data, and CSound). Artists were beginning to use code as a creative material to express music, visuals, choreography, robotics, video, and computer games. With code as the material and the laptop as a studio, the traditional divisions between art, music, architecture, design, and game development blurred, and educational institutions began to respond with new interdisciplinary approaches to learning how to program computers. By the year 2000, prototypical live coders began to arrive on the scene with a distinct approach to live programming, straddling performance and creative computing. These coders asked: Why not simply use the technology to *show* what we are doing? Why not *show the screen* and be more transparent about how we are conversing with our machines in our own languages?

Live coding involves showing the screen or making visible the coding process as part of a live performance. Broadly speaking, it describes the improvisatory real-time composition of predominantly computer-generated audiovisual material, in which the writing of code itself (or other executable instructions) is presented as a live event for an audience. Alongside witnessing the coder engaged in the live act of coding (laboring at their laptop), the code itself is also presented—typically projected—in real time as it is being worked on as a visible part of the performance. In one sense the imperative to show the screen might be considered a response to the audience's frustration or need to *see* something during coding performances, or even a way of foregrounding the

technical credibility (even virtuosity) of creative coders. However, for many live coders the practice of showing the screen is a critical gesture in its own right.

Despite reluctance to be constrained by definitions, one popularly cited formulation is that live coding is best characterized as *thinking in public*, a phrase derived partly from the etymology of programming as *writing in public* (Greek *programma*, from *prographein*, "write publicly"). For some live coders, making these private intellectual and creative activities publicly visible has a liberating effect, while at the same time introducing an imperative of clarity within coding and turning each algorithm into artwork accessible through simplicity of purpose and expression. Live coding unveils the underlying operational layer of activity beneath the more familiar, readable gestures of computational performance. Commitment to a mode of thinking that is open and creative, especially when made public, can thus acquire the status of a political act.

When interpreted in the context of cultural experience, live coding is not only fundamentally an "open work"[10]—inasmuch as constituents of it are left open to the laws of improvisation, chance, or intervention by the public—promising an aesthetic experience that matches the networked online community aspirations of the internet era (specifically free software principles) but, significantly, a broader DIY, punk, and postpunk ethos. The ambitions of such work are far-reaching for technologies that support new styles of conversational programming—that are nonlinear and routinely interactive, with software infrastructures that are not static monuments to the achievements of the past but dynamic processes of engagement with the future. The temporality that is implicit in technologies of control becomes subverted by software in the *present tense*. The distinction between human action in the moment and systems-based planning has been a constant tension for the theorists of human-computer interaction. As we explore in the later chapters of this book, the intersection of these modes of thinking with the socioeconomic and corporate infrastructure of the software industry is unavoidably political.

The capacity of live coding for making visible counters the *smart* paradigm in which coding and everyday life are drawn together in ways that become imperceptible. The invisibility here operates like ideology, where lived experience appears increasingly programmed, and we hardly notice how ideology is working on us.[11] If we follow this logic, then we do not *use* computers; they use *us*. Along with the disappearance of the computer, as one of the tenets of contemporary interface design established through technical programs of pervasive and ubiquitous computing,[12] artist Olia Lialina identifies that the *user* is disappearing as well—both the phenomenon and the term.[13] This is a problem for her (and us) inasmuch as *Big Tech* wants computers to be invisible so our experience of using them becomes seemingly natural.[14]

Against received wisdom that would tend to be skeptical of the term *user*,[15] Lialina reclaims the possibility of what she calls the *Turing Complete User*, referring to users who have more autonomy over computer use regardless of the primary purpose of an application or device. As Lialina states: "Being a User is the last reminder that there is, whether visible or not, a computer, a programmed system you use."[16] It is in this sense, too, that we invoke the user in the title of this book.

Critical-Creative Contexts

Live coding emerges through a critical relation to the wider programming and software-engineering context. However, it has also evolved in dialogue with the various creative practices that find new expression in and through live coding, including choreography, the visual arts, poetry, and especially music. In one sense, in the context of live coding, music often becomes a metonym for other performance practices. However, this is not meant to reduce or homogenize all other art forms, and within this book we explore how ideas, practices, and theories emerging from wider interdisciplinary contexts open up new ways of conceiving live coding's distinctiveness. Still, the musical analogy warrants attention, for it invites particular consideration of the specific things that live coding *does*.

For musicians in the classical notated tradition, every note they play is predetermined by the composed score, to which live performance adds expressive adjustments. In contrast, performers of jazz, folk, and rock music might follow a chord sheet but often have the freedom to choose notes within those chords. Free jazz improvisers have even more freedom. But a live coding musician is like an improvising composer, able to transform the whole structure of the piece with a few keystrokes. The code is the score, and the computer performs the music (in a sense) as the audience watches it being written. The live coder breaks down and works outside the established dichotomies of score/performance, composer/performer, and composition/improvisation.

The technologies of music-making are diverse in their acoustic, electronic, and digital forms. Established genres of recorded music control many layers of adjustment, from basic acoustic vibrations to electronic filtering, sampling, mixing, and remixing using tape loops, turntables, or disk drives. As digital alternatives have become available at all of these different layers of sound production and manipulation, all are accessible via code, turning the laptop into a kind of universal *instrument* whose own capabilities and boundaries can in turn be redefined.

The capacity of live coding to have an impact on the production of music is clearly evident. However, we argue that all performance practices (including music) offer a special

way of understanding software and that this has radical potential for all software—not only for artists, their audiences, and art theorists but also for engineers, philosophers, and activists. Scripting a performance is like programming a computer because both involve ordering events in time. Music and dance are art forms concerned with movement over time, from fluctuating waveforms or movements making up individual actions to sequences of actions and the rhythmic patterns in which they play out. Everybody knows that performances can be captured digitally, but it is not so widely understood (or even accepted by computer scientists) that computers and algorithms are fundamentally concerned with time or that using computers and making software is a kind of performance in itself. In these terms, live coding helps us to gain new insights about what software can be.

Programming languages, like languages in general, offer ways to describe things compositionally, through a structured system of communication. Programming languages are often used to describe algorithms, but we can also describe algorithms with human languages. Language comes alive through the body, through communication with others, and through writing systems. In this book we argue that live coding can transform human experiences of technology through these same connections.

Open Potential and Interdisciplinary Perspectives

As stated at the outset, this book is not a conventional user's manual. The title borrows from the combinatory literature of Georges Perec and his 1978 book *Life: A User's Manual*, a collection of interwoven stories based on the lives of the inhabitants of a fictitious Parisian apartment block.[17] More than a passing reference to Perec, the experimental writers group OuLiPo (Ouvroir de Littérature Potentielle, of which Perec was part) draws attention to the careful, even programmatic, use of language and in turn has helped us better understand our own endeavor of writing this book on live coding. For example, the French term *ouvroir* refers to a place where people work together on a difficult task, deriving new techniques; more precisely, the example is given of a sewing circle, which we believe is a good metaphor for the practice of live coding. The *littérature potentielle* of OuLiPo speaks of a search for new forms of writing, as Perec states: "We call potential literature the search for new forms and structures which may be used by writers in any way they see fit."[18]

We see live coding (and our attempt to write *with* it as much as *about* it) operating in this spirit, as a search for new arrangements of form and structure while staying mindful of the formal rules and constraints associated with computing in dialogue with creative practices such as music, choreography, and the visual arts. By appropriating

Perec's title, we indicate our ambition to open up the forms and structures of live coding to close description, analysis, and experimentation, revealing it to be in a perpetual state of potential transformation into something else. For us, live coding has something of this sense of reinvention, an ability even to unsettle the relationship between code and life—and that is what this book is about.

The composition of the authorship of this book also reflects OuLiPo's interdisciplinary perspective (which in its case included mathematics, computer science, and literature) by bringing together different disciplines and orientations within a shared project. Our own writer's group embraces diverse practices and theories, as well as conventions and histories, drawn from music, interdisciplinary design and software development, software studies, and network culture alongside areas of artistic research, contemporary art, and performance. Live coding operates at the threshold of these different practices and disciplinary perspectives, and we wanted to reflect that in the style of the book itself. We write from *within* the field of live coding, as practitioner-scholars writing from the insider's perspective, from the viewpoint of live coding performers and software innovators, as well as through wider interdisciplinary scholarship that considers how live coding relates to a wider contextual field, including situating live coding within philosophical, political, and performance-based practices. Our interdisciplinary exchanges have not only happened on the page and in the process of writing the book. Rather, over several years (and throughout the duration of the book's development) we have talked, discussed, and explored live coding in dialogue with various research projects, networks, and conferences, as well as through live encounters within numerous festivals and algoraves.[19]

Each and every chapter has been coauthored in various ways. Certainly, this has been a complex undertaking. At times, different contributing voices become tangible through a perceived shift in style or semantics or through the meeting of different—even seemingly incompatible—references or ideas. Over many years we have gradually gathered fragments of thoughts and ideas. In places, the transition from one voice to another might appear smooth and seamless; elsewhere, the reader might notice the sudden break or change in tack. Through this approach to coauthoring the book, we draw attention to the etymological relation of *text* to *textile*: from the Latin *textus*, literally "a thing woven," or from *texere*, meaning to weave or interweave, to braid or fit together.[20] In doing so we reflect the collaborative principles of live coding itself and the desire and potential therein for bringing different systems into dialogue. In writing together we have also become attuned to the potential of writing the book itself as an improvised, collaborative performance.

Live coding necessarily draws attention to the writing machine—including laptops, source code editors, and so on—and the material production of text or code, book, or

even computer hardware.[21] It is also connected to the body of the author and reader (producer, worker), and it becomes clear that writers, readers, texts, coders, machines, and codes all have bodies and that these become operative under particular sociotechnical conditions. Informed by the practice of live coding—and our skepticism about some of the conventions of academic writing and its singular authoritative voice—in the process of writing this book we began to explore some aspects of liveness, experimentality, and reflexivity within our collaboration.[22] To focus attention on the performative dimension of live writing as analogous to live coding calls into question some of the static assumptions of communicative forms and instead foregrounds material conditions and their effects, as well as the wider sociotechnical infrastructures through which they are served. It is also worth remembering that all writing *is* technology, and live writing, like live coding, is able to activate slippages of meaning and ultimately demonstrate how writing subjects and objects become thoroughly entangled.[23]

In writing this book, we also reflected on the jumbled experience of time that the writing of books conduces.[24] By writing about writing as we write, we identify a parallel to the way that live coders edit code as it runs. In this way, examining live coding and live writing together usefully confuses any strict definitions between them, as well as between the act of writing and its execution, allowing us to rethink some of our preexisting notions of notation, liveness, temporality, and knowledge production, which in turn become the focus for the various chapters (4–7, respectively) of this book. While we have only gestured toward this experimental and reflexive attitude toward writing about live coding, it does suggest another book yet to be written (and one at times we thought we were writing here). For now, the book that you are reading takes a more conventional form.

Navigating the Book

The structure of the book is broadly bipartite. The first part is more practice focused, offering an account of the origins, development, and aspirations associated with the evolution of live coding alongside presenting documentation and examples of live coding practice. The second part is more speculative and conceptual in its register, allowing space for discussion of the many ways live coding reflects and informs wider cultural and political concerns. In this sense we identify live coding as a *critical technical* and *aesthetic practice*, able to activate sensemaking across interdisciplinary fields.[25]

Chapter 2, "Partial Histories," informed by research interviews and primary sources, focuses on the history of live coding, taking our point of departure from the TOPLAP manifesto of 2004.[26] Far from the intention of establishing a canon here, we take live

coding to be a way of addressing some of the assumptions of historicism more broadly and of the progressive technological development that we develop in later chapters. It highlights some of the wider conditions from which live coding has evolved, including the recent history of computer-based music (since the 1980s) and the interest in digital culture within art schools around the mid-1990s, alongside an increased wider cultural interest in creative coding (since the turn of the millennium). We acknowledge various technological catalysts and precursors to live coding, the influence and significance of specific individuals and collaborations, and the importance of receptive and proactive venues and festivals in creating a context for the emerging practice of live coding. We chart the arc of this burgeoning practice from its inception and instituting moments to its becoming established within various institutional frames while arguing how the insurgent and irreverent imperative of live coding has continued to thrive through the new genre of algorave.

The third chapter, "Expositions," presents live coding in its singularity, exposing the specific approaches through which live coding manifests within a diversity of different practices. Forming a parallel history of the field, it includes diverse voices from live coders themselves as reflective performers and innovators. Occupying a central position within the book, the focus on distinctive practices spans the different waves of live coding, from the more tentative explorations preceding the formation of TOPLAP in 2004 to the focused campaigns of popularizers and the cultural transformation of live coding as it has spread around the world.[27] It includes both the creators of new live coding tools and those who have developed artistic practices through using those tools. We do not attempt to synthesize a single narrative for this chapter but provide an opportunity for the diversity of the field of live coding to be represented through individual voices, through rich accounts of practice itself. We refer to these presentations of practice as *expositions*, a term from the field of artistic research for describing how the epistemological contribution of a given practice is exposed, often through a combination of the practice, its documentation, and writing.[28] The epistemological dimension of live coding and the question of "what live coding knows" is further explored in chapter 7.

Following the practice-based expositions is a shift in orientation toward the wider issues that live coding raises in relation to notation, liveness, time, and knowledge, as well as its future. Chapter 4, "Notation," focuses specifically on the notational nature of the live coding performance. The generative relationship between a notation and what is notated is what drives generative creativity in the live coding field. The perceptual gap between the notational map and the generated territory allows the live coder to reach beyond their imagination and work with notation not to efficiently realize a ready-made idea but to *follow* an idea to see where it takes them. The function of

notation in live coding can be seen as threefold: it is the syntactic structure read by the language interpreter that executes the program, it is the action or movement of the performer that is projected to the live audience, and it is the music itself as notated by the live coder. This chapter unpacks these ideas further, exploring how the momentary nature of a live coder's notation might be closer to speech than to text. Or rather, live coding practice finds itself caught between two worlds, as it is too ephemeral to be score-based culture and yet too centered on text to be oral culture. The focus is therefore not only on the notation but what is notated and the activity of notation—the nature of the deterministic algorithms that live coders work with and the dynamic ways in which they are crafted. By examining how live coding challenges tensions and dichotomies such as those between determinism and liveness, between musical improvisation and composition, and between oral and written culture, we find new approaches to notation as a dynamic, live medium.

This quality of liveness is explored further in the chapter 5, "Live Coding's Liveness(es)." It explores the implications of live coding for our understanding of liveness by asking: What kinds of liveness are produced within live coding, and with what effects? What does this indicate about the relations between technology, performance, and even *life* that live coding suggests? The chapter draws on different theoretical ideas of liveness and performativity to demonstrate that live coding does not sit easily within any singular theoretical framework: its liveness must be apprehended from more than one epistemological and ontological perspective in which the *hierarchy of liveness* conceived in computational terms collides with a wider discourse on embodiment, vitality, and performativity. The chapter explores how complex conceptualizations of liveness are negotiated through the human-machine relations central to live coding, in turn raising wider contemporary concerns about what it means to be alive, operative, and actively present in the world. Live coding presents a direct challenge to the conventional understanding of liveness and to the lived experience of time, both with respect to the role of the programmer and user and, crucially, through the way the machine understands time, whether in a wiki edit, a keystroke log, a page render, or a print queue.

Chapter 6, "Time Criticality in Live Coding," explores how live coding activates the present in all its complexity. The time criticality we speak of points to this inherent processuality of the computer and programming to perform and express dynamic operations in the present: it is both critical on a technical level and on a conceptual level and moves toward *criticality* in the sense that we emphasize practices that actualize potentialities in real time rather than simply expose problems. Across the chapter as a whole, live coding offers a complex multitemporal human and *more-than-human* experience of time—human and machine times become entangled, both in and out of

what we conventionally understand as time. In exemplifying the coming together of multiple temporalities and different types of time, the practice of live coding contributes toward new understanding about our contemporary temporal experience. Moreover, how does live coding *itself* temporalize and actively produce—activate, intervene in, invent, and reorganize—as much as *reflect* different experiential temporalities? Thus, we not only acknowledge that time plays a crucial role in live coding in terms of the unfolding of time in its performance—as in a timeline or score—but also demonstrate how time can be manipulated, and indeed produced, through such means.

In asking "What Does Live Coding Know?," chapter 7 explores the engineering contexts in which the necessary technical knowledge has been generated and applied and the contexts of creativity where *know-how* from several perspectives crosses the boundaries of computer science, craft practices, and artistic research, as well as the sense of indeterminacy that is inherent to the medium. Our intention is to explore *beyond* the knowledge needed to practice live coding, extending to the knowledge that is acquired or that emerges, or is even assumed, in and through that practice. Live coding comprises technical, artistic, and philosophical inquiry, for it not only draws on and from specific fields of knowledge but, as a practice, asks specific epistemological questions. Here, we can draw on the interdisciplinary work of Philip Agre, whose concept of a *critical technical practice* pertains to the philosophical enterprise of artificial intelligence as pursued through technical work,[29] where critical and cultural theories intervene in engineering practices as a way of inviting reflection on the underlying assumptions and ideologies within technological design. Live coding presents a challenge to our categories of knowledge, in both its scholarly and technical-professional realizations. Of specific interest for us is the way in which it operates at the threshold of different species of knowledge, troubling its classification. In posing the question "What does live coding know?," the intention is to expand beyond an anthropocentric and culturally specific understanding. Here, what live coding knows is not synonymous with what the live coder knows but rather refers to the epistemological potential of the practice itself, including the multiple knowledges arising in and through the collaboration with machines. Our suggestion is that the live *intra-actions* of programmer, program code, and the practice of coding defamiliarize knowledge production and expose how making and thinking might escape familiar forms and normative applications of inscription practices.[30]

The final chapter, "What Does Live Coding Want?," shifts the focus from what live coding *knows* to the question of what it *wants*—inviting dual reflection on both the agency of code and the future of live coding. This chapter initially draws out some of the political implications relating to the operations of algorithms. Algorithms, which increasingly manipulate and control our social systems, are not as fixed or as

deterministic as they might first appear but rather are emergent and reactive phenomena, subject to constant *live* updates. They are also part of larger sociotechnical assemblages and infrastructures that are constantly evolving and subject to variable conditions and contingencies that include the lively contributions of coding or writing. Perhaps what is at stake here is a deeper exploration into the ways that space and time are constructed when coding and writing and maintaining the best practices of the arts and the academy in the face of corporate data infrastructures. Live coding is an open-ended performative process that attempts to reject deterministic or previously held certainties over the ways that meanings are generated and disseminated. This provides a counterspace for agency in human and nonhuman entities that is produced through a fuller understanding of the operations of the material-discursive systems that we are written and coded into. In the case of writing this book, we acknowledge that to some extent it also *writes us*.[31]

Live coding conceives of technology as fluid phenomena open to transformation and exploration, including through the live redesign of instruments or the live rewriting of scores. Live coding rejects easy definition, continually challenging its self-understanding through the practice of defining and redefining itself as a public performance—in the way a Wikipedia entry invites rewriting. Such a mode of writing—done with "shaky hands"[32]—expresses the ability to move, change, and explore the unknown. Writing has no beginning or end in this way as it opens itself up to its relations with existing works and its future extensions. The issues that we engage in this book in reference to live coding continue to be developed through ongoing work, inasmuch as all books are provisional and open to multiple interpretations as well as further modification.[33] Thus, any sense of a beginning or end to this introductory chapter (and the book more broadly) is only a temporary holding position in lieu of further thoughts and future developments, which ultimately serves to demonstrate how readers might become writers.

2 Partial Histories

Instead of attempting to establish a historical canon for live coding, this chapter recognizes that live coding is a way to question assumptions of historicism, as well as liveness and temporality, which are addressed in later chapters.[1] We approach the idea of *partiality* through the concept of Donna Haraway's *situated knowledges*: we do not adopt a universal perspective but recognize that knowledge is produced in lived realities and in doing so makes our partiality transparent.[2] So in calling this chapter a partial history (or rather, *histories* in the plural), we draw attention to how histories are created. As such, we urge readers to remain skeptical of how we have pieced together some of the details of the development of live coding and how we have made sense of events *after the fact*. Going beyond the contingency of any history (given the fallibility of human memory, the instability and partiality of events, and the complexity of emerging digital narrative forms and the forces that shape them), a straightforwardly historicist approach must be questioned in relation to the fundamental liveness of live coding.[3]

The narrative history of live coding that we have assembled in this chapter has therefore been prepared in a manner that echoes live coding itself, using a process that has been collaborative, experimental, improvised, and reflective.[4] Moreover, the text that you are reading now draws on the subjective experiences of key practitioners and their memories—embracing the stories *and* the falsehoods—and was developed through a series of interviews back in 2016 with those whom we considered to be key figures in the live coding community at the time. They included some of the authors of this book, who were interviewed by other authors.[5] Based on these interviews, the individuals who appear in the following sections (with initials that will be used when referring to our thematic analysis) are AA: Amy Alexander; AC: Alexandra Cardenas; AdC: Alberto de Campo; AM: Alex McLean; AS: Andrew Sorensen; BatMan: Benoit and the Mandelbrots; DG: Dave Griffiths; DO: David Ogborn; GW: Ge Wang; JA: Joanne Armitage; JR: Julian Rohrhuber; KS: Kate Sicchio; MH: Mike Hodnick; NC: Nick Collins;[6] SA: Sam Aaron; SK: Shelly Knotts; TM: Thor Magnusson. Our choice of interviewees takes

in perspectives of the genesis of the live coding movement in Europe and the US and subsequent import and development in Mexico and elsewhere. We are alert to questions of diversity in choosing such a sample. Women were engaged in live coding from its inception, although in smaller numbers than men. We note in particular that this list reflects the limited ethnic diversity (at least in Europe) of the early community.[7] As live coding techniques have recently found wider adoption, this picture has somewhat changed, as reflected in the variety of expositions shared in the following chapter.

Live Coding Narratives and Nonlinear Histories

Before reflecting on the specific histories of live coding, it is worth briefly considering a wider contextual frame for creative coding, specifically in relation to computer music, from which live coding initially emerged. The history of computer music extends back to 1956 when Lejaren Hiller and Leonard Isaacson began working on their *Illiac Suite*, applying Markov models to generate a musical score. In the following decades, composers and computer scientists wrote bespoke software for score generation and synthesis, but none produced sound in real time, due to the technical limitations of that generation of computers. A key trajectory is mapped through the series of languages, known as MUSIC-N, created by Max Mathews, which along with its descendants, such as CSound, provided the theoretical foundations for much of the software described in this book. By the late 1980s when the period covered by our interviews starts, *computer* music was primarily based on sequencing the notes played by hardware synthesizers and samplers rather than real-time software synthesis. Commercial software design was aimed at simulating recording studios and was rarely used in real-time performance. Software enabling musicians to write algorithmic music, such as Max and Open Music,[8] developed at IRCAM (Institute for Research and Coordination in Acoustics/Music) in Paris, started to emerge from research and academic environments, but it was in the 1990s that mass-produced computers began to be fast enough for real-time audio processing. Programming languages with a focus on real-time audio processing, such as Miller Puckette's Pure Data and James McCartney's SuperCollider, were able to directly synthesize sound from algorithms and filter and combine incoming audio streams and/or stored samples.[9] Later in this chapter, we focus on the pivotal moment at which these technologies intersected with interactive approaches to programming. While real-time audio processing still required relatively expensive computers, by the mid-1990s, individuals were beginning to be able to do this type of work on high-end laptops. By the late 1990s, a new electronic music scene had emerged where people would bring laptops into clubs and pubs, placing themselves (or being placed, as performers) on the stage with their laptop.[10]

In most of these early performances, there was little to see: audiences simply watched a performer sitting on stage without visuals or any gestural movement. The initial idea of the practitioners was that—as electroacoustic musicians had claimed three decades earlier—people would get used to the *nonevent*, or rather the nonvisual event, of the performance. However, the tendency of the audience to keep watching for something, even if just the movement of a mouse, made it obvious that there was space for other things to happen on stage. As video projectors became cheaper, new responses to this opportunity came within reach, including VJing and abstract visualization of the audio signal.[11] Most performance venues became equipped with projectors set up to project onto the stage. Although there are precedent cases of live coding in the arts—such as the Hub in music, Larry Cuba in the visual arts, and diverse experiments with live programming or interactive programming in computer science—it is really the foundation of early 2000s electronic music that becomes the context of live coding's growth as an artistic form, which now includes music, visual arts, dance, and other creative forms.

The 1980s: A Generation of Geeky Artists

The gradual expansion of computer-based electronic music (since the 1980s) and increased cultural interest in creative coding (since the turn of the millennium) both helped to shape the wider conditions from which live coding evolved. However, the personal histories of prototypical live coders reveal a distinctive pattern, which often combined early exposure to technological development and access to creative contexts within which to experiment. The first generation of live coders were children of the late 1970s and 1980s, for whom the computer was both a promise and an obligation. Where they could afford them, their parents bought home computers, but the potential of these machines was often just out of reach. Time spent with ZX Spectrums, TRS-80s, CP/M microcomputers, and Commodores was often grabbed from an older sibling or shared with an eager parent. There were few computer games, so you had to write your own. But with no internet to turn to for advice, the text laboriously copied out of magazines seldom worked. The opportunities for creative expression were often little more than simple beeps or colored blobs on the screen.[12] The "random" [RANDOMIZE, or RND] key word was an essential escape from complete boredom.

Schools in the 1980s were also investing in Apple IIs and BBC Micros, but creative coding was not the first priority in computer science education. Given the relatively limited resources, education in computing was task focused rather than imaginative or playful.[13] Whether or not they had creative experiences with computers, many live coders did have creative childhoods. Many headed for careers in the professional arts through early promise as instrumental musicians, dancers (KS), or composers (SK, MH).

Some won prizes, formed bands, and performed as soloists on piano (NC, AA), trumpet (AS), or percussion (AC) or switched to guitar (TM, AdC) or saxophone (SA) so they could form rock and jazz bands. AM used school equipment to experiment with a drum machine. At the same time, some also followed more stereotypically technical interests. SA became obsessed with programming his graphing calculator, JR coded on paper because he didn't have a computer, and DO, whose home computer had limited software, wrote C code in notebooks with a pencil until his parents finally bought a C compiler for his birthday.

This ensemble of *geeks* and musician-technologists did not meet each other,[14] or learn there were others like them, since children had no access to the internet in the 1980s. DO remembers a 1985 computing camp where the most memorable experience was not writing code but sending his first email. This "weird" combination of interests—both art and technology—was sufficiently unusual that without access to others via the internet, live coders often grew up working in isolation from a wider sense of a community of practice. It was years before AS (based in Australia) could experience related work. Even after hearing of the London live coding scene and recognizing that it was the same thing he was attempting, he could find only a single online video of live coding (Ge Wang and Perry Cook using ChucK).

The Art School Shapes Digital Culture
For some future live coders, it was a challenge to find contexts for combining the technical and the creative.[15] However, their musical and performance talent led many of this first generation of live coders to art school, and they all remember the tutors who first inspired them to experiment with generative systems and digital media. Notable figures who influenced and inspired our nascent live coders included Larry Cuba and Morton Subotnik at the California Institute of Arts (AA), William Latham's recruitment of students from Bournemouth University (DG), Martin Robinson at Middlesex University (NC, TM), Perry Cook and Paul Lansky at Princeton University (GW), Juan Reyes at the University of Colombia (AC), Kurd Alsleben at the Hochschule für bildende Künste in Hamburg (JR), Andrew Brown at Queensland University of Technology (AS), Helmut Dencker at the Hochschule für Musik in Graz (AdC), and Scott Wilson at the University of Birmingham (SK). It was clear to both tutors and students that conventional scripted notation, in the digital era, might be a mechanical constraint foreign to the creative opportunities of free improvisation and the process-based and experimental arts. As the first digital generation of students were exposed to these practices, they and their tutors seem to have realized together that code could be treated as either a medium, a craft material, a composition system, or a performance notation—principles that were

increasingly explored in degree show pieces or in new societies, collectives, and collaborations between tutors and students. Most of this activity took place in graduate arts programs around the mid-1990s, where access to sufficiently advanced hardware and software, and much time for exploration at hand, enabled tutors to teach experimental classes in electroacoustics (for musicians), computer music (for sound engineers), or interactive and media art (for graphic designers).

Slub

One of the most influential of these collaborations was between two people who initially met as students: Adrian Ward, when completing a hybrid arts-computing degree (bachelor of science in media lab arts), and Alex McLean, who was frustrated by the lack of creative opportunity in his applied computing course (bachelor of science in computing), both at the University of Plymouth in the UK (where Geoff Cox was also teaching). Ward had concentrated on the subversion of standard digital media tools in his program *AutoShop* (1999), which offered a satirical commentary on the functionality of Adobe's Photoshop.[16] Ward and McLean's shared desire for programming to be a creative activity was revived when they met again after both had graduated and moved to London.

They became regular collaborators, exploring the relationship between packaged and improvised software in "The Generative Manifesto," a precursor to the TOPLAP manifesto that was offered to the public in a Perl community event at the Institute of Contemporary Arts (ICA) in London in September 2000, during which Ward shouted the manifesto over a soundtrack of rhythms synthesized by McLean. The two soon gained an international profile, with Ward winning the software art prize at Transmediale in 2001 for his next project AutoIllustrator (2001) and McLean winning the same prize the following year for forkbomb.pl (2002)—a simple script that would visualize the process of crashing the machine it was run on.[17]

The Generative Manifesto

Performing under the name slub,[18] Ward and McLean's "Generative Manifesto," as preserved in the handwritten original reproduced here, advocated:

1. Attention to detail—that only hand-made generative music can allow (code allows you to go deeper into creative structures);
2. Realtime output and compositional control—we hate to wait (it is inconceivable to expect non-realtime systems to exhibit signs of life);
3. Construct and explore new sonic environments with echoes from our own. (art reflects human narrative, code reflects human activity);

Figure 2.1
The original handwritten slub "Generative Manifesto."
Source: From Adrian Ward and Alex McLean.

4. Open process, open minds—we have nothing to hide (code is unambiguous, it can never hide behind obscurity. We seek to abolish obscurity in the arts);
5. Only use software applications written by ourselves—software dictates output, we dictate software (authorship cannot be granted to those who have not authored!)

The ICA event where this manifesto was delivered marked McLean and Ward's second public performance as slub, and it occurred well before they had contacted other live coders. Indeed, although the two had explored live coding in passing at an event earlier that year,[19] on this occasion they ran preprepared scripts from the command line, rather than writing their code live. They were concerned with real-time control and with asserting their creative agency as programmers writing code to make music, but several years passed before they put these two motivations together to become an exclusively live coding collaboration. As others report, despite all the ingredients being

there, it seems that the significance of live coding, which seems obvious in retrospect, only really became apparent when communities of practice began to form around it.

The Foundry and Public Life
The growing accessibility to the internet was a significant factor through this period, allowing experimenters to make contact with communities of practice beyond their local environment. KS reports looking for dance on the internet, SA was searching for other calculator hackers, and AM was building online communities via bulletin board systems. However, the live environments of many venues and project spaces, as well as conferences and festivals, are what really provided a frame for making connections and sharing practice. The emergence of live coding was shaped not only by the evolution of the live coder as a performer but in relation to an audience that participates in the way that *thinking-in-public* is made visible through coding. Around the turn of the millennium, with the first internet boom, code was slowly entering public consciousness, as code became popularized in advertisements, on television, in magazines, and on film through design tropes such as CamelCase typography, arrays of zeros and ones as binary signifiers of the digital, and the code aesthetic of the *Matrix* movies.

The generative music scene in London gathered an audience through some remarkable venues, including the Foundry pub in Hoxton and the literally underground Public Life, an ex-public lavatory in Spitalfields curated as an experimental venue by Siraj Izhar from 2001 to 2004.[20] The Foundry pub was set up with the support of Bill Drummond, well known for his pop music disruptions as part of the KLF. Drummond's poster titled "I COULD FUCKIN' DO BETTER THAN THAT" was hung in the Foundry as an open invitation to artists to participate. Many experimental events, including the first slub performances, were held here. Public Life was run as an open arts collective with a similar focus on experimental digital culture, with the following rules of operation: "1. not to solicit activity, all activity had to be self-initiated, volunteered or uninvited" and "2. not to say no to anything, reject anything but attempt accommodation in some way." The program of events in late 2002 included Plug and Play nights, open-source occasions where participants were invited to "bring data/bring laptop/tech." Adrian Ward and Alex McLean performed as slub, while Nick Collins appeared as 3play with John Eacott and Fabrice Mogini, students working with Martin Robinson, who was teaching one of the few SuperCollider-based courses at Middlesex University at the time. Other Middlesex students organizing events at Public Life included Thor Magnusson and Enrike Hurtado, who organized events where people would use the *ixi instruments* they made as part of their master of arts degree.

Partial archives of the Public Life calendar show the determination of those in the scene not to take themselves too seriously. Variously described as "dead-eyed generative techno boffins *slub*" and "stub et de l'autre coté de slab puisque slub existe," slub and colleagues reveled in a geeky aesthetic that both acknowledged the dubious fashion status of this underground genre and exemplified the art-school habit of tongue-in-cheek "pretension" (typified by the use of manifestos). Although showing screens to the audience was central to the ethos of both Public Life and the "Generative Manifesto," it was not presumed that the performers would necessarily be writing code at the event. AM remembers that his code was generally prepared in advance and that Adrian Ward, who did write code while performing, did not make a big thing of it.

Read_me/Runme
The London scene around the Foundry and Public Life and the "Generative Manifesto" of slub and their software art prizes at Transmediale were all political in their motivations and intentions. This spirit of art activism linked up with an international community associated with the Read_me festivals curated by Olga Goriunova and Alexei Shulgin and their online incarnation at the runme.org website. After an initial event in Moscow in 2002, the second Read_me/runme was held in Helsinki in 2003. Amy Alexander and Alex McLean were invited to contribute to the selection and curation of the festival, working closely together in AM's development of the art database runme.org (with conceptual input from Pit Schultz, Florian Cramer, Matthew Fuller, the Yes Men, and Thomax Kaulmann). Runme.org became central to the Read_me festival concept as a communal catalog, submission system, and repository for executable open projects that recognized the emergent practices of coders.[21] The third iteration was in August 2004,[22] where Read_Me 2004 (hosted by Aarhus University) was immediately followed by a joint Runme/Dorkbot City Camp hosted by the Jutland Academy of Fine Arts, attended by many of the live coding community and for some (such as DG) their first experience of writing code in public. Amy Alexander, Alex McLean, Nick Collins, and Fredrik Olofsson memorably took to the stage all at the same time, with an array of projectors showing all of their screens.

The Birth of TOPLAP
The specific term *live coding* appears around the year 2000, although it must be recognized that the terms *live programming* and *live coding* were being used interchangeably at that time. It seems there was something in the air, with a number of disconnected developments—the release of early versions of the Just In Time programming library for SuperCollider in 2001 by Julian Rohrhuber, experimental programming workshops,

the first performances from collaborative ensembles such as slub and Powerbooks_UnPlugged, the release of the ChucK on-the-fly language by Ge Wang in Princeton[23]—all leading up to the establishment of the international live coding community TOPLAP at the Changing Grammars symposium convened by Renate Wieser and Julian Rohrhuber at the HfbK in February 2004.

Changing Grammars was a politically engaged festival of code-as-art, a "live audio programming symposium," whose advertised purpose was recognizably to discuss live coding as we know it today: "Some computer languages allow changing a running process on the fly by rewriting the code that defines it. Applied to computer music this means that one can write sound compositions while they are already playing."[24] The symposium brought together different forms of collaborative art. It was inspired by live improvisation in clubs, the conversational art by Antje Eske and Kurd Alsleben, network music as pursued in the work of Alberto de Campo, and a radicalization of open source as collective thinking—the name encapsulating the ambiguous power of grammatical law.

Changing Grammars was the watershed moment of live coding, as the meeting at which TOPLAP was formed and immediately after which the TOPLAP manifesto was first drafted. The (temporarily named) Temporary Organisation for the Promotion of Live Algorithm Programming was constituted, continuing as an online wiki and email discussion list that included additional software artists and live coders outside Europe, such as DG, GW, and AA. The logo, designed by Adrian Ward, symbolizes both the centrality and provisional/reversible status of the *laptop* as the name then given to an electronic music genre that was both technologized and commoditized.

The TOPLAP Manifesto

The TOPLAP manifesto itself is as "temporary" as the organization and has only ever been published as a draft, in 2004. The authors of the manifesto insist that it was never

Figure 2.2
The TOPLAP logo created by Adrian Ward.
Source: Wikipedia, "ToplapLogo," last modified April 20, 2011, https://toplap.org/wiki/ToplapLogo.

(and shouldn't be) really finished—and of course that TOPLAP is a temporary organization.[25] The manifesto was originally shared as an openly edited wiki document, settling on the following draft during the space of a year.[26] The manifesto states:

We demand:

- Give us access to the performer's mind, to the whole human instrument.
- Obscurantism is dangerous. Show us your screens.
- Programs are instruments that can change themselves.
- The program is to be transcended—Artificial language is the way.
- Code should be seen as well as heard, underlying algorithms viewed as well as their visual outcome.
- Live coding is not about tools. Algorithms are thoughts. Chainsaws are tools. That's why algorithms are sometimes harder to notice than chainsaws.

We recognize continuums of interaction and profundity, but prefer:

- Insight into algorithms
- The skillful extemporisation of algorithm as an expressive/impressive display of mental dexterity
- No backup (minidisc, DVD, safety net computer)

We acknowledge that:

- It is not necessary for a lay audience to understand the code to appreciate it, much as it is not necessary to know how to play guitar in order to appreciate watching a guitar performance.
- Live coding may be accompanied by an impressive display of manual dexterity and the glorification of the typing interface.
- Performance involves continuums of interaction, covering perhaps the scope of controls with respect to the parameter space of the artwork, or gestural content, particularly directness of expressive detail. Whilst the traditional haptic rate timing deviations of expressivity in instrumental music are not approximated in code, why repeat the past? No doubt the writing of code and expression of thought will develop its own nuances and customs.[27]

With clear influence from "The Generative Manifesto" of McLean and Ward, perhaps its most famous injunction is "Show us your screens"—a mantra of the live coding community.[28] However, even this central phenomenon of the live coding movement is contested. Some regard the showing of screens as explanatory (GW) or didactic (SA), as simply a way of sharing their way of making music (for slub), while for others the gesture is underpinned by the materialist principles of granting access to the means of production, as discussed in later chapters of this book. The founders of TOPLAP were fully aware of the irony of an improvised culture being documented and systematized: the assertive style of the manifesto is parodic and, like all manifestos, *algorithmic* in

the sense of being program-like and able to generate new sociotechnical forms. In this sense it follows a long tradition of technology-based manifestos and declarative calls to action.[29] However, our own interviews (AM with AdC) acknowledge that "even if the TOPLAP manifesto obviously is intended as tongue-in-cheek, it did have an undercurrent of real ambition."

Catalysts and Precursors

So far we have focused on the genesis of the TOPLAP live coding community between 2000 and the present day, in recognition of the rich development of music and arts practice that came out of physical and online meeting points. It is also important to recognize precursors and catalysts, where individuals or small groups engaged in activities and developments that could be conceived of as live coding even if these people never viewed their practice as such or found value in the term *live coding*.

Interactive Programming

The propagation of the Forth programming language through the 1970s was a significant event in the development of interactive programming for real-time applications, as the language architecture allows operations to be interactively (re)defined while the program is running, with a core that is unusually fast and lightweight.[30] In 1979 Doug Collinge created the Moxie language for timed procedures, delivered originally as a Forth package and later reimplemented by Roger Dannenberg in a C version called Moxc,[31] described as an "integration of procedural and declarative score-like descriptions of interactive real-time behavior."[32] Dave Anderson and Ron Kuivila began working together in 1984, initiated by Kuivila asking if it would be possible to keep access to the Forth outer interpreter while running his concurrent thread package. It is explorations in this style that have enabled live coding as we understand it now, and according to the TOPLAP wiki, Kuivila is the person responsible for the first known performance of what we would now recognize as live coding, at STEIM Amsterdam in 1985.

SuperCollider

If the formation of TOPLAP was a pivotal moment in the crystallization of live coding as a performing arts genre, the next most significant occasion (though earlier in the timeline) may well be a workshop that was presented at the International Computer Music Conference (ICMC) in 2000 by James McCartney, author of the SuperCollider music programming language.[33] McCartney's work influenced many of those we interviewed. Indeed, it is hard to ignore the number of live coders whose first experiences of coded music came from tutors who were the early adopters and teachers of

SuperCollider. Even TOPLAP owes its existence to McCartney's work; SuperCollider was the main programming language used at the Changing Grammars meeting.

Versions of SuperCollider were already in circulation before 2000, and some schools were using those early versions. But McCartney's workshop at the International Computer Music Conference 2000, where he demonstrated fluent synthesizer programming in a text-based language, made a huge impact on many of those who attended. His workshop involved a live software demonstration, not a musical performance, but many of those present recognized the potential for using code as a musical instrument, rather than as a means to build instruments.

The basic operating principles of SuperCollider are squarely in the tradition of the MUSIC-N family of digital synthesis systems, continuing Max Mathews's original invention of a modular system of software unit generators that are connected into a logical network. Conceptually, this is the same operating principle as modular analog synthesizers, which are connected into a network using patch cables, and of the Max/MSP language, which visualizes the patch cables as connecting lines in an on-screen diagram. McCartney's first version of SuperCollider provided a text programming interface to this underlying model, but Version 2 of SuperCollider transformed the programming experience by changing the style of control language to that of Smalltalk—the innovative language developed by Alan Kay and others at Xerox Palo Alto Research Center (PARC) that underlies a recent resurgence of interest in "live programming" within the software engineering research community.[34]

It is notable that Collinge's original Moxie referenced Smalltalk, and also the Simula language that had inspired it, relating the event-simulation functionality of Simula to a causal model of music in terms of processes and events, which he felt would become the foundation of a far more powerful descriptive model. Certainly, for Kuivila, SuperCollider was the first environment that he believed had retained the interactive programming quality of Forth while allowing much richer programming abstractions.

Immediately, SuperCollider 2 encouraged live experimentation. In particular, from the moment when the interpreter remained usable during synthesis, it allowed for a redefinition of functions at runtime (in the same way that words could be added at runtime to the Forth dictionary). These functions could be picked up by sequencing unit generators like Spawn, and Kuivila created a TSpawn function that introduced the ability to trigger this update. This was used in the early versions of Rohrhuber's work on proxy systems.

It is within the SuperCollider community that we see terms such as *live programming* and *code live* used around 2000–2001 by Julian Rohrhuber and Fabrice Mogini, respectively. Indeed, at the launch of the *Morpheus* CD-ROM (a disk that contained a

runtime version of SuperCollider with generative music pieces by five composers) in 2001, Mogini was live coding in a London Shoreditch nightclub, projecting code onto the wall and writing SuperCollider patterns in a specific graphical user interface system he had built.[35]

It is no coincidence that these developments were all taking place within SuperCollider 2. Its extreme conciseness, together with its repository of interesting examples that could be easily rewritten and combined in live textures, foregrounded code as public artistic expression. Its design prompted users to run different parts of their code concurrently, changing parameters continually as the music evolved. However, a considerable advance for live coding came with Rohrhuber's introduction of proxies, which made it possible to rewrite any component of the program at runtime. Instead of preparing the parameters for live interaction, the whole programming activity became an integral part of the running program. The proxy system was also used in improvisation to share and access code running on multiple computers, enabling the live laptop network music performances of the PowerBooks_UnPlugged ensemble.[36]

The Growing Community
The pioneering years of live coding in the early 2000s were followed by accelerating growth of the live coding community. It has now grown to include so many prominent individuals that it would have been impossible for us to interview them all or even to fully document the expanding circles of those involved. In the months and years immediately after the formation of TOPLAP, those who attended and participated in the early events (such as DG) developed their own tools and performance practices. Increasing coverage in forums enabled a wider network of explorers to identify their own work as live coding, as when AS saw a *Slashdot* article by AM on hacking Perl and recognized that his own "live" exploration within a read-eval-print loop could be performed in public, leading directly to the first live coding performance in Australia by Andrew Brown and Andrew Sorensen (as aa_cell), at the Australasian Computer Music Conference in June 2005.

As academic music departments started to incorporate live coding (or at least, further attention to SuperCollider) into their curriculum, they created a generation of performers who had an established framework within which to explore. AC was already familiar with computers as media-processing tools but had not considered herself to be a coder until Ernesto Romero taught a live coding class in Mexico in 2009, leading to her own first public performance in 2010. SK had already used digital music tools in high school and found that Max/MSP and SuperCollider were part of her undergraduate curriculum in 2006 and 2009, respectively. For her, coding in itself was not a

conceptual commitment but a tool available as part of the repertoire of free improvisation practice, in which she saw little real distinction between digital and analog synthesizers. She did not perform explicitly as a live coder until 2013 but quickly became a core member of the UK community.

JR and AdC were visiting professors in Karlsruhe who taught SuperCollider in 2009 to students at the Institute for Music Informatics and Musicology, including Juan A. Romero, Holger Ballweg, Patrick Borgeat, and Matthias Schneiderbanger, who then formed the live coding collective Benoit and the Mandelbrots. They say that their first performance later that year was memorable for being even "more nerdy than Kraftwerk" because they had not yet acquired laptop stands and were obliged to sit on the stage while typing.

Although more could be said about the institutional grounding of live coding through educational establishments, including the teaching of environments such as SuperCollider, Pure Data, Max/MSP, CSound, ChucK, Hydra, and TidalCycles and the widespread rollout of Sonic Pi into schools as well as universities (currently approaching its two-millionth reported download), much of the community growth and education has been through workshops organized by art institutions, media labs, universities, and various festivals. As examples, John Eacott organized the SuperCollider summer school at Westminster University in the early 2000s; Nick Collins, Fredrik Olofsson, and Sergio Luque gave SuperCollider workshops; Thor Magnusson and Enrike Hurtado organized ixi workshops on audiovisual programming across Europe; Bruno Ruviaro and Fernando Lopez-Lezcano at CCRMA at Stanford, and a large open-source Pure Data community, with people such as Derek Holzer, Gunter Geiger, and Hans Christoph Steiner, was active in open-source audio programming education. Various institutions, organizations, and collectives were instrumental in this spreading of skills—notably, Centro Multimedia, Centro Nacional de las Artes in Mexico, the Studio for Electro-Instrumental Music in the Netherlands, Access Space in Sheffield, and l'ull cec in Spain, which organized a coordinated program of SuperCollider education through a series of workshops at Hangar Barcelona.[37]

The mixture of curiosity, enthusiasm, and engagement shown by technical audiences has become a staple of live coding performance. At programming language and tool conferences, especially, there is a long-standing tradition of live demos exhibiting the convenience and efficiency of new technologies by showing that sophisticated results can be achieved in view of the eyes of the audience.[38] A second wave of live coders, such as MH and SA, extending the technical tools developed in earlier live coding experiments, were already familiar with this kind of code performance before they started to explore musical ideas of their own. For more technical audiences looking

to develop their own skills and understanding, knowing how the tools work and how effects are achieved is greatly valued, leading to performances that often consist of a lecture or seminar followed by music improvised in the moment.

Live coding has also extended beyond the performance of music and projected visual effects to explore the potential of code in association with dance or poetry. KS is a dancer and choreographer who had used digital tools such as Isadora and Processing to create dynamic stage sets and had an intuitive understanding that these were themselves a kind of choreographic notation. After meeting AM, she began to explore the intersections between long-standing questions of notation and improvisation in dance (to be discussed further in chapter 4) and the potential of live code as an improvised score.

As with any performance or musical genre, we stress the point that live coding is a community construction. Performance implies an audience; it is a fundamentally social enterprise. The tools used in live coding may be constructed in private, and live coders develop their skills with personal preparation, but experiences of community were central to the development of everybody we interviewed.

For those live coders educated in a Western art school tradition, ensemble performance and studio settings are everyday routines. Just as with the art-rock bands of the 1960s and 1970s, several prominent live coding groups developed directly from groups of art-school contemporaries, including Benoit and the Mandelbrots and the Public Life regulars 3Play. However, the cultures of education in technical practice are very different. In comparison to art schools, there is far less expectation that computer science and software-engineering students will work closely with their peers on an everyday basis. As a result, the communal experience of live coding, for these individuals, was challenging but transformative. SA discovered a completely different kind of creative experience through a classic rite of passage, forming a band (under the name Meta-eX, with his brother-in-law Jonathan Graham), while GW recalled that his undergraduate interest in algorithmic composition, to be followed by research in the Western contemporary tradition, underwent an epiphany when he had to explain his plans to band members he met at a party on the way to start his PhD in Princeton.

For a traditional music school or conservatoire context, the community of live coding may be difficult to accommodate within conventional group structures given the quite different pace and rhythm of (intermittent) edit and (continuous) execution, in contrast to the conventional instrumentalist's constant adjustment of note articulations but near inability to discuss the work while still making sound. DO did not really start live coding until 2010, with the formation of Cybernetic Orchestra. For him, the medium of code leads to forms of sharing beyond those needed for more individual musical practices. While instrumental performance gestures happen in the moment,

code gestures are temporally distanced from their effects and thus able to accommodate a parallel time stream of discourse, through which members are able to consider and grasp what others have done. Of course, code can also be an explicit technology of control, allowing those inside or outside the group to expose or impose individual intentions to a much greater extent than possible with conventional instruments.

Whether or not live coding is *intrinsically* communal, the network of personal contacts that have been described here were essential to the development of the form. Notably, AM extended the community through personal connections, such as an office across the hall from JA or meeting AC while learning SuperCollider from Romero. Once able to perform in public, the memorable venues and events of the experimental arts scene resulted in lasting impacts—two remarkable algoraves in the art vessel *MS Stubnitz* in April and May 2013; SK, BatMan, and DO visiting a tiny island in Venice for the laptop orchestra/ensemble festival Laptops Meet Musicians in July 2011; JR and RW live coding a musical accompaniment to silent movies as *Signifikantelstadl* starting in 2005; or the Hamburg-based band ginkgo turning a chill-out room into a mock office.[39]

Revising Histories, Reshaping Communities

Existing at the intersection of performing arts and computer science, live coding risks the same challenges and problems with diversity that continue to persist within these fields, as well as within technologized performance cultures more broadly.[40] Certainly, the fields of electronic art music, computing, and software engineering are not widely recognized for their diversity. However, since live coding is neither conventional software engineering nor mainstream art or music, it arguably has the capacity to emerge as a community of practice relatively free of the hierarchies and expectations that have habitually dogged its neighboring disciplinary fields.

The rhetoric of live coding's emergent community is often portrayed as inclusive, even utopian—an invitation for new collectives to form or a welcome offered to people of diverse artistic, educational, ethnic, and gender backgrounds. However, although the contour or boundary that gives shape to an emerging community creates conditions of belonging and commonality, it can also mean that there will always be individuals who do not belong or remain unrepresented.[41] While live coding aspires to be an inclusive community of practice, it is not always as simple as that. As live coder JA points out, "Computing has been coded masculine."[42] The gateway of entry might well be open in principle, but this does not always mean that its threshold is easily crossed. Networks and communities emerge through complex webs of association and initiation, friendship, and fraternity. Educational experiences can often create conditions of

expectation and convention, establishing unspoken rules and permissions, possibilities, and limitations. For example, the early educational experiences of prominent digital artists such as AA were significantly shaped by the continual socialization of women *not* to be the stereotypical coder. While the educational climate has changed, female live coders, such as AA and, more recently, ALGOBABEZ (JA and SK), have ironically appropriated the persona of the stereotypical performing nerd, celebrating the counterexpectations of adopting subversive gender identities. Increasingly for some female live coders, however, the challenge is also one of moving beyond ironic critique toward actively shaping and redefining the future of live coding in more affirmative terms.[43]

In spite of the aspiration of live coding to be inclusive and diverse, and though female coders such as AA, AC, and SK have become key figures within the live coding community, the number of male live coders arriving in the community constantly threatens to dominate. Due to the rapid increase in its size, there is a real risk that the growing community will become less diverse than even at its inception, potentially recapitulating the historical displacement of women pioneers in electroacoustic music and the sonic arts.[44] Tactics for addressing the continuing gender diversity imbalance take two distinctive approaches: the active reshaping of a community through interventionist and activist strategies and the rewriting of existing histories as a corrective toward a more inclusive narrative to reimagine a different future. Projects such as OFFAL (Orchestra for Females and Laptops) and the duo ALGOBABEZ have affirmatively foregrounded the female gender of their performers.

Significantly, many female live coders have also been instrumental in establishing specific communities and educational opportunities for supporting women's engagement in live coding, reshaping the future of live coding through advocacy and activism, through women-only workshops, and through mentoring and other initiatives to widen participation. For example, in the UK a pivotal moment for redressing gender balance within live coding was the free all-women Live Coding Workshop led by the Yorkshire Sound Women Network at Huddersfield University (December 2015) and funded by the Arts and Humanities Research Council Live Coding Research Network, which introduced twenty women to ixi lang and SuperCollider.[45] Further widening participation, JA has since led live coding workshops at the National Media Museum in Bradford, England, as part of "Make Some Noise," which targeted students (around the age of eight to nine years) from areas with low socioeconomic backgrounds. In 2019 the Northern Sound Collective hosted a series of symposiums, workshops, and hackathons (open only to women, including trans women and nonbinary people) with the theme "Automation and Me: Living an Algorithmic Life" to explore themes of bodies, technologies, and automation.[46]

In her article "Finding Joy in Error and Space to Fail In," JA argues that "in computer science pedagogy, one argument that has been put forward to explain the lack of engagement from women is their fear of failure."[47] A significant characteristic of the advocacy and education platforms described above is that they reportedly create safe spaces for failure, for taking risks and trying something out. Rather than foreground the need for technical virtuosity, such all-women and nonbinary opportunities offer, as JA argues, "underrepresented groups . . . a safe space to fail in their learning . . . a space in which to fail constructively."[48] Strikingly, JA reports that while many female live coders feel encouraged by advocacy and educational projects and even by the inclusive culture of algoraves, they continue to feel excluded from key community spaces such as the live coding Slack channel.[49] JA argues that "the dominance of technical discussion on Slack underpins the maleness of the forum,"[50] where the focus of discussion on tools and technicalities can both alienate and undermine female coders.

The introduction of algorave guidelines has also been an important gesture in changing a culture within the live coding community[51]—for example, by encouraging promoters and organizers to program lineups that reflect a greater gender balance and diversity more broadly. This is a positive intervention, yet there is still a risk that such practices inadvertently reinforce the sense of live coding as a predominantly white male culture whose rules and codes might be modified (slightly) to better allow *others* in. How can the live coding community become truly inclusive, not simply allowing or giving access to a wider diversity of individuals but rather becoming truly co-constituted and actively reshaped by the diversity of its evolving members? How can the language of inclusivity shift from one of "letting in" and "opening up," inadvertently reinforcing a sense of its own boundaries and gatekeepers, toward something that better reflects the transformative possibilities of greater diversity? In order for live coding to be a connecting force across diverse communities of practice, structuring hierarchies should continue to be rejected and shaken up when formed.

In compiling the partial histories of live coding, we have become increasingly aware of omissions and exclusions and of various biases, privileges, and blind spots, not least in relation to matters of diversity. Live coding aims to be inclusive; still, its evolution has been (and continues to be) uneven and nonlinear. While the early histories of live coding have a specifically European focus, in recent years the practice has evolved and developed into a truly global phenomenon. As live coding practices and communities develop in Africa, India, Japan, and Mexico, they are shaped and informed by the distinctiveness of those geographical, cultural, and sociopolitical contexts. The increasingly international nature of the live coding scene, particularly the strong communities that have grown in Central and South America, has begun to counteract its previously

European- and US-centric focus. For example, the /* vivo */ festival in Mexico City in 2012, the International Conference on Live Coding (ICLC) in Morelia in 2017, and the "Livecoders latinoamericanos" day programmed at the ICLC in Madrid 2019 revealed the radical vibrancy of the Latin American live coding communities to the wider scene, with the ICLC now held in both Spanish and English. While diversity in the live coding scene has been discussed and confronted from the early days, the focus has tended toward issues of gender, rather than aspects such as race and class.[52] However, events such as the police murder of George Floyd on May 25, 2020, and the impact of the Black Lives Matter protests that followed brought the matter of race into focus with a heightened sense of urgency, calling for intervention and activism beyond expressions of solidarity and performative allyship. The (Algo|Afro) Futures mentorship program is an initiative led by digital artist and curator Antonio Roberts in England that supports four Black artists in the West Midlands area who are in the early stages of their careers. The first cohort of this program—digital artist/musician Rosa Francesca, fine artist/filmmaker Emily Mulenga, mixed-media poet Samiir Saunders, and musician/illustrator Jae Tawallah—were encouraged to explore live coding from the perspective of their own practices rather than *fix* any problem in the existing scene. They approached the theme from an intersectional standpoint, bringing varied interests and backgrounds in neurodiversity, embodiment, anticapitalism, feminism, queerness, postcolonialism, and disability justice.[53]

In parallel to the interventions and activism intent on changing the existing culture of live coding, there is also potential in revising the history of live coding itself, revealing alternative narratives in which the historical presence of people who are disadvantaged and/or underacknowledged (based on gender identity, ethnicity, or class, for example) are properly recognized within the evolution of computational technologies. The trouble with histories—partial or otherwise—is that the collective memory of events and the visibility of certain individuals or practices afforded within a particular historical narrative are inescapably conditioned by the privileging norms of the social and cultural milieu itself. At times, then, a more active reading of alternative histories—of a more overtly revisionist or reparative history—becomes critically necessary for addressing those existing and persisting blind spots and exclusions, for telling *his*-story from a different perspective. For example, at the International Conference on Live Coding in Hamilton (2016), Amy Alexander's keynote "At the Margins" highlighted historical examples within computer science and the arts that were considered *marginal* or peripheral in their time but have had a long-term impact on their fields.[54] These included the seemingly clerical work of early telephone switchboard operators alongside the innovations of influential female programmers, including Rear Admiral Grace

Hopper, a pioneer of computer programming who popularized the idea of machine-independent programming languages, leading to the development of COBOL, the early business-oriented programming language.

Certainly, the role of women within the evolution of computer technology and programming generally requires ongoing reappraisal. The pivotal contribution of named individuals such as Ada Lovelace (1815–1852, known for being the first "computer programmer" writing an algorithm for execution by a computer—Babbage's Analytical Engine) or Margaret Hamilton (credited with invention of the term *software engineering*[55]) must be remembered in the context of innumerable unnamed others, such as the thousands of female "human computers" operating in the 1940s whose skill, knowledge, and dexterity have been historically undervalued. While software engineering emerged from the space program, in the military and patriarchal context of the Cold War, the golden age of electronic and computer music took place in more independent, less hierarchical, and therefore less male-dominated scenes. As it has developed, both commercial and academic power structures have formed,[56] but these do not necessarily represent the diversity of the early pioneers. Reflecting on the stellar lineup of the 2016 Mothers of Invention festival in London, Laurie Spiegel commented:

> Why so many women in early electronic music? Back then there were very few women composers of any kind. That was partly because men controlled access to performance, presentation, preservation and publication resources (concert venues, print and vinyl, concert halls, orchestra, radio airplay . . .). In contrast, electronic equipment did not treat women any differently from men. We were able to turn our musical ideas into sound and then play them for people without the almost-always-male establishment gatekeepers and their biases.[57]

There have been conscious efforts to reject such hierarchies from developing in the live coding field.[58] Beyond the reparative retelling of an existing evolutionary chronology, there are parallel attempts to radically rethink the chronology itself, to establish alternative historical references to contemporary coding that in turn invite a rethinking of its possible future.

Textiles and Coding

One attempt to revise or even rewrite the historical evolution of computing and coding, specifically in relation to live coding, can be witnessed in recent research projects that reconsider the links between coding and textiles. The development of the Jacquard loom is often credited as a key precedent in the evolution of computational hardware. First demonstrated in the early 1800s by its inventor, Joseph Marie Jacquard, the Jacquard loom served to simplify and accelerate the manufacturing of textiles using a system of punch cards to control a mechanized process of weaving. These punch cards

inspired the use of perforated cards by Charles Babbage in his Analytical Engine, and the Jacquard loom is thus considered a key technical precursor in the history of computing.

However, this focus on hardware and machinic evolution often neglects the cognitive connections between weave and code.[59] Indeed, as philosopher and cultural theorist Sadie Plant asserts, "The computer emerges out of the history of weaving. . . . The loom is the vanguard site of software development." By eschewing the well-established (accepted, normative) relation between the technologies of weaving and coding, research projects such as Weaving Codes/Coding Weaves (2014–2016) have focused more explicitly on the qualities of cognition and creativity emerging within traditional handloom use and how the handweaver's sense of embodied cognition can be extended to the practice of coding.[60] The project argues that automated Jacquard weaving is antithetical to the principles of live coding—its planning in advance seems closer to the hands-off, automated *generative music* ethos developed since the 1950s—and so to find analogs to live coding, we have to look for roots that go further back in history.

Multimedia artist and technologist Paola Torres Núñez del Prado has connected live coding with Peruvian textile practices through her *Textile Patching* performances, live coding with embroidered interfaces at the International Conference on Live Coding in 2017. More recently, she has launched the Neokhipukamayoq manifesto,[61] presenting a vision for technology grounded in a heritage based on *Khipu*-making, the pan-Andean method of digital memory storage with knots in string, known for its use by the Inca Empire for recordkeeping. In this manifesto Núñez del Prado brings forward a living history of technology that is respectful of its origins as well as its contemporary presence in Andean culture and mindful of its growing presence in the arts worldwide. The importance and indeed urgency behind this manifesto is in asserting a technological hierarchy where Indigenous thought systems are respected, where data representation is literally textile and connects with a wider vision of ecological equilibrium. Where live coding proposes a vision of technology with the programmer part of the program, the Neokhipukamayoq manifesto steps back to include culture and the environment in the loop. As stated in the manifesto:

> In these times of climate emergency, it is imperative not only to question the materials used in our practice nor their energy consumption nor their carbon footprint, but their design, symbolism and historicity. . . . Another technological narrative from the arts is imperative, one that will begin with the study of divergent technological expressions of the past and present.

From Instituting Moments to Institutional Frames

The focus on textiles (and especially ancient textile processes) traces live coding back to its earliest of precedents, conceived as an "instituting moment" for live coding practice.

However, the insurgent energy of the instituting moment or movement—the emergence of something new or novel—eventually becomes absorbed by or becomes itself an institution.[62] The TOPLAP manifesto was important in galvanizing the terminology, spreading it, and contributing to the realization that programming computers live on stage is a valuable activity. Many of the early live coders who started out as young artists and student rebels have now graduated to become academics—research fellows or tenured faculty—while others are loosely connected to academia even if working as independent artists.

In combination with the continued growth of the live coding community and its intersection with the goals of technology researchers as they design more dynamic software-engineering tools, the dynamism of this cross-disciplinary enterprise has inexorably led to research grants, conference series, and academic publications. The German computer science research center at Schloss Dagstuhl hosted a 2013 meeting dedicated to live coding for art, education, and engineering—an event at which the plan for this book was first proposed.[63] Subsequently, funding for a Live Coding Research Network from the UK Arts and Humanities Research Council, directed by Thor Magnusson and Alex McLean, supported a diverse range of events and meetings, starting with a launch event in March 2014 at which NC was invited to present a comprehensive history of live coding. Following a series of workshops and symposia, the first ICLC was organized by the Live Coding Research Network in 2015 and held at the University of Leeds.[64] A parallel series of events, whose organizers were also represented at the Dagstuhl meeting, has focused on engineering rather than the artistic implications of liveness in software development.[65]

At the same time, live coding has resisted the hierarchies of control that sometimes build around academic disciplines, and much of the creative and technological activity now takes place outside of institutions. The current wave of groundbreaking new systems, such as Hydra, Orca, Flok, Improviz, and Bespoke, have all been developed by independent practitioners, and the ICLC has increasingly promoted an atmosphere that is as much a festival as an academic event, aiming to be accessible to those without institutional backing through free or low-cost entry and travel grants. Likewise, projects born in academia, such as TidalCycles and Sonic Pi, are now thriving as independent projects sustained by their communities. In the case of TidalCycles, this is via Summer of Code grants and an OpenCollective fund, while Sonic Pi receives support from donors via Patreon. Nonetheless, academic research continues apace, research projects and studentships continue to be funded, and centers such as the Networked Imagination Laboratory at McMaster University are able to benefit from exchanges with other thriving cultures of practice, such as Colectivo de Live Coders in Argentina and

NL Coding Live in the Netherlands, among the thirty-two local communities loosely affiliated as TOPLAP *nodes*.[66] In 2021 the European Culture–funded project On-the-Fly included both artistic and research residencies in a varied program held at collaborating institutions in Barcelona, Ljubljana, and Eindhoven. As it does in many other areas, live coding challenges the accepted institutional distinctions, including that between the artist/practitioner as distinct from the academic.

Algorave

While the *instituting energies* of live coding have been absorbed and assimilated into institutional practices, and indeed while many of the first generation who are still active as live coders operate within these institutional frames, the insurgent and irreverent imperative of live coding persists. Parallel to the increasing institutionalization or even professionalization of live coding, the new genre of *algorave* has emerged. Coining the word *algorave* as the name of a new genre was a decisive moment in the history of live coding. Informed by NC's own research into the development of electronic pop music genres, AM and NC realized that a musical genre could become a rallying standard for a wider understanding of live coding.

Figure 2.3
Algorave logo designed by David Palmer, a "spirangle" based on the three-armed algorithmic structure of the Brigid's cross.
Source: Wikipedia, "Algorave," last modified September 12, 2021, https://en.wikipedia.org/wiki/Algorave.

Though the word *algorave* is undoubtedly ironic in part, just as was the case with TOPLAP, it caught the imagination of both an older generation of music and technology writers who had participated in the rave scene of the 1980s and a younger generation of nightclubbers accustomed to electronic dance music. For example, MH was among a new generation of live coders who were inspired to use their technical skills to recover earlier music ambitions (in his case, as a promising young composer before entering the software industry). The popular technology magazine *Wired* published a short profile of algorave,[67] following a key early event on the "art ship" *MS Stubnitz*, followed by articles in *Vice*, *Dazed and Confused*, and the *Wire*.[68] This media interest exposed a new audience to the phenomenon of live coding that was many times beyond what had been seen at that point. In turn, as the practice has developed so have emergent guidelines for algoraves, which while demonstrating resistance to institutions or institutionalization, as well as against hierarchies, nonetheless stipulate an underpinning ethos and set of principles.[69]

A key question for live coding is what happens when the method becomes ubiquitous, accepted, and familiar. When the novelty of the performative situation wears out and the practice infiltrates regular club events or festivals (such that there is no need to advertise special "live coding" or "algorave" events), will this mode of practice simply become part of mainstream programming, irrespective of the method of performance? Many of the live coders interviewed remain on the periphery of the technical, academic, and commercial establishment—and are concerned that growing mainstream audiences might lose the spirit of anarchy and subversion out of which the movement has grown. Indeed, Thor Magnusson has argued that although live coding is a term that has an important initial function when we introduce and explore this way of working with our machines, at some point the method will be so natural—to program a computer in live contexts—that we will not need to focus on the method anymore.[70] This transition from marginal to mainstream can be witnessed in relation to video art, media art, or, to a certain extent, even live art—specific named practices that were once clearly differentiated and invited dedicated attention and audiences, but have gradually been assimilated into contemporary art more broadly.

One way of thinking about these different arcs—from instituting moment to institutionalized practice or from interest in the medium- or method-specificity of an emerging practice to assimilation into the generic mainstream—could be through a wider consideration of group dynamics and group formation. In 1965, education psychologist Bruce Tuckman conceived a model for describing the different stages of group formation, which arguably can be seen at work within the evolution of the live coding community: forming (setting the stage), storming (meeting conflict and tension),

norming and performing (implementing and sustaining projects), outperforming (expanding the original initiative and integrating new members), and adjourning. This last adjourning (sometimes even called mourning) stage is double-edged because the expansion of an original initiative also involves breaking up or moving beyond the original group dynamic and even a sense of letting go.

New live coders—shaped by changes in technology and culture—continually add to and modify the practice of live coding and the understanding of its potential. As the practice of live coding reaches different geographical, cultural, and socioeconomic contexts, it inevitably changes. Certainly, the lived experience and articulation of live coding practice is going to vary depending on whether you are a live coder living in Europe, Japan, Mexico, Argentina, North America, Australia, or India. While the internet promises a shared global platform, in reality, practices, ideas, technologies, and theories circulate at different speeds and rhythms through different intensities and durations. The community of live coding might be described as being in its norming, performing, or even adjourning stage in one context, while in another context it is still nascent, still emerging. Indeed, our biographical interviews regularly drew attention to themes of empowerment, emancipation, and education as implications of the live coding movement. Despite the prevailing spirit of modesty and ironic detachment that has surrounded the development of live coding, initiatives such as AM's engagement with refugee-related arts and diverse community groups, or SA's fervent educational campaigning, demonstrate real engagement with the mission that has been central to the philosophy of live coding since its founding manifestos.

This book itself is pitched at an interesting moment in the history of live coding, within the arc of live coding's evolution. This chapter narrates a partial history of live coding from its emergence, through its evolution, to the point (now, as we are writing) where the stories composing this history are becoming more difficult to track and trace. TOPLAP has itself dissolved into a loose affiliation between geographical nodes with independent identities and online communities, where perhaps more discussion takes place in Spanish than English, with international activity centered around particular live coding environments.[71] In a sense, then, the book could be read as a marker or signal of a transition already taking place within live coding or perhaps (if live coding is conceived to be entering its adjourning/mourning phase) even as its obituary. Yet the complex interdisciplinary, intercultural landscape of contemporary live coding, connecting with heritage practices in order to look to the future, means that it has become increasingly problematic to view the evolution of this practice as a single linear arc. Not only is the live coding landscape always changing; its community spans multiple intersecting landscapes with a commitment to keeping ideas alive and changing that

itself disrupts and dissolves hierarchy. Additionally, the tension between disciplinary discourses—for example, between art and engineering, as we discuss in chapter 7—has been perennial in every field of technical innovation, with craft, design, and indeed music often to be found in the contested intersection. It therefore seems likely that these alternative perspectives and communities will continue to grow into the foreseeable future.

Eighteen years on from the critical gathering of the Changing Grammars symposium of 2004 and the drafting of the TOPLAP manifesto, this book hinges on a moment in live coding's evolution when it is just about still possible to narrate a partial history, however fallible, at a critical juncture from where the practice of live coding now diverges and diversifies in ways we cannot yet tell. While this chapter has attempted to give some kind of coherence or contour to the arc of live coding's development thus far, chapter 3 presents live coding in its singularity, exposing the specific approaches through which live coding manifests within a diversity of different practices. Neither comprehensive nor exhaustive,[72] these expositions are conceived as personal perspectives on the practicing of live coding *by* live coders.[73] The chapter includes both the creators of new live coding tools and those who have developed artistic practices through using those tools. Some identify primarily as technologists, some as composers, and some as performing artists. As editors of this chapter, we do not attempt to synthesize a single narrative. Rather, we provide an opportunity for the diversity of live coding to be represented through rich accounts of practice and allow the practice to speak for itself and on its own terms.

3 Expositions

Rangga Aji, Alejandro Albornoz, ALGOBABEZ, Rafaele Andrade, Jack Armitage, Pietro Bapthysthe, Lina Bautista, Renick Bell, Ashlae Blum(e), Alexandra Cardenas, Lucy Cheesman, Joana Chicau, Nick Collins, Malitzin Cortes, Mamady Diarra, Claudio Donaggio, Jason Freeman, Flor de Fuego, Sarah Groff Hennigh-Palermo, HAUS++, Mike Hodnick, Timo Hoogland, Miri Kaat, Abhinay Khoparzi, Shawn Lawson, Melody Loveless, Mynah Marie, MicoRex, Fabrice Mogini, Kofi Oduro, David Ogborn, Jonathan Reus, Antonio Roberts, Charlie Roberts, Jessica A. Rodriguez, Iris Saladino, Kate Sicchio, th4, Anne Veinberg and Felipe Ignacio Noriega, Rodrigo Velasco, Elizabeth Wilson, Anna Xambó

Photo by Alieneta Firdausi

Photo by Ahmad Mulkan Karim

Rangga Aji
Program Director: October Meeting—Contemporary Music & Musicians,
Special Region of Yogyakarta, Indonesia

For me, live coding is a method that could be implemented in any kind of artistic practice. I live code in my music performance work and sometimes also for live visuals. I got interested in live coding when I saw it as another possibility in art and music creation, especially given the generative ideas that could be implemented on it. The way of projecting/showing the coding process also adds the variant of presentation, especially in the ontology process of electronic music.

I love to share what I know about live coding practice with people. Sometimes I do little private live coding sessions for individuals or groups, online or off-line, helping with installation and teaching a bit about Sonic Pi, FoxDot, TidalCycles, and Hydra and then Estuary, Troop, and Flok for the possibility of remote live coding. I also made an introduction video about live- coding music and visuals in Bahasa Indonesia.[1] I feel like it still couldn't provide a better explanation of live coding, but I decided to make it happen so people could at least become intrigued enough to try to learn it by themselves.

For me, both live coding from scratch and live coding from prepared code are exciting and promising for my live coding practice. With the first method, I can learn how to directly or slowly decide what kind of musical structure I want to build without depending on any prepared code. With the second method, I can have some control over my music composition while introducing aspects of live coding. I'm also thinking about the possibility of both approaches in exploring the idea of certain musical etude compositions for live coders.

Based on what I've been experiencing in Indonesia, live coding is starting to slowly emerge. Even though only certain people became intrigued and started their own live coding activities in certain places here, I think it will soon become something unexpected, but I'm not sure what.

One thing I've noticed is that live coding often brings up a new topic to be discussed—for example, the idea of remote live coding and an ensemble. I remember a discussion about this with fellow live coder friends from Indonesia and India, Maria Maya Aristya and Abhinay Khoparzi.[2] One of the many things we talked about was the musical possibilities that could be implemented in a remote live coding performance as an ensemble. This is exciting for me since it seems like it could be the opening of further possible perspectives.

https://linktr.ee/ranggapuraji

Alejandro Albornoz, a.k.a. co(n)de Zero, and Christian Oyarzún.
Image credit: Constanza Lobos

Image credit: Alejandra Caro

Alejandro Albornoz, a.k.a. co(n)de Zero
Universidad Austral de Chile,
Valdivia, Chile

For me, live coding is a fresh way to embrace live electronic music, a field I've been involved with since 1989. With my band Arteknnia, we moved from electro-industrial live acts with synths to synth-pop by MIDI sequences, drum machine, and guitar. After 1995 I started to compose just with a synth and cassette tapes, resulting in my ambient/electronic dance music solo project *Mankacen*. From 2003 onward, this was in parallel to my electroacoustic output in a more "academic" compositional path. Whatever the style, I've used different DAWs (digital audio workstations) extensively, which progressively led me to lose interest in performing electronica, focusing my practice on acousmatic. I discovered TidalCycles during a gig by Yaxu (Alex McLean) in Sheffield in 2015. It blew me away, so I've started to learn first ixi lang and then Tidal. I felt that I was in front of a completely new way to perform, something that matched with my incipient ideas on using simple algorithms in a fresh live situation. Before that, I would say since 1999, I was using simple algorithmic procedures to get some materials but, usually, in deferred time.

I think showing the code on your screen is so nice, friendly, and transparent. Something very important for me is to perform from scratch . . . that's so adrenaline pumping and challenging, making me feel alive. There is enough room to mix stable pulsating pattern structures and textural material. . . . TidalCycles in particular allows me to create new electronic tracks and at the same time materials that I use in acousmatic composition. Probably, this would be my only and modest contribution: an unbiased approach in terms of styles or aesthetics, moving between broken post-techno structures, glitchy textures and rhythms, Chilean folklore patterns, and granular synthesis. All of this operates in a recursive personal ecosystem, from which outputs are electronic tracks and acousmatic pieces. Among all this, I've developed a special interest in working with voice and words. However, in spite of the possibility of creating known musical styles, the most relevant aspects for me are the unexpected structures and sounds provided by these techniques.

I lived in Sheffield, UK, between 2015 and 2019, where I started to be in touch with TOPLAP, Tidal Club, Eulerroom, and Algomech Festival, among other live coding instances. Since then, I've returned to my country, Chile, with the intention to spread the practice and tools to as many people as possible. This is an ongoing project that is growing slowly and has been heavily affected by the COVID-19 pandemic. In this endeavor it has been very important to be in touch with people and groups, including live coder and media artist Christian Oyarzún, the cultural center Taller La Cisne Negro, and the Pueblo Nuevo netlabel. Hopefully, we are intensifying our activities this 2021, which includes holding the International Conference on Live Coding (ICLC) in our city, Valdivia. Live coding is still very new here, but I'm convinced it is a great tool, even beyond artistic outcomes. I see it as a way to gather people through open and democratic spaces involving art and technology, especially for children and young people's education.

alejandroalbornoz.wordpress.com/conde-zero/

Photo by Antonio Roberts

ALGOBABEZ (Shelly Knotts and Joanne Armitage)
UK

ALGOBABEZ came together through a shared skepticism of code-bro cultures, a flurry of estrogen, and overloaded algorave lineups. Collaboration was inevitable. We were both performing regularly as solo performers but were drawn together by the maleness of the scene. Our first performance took place in the corporate sheen of the Open Data Institute as part of the Leeds Digital Festival. We felt a sense of disrupting the atmosphere—when we started playing, the crowd changed. The women moved forward; the men moved backward. We had to let rip! Though totally unplanned, this set up a "legend" around ALGOBABEZ as an obnoxiously noisy and unapologetically feminist double act.

Our individual live coding practices meant we naturally fell into specific musical roles: Shelly making textural drone sounds and Joanne tending toward rhythmic material, juxtapositioning Shelly's lo-fi software synth sounds with Joanne's hi-fi MIDI instruments.

Beyond algoraving, we have looked at new ways of knowing and controlling sound through performance (i.e., BabeNodes, Vibez, Chemical Algorave), combining Joanne's knowledge of physical computing and Shelly's skills with biometrics and algorithmic systems. Shelly's experience in networked music has enabled our continued collaboration as the physical distance between us has increased.

We both engage with feminist theory in our academic work, and this has informed the way we present ALGOBABEZ. Connecting *ALGO* to the ironic use of a term of endearment allows us to overtly perform gender in academic and electronic music scenes, where women are underrepresented. We've used this "ironic gender performance" as a way to build narratives around our work. As a band, we've rejected the use of prewritten code and structures—acting in the moment, responding to context, audience, mood, alcohol consumption, and each other. Before performing, we don't discuss structures, preferring to just bounce off each other, developing a structure as we work, continually creating and resolving tensions. We work to strip back dense textures and create space for each other across the frequency spectrum. We work on other computer music projects that are centered around collaborating with, teaching, making space for, and promoting women in the field. One joint project is OFFAL (Orchestra for Females and Laptops), an international telematic women-only laptop ensemble who perform through audio streaming and web interfaces.

The sound world of algorave has changed as a result of ALGOBABEZ taking noisy sounds and seamlessly integrating them into four-to-the-floor beats. We didn't set out to play a particular genre or type of music, but this emerged out of improvisation and performance—we reference the more experimental side of live coding (often concerned with SuperCollider synthesis) and transpose it into the algorave context while projecting ourselves as bad-ass women. We've seen this experimentation with sound propagate across the scene since we started playing.

ALGOBABEZ has also made a significant contribution to diversifying the gender balance in the UK algorave scene through teaching workshops and acting as role models. Through this, we have achieved a critical mass of women who are performing, teaching, and organizing live coding activities.

https://twitter.com/algobbz; https://algobabez.bandcamp.com

Photo by Felice Hofhuizen

Photo by Paulus van Dorsten

Rafaele Andrade

Knurl, an interactive and open-source cello, is a creation of the composer and cellist Rafaele Andrade. It has been reaching audiences all over the world for its nonstandard vision, bringing music into political, technological, and environmental discussions. This project brings open-source practices, sustainable three-dimensional printing, creative coding, and sustainable energy sources into the hands of a diverse team composed of local artists, designers, scientists, and programmers. Besides Knurl, Rafaele explores themes such as climate change, globalization, and feminism in her own artworks; every matter matters, and every message is also part of an ongoing process.

Knurl is a product of creative coding and open-source culture: its interface and web platform were designed by members of Netherlands Coding Live at the instrument inventors' initiative in the Netherlands. During its year of development, it became the product of an artistic research organization (Knurl Lab) that brings creative coding into the hardware of a musical instrument, in dialogue with issues that our music world has been facing (climate change, globalization, and so on).

The intention to unify its creative approach as a single process is clear: to develop an idea through active practice. It is to collapse prototypes, one after another, and collect as much feedback and evaluation as possible. To create is to finish thousands of such cycles as a deep experience into your personal life. Rafaele believes that these experiences can be enhanced by using all your senses, your body, your well-being, and your health.

As science moves forward with the development of new tools, the invention of new musical instruments can also open a new chapter in music history. Realizing that Knurl isn't only an instrument but also an interface, a platform, and a piece of hardware, this project intends to solidify those results, testing their applications as tools that also represent cultural heritage.

New repertoires for the cello and electronics in collaboration with other instruments have been made and presented at international music festivals, conferences, and artistic residences. The intention is to explore how instruments and technologies can create new bounds and approaches between their users, creating new forms of relationships and entertainment. Creating new instruments also provides the opportunity to explore sustainable practices—for example, ways to capture sunlight or even sound output as energy storage, as well as the development of biodegradable materials for acoustics solutions.

Photo by Maggie Kane https://www.instagram.com/streetcat.media/

Jack Armitage
UK

Live coding is a set of tools and methods for sculpting dynamic musical systems via algorithmic notation, often but not exclusively through the medium of text. I first engaged with it as a way to escape the limits of traditional music software, and still do. Since I started I have pursued two goals with my live coding practice. First, I strived to raise live coding to equal status musically with pop and dance produced via traditional means, to humanize coding and inspire "noncoders" to reclaim it from the techno-academic elite. Second, I have used it as a platform to research more richly embodied forms of dynamic musical media, to liberate us from the anachronistic typewriter-and-paper-emulator interfaces that demean us daily. While I have in my view contributed significantly to the first goal, its measure of success is whether I inspire anyone to surpass me, and so far that hasn't happened, but I remain optimistic. The second goal has so far been open-ended and long-term oriented, with only a few short papers and prototypes to speak of.

I see my practice as locked in tension and even opposition with other live coders, and I suspect that others feel the same way (about themselves and me). This tension arises when I import mainstream pop/dance references into live coding and similarly when I take liberties with live coding dogma. This is a necessity when performing on pop/dance music lineups where I am the only live coder, but for me it also highlights the frequently self-serious presentation of live coding and its often spartan musicality. At the end of the day, there is always something about other live coding practices to be inspired by; it's especially inspiring to see first-time performers, which is frequent in the live coding community as compared with other music communities I've been part of.

Since my primary goal has been nontechnological and I arrived in the scene at a time when powerful live coding systems had already matured, I have dedicated my system design energy toward the future and lie in wait for the appropriate moment to act. This is another way of saying that I haven't actually built anything myself yet.

Coding in the large is gradually becoming live by default, and the days of coding as a singular practice of moving text using a typewriter are numbered. Consequently, live coding itself as a stand-alone term or field does not have a future: it will not permeate more than it already has, and it will soon be outmoded by younger generations who look and talk differently. However, its impact as a stepping-stone is already in my view historically undeniable. As for the future, I believe that the things that reference live coding (explicitly or not) will be numerous and marvelous.

As it is not a general term, I doubt that live coding means anything to the "general public" other than something technical sounding and thus vaguely threatening. If as an experience it is foisted on an unsuspecting public, audiences initially perceive live coding as a curious academic gimmick with a poor technique-to-music ratio. If they manage to stay through a whole show, they start to see that every performer's approach and music are different and that, rather bizarrely, this means there must be a whole subculture of this stuff going on somewhere—and they would be correct. But in the future, the general public will be much more likely to live alongside the offspring of live coding than the parent.

jackarmitage.com

Computer artwork by Diego Moreira Guimarães

Photo by Mari Moraga

Pietro Bapthysthe (Diego Dukão and Berin)
Brazil

For us, live coding began as another way to explore our musical interests together. Over time, it proved to be a perfect fit because we feel more able to reproduce what we are imagining without having to struggle with the physical limitations of instruments.

We started to explore live coding together as a practice in June 2019, during a Python conference in the northeast of Brazil. Starting with live coding as an improvised way to have a party to celebrate the end of the conference was amazing! It helped us to grow a strong need to promote a community in Brazil. Since then we've been active members in Algorave Brasil, helping newcomers, organizing events and workshops, and sharing content about live coding. During 2020, we also released monthly records with recorded live coding sessions.

The live coding tool we use the most is FoxDot. We've already made a few contributions to the project and to Troop as well. But we also have our own SonicBox, which is a mobile app that interacts with Sonic Pi, allowing us to make improvised melodies with a mobile device, together with the music being played by FoxDot.

Currently, here only people that practice live coding listen to live coded music. It's a small niche—a very prolific one—but small. We think that will change and that live coded music will blend with regular music and that sometimes we won't even know, for example, that rap that is playing was made with live coded music. We also think that schools will adopt live coding to teach programming and music at the same time because it is such a good way to learn both of the subjects! Teachers and students will love it.

A lot of people think they could never play an instrument, and a lot of people think they could never program. So when they hear that you deal with both things together, they think that it could be the most intangible thing ever. But when you show them your live coded performance, they enjoy it or, at least, find it interesting. And when you spend just a few minutes showing them your code and explaining what you're doing, they start to think "Hey, I could learn that."

pietrobapthysthe.bandcamp.com

Lina Bautista performing as Linalab.
Image credit: Iván Paz

Lina Bautista
Spain

For me, live coding is a practice in which the brain has a unique connection with the music and the public. It is a particular way to show your thoughts. When I started with live coding, I was just curious about different performative practices, in search of my way. What I found is that live coding really makes me perform in a singular way. I can almost hear my brain going fast, making decisions and reacting to sounds. Live coding is also about the community. I think it is a safe space to learn, make mistakes, get support from others, and have fun.

I think that my role in the community has been about encouraging people to get into live coding by performing in different contexts and through connecting people. I started TOPLAP Barcelona along with Iván Paz, and since then, the community has been growing with the care and ideas as I learned it: sharing and working together, although in the community we do not all use the same tools or play the same musical genre.

My performing style is basically starting from scratch and using just a few lines of code during the session. In this way I try to make good sessions with a few elements, and I try to make the code simple and understandable so the general public can feel more included, encouraging them to do the same.

I'm aware that live coding is moving faster into the mainstream. We can perceive that in our context. I've worked hard to explain to institutions, festivals, and projects that live coding is not only adding some code to the screen. It is about the way you do things and about a community that works in a particular way. I also see that each time more live coders develop their own tools, languages, and libraries. I see more relationships between hardware and tools, such as the use of artificial intelligence (AI), for example. I think all of that will take live coding to new and exciting places.

Some people just enjoy a session, like an algorave, because it is a kind of geeky party. They feel they are in *The Matrix* surrounded by code; they do not feel the need to understand the exact meaning of it all. I have also seen that some people feel excluded because they don't know what the meaning of the code is. They believe we're a closed and select group of nerds where they don't belong. It is here where I think we have to work harder.

linalab.com

Photo by Jun Yokoyama

Photo by Jun Yokoyama

Renick Bell
US/Japan

I perform with my Conductive system, a Haskell library for live coding autonomous processes and generating patterns of things like rhythm, samples, or event density. I use it to create large volumes of patterns and audition them for audiences; the sounds are new for them and me. I am beginning to use it to control hardware synths and interact with other people's systems.

I have been making electronic music for over twenty-five years. Around 2003, frustration that I couldn't perform it live like I had in punk bands led me to return to computer music languages from university, like Csound and SuperCollider. In graduate school I developed a generative music system with a graphic interface that worked technically but was unsatisfying to play with a mouse. Thinking the limitations came from the graphical user interface (GUI) library, I sought better tool kits in different languages. I had read Alex McLean's "Hacking Perl in Nightclubs" in 2004; it had seemed novel and hilarious, but I didn't consider trying it. However, by 2007 I realized I was making music with code almost as well as I had with the GUI, and the potential became clear: using my typing skills with the enormous powers of abstraction available through live coding, I could go far beyond. I had been watching McLean blogs about Tidal development and wanted to use it, but as it wasn't publicly available then, I started coding Conductive.

As Conductive became familiar, I imagined how the possibilities could be increased. Simultaneously, the software sometimes demonstrated possibilities I hadn't imagined, changing my direction for Conductive. This has given me an inexhaustible list of things to try in performance and features in Conductive to add or improve.

I perform often in Japan, where people increasingly know about live coding or practice it. Of several algoraves we have held in Japan, there have been two in Tokyo where people had to be turned away at the door. I also have many chances to perform internationally outside of the live coding community and observe an increasing interest in live coding.

I see three challenges for live coding based on comments from outside of the community. First, some perceive a lack of immediacy, believing that live coding is not developing as quickly or as much as other electronic music, live or DJ. Second, some feel that live coding emphasizes process to the detriment of sonic results, neglecting aesthetic aspects like the mix of voices in arrangements and other factors related to current developments in various subgenres. Third, recognizing that live coding makes possible things that are hard or impossible for traditional tools, some say that live coding misses opportunities to explore new types of music and express frustration over live coding that incompletely imitates existing genres rather than further exploring the unique territory live coders can access. While we can argue with these perceptions, taking them seriously can be useful. Live coding can progress both technically and in how it is perceived in the electronic music world by accepting these challenges.

renickbell.net

Photo by Ashlae Blum(e)

Ashlae Blum(e)

As a musician with a background in live musical performance as well as engineering physics, live coding is a natural extension of my musical expression and artistic practice. For me it feels almost the same to create music with live coding as it does with an instrument, minus the tactile feel of playing the actual instrument itself and plus a lot more prep work beforehand. I like to experiment with a variety of tools and workflows, and my most fluent languages are currently FoxDot, SuperCollider, TidalCycles, and Hydra, in that order.

As a trans nonbinary musician, I've experienced lots of "othering" in the music industry. After hitting the glass ceiling there a few too many times, I began to question my identity as a musician and wanted to redefine the role music had in my life. I decided that if I could still have an emotional relationship with music, even if I was "just" programming it, I was actually meant to be a musician, and here we are three years later. I started live coding by myself. I just kind of accidentally learned about it on the internet while I was teaching myself Python and, after doing it for a year, was shocked to find that there were actually many people who also live code and that the community was so international. I felt like I'd discovered a kind of lost Atlantis that I had never experienced in other music scenes I'd previously been part of.

One thing I've been working on is a methodology for live coding that uses a nonlinear, layered approach to performance inspired by the modular impressions I've arrived at through making music with live coding software. It draws on aspects of live coding, music production and performance, and methods from physics. I've termed the process *Modular Geometricity*.

My system is an approach or way of thinking about the creative process rather than a specific set of tools. (I guess the tools are the mind.) Since that which we create is but a reflection of our thoughts and the actual software/hardware we are working with (i.e., other people's minds), it is inherently a collaborative effort, even if one is unaware of the history of technology.

All rivers flow to the sea; I think that since most live coding software stems from principles that are deeply embedded in the history of music and technology, fundamentally, most of the current live coding systems are just iterations of the same process. Most of this relates more to communications theory and electrical engineering, I think, than to music itself.

How people see live coding is dependent upon the tech literacy of the audience, which is also inherently dependent upon factors such as economic mobility and demographic representation. Currently, it is an underground scene, which will likely shift if pop and mass media get their hands on it. Generally, I think the idea of coding as art is still quite foreign or even to-be-avoided by the masses. This is okay because it will change.

I see the future of live coding through shader-patterned glasses.

ashlaeblume.bandcamp.com

Photo by Udo Siegfried

Alexandra Cardenas
Colombia/Germany

Live coding is a technique to create live generative art. As a composer, I was immediately attracted to it because it offers the capability to think and create in a way that is close to my own musical thought. From the beginning I was highly interested in music, mathematics, live electronics, real-time compositions, electroacoustic music, and electronic music. At the same time, my interests let me discover different traditional kinds of music from around the world. Through the study of African, Caribbean, and academic percussion, I got deeply interested in the patterning of sounds to create different kinds of music. Through my studies in electroacoustic music and orchestration, I studied with a passion different ways to create and mix sounds in order to create music.

After many years of working with Max/MSP, I found SuperCollider. Working with code offered me the opportunity to get rid of any graphic metaphor and allowed me to describe my musical ideas with a language much closer to what I had in mind—something different than digital boxes and cables and even different than expensive physical electronic instruments. Feeling so comfortable describing music in this way, I spent a couple of years learning the basics of SuperCollider. Even though I was passionate about it, it was a complicated language for me to learn. Thanks to SuperCollider I discovered live coding, and with it I could fulfill my dream of being able to generate infinite sounds, forms, and textures in a live manner. I always wanted my music to sound different every time it was played.

Since the beginning, I have been annoyed by the linearity of time and the linearity of music. I feel I am still beginning on this journey of discovering. I will always feel like a rookie when it comes to creating live coded music. And I love this feeling because I know live coding offers infinite opportunities for music, art, and our society. As a touring live coder, I have traveled around the world teaching and performing my music, helping to exchange knowledge and create communities around live coding, and founding several TOPLAP nodes.

http://tiemposdelruido.toplap.org/

Photo by Antonio Roberts

Lucy Cheesman
SONA, UK

Hi, I'm Lucy, and I'm a live coder.

I've been making solo music as Heavy Lifting using TidalCycles since 2016. I still kind of think of myself as a newbie even though four years (and counting) is a pretty long time. I think in part it's because I feel there is always so much more to learn and do. I teach a lot of workshops on Tidal, but I feel like I'm learning as much as the participants every time; my relationship with the computer changes each time we ask a question.

I use various languages, depending on what I'm doing (I've done performances with Tidal, FoxDot, SuperCollider, ixi lang, and Orca), but I'm always drawn back to Tidal, probably because of how it thinks about time and the seemingly infinite possibilities it gives you for sample manipulation. I've always been interested in sampling as a means of making music, particularly taking sounds that are familiar and reusing them in perhaps unfamiliar contexts; Tidal lets me do this in powerful and unexpected ways.

Sometimes my performances are serious or maybe explore some kind of lofty themes, but more often I'm just laughing at my own jokes. At the end of 2015, I went to a live coding workshop for women run by Joanne Armitage and Shelly Knotts, who told us to embrace error; I took that to heart. I think by removing the pressure to be accurate, live coding creates a pretty unique environment for experimentation. In my case I use that freedom to be quite silly; in the picture I'm performing a set using only samples from that year's Eurovision Song Contest (it was happening on the same night), accompanied by some beautiful visuals by Antonio Roberts. I think that writing code can be seen as a superserious dark art, and I hope that irreverent and fun live coding performances can go some way to dispelling that myth.

I'm lucky enough to live in Sheffield, where there is a really strong live coding scene fostered by Alex McLean (a.k.a. yaxu); we have regular algoraves and the wonderful AlgoMech festival. I try to do my bit by running gigs, meetups, and workshops. I was given so much support starting out in live coding, and I really want to pass that on to other people. One of the key features of live coding to me is that openness, and I'm not just talking about free software but the intention to collaborate in nonhierarchical and noncompetitive ways. The next step is to dismantle capitalism—see you there <3.

heavy-lifting.org

Screenshot of Joana Chicau live coding visuals in a web browser

Photo by Marco de Swart

Joana Chicau
The Netherlands/UK/Portugal

In 2016 I started a transdisciplinary research project that interweaves web-programming tools and environments with performance and choreographic practices. Since then I have been investigating diverse notation systems from both dance and web programming, which I then merge into a hybrid form of algorithmic composition: a "choreo-graphic-code" that brings new meaning and produces a new imaginary around the act of coding.

Choreography in the context of this research project is seen as a writing or a metalinguistic space for thinking movement and countermovement in the (de)construction of web tools and digital media environments. The liveness of code writing became a way to activate the choreo-graphic-code, exposing various processes and dynamics of web computing while enhancing the physicality of the body—the body that is in constant friction between the constative (reality describing) and performative (reality producing). Engaging with different forms of choreographic thinking has been a way to bridge and enhance the somatic and semantic within coding.

I believe improvisation is key in live coding practices in general, and within my performances I hope to take this notion both as a technical and physical condition and bind the procedural with the conceptual and corporeal layers of live coding.

My practice reflects on the intersection of the body with the constructed, designed, programmed environment. It aims at creating new alternative circuits within the technological sphere of programming languages and possible encounters with the sensorimotor structures that regulate our bodies and movements, hopefully contributing to a different mode of embodying live coding tools and systems of notation and of appropriating digital technologies.

Kate Sicchio has been one of my most important sources of inspiration. A few years ago while I was still writing my thesis, I was introduced to Kate by Alex McLean. Later we all met in person at the ICLC 2016! I still try to follow her work as closely as possible. Another important aspect of my practice is the use of coding languages and its performative instance to build diverse, inclusive, and plural discourses, as well as a site for nurturing collaborative and open work. Such critical thinking and activism on gender equality and inclusion have been brought to discussion within the community by Shelly Knotts and Joanne Armitage, among other feminist live coders. I feel very close to their thinking and have already engaged in public discussions with them.

As in most live coding practices, my system and methodology focus on the use of free/libre open-source models and are concerned with widening the ways in which digital media and computation are presented and made accessible to the public.

joanachicau.com
jobcb.github.io

Periodic table sequencer and IBM six qubit frontend in SuperCollider. Image credit: Nick Collins (Live Dog, Inc.)

Nick Collins
Durham University, UK
composerprogrammer.com

Jack Code's Rebellion

A single character change in text can have enormous consequences. In Terry Gilliam's administrative nightmare *Trazil* (1985), *T* becomes *B*, *Tuttle* becomes *Buttle*, exchanging life and death; in the page title, Jack Cade's fifteenth-century rebellion takes on a contemporary repercussion. From Shakespeare's *Henry VI*, part 2, subtly rewritten, we now find a beautiful anticipation of the theater of live code: "These hands are free from guiltless blood-shedding, This breast from harbouring foul deceitful thoughts. 0, let me live! Code: I feel remorse in myself with his words but I'll bridle it; he shall die, an it be but for 'pleading so well for his life . . .'"[3]

Changing your mind while you act in the world is nothing new; it is at the heart of survival and improvisation, an essential part of the history of humankind, with language's versatile generativity a great creative backdrop. But explicit interaction via a computer programming language, as artistic activity often framed on a concert stage, was a step change in intent of which I have been privileged to be some small cog.

The historical precedents are fascinating, from mathematics and games, through role playing to drama, touching on political systems and the cultural history of algorithms. Varied topics from human life can underlie live coding dramaturgy, and this wider net of human subjects has provided a rich grounding for much of my own live coding work. In the algorithmic choreography laptop duo Wrongheaded (with Matthew Yee-King), once-off performances included a live teddy bear dissection with liberal tomato sauce, a séance evoking the ghost of Alan Turing, and "The Gospel according to Wrongheaded."[4] A more recent and I hope never fully formed project, Live Dog, Inc., has drawn on varied inspirations to motivate improvisational coding, from satire of existing music (Johnny Bash's "Live from Fortran Prison," HadIORead's "Discothick") to hard science including a live-code-controlled periodic table and six-qubit quantum computer experiment sequencers.

I wonder if what I think about live coding has changed over the years; that would seem an entirely appropriate state of affairs. I revisit my attitude to live coding once in a while, though I wouldn't like to reinvent the repeal. Yet re:rerereading some "thoughts on live coding" I wrote quickly in 2004,[5] I find that I wouldn't change the text so much, and the profoundly deep live coding insight I crave remains beautifully elusive. Perhaps I should leave behind the occupation of live coder, for as a bezzific proverbial 1857 poem cries, "A change is as good as a zest,"[6] where *T* is to *B* as *R* is to *Z*. As Click Nilson once wrote, " ".[7]

Malitzin Cortes, "Generative promenade or Nightmare catcher," Modern Art Museum, Mexico City, 2019. Photo by Malitzin Cortes

ACI Asia Culture Center. Foodhack 2019 ISEA Korea 2019
Photo by Asia Culture Center

Malitzin Cortes (CNDSD)
TOPLAP Mexico

Live Cinema Coding
Nonlinear stories, abstraction, and audiovisual synesthesia in the contemporary context of code

In the 1960s, artists and filmmakers began to challenge the conventions of audiovisual language, creating more participatory roles for the spectator. The constant development of design, film, and computational technologies pushed these works further forward. They left linear, classic cinematographic language behind, taking film outside cinemas and into art galleries, abandoned factories, and outdoors, implementing different forms of experimentation through multiscreen projections. A great reference for what we can see today, which in 2020 is seen from a distance with our festivals of electronic music and digital art and the "language of new media,"[8] is *Light Music* (1975) by Lis Rhodes. It is composed of two "films" projected in a smoky room, with an intense sound composition created from flashing patterns on the screen, demonstrating that emotional, perceptual, and immersive experience is nothing new.

Live cinema coding is a hybridization between live coding and more established practices of expanded cinema and live cinema, generating new stories and open interpretation. These practices have their own tools, with possibilities that are not only technological but also aesthetic. On-the-fly programming creates sound phenomena conducive to these new possibilities and is able to generate music of any genre. Visually, it has joined the world of generative creativity and computational thinking in the arts (creative coding) and is available to all artists, not only those specialized in science and technology.

The creative work and research that I have carried out with digital artist and programmer Iván Abreu over several years has combined our technical skills and artistic passion for the console, not only as a way to preproduce audiovisual content, from the keyboard and logic of a program, but also to tell stories and compose music that emerges from, and through, algorithms. In this way we have used different tools for live coding, such as SuperCollider, Hydra, Orca, and Pure Data, but above all, for its efficiency, community, and functional way of creating and ordering anything in time, we use TidalCycles. It can generate complexity from very little code, and we have found enormous poetry in the syntax that takes us from within to achieve a sound and visual idea. From the mind to the algorithm and then to the screen, a palindromic pattern can be sonic and/or visual, evoked by typing Tidal's palindrome function from the keyboard. We are now developing and contributing systems back to the community, not only to understand the complexity and compositional beauty of Tidal but also to find ways to hybridize different tools and programming languages with a single reason: to tell intense stories with sound, light, and images in real time.

malitzincortes.net
https://vimeo.com/cndsd

Photo by Mamady Diarra

Photo by Mamady Diarra

Mamady Diarra
France

Live coding? For me this is really brand new. I had already learned some programming, nothing more. . . . I discovered live coding while watching an interview with someone talking about making music through code with a system called Opusmodus. The price of this software calmed my interest, but I was curious. Then along the way, I started to find out more. A friend told me about a live coding workshop that would take place in Paris organized by NO School Nevers! I went for it without hesitation. I was excited to meet the creator of the open-source software TidalCycles (Alex McLean), which I use most often in live coding. The coding aspect, the accessibility, and even the active, caring community led me to use this software over any other.

I'm always excited to attend an event that brings together other live coders. It's always informative and really interesting. My first live coding gig was at the 7° Festival Ambient de Paris in September 2020, where people gathered outside of the live coding scene with people who had mostly never heard of live coding. I was surprised. The audience was receptive and came to ask me questions at the end. It's heartwarming to see how live coding can affect so many people.

The live coding system is an experimental field, constantly questioning itself. This is unique to information technology and to tech in general. But it is true that in the live coding system there is a lot more unpredictability. Sometimes I feel like I spend more time engineering . . . solving problems . . . It's alive!

https://afalfl.bandcamp.com/

Photo by Claudio Donaggio

Claudio Donaggio
TOPLAP Italia

The year 2015 was a difficult one for me, both physically and mentally. One day that year I saw a video on YouTube by Andrew Sorensen. At the time, I had never written a line of code in my life but I was fascinated. I started immediately with Sonic Pi. Live coding and, even more, the community of live coders around the globe helped me to gain enough self-confidence to beat my own demons and believe in myself. And that's how I started. To me, live coding means "complete freedom from genre and labels," which is what I have always been looking for in musical and artistic terms. Being able to talk with the machine through code and improvise electronic music is the core essence of live coding practice, in my opinion.

I like to work with different environments and languages. I would not know where to start in order to create a system like Tidal or Sonic Pi, but I try to be as much of a polyglot live coder as possible! I am one of the administrators of the Live Coding Italia community on Facebook and Telegram. I hope one day that my contribution will be to have spread the practice around as much as possible in my own country.

My hope is that live coding will not only be designated to the academic world but be adopted, as a technique, by more performers and artists. Nothing against it, but "Be wary of institutions" is my motto. I do think more and more people will become interested in the possibilities of live coding, and I try to help newcomers as much as the community helped me when I started out.

I've seen different reactions from people to live coding. At first they are like "This is something for nerds!" and then when they experience an algorave, they're gobsmacked! Generally, I think it is perceived as difficult to understand, initially. That's why it is always good to start a performance event with a talk, in my own opinion and experience.

https://twitter.com/Etol_livecoding

Image credit: Georgia Institute of Technology

Expositions

Jason Freeman
Georgia Institute of Technology, US

As both an artist and a researcher, I use technology to engage others in creative and collaborative musical activities. While I do occasionally perform myself and create music for professional musicians to perform, I far prefer to devise contexts in which anyone can express themselves musically.

I was initially drawn to live coding as a performer (in the early 2000s) because I could reveal the often arcane practice of algorithmic composition to an audience in a high-risk, improvisatory way. In those early performances, audiences were impressed by the complexity of what I was doing, but they did not understand it at all. I found this dispiriting and abandoned live coding altogether for a few years. Beginning in the late 2000s, I found new ways to approach live coding that were more in sync with my own sensibilities. I developed new environments that shared the experience of musical coding with others instead of sharing my screen with an audience.

Live coding can be a virtuosic activity that is the culmination of years of practice. It can also be a test kitchen that pushes the design boundaries of computer music languages. My practice is neither virtuosic nor innovative in these ways. Instead, I explore how simple systems that are grounded in familiar paradigms can get novices excited about creative coding.

My students and colleagues and I have created a couple of environments over the years, but my current focus is EarSketch (created with Brian Magerko and many others). It is designed for kids who don't know much about music or coding. You write code in Python or JavaScript to remix loops from an audio library, and it shows the results of executing your code in a multitrack audio view. It very quickly gets kids excited about music, and coding, and sharing what they've done with their friends (as the photo illustrates). While it does support live coding, it's the coding (not the liveness) that is the focus.

I admire the many virtuosic live coders out there, but I'm not one myself. I don't perform often as a live coder anymore and when I do, it is usually in an educational rather than a pure performance context. For me, the classroom is the most exciting place for code to be right now, whether live or not.

EarSketch has a much lower barrier of entry (both musically and computationally) but also a much lower ceiling than other systems. It's also deeply situated in commercial music—both the library of audio loops it uses and the DAW paradigm that inspires both the interface and the programming API.

http://earsketch.gatech.edu

Photo by Federico Sande Novo. Courtesy of Museo de Arte Moderno de Buenos Aires.

Photo by Federico Sande Novo. Courtesy of Museo de Arte Moderno de

Photo by Nahuel Zeta

Flor de Fuego
Facultad de Artes, Universidad de La Plata, Buenos Aires, Argentina

Nowadays, live coding is one of the most important practices for me. I explore and try to hybridize sound/poetry/visual/body in my live coding performances. I was prompted to engage in this research from wanting to create audio/visual sets and then found a whole world of limitless possibilities.

I'm an active collaborator within the Hydra community (software made by Olivia Jack) and help organize the Hydra meetup. I give a lot of talks and workshops around this software and also tend to explore and research it. I teach Hydra in high school for teenagers, and I'm also an active member of the CLIC (Live Coders Collective/Colectivo de Live Coders). I think my contribution to live coding practices is related to education but also art because I have an art university education background, and I'm really influenced by that.

I do live coding alone, but I'm also part of collaborative projects, such as c0d3 p03try (Rapo and Flor de Fuego), and lately have been researching potential connections between net.art and Hydra, together with Naoto Hieda. I also participate in different algoraves from mostly Latin American communities.

I imagine live coding will further develop, with more collaborative interactions and hybrid performances and with many more people getting involved. Currently, I think people usually don't understand what live coding is until they see a live performance, and when that happens they seem very curious about it. Is not enough to explain it; you have to experience a live show.

https://flordefuego.github.io/

Image credit: Molly Gunn and Westley Hennigh-Palermo

Sarah Groff Hennigh-Palermo
Codie, US

I started live coding via Live Code NYC meetings in 2017. The meetings were essentially an excuse to see friends and yell about compilers. The "actually performing" part I was less sure about. Then Kate Sicchio convinced me that if I performed with her, I would get to write a visuals framework. Being the kind of girl who is unable to turn down the chance to write an SVG (scalable vector graphics) framework in ClojureScript, I agreed. We performed once, I fell in love, and our collective, Codie, was born. The third member, Melody Loveless, joined us a few months later.

When we started, the New York scene was still relatively new. Kate had moved to New York from Sheffield and founded the group with a few other folks. This was a great opportunity for us because the group was small enough to allow everyone to play every show they wanted, and so in 2018, we played something like twenty-five or thirty shows. These were mostly in dark bars in Bushwick, but we also did some more reputable venues.

I think the New York scene then was, for better and worse, a bit "artier" than in some other places—people understand our shows as art events and expect a lot more weirdness than bangers, per se. It also meant that there was a lot of focus on pairing musicians and visualists before shows and sometimes even practicing together. Codie takes this to an extreme in that we practice a lot; we're a proper collective. I like to think we were an example for the rest of the scene.

This approach—rather than visualists showing up the day of and asking who wants vis—is really vital because it opens a space for deep collaboration. Instead of linking together sound and light through audioreactive visuals, which I always find a bit dull, we are able to link through a basic agreed rhythm and then play off one another in a way that's only really possible when you play together a lot. It makes for a really rich dialogue. We've also elaborated on it in short films we've done together.

This way of computing also helps me "unthink" the engineering I do as my day job. It allows for a relationship with computers where they are more like plants, rewarding cultivation and experimentation. That experience then flows into my nonperformance art, which has become a counterpractice to the sort of technical mystification and dystopic AI projects that are popular now. I'm looking to unfold a space outside new media hucksterism and unquestioning engineering positivism.

In the future I would like to see more attention paid to the seriousness of live vis. It still feels like we are the little sisters in a lot of cases. There are not always vis talks at conferences, and at shows you often get the setup equivalent of playing your tunes through a boom box. But it's not like I'm organizing anything these days, so maybe I should step up instead of just wishing!

http://art.sarahghp.com/

Screenshot by Akihiro Kubota

HAUS++
(Hirozumi Takeda, Yosuke Hayashi, Takanobu Inafuku + Akihiro Kubota), Japan

P-Code is a minimal language for live coding sound performance.[9] The code is interpreted from left to right, divided into numbers and other symbols, and then executed. All symbols that cannot be interpreted are treated as white noise, making it an error-free language.

The syntax of P-Code is minimal, but the input methods are diverse. You can write code in a variety of ways, including via keyboard, image optical character recognition, handwritten input, and voice input.

Collective live coding sessions with multiple participants are also possible. P-Code Playground is a chat environment where the P-Code can be executed. The codes and texts entered by the participants are recorded, along with the time they are entered, and can be replayed using the playback function.

R3PL (random regular expression read-eval-print loop), the new runtime environment for P-Code, now allows input with regular expressions. Code written in regular expressions is, so to speak, a potential code that is fraught with indeterminacy.

Live coding is a never-ending open challenge to go beyond "improvisation."

p-code-magazine.github.io

```
do
  let rfreq = segment 1
      seq = "{1@7 1@11 1@21 1 1 1 1@3 1@3 1@3 1}%16"
      dg = reduce
      chain mod p = sb 0.2 (mod) $ one 0.3 $ shift $ one 0.2 $ shift $ roll 0.2
                     $ dg $ struct seq $ p
  d1
    $ cpsDisc minTempo maxTempo
    $ limit
    $ stack [
    padOn $ slow 3
      $ (|+ note (shiftBy 4 $ choose [0,12]))
      $ (|+ note (scale "ritusen" "{0 -2 -4 -1 -3}%16")) $ pad5n
    , samplestart (segment 1 $ range 0 127 $ slow 10 rand) # midichan 4
    , sampleend (segment 1.1 $ range 0 127 $ slow 21 rand) # midichan 4
    , useIter (iter 16) $ stack [
      kickOn $ chain (# pad4n) $ pad3n
        # legato (range 0.5 1 $ shrand 100)
      , harmorOn $ (2 ~>) $ chain (# gain 0.4) $ harmor # note "-12" # speed007chan
      , perc1On $ often (off (0.0625/2) id) $ chain id $ pad11n
      ]
    , perf4 (segment 1 $ range 0 127 $ shrand 101)
    , perf7 (segment 1.3 $ range 0 127 $ shrand 103)
    , perf8 (segment 1.25 $ range 0 127 $ shrand 202)
    , scene (segment (1/2) $ range 0 sceneRange $ shrand 9991)
    -- harmor cc's
    , stack [
      ccv (rfreq $ ccrand 10 100 133) # filter1
      , ccv (rfreq $ ccrand 10 100 233) # filter2
      , ccv (rfreq $ ccrand 0 127 333) # unidetune
      , ccv (rfreq $ ccrand 0 64 433) # phwidth
      , ccv (rfreq $ ccrand 40 80 38282) # phspeed
      , ccv (rfreq $ ccrand 5 127 533) # envattack
      , ccv (rfreq $ ccrand 0 127 7283) # envdecay
      , ccv (rfreq $ ccrand 100 127 633 ) # filter1width
      , ccv (rfreq $ ccrand 127 127 733 ) # filter1env
      , ccv (rfreq $ ccrand 100 127 833 ) # filter2width
      , ccv (rfreq $ ccrand 127 127 933 ) # filter2env
      , ccv (rfreq $ ccrand 0 127 1033) # timbre
      , ccv (rfreq $ ccrand 64 64 1133) # amprel
      , ccv (rfreq $ ccrand 0 127 7) # harm
      ] # speed007chan
    ] # cps (140/120/2)

    hush
```

TidalCycles code.
Image credit: Mike Hodnick

Mike Hodnick

When I first saw TidalCycles, I immediately recognized that it excelled at rhythms and patterns. Being a programmer and a percussionist, it looked like the perfect match for me. But I saw further than that; I envisioned that TidalCycles could create endless permutations of complex rhythms spiraling out of control. I was also tired of making music with a DAW because it was tedious. TidalCycles helps automate the music I really want to make.

TidalCycles allows you to write computer code to make music, but not just any music; it allows you to bend and break dozens of patterning and sequencing conventions. Through small amounts of code, you can create minutes of ever-changing musical patterns. I think it's arguably one of the greatest music sequencers ever made.

It's a cliche, but the best musical moments are when accidents happen. TidalCycles exponentially increases the frequency of those accidents not only because it is live code but also because it requires very little code. Small changes can result in large musical differences. I've built my musical practice around experimental workflows that exploit specific features or quirks about TidalCycles; for example, "What if I create ten patterns that focus on TidalCycles's *XYZ* this week?" Through Tidal's MIDI capabilities, I've also been able to take these experiments to hardware and software synths, which has really opened up the sonic possibilities.

I started out with the 365TidalPatterns project, as my way of learning Tidal out in public. The goal was to create a small one-minute pattern every day with the samples I had in my own library. I never really set out to make those patterns into a final, cohesive project. I valued quantity over quality. The day-to-day flow made me comfortable with doing small experiments and shelving them. I had source code and an audio file for every pattern. I learned much later that I could then go back to those patterns I liked best and shape them into final compositions. I continue that practice to this day.

The international live coding community is one of the most open and welcoming groups of people I have ever known. It is continuously helpful, and we all support each other's efforts to learn and create. The community also actively works for positive changes in diversity in the digital arts. Helping build a local community has been challenging. It takes a lot of persistence!

http://kindohm.com/

Photo by Zuzanne Zgierska

Photo by Paulus van Dorsten

Timo Hoogland
nl_cl (Netherlands Coding Live), HKU University of the Arts, Utrecht

Before I started to live code electronic music, I was mostly spending my time performing with drums and programming audiovisual installations and compositions. I've always felt the urge to perform onstage, so I was looking for ways to translate my programmed audiovisual works to a live performance. By connecting a controller to the software, I felt disconnected from the music and sound when only controlling dials, sliders, and presets. While with drumming I can improvise, be in the moment, get into a flow, and have this immediate connection between my movements and the sound, with the controller and computer I felt restrictions that did not improve my creativity onstage.

My first encounter with live coding was an eye-opener in the sense of how creative coding and electronic music could be performed. Live coding is a form of expression that most closely matches my performing style with the drums. Via coding I can combine and explore many fields of interest, such as polyrhythms and algorithmic composition, in real time. Also, similar to the drums, I can extend my instrument with new functionalities, adding new flavors to my sound palette and either rehearsing performances or improvising onstage. On top of that I can also let the code give me new and unexpected results, as if my instrument is also partially the composer or band member.

I experimented with systems like Max/MSP, Sonic Pi, and SuperCollider but decided to design my own language that fits my approach to performing electronic music. The result is Mercury, a language focusing on the quick expression and communication of live coded audiovisual performances. The live coding scene strives for openness, transparency, and inclusiveness, and for that reason Mercury code has clear and human-readable syntax. This allows the performer to focus on the composition and keep the audience engaged. The responsive text editor adjusts font size to keep code visible, similar to the earlier Fluxus live coding environment. Furthermore, the editor only allows thirty lines of code. This restriction forces me to erase code and make creative choices during a performance.

In my latest performance, I combine drumming and live coding, exploring ways to improvise with electronic music while playing an acoustic instrument. The computer functions as a second performer, listening for patterns played on the drums and making decisions to change the code.

Up until now I think the audience for live coding performances could be categorized into two groups. One group would be people familiar with code, who mostly understand its effects on the sound or visuals. The other group consists of people encountering live coding for the first time and who are surprised by its possibilities. Some may even find it impressive and almost like "magic." But as creative coding becomes more widely known and coding is taught in more places, I see that live coding for its own sake starts to have less impact, forcing artists to start searching for new live coding approaches or be more critical of their output. In the (near) future, live coding will surely find its way into a wider variety of genres and disciplines where the focus is not necessarily on the live coding itself but more on the results.

https://www.timohoogland.com

Photo by Antonio Roberts

Miri Kaat
UK

I am a UX (user experience) designer, researcher, and strategist with ten-plus years of professional experience across music, games, and education, and my educational background is in game design and web technologies. Just making impressive technology isn't enough—it needs to have an emotional impact. I work toward bringing digital interfaces to music creation, producing new and accessible ways for artists to interact with technology. Working in the music industry has enabled me to work as an artist, designer, and technologist. It's connected me to a huge network of creative practitioners, industry practices, learning resources, tools, and technologies.

From working in this industry, I have also experienced the gender and racial imbalance. I wish to address this more by teaching, inspiring, and enabling people from minority backgrounds and introducing them to the joys of live coding. I have been involved with live coding as a performer, music technologist, and educator. I have also immersed myself in the algorave music scene. Perhaps most importantly, I've worked to help others do the same, hosting events and workshops for women and nonbinary people, who often feel excluded from music technology.

My artistic practice is in audio-responsive multimedia. I use SuperCollider with TidalCycles for live coding music and Max/MSP for generative audio and visuals. Being a musician, influencing the creation of music technology solutions, and coming from a minority background give me the insight to provide music technology training for underrepresented groups. I am lucky that my interests lie at this intersection in music, technology, and accessibility. This, in turn, feeds my UX design practice.

I am passionate about science, technology, engineering, and mathemathics education and promoting music technology skills for people from minority groups. I have conducted workshops and performances all over the UK and internationally. My aim is to create an impact using the power of music, art, and technology as a force for social change. I am among some of the pioneering women in live coding within the UK. I believe live coding is especially good for teaching creative coding skills. I released my debut EP with Establishment Records in 2017, a release that saw media acclaim from outlets like *Resident Advisor*. This was composed and recorded using SuperCollider and TidalCycles.

I believe the live coding scene is poised to reach a much greater level of diversity, collaboration, and innovation in the future. I believe that artists and musicians can feel disenfranchised with technology; this is a major issue that the music tech industry faces right now. Inspiring and enabling people to work with new music software solutions is a step toward bridging that gap. My long-term goal is to enable and mentor minority leaders in music technology.

https://mirikat.github.io/

Livecoding jam with Abhinay Khoparzi, Akash Sharma, and Joshua Thomas.
Photo by Dhanya Pilo

Workshop on the Marching JS livecoding platform.
Photo by Abhinay Khoparzi

Abhinay Khoparzi
Algorave India

Although there had been workshops and one-off events, a live coding "scene" didn't develop in India until Algorave India came to being in 2018. The first few events at Algorave India were supported by the Open Codes project by the Goethe-Institut and Zentrum für Kunst und Medien (ZKM) as part of their *Open Codes* exhibition. This happened after some friends and I (including longtime practitioners such as Rebecca Fernandes and Akash Sharma, as well as visionaries such as Dhanya Pilo) saw the renewed interest in the experimental/noise music scene brewing in the bigger cities in India. We wanted to recreate a truer form of the experimental gigs we used to organize a decade earlier, as well as showcase local talent that had been lurking in the shadows.

We soon moved to independent events funded by the community and ticket sales, starting with a postworkshop event with a local creative-coding community at Walkin Studios, Bengaluru. These independent events seemed like a better way to engage with and bring together fragmented creative-coding communities in the city. Even though there had been a long-lasting subculture of algorithmic practices in the country, it had always been hidden away in art galleries that mostly highlighted European and US artists. Algorave India and live coding in general have fared well in making the creative-code scene more approachable, reaching outside the realm of "geeks" and art nerds.

The immediacy of results and the quick feedback in the process of live coding have been especially useful in getting people out of initially feeling intimidated by programming and mathematics in general. Performances themselves become miniworkshops where one-on-one and one-to-many interactions with audience members can develop into a learning space. Many contemporary artistic practitioners who were stuck in small towns, including people who didn't believe they could show their beginner code and early experiments, came out to events and shared their works on various forums and social channels.

Engaging with other communities, specifically in Canada and Latin America, has been especially fruitful in terms of collaboration and the exchange of cultural ideas, as well as crossover events that feature artists with different skill levels joining network music ensembles.

https://khoparzi.com
https://algorave.in

Four time-lapse examples of live coded graphics.
Image credit: Shawn Lawson

Shawn Lawson (Obi-Wan Codenobi)
Arizona State University, US

I often describe live coding as driving a race car while simultaneously attempting to change the engine oil: plausible, dangerous, and exciting because the audience is there not only for the roaring success but also for the spectacle and possible tragedy of the crash. Then I continue on by saying they will be able to see the code I'm writing as it's written in addition to the visual performance. In a way, there's a demystification of live performance magic, yet I think this makes the experience more sublime because the viewer is along for the ride (a passenger) in this race car.

I've built a few live coding editors—namely, the Force (GLSL), the Dark Side (GLSL and TidalCycles), and LiveWare (GLSL and Lua). The Force autocompiles and, if successful, then executes the GLSL while you're typing. The Dark Side mixes the TidalCycles language into the Force so that both can be written in the same text buffer by multiple users telematically. Lastly, LiveWare is a Lua binding on top of LibCinder with additional functionality brought in from the Force. Each has different degrees of Open Sound Control (OSC), MIDI, and WebSocket connectivity. All have audio input.

I suppose my live coding practice is heavy on tool building and my own very individualized software needs. With the Force, there were other GLSL live coding systems, but none were designed or tuned for performance. For the Dark Side, my Rebel Scum collaboration with Ryan Ross Smith encountered a physical dislocation. We needed a method of continuing the collaboration telematically without compromising audiovisual quality. With Liveware, I was feeling the need to explore graphics outside of the bounds of GLSL. I'll have a visual idea and then spend time creating an environment that is capable of supporting the vision if it doesn't already exist. Even well before I started live coding, I was writing my own interactive art software. I find that off-the-shelf software is typically too formulaic, constricting, or not quite capable. While this is an extra burden (toolmaking), I think it's accepted as part of the practice.

Media-wise, there are a limited number of live coders for visuals. Online forums for visualists and internet platforms (Vimeo) have been successful at allowing us to find and share progress with each other. With collaborators, we rehearse material, try new material, talk quite a bit about what kind of material we should assemble for the next work, and strategize which calls for proposals to apply to. That all sounds more businesslike than it is in reality, which is significantly more free-form and even chaotic.

http://www.shawnlawson.com

Melody Loveless and Caitlin Cawley.
Photo by Melody Loveless.

Melody Loveless
Codie, US

I initially started live coding after being encouraged to join LiveCodeNYC, a meetup group that organizes meetings and algoraves in New York City, by Kate Sicchio and Sarah Groff Hennigh-Palermo. Afterward, Kate and Sarah invited me to join their live coding audiovisual group, Codie. Since then I live code in multiple projects, including a collaboration with percussionist Caitlin Cawley and a solo project in which I record and manipulate samples of my voice.

Objectively, it makes sense that I would be drawn to live coding. I am trained in percussion and music composition, I work with creative and interactive technologies, and I've enjoyed patterns, minimalism, and conceptual art for a long time.

A major quality that drew me to live coding was how processes are highlighted. I often use process as a way to structure events and as a metaphor for ideas that I am meditating on. For example, in my sound installation *Memory Room* I juxtaposed and alternated between field recordings of water and pink noise as a metaphor for how memories can be replaced over time without people noticing. When I understood that live coding highlights processes, I immediately became intrigued.

My initial experiences teaching live coding to kids and young adults with special needs and social-emotional learning disabilities especially inspired me to think deeply about my role as an artist and educator. As is the nature of most creative technologies, live coding has the potential to empower people to participate in and create art—regardless of their artistic knowledge or comprehension of the underlying systems being used. My aforementioned experiences specifically highlighted this idea and showed that reducing participation in music to the execution of syntax has the potential to open performance opportunities to people who would not be able to participate otherwise. For example, the loop-based nature of live coding technologies could allow people who struggle with movement, like those with motor skill disorders, to "play in time."

Pedagogically, live coding has been a great tool for discussing and demonstrating electronic audio and visual principles. For example, when introducing Hydra's operator functions, I also discuss pixels and additive color mixing while demonstrating mathematics in action. I also emphasize the idea that current live coding technologies are a continuation and extension of previous technologies and art movements by contextualizing these tools to their inspirations and related technologies. Examples of this include how I introduce analog video synthesis before demo-ing Hydra and how I connect live coding music to tape music, turntables, synthesizers, and process music.

When performing, the role of time and synchronization varies greatly depending on the project. In Codie, we often just start our technologies to begin a performance. Once performing, Kate and I will refer to Sarah's visuals for cues. In contrast, Caitlin and I discuss frameworks for improvisation ahead of time and sometimes coordinate specific moments. While each collaboration has its own challenges, when performing alone, the added layer of singing makes this project the most difficult to execute.

melodyloveless.com

:why_is_the_default_question

```
live_loop :something_keeps_pushing_forward,
  sync: :time do

  end

live_loop :why_is_the_default_question,
  sync: :the_need_for_structure_appears do
```

```
live_loop :no_need_to_stay_in_the_city, sync: :time do
  in_thread do
    sit_by_the_river
  end
  sample BIRDS[1], amp: rrand(0.4, 0.7), rate: rrand(0.5, 0.9),
    pan: rrand(-1, 1)
  sample FROGS, amp: rrand(0.4, 0.7), rate: rrand(0.6, 0.9),
    attack: 1, release: 2, pan: rrand(-0.3, 0.3)
  sleep sample_duration(FROGS)
end
```

```
live_loop :the_moment_for_reflexion_is_over,
  sync: :something_keeps_pushing_forward do
```

```
live_loop :inner_peace_is_a_fleeting_experience,
  sync: :time do stop
  with_fx :gverb, mix: 0.5, amp: 0.5 do
    binaural_beat_generator(amp: 0.05,
      channels: [BASE, CH7], time: 8)
  end
end
```

```
    end
  end
end
```

Ɛαπth +⊙ ∀ßiGaiʃ

Image credit: Mynah

Mynah Marie, a.k.a. Earth to Abigail
TOPLAP Israel

When I started performing as a live coder, people would ask me, after my shows, "Why choose live coding? Why not use a traditional DAW?" It's a fair question. I remember asking myself this many times at the beginning.

When I discovered Sonic Pi—the live coding platform I use for most of my performances and streams—I knew I had found something incredible. I didn't know exactly why it was incredible; I just instinctively knew it was. I felt the possibilities without having the knowledge to experience them clearly. I became obsessed with finding answers to this initial "why." It awoke a curiosity in me I didn't know I had and kept me up at night with a thirst for knowledge I never seemed able to satiate.

This "why" helped me find my creative freedom. Earth to Abigail isn't me—it's the space I'm creating in. I'm not alone onstage. When I'm live coding, my laptop is more than a tool. It's a companion, a source of inspiration, an entity I can have a conversation with. I'm the master of my own creative universe, and through this conversation with my computer, I have access to constant sources of inspiration, challenges, and surprises. Ultimately, it's this conversation happening through the code that keeps the creative process interesting and evolving. Because of that, you could say it's a love for communication that drives my passion for live coding—communication with an artificial "being" that has capacities I don't possess and communication with the audience through the music and the words on the screen.

Programming languages have an expressive value beyond their initial function of "building things." And computer languages are mostly rooted in the English language. Music is also a language, with its own set of rules, vocabulary, and syntax. When I'm live coding, most of the time what I'm really doing is "painting with sounds" the story I'm writing with words in the code projected on the screen.

Now the initial question of "why" has been replaced by "why not?" Why not strip away all the boundaries of why people write code in the first place? Why not use code to express emotions? Why not unify the language of code, the language of music, and the English language into one work of art? Why not make the artistic process itself the essence of a performance? This "why not" gives me freedom as an artist and fuels my never-ending passion to keep learning, creating, and sharing this creative space.

https://www.earthtoabigail.com

Photo by Jorge Ramirez

Photo by Steve Welburn

MicoRex
Mexico

Jorge: When in architecture school, I started live coding, influenced by diagrammatic thinking and macro-micro relationships. You build up a system in a musical context, and whatever you throw in affects the perception of the whole piece; also the system.

Tito: Live coding is an opportunity to get involved expressively and theoretically with the people who attend the live show and with other live coders. I love live coding because it gives me the thrill of present tense, feeling, language, and thought.

T: Before MicoRex I started promoting live coding as an academic practice in the Mexican electronic art circuit through the Centro Multimedia.

J: MicoRex ended up being very influential for lots of acts that came afterward since live coding and bands were not existent before that time. It helped to free experimental coding from electroacoustics and present it as a joyful, fun, and edgier practice.

J: When we started becoming international, we found acts that were trying to bring live coding into the club realm, the first generation of algoravers—like Alo Allik, Glitch-Lich, slub, Shelly Knotts, Benoit and the Mandelbrots, Norah Lorway, Kraftwife, Frederik Olofsson, Renick Bell, Luuma—like-minded acts, but everyone had very different styles and systems.

T: As Mexican live coders, we all shared a common minimal style since we came out of the same school of practice. Eventually, each live coder found their own programming style, and MicoRex would distinguish itself from the others in the performance sense: the inclusion of voice, DIY controllers, and more or less closed traditional musical structures.

J: Our system is designed by thinking about the music we want to create. Music first, technology after. It relates to other systems in goals but not in design. Elevator pitch: it's a live coded, networked, audiovisual act with voice and physical interfaces triggering OSC messages through a GUI system.

T: We do synthesis, not sampling. And, though we come from a "from scratch" live code scene, we also use ready-made algorithms. We don't use a messaging network system like Republic or MandelHub. We just send the raw data and trust our musical and supernatural monkey abilities. More like when playing in a band because, oh!, MicoRex is a band.

J: It's mind-blowing to witness a kind of normalization in a nightclub setting. I experienced violent reactions to live coding for dancing in Mexico! Now, the global network of live coding parties is becoming more established. There are more systems and tools, and so acts are becoming more easily expressive.

T: Yet live coding has limits as an expressive tool. You can't prepare all the musical aspects you want to present. Live coding has not this aim at all. It's an opportunity to play in a way in which improvisation and knowledge are more appreciated than a perfect final presentation. It is a phenomenon of our time and capabilities.

Live coding and using charts for computer-aided composition.
Image credit: Fabrice Mogini

Fabrice Mogini

There are many definitions of live coding; mine is: writing and editing computer code while the music is playing. This could be for a performance in front of an audience or, in my case, for improvising, composing, and getting direct feedback while testing new ideas.

Before I started using an audio programming language, my compositions required a lot of calculations using charts, grids, a deck of cards, and so on. I could not believe my luck when around 1998 I gained access to SuperCollider 2.1 while studying for the Sonic Arts degree in London. My dream of fast and precise calculations was finally becoming true! The main problem was that once I had programmed something new—for instance, a new part in the middle of a composition—I had to wait until it actually played to hear and assess the quality of the edit. Because the music was generative, it was not easy to fast-forward, as can be done with a sequencer. Another problem was that while the expanded computing capabilities allowed ever-more complex calculations, there were now too many parameters to be serialized. The music was becoming too much of a mental abstraction rather than based in real-time perception. This is when I embarked on a quest to change and eventually write code in real time so I could hear what I was designing straightaway. Rather than just switch algorithms or edit certain parameters, I was trying to write some of the code in real time. Although I incorporated some of these techniques in live performances, my main incentive for live coding was to expand compositional capabilities while preserving real-time control and feedback. I also coded jazz improvising algorithms ("Memory" in *Morpheus* CD-ROM) and realized that live coding is a necessity for truly live improvisation.

I started to use the expression *live coding* around 2002; I remember by then that Alex McLean had already used some form of live coding in his performances with slub. In September 2003, I advertised my live coding set with SuperCollider at the 291 Gallery, Hackney, London. While the set was based on controlling, editing algorithms, and sending data in real time to Director/Lingo for visuals, there was nevertheless a part for live coding. By then I had also created the London SuperCollider course (2002–2004) at Rising Tide, London, which in 2003 included a lesson with a handout titled "Live Coding." This handout was later presented during a workshop at the IDM (Intelligent Dance Music) Summer school, London, where I had been invited as guest lecturer. At that time I often performed with composer/researcher/live coder Nick Collins; our performances, notably, included a live coding duet at the Royal College Art Bar, London, in June 2003, with real-time visuals by Fredrik Olofsson. Finally, many of our SuperCollider "tricks" and fixes were solved when researcher and performer Julian Rohrhuber improved the SuperCollider language to make live coding more accessible. Only then did I realize how many practitioners were showing an interest in that art form.

I am amazed to see how live coding has evolved in the last twenty years. There are still so many different avenues to explore, and I hope to see a future where coders won't be overwhelmed by the technological aspects but will also create beautiful music.

www.fabricemogini.com

Livecoded Splatter in Livecodelab.
Image credit: Kofi Oduro (Illestpreacha)

Altered live coded piece.
Image credit: Kofi Oduro (Illestpreacha)

Kofi Oduro (Illestpreacha)
Montreal, Canada

Live coding to me is giving a digital extension /
 Of myself, where it has a new form
A form of digital representation / A form that
 breathes through the environment
Where it can mimic a therapist / A scientist or
 simply just another experiment
Of playful interaction / Or meaningful actions
 that leads
To both addition and retraction / Retracting
 the mind to a place
Where the mind breathes / Through the bits
Giving clues as the feedback / Gives what the
 program believes
From the keystrokes that are being hit / The
 mathematical equations
That are feeling split / Where the emergence
 of creativity
And randomness meets up quick / As the
 mind goes through its own stack
Merging the elements / From numeric to digital
Analog to pivotal / Seeing how the lines of
 code/ When given the chance to roam
Flows through the ears / Through the eyes
 they visit
Where the variables / Are given in doses that
 are edible
As the goal is to be laid back in swarms / As
 not to give the senses a storm
But rather allow for curiosity / To emerge like
 rain does to a worm

Live coding to me is just like this poem /
 Pieces adding together
To paint a picture for worse or better /
 Jamming with myself or others
As we are on a journey below and swim
Swimming with imagination
Improvisation with no intimidation
Where the culture allows for conversations
With no limitations
To the ideations & creations
That help the ideas be their own levitation
As they signal from the head
To the fingertips
And if vocalize, through the passage of the lips
As the vibration in the air
Mixes with the intent
Blends with the indents
That can be seen on here
When a spark is needed
It provides the flare
When a thought disappears
It reappears with a vision that is clear
As needed

Poetry is Code
Code is Poetry
Code occurs outside the computer screen
As it comes thru the journey, a human seen
And put together is the nature of this live
 coding scene
For these are my thoughts, when asked to reflect
Of live coding, which I came to respect

https://portfolio.illestpreacha.com/links
https://colorscape.illestpreacha.com/
https://instagram.com/Illestpreacha

Punctual live coding language.
Image credit: David Ogborn

David Ogborn
McMaster University, Canada

To define something is to stake a claim to its future, to make a claim about what it should be or become. This makes me hesitate to define live coding. Forced to choose from a number of "operating definitions," the one that gives me the least anxiety is to think of live coding as the "theater of code." This is not only a theatrical space constructed from code but rather a theatrical space that thematizes code (and computing and software), asks questions of these things, exposes the skeletons in the closet, and maybe even allows for catharsis, reconciliation, and new visions of collective possibilities. This can sometimes be iconoclastic, but it need not be. With repetition, even simple interventions in the machine gradually become larger shifts. To constitute live coding as theater is to resist constituting it instrumentally (i.e., as simply about producing things more efficiently or in novel ways) and to insist on an irreducible role for representation and interpretation.

My path around live coding has been influenced most immediately by my role as the founding member of the Cybernetic Orchestra, a laptop orchestra at McMaster University that has been meeting and performing continuously since early 2010. That, as well as my teaching in the Department of Communication Studies and Media Arts, puts me into almost daily contact with situations in which different people are encountering and responding to live coding in different ways. At the same time, live coding is a site where personal interests of longer standing intersect: live electronics, improvisation, philosophy, education, free software, generative music, politics, and maybe even science fiction. My live coding activities take different forms: performing by myself or in a duo with either an autonomous agent I am cultivating (Daem0n) or with tabla player Shawn Mativetsky (as very long cat); weekly Cybernetic Orchestra rehearsals; developing and maintaining multiple software platforms; writing about these things. . . . Perhaps my most obvious contributions will be as a popularizer, as I have introduced many thousands of university students in large survey courses to live coding over the years. I hope to contribute to establishing interpretation and critique as elements of live coding culture.

The software systems I have been developing in recent years are strongly oriented toward collaborative, geographically distributed live coding. Estuary is a sprawling web-based platform for live coding, developed with the support of two grants from Canada's Social Sciences and Humanities Research Council (which also strongly supported early research around the Cybernetic Orchestra and the second ICLC in 2016), and "hosting" a growing number of independently developed live coding software projects (thanks to the magic of open-source licensing), including my pet project, the audiovisual language Punctual. The idea of supporting and mixing up multiple languages has been a fixation in my technological work (earlier, for example, I worked on a "language-neutral" synchronization system for live coding ensembles). This is motivated by the idea that monolinguistic cultures and ethnocentrisms are mutually reinforcing. Live coding, performing a theater of linguistic plurality and complexity, may create a space for less anxious, more welcoming futures.

http://www.dktr0.net

Photo by Jojojo star

Photo by Jojojo star

Jonathan Reus
University of Sussex, The Netherlands/UK

My first encounter with a live coding performance was at the Studio for Electro-Instrumental Music around 2012 or so. I remember finding it intriguing but also kind of impenetrable. For me live coding tends to be a way of working and thinking creatively rather than exclusively a performance practice.

I started using SuperCollider years ago when Marije Baalman and I started a music/programming meetup group in Amsterdam. Marije was at the time a major contributor to the SuperCollider code base, and she made a pretty compelling case for using it. I found it to be an expressive and immediate way to sculpt ideas in time, but I've never thought of myself as live coding. It's more that the act of making anything using an interpreted programming language involves live coding in some sense, be it an installation, a piece of music, or a light-control GUI for a theater production. The creative process is more like sculpting than engineering. You build up a little bit here. You remove a bit there. You work in small gestures, not entire programs.

I have performances that involve pulling apart computers while they are running different software where all the sound material is generated from a combination of the metal, plastic, and electricity of the computers. Live coding makes an appearance in these performances as a dramaturgical and narrative element. I might run epistolary commands in the terminal or write missives in a text editor, and these add to the storytelling of the performance. Other work, like *Anatomies of Intelligence* (my collaboration with Joana Chicau), goes so far as to use live coding as a kind of epistemic philosophy to engage with larger themes, such as the spectacle and theatrics of scientific knowledge or bias in the data corpuses of AI systems. Anatomies of Intelligence uses a bespoke system that exists within a web browser. In the latest version of this performance, we created a "Virtual Theater," a website that Joana and I remotely access and relay JavaScript commands to. Everyone who is visiting the site gets our JavaScript commands relayed to them and executed in their browser, directly manipulating the web page, including graphics and sound. We compose a very specific narrative for each performance, with room to improvise, and perform together using a shared text editor.

I'm hoping that live coding stays idiosyncratic, and that the community continues to grow. And, especially, that artists and toolmakers think outside of established audiovisual performance norms and communities. Reach out to unusual audiences, remix, and collaborate. Recently, I organized a Zoom aerobics workout class, the ALGO-RHYTHM DANCE WORKOUT, with a dance instructor teaching a routine to live coded visuals and music. It was beautifully absurd and absurdly fun.

jonathanreus.com

Chemical Algorave
Photo by Antonio Roberts

Chemical Algorave
Photo by Antonio Roberts

Antonio Roberts
UK

During my time with BiLE (Birmingham Laptop Ensemble) I had already started making live visuals for electronic music, although this was more a case of manipulating existing software and code. Knowing people such as Shelly Knotts, who had already performed at algoraves, gave me an entry point to start live coding in early 2014. At that time there were relatively few people live coding visuals, and so I found myself in a unique position.

My live coded visuals start off with a simple geometric shape, usually a cube. I might then start to manipulate that one cube by rotating or scaling it. Then I will multiply the amount of cubes and have them spin in different ways, changing colors or changing size depending on other factors such as the amplitude of the music. I try to code and present this in a way that is clear enough for the audience to see how I arrived at the result on-screen, but inevitably, it ends up looking messy!

Building your code slowly over time is not a bad thing. In the thirty minutes or so you typically have for a set, you can build up your visuals slowly or scrap it all and start again. Don't exhaust your code and yourself by building up all of your code within the first five minutes.

Both VJing and live coding music have a strong visual element, and I feel they both seek to demystify how computer art is made by showing the process. I have definitely seen a tighter integration of music and visuals as live coding practice has matured. For example, artists now have visuals that react to the music in more ways than just amplitude. Some programmers are even building visuals into what was initially only audio software.

http://www.hellocatfood.com/

```
piano = tracks[0]

piano.note.seq(
  line( 1/2, 4, -4 ) [ 3.87 ] [ 3.87 ] ,
  [1/8,1/8,1/8,1+5/8,1/3,1/3,1/3]
)

piano.note.seq(
  line( 1/2+.05, 6, 2 ) [ 2.06 ] [ 5.94 ] ,
  [1/8,1/8,1/8,1+5/8,1/6,1/6,1/6],
  1
)

piano.note.seq(
  line( 1/2+.1, 8, 2 ) [ 2.00 ] [ 7.92 ] ,
  [1/8,1/8,1/8,3+5/8,1/8],
  2
)

v = sine( 2, 30, 28 )
piano.velocity.seq( v [ 2.01 ] [ 57.99 ] )

piano.note.seq(
  sine( 2.25, 10, 3 ) [ 7.00 ] [ 13.00 ] ,
  Lookup( line( 2.1 ) [ 0.00 ] [ 1.00 ]  [ 1/5,1/2,1 ] ),
  3
)

piano.note.seq(
  sine( 2.5, 14, 4 ) [ 10.00 ] [ 18.00 ] ,
  Lookup( sine( 4.25,.5,.5 ) [ 0.00 ] [ 0.84 ]  [ 1/6,1/2,1,2 ] ) ,
  4
)
```

```
a = Stripes()
a.xCount = 150
a.yCount = 150

c = Kaleidoscope()
c.sides = .5

d = Focus()
d.waveFactor = .0005

e = Film()
e.sCount = 8

f = Kaleidoscope()
f.sides = 1.5

g = Focus()
g.waveFactor = .0005

h = Dots()
h.scale = .05
```

Top image: Annotations in Gibberwocky show waveforms that are periodically sampled to generate musical patterns. Bottom image: Multiple post-processing shaders stacked in Gibber to create an abstract form.
Image credits: Charlie Roberts

Charlie Roberts
Worcester Polytechnic Institute, US

Gibber is a browser-based environment for audiovisual live coding. It primarily uses JavaScript as the end-user language while offering affordances for both music and graphics programming. A dedicated server supports user publication of sketches, real-time chat, and a variety of other collaborative features. A trio of derivative live coding systems coauthored with Graham Wakefield—collectively named Gibberwocky—borrow many aspects of Gibber's interface to target external applications, including Max/MSP/Jitter, Ableton Live, and generic MIDI communication.

When I initially began work on Gibber, I was already working extensively with browsers and JavaScript, creating end-user frameworks for interface design. I wanted to explore the potential of JavaScript as a live coding language and the potential of the browser as a vehicle for the collaboration and dissemination of creative work. By chance, at the time these interests were coming together—in 2012—the Web Audio API was released for browsers, enabling real-time synthesis in the browser using JavaScript alone. Gibber was one of the earliest systems created for live coding performance in the browser; now there are a variety of excellent options.

Running in the browser makes Gibber an easy match for introducing people to live coding; no extra software is required. This has helped enable workshops all over the world that use Gibber to teach the basics of live coding and computational media. A variety of summer camps, after-school programs, and university courses have also used Gibber heavily.

One significant area of research I have been exploring with Gibber/Gibberwocky is the use of dynamic annotations and visualizations in source code that documents the state of running algorithms; many of these are shown in the top image on the left. Heavily inspired by Thor Magnusson's ixi lang, the feedback provided by annotations/visualizations is typically what I receive the most positive comments about after performances; perhaps with more practice someday audiences will respond similarly to the music I create.

Gibber seems to have found a niche as a live coding system for beginners. Its reliance on the browser makes it easily accessible but also stops advanced programmers from using their preferred code editor for performance—and the editing interface is, of course, a critical component of live coding. I hope to eventually attract more advanced programmers via Gibberwocky, which provides unique integrations with artistic production software not found in other live coding systems, and also by porting Gibber and Gibberwocky to run inside other editors. Gibber and Gibberwocky have drawn inspiration from a number of other live coding systems, especially ixi lang, Tidal, and Extempore.

The continued development of Gibber/Gibberwocky is highly dependent on my performance practice. Typically, I have an idea I'd like to explore in a performance—perhaps musical, perhaps an interaction technique—and this spurs subsequent development work. As an academic, the research potential of new features is also an important consideration when deciding which elements to focus development on.

http://gibber.cc

Screenshot from live coding performance INVOCACIONES.
Image credit: Jessica A. Rodriguez

Jessica A. Rodriguez
Mexico/Canada

Invocaciones ("Summonings") is a series of performances that arise from the need to explore my artistic practice through the voice of female poets, mixing live coding practices (or code on-the-fly) with electronic literature (or expanded literature practices through digital environments) and exploring the poetic possibilities of code and what speech it activates.

For the performance *Invocaciones*, I remixed the poem "País de la Ausencia" by Chilean writer Gabriela Mistral, which explores images about identity, place, and territory. Through the author's voice, I made a reinterpretation of the poem, expanding her words through different sound layers that move through a stereophonic space. I use TidalCycles to create speech patterns (transforming voice samples) through cacophony, juxtaposition, delay, echo, and oversaturation to deconstruct and reconstruct the poem over and over again throughout the performance.

Additionally, I use prerecorded cello samples by Mexican-Brazilian cellist Iracema de Andrade. The visual part contains a video (running in the background) of the Paricutín volcano in the state of Michoacán, Mexico.

https://andamio.in/production
https://vimeo.com/jessicaarianne

Screenshot of live coding with TidalCycles and Hydra.
Image credit: Iris Saladino

Iris Saladino
CLiC (Colectivo de Live Coders)/TOPLAP Argentina

I am a sound-oriented multimedia artist. I live in a world in which in order to make a living out of art you must conform to the market, the "culture industry."

Live coding is a practice born in academic environments but now exceeds them, flowing into groups of people with different backgrounds who voluntarily study and share knowledge, mainly in digital spaces. Invested with ideas from free software culture, live coding creates new flows of information and power, challenging notions such as verticality, hierarchy, professor, pupil, author, creator, artist, technologist, talent, idol, and art. Communities operate by decentralizing and horizontalizing information, processes, events, and decisions with respect for others as the core of all interactions. We aim for collaboration and we mistrust competition.

I am a member of CLiC, based in Buenos Aires, Argentina. It started as a small group and now is a large one. Cyberfeminist oriented, this community is where I discuss the most interesting topics, such as technology, ethics, politics, aesthetics, philosophy, and art theory among others, which are all very important to me as a creative person. We do not always agree, but it is nice to deal with differences when the environment guarantees tolerance and cordiality. We share technical and scientific information, and we help each other to solve code or tech problems. My consciousness of the context I live in increases thanks to this group, and with it my actions in the world, my artwork included.

I live code my music using SuperCollider and TidalCycles and my visuals using Hydra. When coding sound, I usually feel like creating floating, circular moving structures: sounds emerge and disappear and change position, duration, and timbre; the whole combination creates convergence and divergence on different levels. I become entranced creating those structures, making them turn, imagining processes, and typing them, exploring audio samples and digital synths to their limits. I play and there is a pure joy in which the rules are not for winning (success over others or other's approval) but for sustaining the development of the activity across time, just like a child's free imagination.

I often jam with live coders from around the world using flok, a collaborative peer-to-peer online editor. Even when not sharing a physical space, sound keeps allowing us nonverbal communication by interacting with coded processes. We hear, complement, and understand each other, we answer the sound proposals of our colleagues, we learn from each other, and we have a lot of fun. We can embrace error as imperfect beings, recognizing and enjoying our diversity.

The whole thing I describe composes a poetic, new model for art and social interaction in digital environments. It fills me with hope for the future.

https://iriss.netlify.app/

Photo by Kamil Kurylonek, 2014

Kate Sicchio
Virginia Commonwealth University, US/UK

My main live coding practice focuses on live coding performance scores for dancers performing choreography for the stage. Dancers improvise movement based upon instructions that are projected into the performance space. I have explored this in many ways, including using pseudo code to create rules for dancers, live coding haptic feedback in costumes, and using machine-learning algorithms and an image database to create a visual score. This work is typically shown in black-box theater spaces as a live, improvised performance.

I started live coding after exploring the concept of computer hacking as a way to repurpose and to extend this repurposing beyond technology. If I could hack my kinect to work with a laptop, could I hack a piece of choreography to change the intended outcome? *Hacking choreography* became an umbrella term for many works I made in which a choreographic score would be changed live in a performance setting.

I started this work before discovering the live coding community. Once I saw the TOPLAP manifesto, I realized this reflected my choreographic work and underlying ideas. The use of the projection to see the code and the changes, the live interpretations of the instructions, and the performers thinking and making decisions as part of the performance were all things I also wanted to highlight in the work. From here I went on to create two different programming languages for live coding choreography, Terpsicode and Studio//Stage.

I have collaborated with other live coders in different ways. Rodrigo Velasco has composed sound for my work, and Nick Rothwell collaborated with me on creating a system for live coding clojure to create animated text. I worked with Thomas Murphy on a live coding environment for images to create a visual choreographic score. But a much more in-depth collaboration has been my piece with Alex McLean, *Sound Choreographer <> Body Code*. This work creates a feedback loop between McLean's live coding of sound and a generative choreographic score I am performing through using sound analysis and motion tracking. These technologies connect our two forms of improvisation and affect our decisions within that performance.

Currently, I also live code music as one-third of a trio, named Codie, with Sarah Groff Hennigh-Palermo and Melody Loveless. We wanted to become more involved in the algorave scene and saw the formation of Codie as a way to participate. What is interesting about Codie is that our audiences always dance to our sets. So, despite not explicitly coding instructions for movement, we have managed to create performances where people are dancing to code, as found in my choreographic works.

http://sicchio.com/

Photo by Clément Merle

th4
France

For me, live coding is not just creative coding, as it involves some kind of live component, which could range from completely improvising a piece of artistic code onstage to tweaking an already prewritten algorithm. I came to live coding in a fairly traditional way: I come from a computer science background, and I wanted to make music. DAWs were a bit obscure to me, and I felt that my prior knowledge of programming would give me some kind of head start to make up for my relative inexperience in music. I almost exclusively work with TidalCycles, and I feel like that scene is more oriented toward the rhythmic aspect of the practice, while mine is much more on the harmonic side.

In the future I think we're bound to see AI play some kind of role in music in general, particularly as a tool to generate unexpected ideas, and it would greatly surprise me if this didn't make its way to live coding in some way or another, even though I don't imagine it completely taking over and leaving no space for more "handmade" algorithmic creation.

From my experience performing in front of non-code-literate audiences, the visual aspect of a live coding performance can exert some fascination on the general public from the esoteric aspect of lines of code that you don't understand giving birth to a piece of music or visual art. This can also, on the other hand, be a good pedagogical starting point to break down the code into something understandable.

https://th4music.net

Photo by Cihad Caner, reworked by Felipe Ignacio Noriega

Anne Veinberg and Felipe Ignacio Noriega
CodeKlavier and Off<>zz

Overture: Anne Veinberg (Aus, NL) is a pianist, and Felipe Ignacio Noriega (MX, NL) is a composer and programmer. Since 2013 they have formed a music and research duo, Off<>zz, with the mission of bringing live coding into the classical music sphere. In 2017 their main focus shifted from primarily performing as a duo to creating a fused practice in which one makes algorithms by playing the piano. This project is called the CodeKlavier. The CodeKlavier employs the piano as an instrument for live coding and is influenced by musical thought to drive programming language design.

Thema Adagio: The CodeKlavier spawns from treating musical gestures on the piano as the syntactic sugar that can generate code constructs such as variables, snippets, conditionals, and function definitions. The implementation of the CodeKlavier is strongly based on functional programming concepts and music analysis. It comprises three main areas: (1) The parsing of piano playing into programming expressions, otherwise known as the *piano parser*; (2) The creation of algorithmic structures from the parsed building blocks; (3) The code outputs, which can be developed on any live coding platform. The latter allows us to collaborate with different creative coders to "piano code" on a wide variety of artistic planes. By 2020 these collaborations included code output extensions developed by Patrick Borgeat, Timo Hoogland, Joana Chicau, and Sebastian Pappalardo.

Allegro variazioni: Although mostly associated as a duo and for their work on the CodeKlavier, their individual projects are also intimately involved with live coding. Felipe has been exploring live coding and humor through the hip-hop band Panda Zooicide, in which live coded beats and a rapper explore the relationships of freestyle rap and the improvisatory elements of the live coding practice. Next to these projects, he also employs live coding extensively in all his output as composer: mostly music-theater pieces for children with the Norwegian-Dutch theater collective Krims-Krams and other collaborations within the classical music sphere. Anne is a professional pianist. Her live coding practice is always connected with piano playing whether it be piano coding with the CodeKlavier, collaborating with other live coders, or attempting to multitask and code via laptop while playing the piano.

Coda: When thinking about live coding, we expect different things. Anne often looks for a fulfilling musical or artistic experience, while Felipe seeks out humor and transparency in the code. We both believe in the powerful connection that the audience members make with the performers when they are able to follow the development, thoughts, and decision-making of the artists and how the performance environment influences all of these. Live coding is a medium that can reflect and highlight this relationship, and that is one of the main reasons why we are seduced by this practice. We also believe that musical intuition and a deeper understanding of music aesthetics and theory can unlock new approaches to technological development.

https://codeklavier.space
https://keyboardsunite.com/offzz
https://pandazooicide.com

Photo by Ali Barilaro

Rodrigo Velasco (yecto)
Mexico/Canada

First, I want to thank all of those who are part of the live coding community, which is an example of openness and diversity. Live coding helped me escape. I consider it a back door or an escape tunnel to reimagine and relearn how to feel and rethink language and programming. In 2011 an interest in escaping from graphic design, making music, and exploring or reimagining both through the use of open-source software fortuitously led me to meet an incredible community in Mexico City. It met in the open-source software workshops and the monthly live coding sessions that took place in the Galería Manuel Felguérez of the Centro Multimedia and were organized by El Taller de Audio del Centro Multimedia. I remain grateful to everyone in the community, especially to those who patiently shared ideas and knowledge with me across and beyond live coding.

An essential aspect that live coding has gifted to my artistic practice is the idea of "algorithms as thoughts."[10] I am interested in poetics and algorithmic poetics, a confluence of language; algorithms as thoughts in movement; and the creation of a space-time that activates "a transversal movement that bonds content and expression as assemblage."[11]

I am currently studying for a master of Design and Computation Arts at Concordia University and developing a research-creation project, a living repository of Nahuatl memory, with the name *Algorithmic poetics*, which consists of an ongoing process of reimagining Nahuatl poetry.[12] Embracing Nahuatl principles expands our perspective in the study of algorithmic poetics, exploring forms of coding that transform how we experience the web.

These interests also converge, although in a different way, in the project I have developed under the alias yecto, which consists of composition and improvisation with sequences of percussive patterns and chords; a state of calm that allows one to experience peace of mind. yecto is at the crossroads of ambient, jazz, and hip-hop, but it is also live coding; the sounds are coming from MIDI signals interacting between TidalCycles and/or the esoteric programming language ORCA, with hardware synthesizers and often chopping samples or playing electric guitar. Regarding the visual dimension, yecto is actively exploring the creation of generative design and live coded visuals, mainly through Processing, p5.js, and Fluxus, and a recent undertaking has been in the study of Hydra and video feedback.

Finally, I want to thank the live coding community around the world, especially my dear friends Ernesto Romero, Alex McLean, Karen del Valle, and Olivia Jack.

https://soundcloud.com/yecto

Photo by Antonio Roberts

Elizabeth Wilson
Queen Mary University of London, UK

I see live coding as a method of notating and enacting creative ideas in a way that is fundamentally human—through language. For me, this most commonly takes the form of creating music, converting musical ideas from the graphemic to the acoustic. Alternatively, I like the definition of live coding as "writing a 'score' for the computer to perform,"[13] as it shifts the perspective from solely human control to more of a symbiosis. The live coding language I predominantly use is TidalCycles. Being based in Haskell, which is a purely functional language, it is easy to build around and augment code by constructing your own functions. Tidal is well designed in its ability to express complicated ideas with compact language, often closely resembling sentences. Because Tidal is capable of a broad scope of expression, I want to extend the creative opportunities afforded to a live coder by building autonomous agents to perform with.

I am really drawn to the idea of being able to share creative responsibilities with the computer. I've always wanted to avoid the constraints of gestural control that come with most musical interfaces. I found that automating processes previously requiring manual skills leaves more mental capacity for traversing unexplored areas of creative spaces and uncovering new territories of ideas. My own research involves incorporating *affective response* into musical generation, mainly in TidalCycles. This is an important consideration for any future autonomous systems in live coding. Approaching the music generation task from a purely computational standpoint detaches it from its essence of inherent emotional expression. This seems obvious for automatic text generation, which considers the narrative and its intended message rather than solely syntactic information. It follows that the same should apply to music and that improvising with machines should be an exchange of meaning.

I'm also inspired a lot by the work of Renick Bell with the Conductive system. I like the way that his "players" seem somewhat alive; that they can get bored of a pattern playing and take over and change things. I often think about this idea of sharing creative responsibility, particularly when performing live. Sometimes things might become overly repetitive halfway through constructing another pattern, so having a machine partner to enact some of the responsibility could resolve these issues. I think we're only just beginning to scratch the surface of how to utilize these kinds of collaborations, especially if we can view destruction as a form of creativity too.

Many experiments in AI have been recreating the works of composers who have been dead for a while, and not enough are creating new music to dance to, arguably one of music's most important functions. However, there's a significant need for more stringent consideration of the ethical implications of where and how we use AI in live coding, which, surprisingly, can still be overlooked. Algorithms are often viewed through the lens of how they are used by large corporations. The word *algorithmic* in itself is not dangerous but can often be seen that way because algorithms can be misused to enforce discrimination or prejudice. My hope is that algorithmic music can help to change the public's opinions on algorithms, allowing them to see how they can be used for things as transformative as art and music.

https://lwlsn.github.io/digitalselves-web/

Photo by Helena Coll

Anna Xambó
De Montfort University, UK

I see live coding as a meeting point between code and music in live performance. With some classical training, and after several years of being in Barcelona-based bands as a bass guitar player, singer, and composer, I started to make experimental electronic music in the mid-2000s. In the exploration of new sounds and the boundaries of the musical language, it has been a natural turn to approach experimental electronic music from a live coding perspective. Live coding brings a DIY approach to building and sharing self-built tools/environments, along with projecting your screen, as stated in the seminal TOPLAP manifesto, while providing an algorithmic approach to performing in which each performance can be different even when based on the same code. Furthermore, the community is unique and formidable.

My contribution to the practice is as a practitioner, academic, educator, and curator. As a practitioner I've been moving from audio synthesis to sample-based music, where I try to explore its narrative using my own as well as crowdsourced sounds. My academic research encompasses inspecting different possibilities of collaborative music live coding (and its related political negotiations) and multichannel experiences with live coding. As part of my teaching, live coding has been useful for demonstration, as well as to promote teamwork and participatory activities in class, including online during this COVID-19 pandemic. As a curator I have been co-organizing live coding concerts in Barcelona (Spain) and Atlanta (US), contributing to the local and international experimental electronic music scene.

My work has been inspired by the first generation of SuperCollider live coders and the SuperCollider community, especially the Barcelona orbit of the Music Technology Group at Universitat Pompeu Fabra, as well as the informal SuperCollider workshops and meetups organized by Gerard Roma and l'ull cec. My practice has been strongly influenced by Gerard Roma's work, starting with a collaboration in the duo Pulso performing with a custom environment he wrote, inspired by Thor Magnusson's ixi lang, and using two code editors in sync.

The democratic and self-organized approach to collaborative live coding proposed by Alberto de Campo, Julian Rohrhuber, and others with the Republic system is also of great inspiration. I have explored group improvisation with Nela Brown's Female Laptop Orchestra (FLO), along with others, where my live coding was combined with a variety of other digital and acoustic instruments. Knowing of Shelly Knotts et al.'s work with OFFAL was stimulating, as well.

I have been working with the Music Information Retrieval in Live Coding (MIRLC) system since 2016, and my recent work is on a follow-up system named MIRLCAuto (MIRLCa), a virtual agent for music information retrieval in live coding. The latter explores the theme of AI and autonomous agents in live coding. Similar live coding systems include Nick Collins's "algoravethmic" remix system and its approach to live coding and machine listening, as well as Navarro's Cacharpo virtual coperformer. The web-based system Sema developed by Bernardo, Kiefer, and Magnusson, which is an ecosystem of live coding languages and machine learning, is also an enlightening project.

I envision the future of live coding as a community that will keep growing in diversity and will keep advancing alongside other related fields. Feminist and decolonizing approaches to

live coding can also open the floor to new, interesting voices and ideas. The combination of code and music seems to either attract or scare the general public. I would say that the audience's degree of computer and programming literacy often affects the understanding of a performance.

annaxambo.me

4 Notation

Having mapped out some of the histories and contemporary examples of live coding's evolution as a performance practice, the emphasis in the following chapters shifts to address how live coding opens up critical issues relating to liveness, temporality, and knowledge production, as well as the notion of notation. This chapter focuses not only on notation but on what is notated and the activity of notation—the nature of the algorithms that live coders work with and the dynamic ways in which they are crafted. By examining how live coding challenges tensions between liveness and determinism, between musical improvisation and composition, and between oral and written culture, we find new approaches to notation as a dynamic, live medium.

As the field of live coding expands, embraced and developed by other disciplines beyond the original traditions of computing and music, the understanding and application of notation practices and principles have also changed and transformed, bringing both the potential for the hybridization of the concept of notation as well as a risk of confusion arising from the lack of shared conventions or vocabularies. However, rather than argue for an agreed definition and application of notation within the field of live coding, we explore if live coding can itself operate as an exploratory site of interdisciplinary exchange wherein the concept of notation is roughened and problematized. The chapter begins by highlighting two research projects that have explored notation within live coding in relation to other disciplines before looking more closely at live coding notations and how they complicate the notion of notation itself.

Live Notation

Initiated in 2012, the research project Live Notation: Transforming Matters of Performance (2012) was established in order to examine the shared vocabularies that may unite two performance practices[1]—namely, live coding (performing with programming languages) and live art (performing with actions). From the perspective of the

live coders involved, this allowed them to examine their practice with fresh eyes, not in terms of what was "new" in a technological sense but what was commonly shared with another, well-developed performance art practice. Certainly, for many live coders, liveness and risk are at the core of the practice. The challenge is not about performing prewritten code; rather, the performance emerges in and through the liveness of the event itself: through a relationship with the audience, other performers, the room acoustics, the previous and following acts, and the adrenaline of the live, which all shape the performance and the experience of performing. Likewise, for many live art practitioners, *liveness* refers to the durational, embodied, nonrepeatable moment of performance. Organized as an "experimental laboratory," the Live Notation project attempted to "approach programming as performance art, performance art notation as code, code as speech, bodies as interpreters," involving "improvisational sound works (where computer code and the artists' bodies become instruments), site-specific time-based art works (where notation becomes the 'piece' as opposed to its recording device)" alongside a series of position papers.[2] An attempt was made to challenge or disrupt the function of notation as that which either precedes performance (as a score or script written in advance and executed live) or that follows in the form of a recording or document of a performance (supporting its future reactivation or replaying) by testing forms of practice where the notation is produced synchronously to performance itself. Reflecting on the specific practices encountered within this project, the term *kairotic notation* (drawing on the Greek term *kairos*, "opportune timing," to be discussed in chapter 6) was proposed by Emma Cocker as a way of articulating the distinctiveness of live notation from simply the performance of notation live.[3]

Live notation, or rather kairotic notation, refers explicitly to practices (including live coding) in which a form of notation is produced as a live event simultaneously (and in fidelity) with the experience it attempts to articulate. Here, live notation is composed in front of the audience through its performance, unlike conventional forms of scripting for performance that are *decomposed* or that disappear as they are performed, as poet and essayist John Hall asserts.[4] Live notation is the kairotic or kairic event of creating an adequate form of articulation simultaneous to the experience or ontology that it attempts to describe. The performance produces its own score, during itself. Live coding is performed as a *recursive loop*, where "notation and execution are collapsed into one thing," breaking down the "false distinction between the writing and the tool within which the writing is produced."[5]

The Live Notation project also drew attention to many aspects of performance that are often ignored or remain invisible within conventional notational languages: those embodied, experiential, intersubjective vitality forces and affects operating before,

between, and beneath the more readable (therefore arguably more writable, inscribable) gestures of a practice. Likewise, through the research project Weaving Codes, Coding Weaves (2014–2016),[6] live coders Alex McLean and Dave Griffiths joined weaver and mathematician Ellen Harlizius-Klück to address the challenges and deficiencies of conventional notational systems for describing complex embodied procedures through exploring the relationship between ancient weaving and computer programming. This project asked, among other questions: How might the complex interwoven procedures of ancient weaving be addressed through coded algorithms, when the tendency in digital rendering of weave is often one of attending to and defining a discrete (isolated) operation or function? How can computational notation accommodate the possibility of two or more weaving techniques within the same fabric? Can computational notation capture and communicate the sense of the tacit knowledge necessary for weaving, the critical deliberation, and the tactile and embodied processes of trial and error in weaver's work with the resistances, tensions, and even unexpected surprises of both the loom and thread? Moreover, how can notation articulate the sense (and value) of the decisions made "on the loom" so central to ancient weaving?

Central to the Weaving Codes, Coding Weaves project was an attempt to dislodge the privileged model of "working out" when an idea is applied to material (having been conceived in advance), in favor of a model wherein various levels of operation and cognition are activated live within the process itself. What emerged through this research was a sense of the complex, combinatorial properties of ancient weaving, which renders any single system of notation or simulation inadequate. The weaver works with multiple notational languages at the same time, live weaving them together as a singular experience or even gestalt. Additionally, different systems of notation can illuminate or privilege different facets of the weave process, in which the tendency is often one of attending to the operational settings of the loom (the heddles, the lift plan) alongside the notation of the product—the resulting weave structure—itself, rather than the temporal, tactile, and even sensuous movements of either the weaver or the thread.

In one sense, the Weaving Codes, Coding Weaves project made tangible that which conventional notational and simulation languages fail to account for but the weaver knows all too well: the importance of timing, timeliness, tension, rhythm; the negotiation of different and even competing forces within the process of weaving; the tactility of a weave's three-dimensionality; and the textural properties of thickness, roughness, density, and stretch. Both ancient weaving and live coding involve a live and embodied process of decision-making that operates in excess of, or perhaps even between, the lines of conventional notational systems. Within each practice, there is a sense of oscillation or even "shuttling" between discontinuous systems of abstract notation and the

continuous experience of a lived process and between the importing of source codes and preexisting patterns and a mode of invention that actively modifies the process as it unfolds. The tensions between the abstract and discontinuous logic of notational systems and the ways in which they become reembodied through practice gets picked up in chapter 5 with explicit reference to the notion of liveness—when the experiential liveness of the performer meets with the technological liveness of the machine.

The Notion of Notation

These two research projects identify commonalities and resonances between live coding and other practices (specifically, live art and weaving). They consider what happens when musical and computational conventions and understandings of notation meet with notational practices developed within other disciplines, including dance, performance and the visual arts, and textile arts, such as weaving and braiding. In so doing they draw attention to how the term *notation* resonates with different meanings and values within different disciplinary traditions, inviting reflection on what the implication of this is for the future of live coding practices. Within the frame of interdisciplinary research and collaboration, is there any real consensus on what is referred to by the term *notation*? Accordingly, this chapter sets out to move from a general notion of notation to address the specific questions that live coding raises as a notational practice.

Notation can operate in different ways within various disciplines, ranging from colloquial use for various note-making practices, to other forms of score, script, recipe, or diagrammatic map, to the development of a formalized notation system with its own clearly defined inner logic. Notation involves the production of marks or symbols, the generation of signs relating to a signless experience. It operates within a semiotic field: What or how is the relation between sign and signification? In one sense, notation is activated whenever a sign or mark is used to stand for—represent. Addressing the problem of notation for interactive media—or the "dangerous quest for a media art notation system"—researchers Simone Boria et al. put notation forward as "an abstraction, a simplification, and intuitive or studied way of writing something down that succinctly summarises the important points of a given situation, process, object or system."[7] They further argue that "a system becomes a notation system when it has a working inner logic using a set of abstract presentations (vocabulary) of aspects of potentially universal experience deemed relevant to be differentiated between, preserved and communicated about."[8]

Boria et al. elaborate the criteria for "notation-system-ability" thus: "Is there an inner logic? . . . Is there a vocabulary? . . . Are the notations potentially accessible to at least one

entity/person? . . . Are other aspects intentionally left out."[9] Additionally, they conceive a general catalog of notation systems that incorporates the following categories: gestural notation—cheironomy or the use of hand signals; scientific notation—the abstractions of mathematicians, physicists, and so on; musical notation—with its associated ideas of score, composition, and interpretation; dance notation—with its genealogy from the pictograph methodology to the real-time one-to-one "notation" of video recording; painting notation—or perhaps, more broadly, a conceptual art tradition involving the principles of instruction and execution while willfully minimizing expressivity; spatial (as in nontextual) notation—maps, data visualizations; computer notation—involving writing code and its execution.[10] Boria et al. identify a spectrum of purposes for notation rather than any singular function—namely, to understand, to navigate, to share and archive, to engineer, to analyze, to interpret, or to disguise. Within the expanded frame of live coding, how can these different systems, traditions, and purposes of notation be investigated in and through practice?

Notation History and Change

To address the specific questions that live coding raises for the practice of notation, we begin with a brief account of the evolution of music notation, which has its origins in early writing systems. Some of the oldest historical articles of musical notation are Hittite tablets, from Ugarit in today's Syria, written in cuneiform some thirty-four hundred years ago. The ancient Greeks had notational systems, too, but most ancient musical writings were written in the form of theory. This makes sense in the age of scarce media, as a theory of music is generative and can produce practically infinite versions of music. Western classical music developed very different ideas of authorship and performance, largely deriving from Romantic ideas about the roles of composers, the musical work, and its interpreters. Medieval monks developed systems for describing intervals, called *neumes*, written above the sung text, but this was more of a memory aid than prescriptive notation. With Guido d'Arezzo, an Italian monk of the eleventh century, we begin to see revolutionary ideas of musical notation. Guido invented the staff notation still in widespread use today, claiming that finally music could be performed by people who had never heard it before.[11] The development of notation in the following centuries represents a rich and exciting history, but from a media theoretical perspective, a drastic change appeared with printing.

Following the Gutenberg press in the fifteenth century and stimulated with the musical culture of the baroque, the primary purpose of staff notation in the West was the documentation, composition, and distribution of music. Early printed works had

plenty of scope for interpretation, improvisation, and extemporization, but written notation became increasingly complex in the twentieth century, partly following developments in print technology. Many of the things twentieth-century composers wrote would not be possible to convey in earlier movable type musical notation and engraving technologies. With new forms of print and graphic reproduction technologies, new modes of notation, such as graphic notation, became easier to work with.

While staff notation has had international influence on the world of music, it is rarely seen in live coding music communities. One reason for this is that a primary motivation for live coding is to engage with music through computational processes, and while staff notation is representable as a symbolic, discrete data structure, it is hardly a computational one. With some exceptions, such as ossia, there is no scope for logic or branching in staff notation, meaning that it is not possible to express any possible algorithm (i.e., not *Turing-equivalent*, in mathematical terms). It is certainly possible to "live code" an instrumentalist, as we find in Magnusson's *Code Music Notation*, created for a collaboration with marimbist Greta Eacott, who took the role of the interpreter in a performance at the International Conference on Live Coding in 2015.[12] In this performance Magnusson wrote notation for the performer in a human-readable algorithmic language based on machine language. Musical scores can, of course, be changed in the middle of a performance,[13] but any computation in the process would happen elsewhere, perhaps to generate that score.[14] Many projects are algorithmic and live in nature, but the typical approach of live coding notation is to adopt the language of the computer itself: the programming language.

Another reason for the lack of staff notation in live coding is cultural. In the West, live coders most commonly draw from urban club and dance music usually originating from the African diaspora, such as New Orleans jazz, Detroit techno, Chicago house, hip-hop from the Bronx, reggae from Jamaica, and jungle from England, as well as electroacoustic, "experimental," and noise musics from alternative and academic computer music practices. All these influences could be considered to be oral cultures, where musical techniques are mainly shared not as formal notations but through demonstrations and word-of-mouth. Indeed, while live coding practice is heavily centered on writing code, it can nonetheless be argued that live coded notation, with all of its ephemerality and impermanence, has features that are closer to speech than to writing. Live coding practice therefore finds itself caught between two worlds: it is too ephemeral to be score-based culture and yet too centered on text to be oral culture.

We return to the question of speech versus notation later in this chapter. In any case it is undeniable that live coding is a supremely notational practice, in which (with some exceptions, such as in live coded choreography) every event arises from notation

with explicit, formal meaning. Indeed, live coding notation is even more explicit than staff notation, whereby some interpretation is generally left to the instrumental performer; by contrast, code is by nature deterministic. What breaks this determinism in live coding is that the code itself is open to change at any point, bringing the computational processes of the machine and the thinking processes of the coder together in a single cognitive loop.

Returning to our historical timeline, the nineteenth century brought the invention and development of the pianola or player piano, for which music could be bought on paper rolls, with notes played via holes punched in the paper, driven by pneumatics. From today's perspective, it is interesting to note that player pianos (as opposed to *reproducing* pianos) were not fully automatic but were commonly designed with expressive controls for tempo and dynamics for a human operator to "play."[15] Indeed, there were once virtuoso concert pianola players, most famously Rex Lawson, who played music composed for the pianola, as well as Igor Stravinsky and Conlon Nancarrow.[16] Some rolls were not only punched with holes controlling the notes but were also printed with lines directing the human player pianist how to work the hand controls in order to fully reproduce the performance of a particular human pianist or even the original composer. Although the naming of a performer may have been more of a marketing device than an accurate recording, the printed lines are a clear acknowledgment that as a notation, the punched holes as notes within a grid of such metronomic rolls are an incomplete representation of music.[17]

Where it is deterministically interpreted, live coding notation, on the other hand, is a complete representation of the media currently being produced by it and therefore sits in its own category: too transient and in the moment to be considered a recording and too complete to be considered a mnemonic notation. But perhaps rather than standing for a brand-new way of thinking about music, live coding instead exposes flaws in how we have, in recent history, come to think about music as an end product, rather than as a live activity.

Live coders perform with code, but it does not follow that the performance is itself coded. That is, live coders embody their code and think through it but are not controlled by it. From the outside, live coding culture could be mistaken for being dehumanizing and lacking expression, but this is a misunderstanding. Live coding is about *disrupting* the deterministic logic between notation and process, bringing it into a creative feedback loop where that logic evokes an unconstrained experience, feeding back into edits that are not predetermined.

This is analogous to the Machinery, a traditional clog dance originally from the working-class cotton mills of Lancashire, UK, which mimicked both the sounds and

movements of machines.[18] The Machinery takes the repetitive processes of industrial technology and acts them out in repetitive, jerky movements, creating noisy clattering and scrapes with the clogs, reproducing the sounds and movements of power looms and other machinery. By embodying the machine in this dance, the dancer does not become a machine; rather, machinic movements become human, and the millworkers regain human agency from mechanization. Looking at live coding in this light, we can see that live coders similarly do not become coded but rather *embody* code.

The Machinery began with women mimicking the movements of machines with their clogged feet while they worked. Eventually, it was brought out of the mill and into the world of mainstream culture and performed without the real machine present. Could the same thing happen with live coding? In the algorithmic dance world, it already has, with choreographers such as Kate Sicchio notating instructions not for computers but for human dancers (see her exposition in chapter 3). Without the computer, the difference between performing logical operations and "playing" logic then becomes much clearer. Dancers interpret instructions on their own terms, exercising agency in ways that are not predetermined.

Experimental Art Traditions of Notation

John Cage's book *Notations* (1968) is a well-known reference for the art of notation in the postwar experimental tradition. Indeed, there is a rich history across the twentieth century to draw upon, echoing experimental practices in language such as OuLiPo, mentioned in chapter 1, the instruction pieces of Fluxus, and avant-garde performance practices more broadly. The connections between notations, programs, and scripts underpin our concerns with how the structures that generate movement are made visible—both readable and writable—and how aesthetic and functional perspectives conjoin in graphic scores and executable forms. Often foregrounded in this history is the way in which scores can be used to generate indeterminacy, as a way to navigate a space of possibilities—for instance, the commonly cited *chance operations* of Cage and the dice games popular among Western eighteenth-century composers.[19]

Another common reference is Luigi Russolo's manifesto *The Art of Noise* (1913),[20] in which all sounds can be considered musical and therefore demand new forms of notation. The Fascist politics to which the Italian Futurist movement related, and of which Russolo was part, should, however, give us pause for thought in their call to discard history. The influence of the visual arts is also felt in the example of Wassily Kandinsky and Paul Klee, in particular, in relating structures and colors in their paintings with rhythm and timbre. Again, Cage—not least in his approach to noise—makes a good example in

his cross-media collaborations with dancer Merce Cunningham in chance operations. To Cage, music comes together with other phenomena in expressing the absence of logic, coherence, and predictability in everyday life. An example from the live coding field that explicitly draws upon this tradition is Nick Collins's *Avscore 37*.[21] It is a graphic score with two channels: player A interprets a succession of framed abstract scenes, and player V follows a continuous staved timeline. Together the score acts as a *suggestion* for how the audio and visual elements might correlate or not. The score itself is computer generated and so folds back onto itself in expressing the creative possibilities of its live performance.

The foregrounding of notation in the form of a code or rules extends the legacy of Fluxus scores and conceptual art instructions and the prevalence of algorithmic procedures within computer art, where code or rules become generative strategies for producing outcomes potentially autonomous of artistic control or agency. Recall the Fluxus performance score of La Monte Young's *Composition 1961 No. 1, January 1* as operating in analogous terms: "Draw a straight line and follow it." Here, as Sol LeWitt remarks, "To work with a plan that is pre-set is one way of avoiding subjectivity," where "all the planning and decisions are made beforehand, and the execution is a perfunctory affair. The idea becomes a machine that makes art."[22] Live coders bring this subjectivity back into view, although given that La Monte Young's composition is so open to interpretation, perhaps it was there all along.[23]

Representation and Style

Antony Braxton broadly divides the world of music practices into three categories:[24] *stylism*, which no longer changes; *traditionalism*, which continues a long history of change; and *restructuralism*, which signals a new kind of music as a break from tradition. It seems that notation has a role in deciding whether a restructuring of music develops into either a tradition or a style. The power of written and printed music (and to an even greater extent, recorded music) is in its capacity for mass production and dissemination, but in supporting the notion of authenticity, or *Werktreue*, individual pieces are less open to structural change. Oral tradition, on the other hand, particularly in folk music, necessarily undergoes change through the act of transmission. But from the perspective of music theory, we could also say that notated music emphasizes change because every piece has its own identity, at times even its own music theory.

When human expression is represented on a computer, whether music, video animation, or choreography, it is reduced to numerical data that are being executed in time. This is most easily seen in grid-based music,[25] in which pitches and durations are given discrete numerical values, typically using the MIDI standard whereby integers on

a linear numerical scale are mapped to the exponential frequencies of musical pitches. Notes can be stored as numbers in lists and chords as sublists. In computer music, timbre is often more important than pitch and can also be represented as numerical values—for example, as synthesis parameters. Relatedly, we can find code libraries for spectral manipulation and machine listening that can organize and manipulate sounds along perceptually salient dimensions, of use for live coding systems. Choreographic representations are perhaps less able to be reduced to grids of numbers, but here computer vision and machine learning may also be applied, such as Sicchio's work in organizing visual material into quality dimensions, creating a space of possibilities that can then be navigated with live coded instructions.[26]

Through notation, then, the live coding performer can engage with any parameter that they judge to be of interest, whether controlling movement, pitch, timbre, or a higher-order rhythmic manipulation. A specific live coding system will afford the control of some or all of these elements, but it is clear from the plethora of available systems that the authors of the systems are not necessarily interested in all. Algorithms are used to describe patterns and shape events in time. The interesting question for artists is *how* this is done because this will inevitably color the output. Live coding systems therefore incorporate methods for their users to generate events over time while continually shaping the result through live engagement with the running program. In the early days of live coding, practitioners would often design their own systems, and the character of the inventor would shine through in the way the system worked. Live coding environments typically supported what the author of the environment wanted to do in a performance. Even today, systems such as Scheme Bricks, Extempore, TidalCycles, Hydra, ChucK, Threnoscope, Foxdot, Sonic Pi, Improviz, and Gibber all exemplify certain views on what is important in live performance, whether that is expressive range, speed of writing, compositional potential, understandability, surprise, timbre, spatiality, rhythmic patterns, visual or melodic progression, and so on.[27]

A live coding language is an environment in which live coders express themselves, and it is never neutral. People who speak more than one natural language are familiar with how language shapes thoughts and personality. A switch to another language might even affect how we move our bodies when we speak. Such effects are especially pronounced in live coding, as the languages are typically high level, potentially designed with particular visual or musical styles in mind and offer particular creative constraints. We can therefore argue that live coding languages inevitably shape the thoughts and actions of the user, but here the user is also a coder. Live coding systems range from being more akin to individual pieces, such as Sicchio's Terpsicode or Magnusson's Threnoscope, to more general-purpose, systems-level programming languages. Where live

coders choose a more general-purpose language to work in, such as Extempore, SuperCollider, Python, Lua, or even the venerable C language,[28] they may choose to simplify the expressive range of the language in order to create their own constraints, providing a more manageable space of possibilities to creatively work within and against.[29] Alternatively, they may extend the environment with additional vocabulary or techniques as a way to forge their own style. This has been called *pre-gramming*,[30] as it involves a preliminary preparation for the live coding practice, a process where language design inevitably merges with musical composition.

Defining Live Coding through Notation

The ideas represented by live coding, live programming, interactive programming, or conversational programming are not new. Indeed, the design of common live coding systems, such as SuperCollider, refers to the cybernetic ideas of Gordon Pask; the live electronics of David Tudor; the programming language design of Alan Kay (Smalltalk), David Ungar, and Randall Smith (Self); and Steve Tanimoto's ideas about levels of liveness.[31] The idea of creating an object or function that can be named and altered while running is appealing for all time-based art forms, whatever the domain (choreography, virtual worlds, robotics, animated graphics, music). What is abstracted and represented is often the work of the language designer, which highlights the compositional decisions involved. For this reason, we have not seen a coordinated effort to build a general live coding language, but many individuals are making their own systems, albeit often released to the public and used by others in studio work and performance.

The notational considerations in live coding systems serve multiple purposes. Designers of the systems have in mind things such as ease of learning, ease of understanding for lay spectators, expressivity, error tolerance, speed of writing/tersity, tracing, manipulation of code history, and many other language-design features that have hitherto not always been considered relevant in traditional programming-language design. This is changing, however, with the (re)emergence of the communities around programming-language experience design and the "future of coding." This resurgence of interest in liveness among software engineers may have been partly inspired by the live coding movement, although interaction designer Bret Victor is much more widely cited as an influence through his well-distributed videos including "Stop Drawing Dead Fish," and the "Future of Programming."[32] Following work with pioneering computer scientist Alan Kay,[33] Victor has since established the independent DynamicLand laboratory, modeled on Douglas Engelbart's earlier Augmented Intelligence Lab, to take ideas around live, tangible, computational environments further.

Algorithmic Pattern

Live coding is an algorithmic art form in that code is written to represent algorithms while those algorithms are being enacted by a computer to generate musical, visual, kinetic, or other live results over time. However, we too often use the word *algorithm* without fully articulating what algorithms are in terms of how they are structured and how they operate. In computer science, an algorithm is often defined as a finite sequence of unambiguous instructions that can be followed in order to solve a problem. This is clear enough but leaves much to say about how those rules are structured and followed.

Magnusson and McLean have elsewhere asked, "How can we directly express musical patterns with computer code?,"[34] examining which strategies the performer can apply in live coding for the patterning of music and which strategies there are at hand for transforming the musical materials. We can algorithmically generate musical data or write them by hand, but live coding does more than that: we apply algorithms to alter these data. The aforementioned text drew upon a 1981 article by composer Laurie Spiegel to frame examples of the pattern methods that can be applied onto musical data or directly used to represent music.[35] Spiegel gives an explicitly nonexhaustive list of twelve categories of pattern manipulation from her perspective as a composer with a foundational role in the development of computer music: 1) transposition, 2) reversal, 3) rotation, 4) phase offset, 5) rescaling, 6) interpolation, 7) extrapolation, 8) fragmentation, 9) substitution, 10) combination, 11) sequencing, and 12) repetition.[36]

From this approach, the basis for pattern in computation (and vice versa) becomes clear, particularly when we consider the lower-level operations of computer machinery. For example, the logical operators "AND," "OR," and "XOR" are instances of combination (combining two values into one), "NOT" is a form of substitution (zero for one and one for zero), and "<<" (left shift) and ">>" (right shift) are forms of rotation. As such, live coder and weaver Dave Griffiths has visualized the state of registers over time while simple calculations are performed by a CPU (figure 4.1) in order to demonstrate the provenance of contemporary computation in ancient textile techniques, particularly weaving and braiding.[37]

From this perspective, computational algorithms and patterns culturally situated in textiles, music, and dance seem closely related. However, this comparison does not sit well in parts of the music field where composers in general use the word *pattern* to describe any fixed sequence, sometimes even in a pejorative sense. Although the centuries-old fugue, as a contrapuntal compositional technique, is based on pattern thinking, some composers would be deeply offended by the accusation that they are

Figure 4.1
Visualization of the eight-bit registers of a Z80 microchip as it performs simple calculations, demonstrating the relationship between computation and weaving.
Source: Computer artwork by David Griffiths.

making mere patterns.[38] Minimalism—notably, the work of Steve Reich in applying a phase operation to a bell pattern in his 1972 piece *Clapping Music*—demonstrates the generative nature of pattern in Western concert halls as additional context for Spiegel's 1981 paper.[39] But the connection between algorithmic patterns and the far longer history of handcraft, particularly textiles, is clear, and we return to the topic of weaving and coding at the end of this chapter.

Since Spiegel's paper, many computer music systems have explicitly included pattern transformation features, from the early Hierarchical Music Specification Language (HMSL), to the Common Music and Bol Processor systems in the 1980s, to SuperCollider in the 1990s and many of the systems developed and used by live coders. The TidalCycles system has perhaps gone furthest in this direction, being designed exclusively for live coding algorithmic patterns. It consists of a *mininotation* for rhythms, heavily inspired by the Bol Processor's polymetric expressions,[40] and an extensive library of combinators offering a wide range of possibilities for manipulating pattern. The live coder is free to combine any number of these functions together, providing a very rich range of possibilities for patterning different aspects of sound at multiple scales. We

return to patterns and TidalCycles in chapter 6, where we compare and contrast different approaches to time.

The capacity for algorithmic pattern to connect disciplines, including with the ancient history of heritage craft practices, allows the practice of live coding to be grounded and enriched. It also allows practitioners to connect their work with their everyday life experiences. In a review of live coding and algorave culture from a feminist technological perspective, Joanne Armitage quotes an interviewee speaking about code as "a way of working through their daily life, adding structures to it and providing functions for being. These lived patterns merge with their daydreams and expressions of color and geometry to form her live coded visuals."[41] In looking beyond the conventional grounding of computing practice in military, industrial, and commercial contexts to the far older and therefore more advanced ethnomathematical roots in pattern, it becomes much easier to see how live coding can develop as a cultural practice.

Machine Collaboration through Notation

Predictive coding is a term used in neuroscience for the way the brain filters out redundant noise (according to context) so that cognition can focus on the perceptual data that are relevant to the task at hand. However, with advances in the field of machine learning, we are getting to the point where a live coder is able to program in collaboration or conversation with a live coding system that has learned about their habits and style. Tanimoto has described levels of liveness in programming languages, where the sixth level represents a state where "rather than simply making tactical predictions, a system might be capable of successfully making strategic predictions."[42]

A number of projects have indeed explored what could be called *artificial live coding*, either as autonomous systems or assistants that suggest edits to human live coders. Interestingly, even relatively straightforward approaches to code generation turn out to be remarkably successful. Ixi lang's autocoder, perhaps the first practical example of artificial live coding that effectively manipulates code based on straightforward rewrite rules, is often used by performers who are the worse for wear or otherwise in search of inspiration.

Research into artificial live coding was prefigured by McLean's work on generating continuations based on Kurt Schwitters's sound poem *Ursonate* (1932),[43] for which he created a domain-specific language to represent rhythm that later formed the basis of the TidalCycles live coding environment.[44] Perhaps because TidalCycles has been designed to be easily readable by both humans and machines, it has since been used as the target representation for a number of artificial live coding systems. Shawn Lawson and Jeremy Stewart's Cibo agents have been developed over several iterations, version

two being trained on code recordings of prior TidalCycles performances, producing a three-dimensional latent space traversed by a recurrent neural network in order to generate a new performance.[45] Simon Hickinbotham and Susan Stepney applied evolutionary algorithms in a system for multiple autonomous agents to live code TidalCycles music together using the Extramuros network music system.[46]

The systems mentioned so far mainly operate only on the notational level, but the MIMIC project brings machine-learning and machine-listening techniques together in a system that encourages end users to create their own live coding languages. A strand of that project, called Sema, developed by Francisco Bernardo, Chris Kiefer, and Thor Magnusson,[47] invites people to create their own live coding languages specifically for machine learning in live coding practice. The MIMIC project workshops have invoked some of the early atmosphere of the live coding community where everyone worked with their own experimental notation and mixing live coding and artificial intelligence aspects also connects with Engelbart's early conception of augmented intelligence. We speculate further on the future of artificial live coding in chapter 8.

Live Notation in Performance

The function of notation in live coding can be seen as threefold: it is the syntactic structure read by the language interpreter that executes the program, it is the action or movement of the performer that is projected to the live audience, and it is the artistic (e.g., choreographic, musical, visual) output of the process that is notated and manipulated by the live coder. All of these require further unpacking, but let's start with the last point. In musical terms, the live coder is concurrently playing and composing. The computer (or any system of interpretation) is executing the music: the individual sonic events are not triggered by the musician. The written code serves as a trace of this conversation with the computer, but since the effects of this conversation are still sounding and transforming (rhythmic stuttering, melodic canons, shuffling, shifting patterns, and so on), the performer will need the code on the screen to consider what they have written and its relationship to the results.[48] The code is a representation of the sounding music process, and through reviewing it the performer plans the next steps, which might include adding new structures, changing running patterns, or deleting parts of what is happening. For this reason existing lines of code in live coding languages represent data structures, functions, objects, or agents that can be altered during performance without interruption in the execution of the artwork.

The relationship between code and results is, however, not straightforward—if it were, the live coder might be better off using conventional sequencer software designed

for working directly on the musical surface of notes. For example, when live coders compose together elements of different lengths, they create polyrhythmic interference patterns, bringing a result with features not present in the source elements. Similarly, if they are live coding behaviors of agents, the musical results are not directly described in the code but are an emergent property of how the agents interact. Conventionally, programming techniques are divided into either an imperative or declarative approach,[49] the first addressing the question of *how* the program should run and the latter addressing *what* the program should achieve. Live coders instead tend toward the question "What if?," where the notation is not used to describe a desired procedure or outcome but instead to simply take the next step in an exploration. Each such step is guided more by the coder's musical results of the previous step as they are perceived and less by an overall plan. The role of notation in live coding then is not to define, prescribe, record, or transcribe but to take a step into the darkness, into which the interpreter immediately throws light.

Recording Live Coding

Live coding is notational, digital, and discretely symbolic yet kicks against the assumptions of recording and reproduction. As we have seen, in many ways it is an example of oral culture, especially where live coders celebrate not saving their code. The transience of the code they write is an essential aspect of being in the moment, held in dramatic contrast to the life of the professional programmer who saves incremental versions, configurations, and releases. Nonetheless, all live coding gestures are via computer systems, which are generally deterministic. If a live coding performance is documented—for example, through a screen recording or recording of keystrokes—such a performance may in a sense be perfectly reproduced. However, one aspect applies here as to any improvised art, whether music, dance, or happenings: the documentation can never capture the unique spatiotemporal moment in which the performance takes place, which is dependent on the social context, historical time, and architectural space.

Live coding therefore treads an uncommon path between oral and written culture, improvisation versus the composed, and the spontaneous versus the arranged. Live coders often start with a blank page, but behind every written function is precomposed or pre-grammed code, often encapsulating a great deal of music techniques, such as syncopations and other transformations. Some live coders operate like jazz musicians: they practice "licks" that are applied in the live context, composing pieces in real time that have to some extent been practiced. Live coding is written, like music notated in staff notation, but it originates as a tradition in which composition happens in real

time, and the results are often abandoned: this music is about the process, the experience in-the-making, and not about the destination.

Increasingly though, Save buttons are disappearing from text editors and word processors because every keystroke triggers a save into the complete history of a document. Experimental live coding systems, such as Troop and FeedForward,[50] are adopting this model, too, following Sang Won Lee's work on *live writing*, in which every key press is saved with a time stamp and able to be recalled and replayed.[51] This signals a shift away from ephemeral live coding that is made for the moment to plentiful live coding, where every action is shared immediately to the creative commons. This is an alternative stand against commercialization; rather than deciding not to save code so there is nothing to commercialize, everything is saved and shared so there is no scarcity to exploit. This brings to mind Mark Fisher calling for collective wealth: "Real wealth is the collective capacity to produce, care and enjoy. . . . This is Red Plenty. . . . Everything for everyone. All of us first."[52]

Between Speech and Writing

Although musical notation systems can be found all over the world, emerging along with writing, musical composition using notation is a relatively recent phenomenon (about one thousand years old). Musicians in many cultures, from the dance music of the Ewe people of Ghana to Hindustani classical music, still rarely show interest in notating their practice. These advanced practices have developed through oral transmission (standing for any form of communication, whether sung or instrumental, other than writing), and although the music *could* be transcribed, its practitioners rarely have cause to do so. In contrast, Western classical music lives through its notation, with music composed, shared, played from, analyzed, and theorized in printed form. This relates to the advent of the printing press in the fifteenth century and the distribution of sheet music, offering new ways of generating income for musicians and composers. These different practices in music culture appear to set a dichotomy between music primarily shared through speech and through play and that shared through notation. Most music cultures tend to have a mix of both but lean toward one or the other.

Live coding sits uncomfortably on the division between oral and written culture. It questions how speech and writing are transformed through their relation to computation and coding practices.[53] On one hand, an archetypal live coding performance focuses on notation to an extreme—everything happens via text. Furthermore, that text is not a mnemonic but a *complete* description in that it is a formal language interpreted unambiguously by a computer. Indeed, rather than a description it is a *prescription* because it

does not describe music but brings it into being. While a human instrumentalist brings their own creative interpretation to playing notated music, a computer interpreter has no such role, beyond perhaps pseudo-random number generation as dictated by the notation. On the other hand, the manner in which live code is articulated is ephemeral. Live code is only notated in order to be changed and, in many cases, deleted. So in a sense, the fleeting, momentary nature of a live coder's notation is closer to speech than text.

Live coders therefore find themselves caught between two worlds. They work with a written notation, distanced from what is notated. They don't directly move to make gestures; they *write about* making gestures. But they still continually manipulate that notation while it is being interpreted, changing lines of code by adding new features and deleting others (we could call these *meta gestures*), and as a result, live coded notation cannot later be printed out and shared.[54] The art is not in the written notation itself but in the *activity* of notation, as performance over time. The programming is part of the program.

We can only conclude that live coding is neither a fixed text nor dynamic speech. However, we will get nowhere by focusing only on differences between practices. We therefore look to understand live coding in terms of how it breaks apart conventional categories and is able to reframe creative practice in terms of live manipulation of symbols, and conversely, we look to reframe live coding as fully embodied interaction through code. That live coders oscillate between literary and machinic modes and practices in live performance—somewhat analogous to speech—leads us to speculate on whether their live writing retains some of the unruly qualities of speaking out (in public). Or perhaps live writing is another way to highlight the unfree conditions under which all communication operates and offers one way to examine its effects and conditions of operation. To write differently, developing new performative modes of expression becomes all the more urgent if we understand human subjects to be constituted in language, as well as able to transform that language and break out of processes of subjectivation.

Paper Rhythms: The Map Is Not the Territory

Previously, we made the claim that live coding notation is in a sense a *complete* prescription for music, as opposed to a mnemonic form. This, however, does not mean that there is a clear relationship between a notation and the real-world experience conjured up by its interpretation. The way we perceive a piece of music may be structured very differently from the way we notate it. This could be a disturbing thought for the live coder, caught between perception and notation.

In order to understand the relationship between notation and what it notates, we can turn to music analysis. Musicologist Kofi Agawu signals a warning for those trying to understand music only through analysis of notation, calling those *paper rhythms*.[55] For example, in an analysis of notated rhythmic timelines such as the African standard bell pattern, it is common to depict them as circular and, as a result, treat "rotated" time lines as equivalent in the same way that octaves are equivalent. According to Agawu, the mistake here is to assume that the *correct* time signature to assign to a rhythm is the one that is easiest to notate, and claims that follow from this mistake are easily refuted by talking to musicians who play the music, by speaking the language that the rhythms relate to, or simply by dancing to a rhythm to feel the true underlying pulse and meter. By looking for musical relationships in notation, we confuse notated paper rhythms with rhythms as they are experienced in the music, grounded in physical and not purely symbolic relations.

On the face of it, Agawu's criticism could be disturbing for live coders because he criticizes music analysis that equates rhythmic representations that look good on paper with those that work well in practice, when these are two very different domains and experiences. But that is what live coding musicians do—they work with paper rhythms as live, musical practice.[56]

Consider the following pattern in the TidalCycles live coding environment:

```
every 3 ("t" <~) $ struct "1(7,12,3)" $ sound "drum"
```

This plays the twelve-beat African standard bell pattern (notated as the Euclidean pattern (7,12,3)[57]) and "rotates" it by one-quarter of a cycle every third repetition. But with his authority as a musicologist of both Western music theory and the music of the Northern Ewe, Agawu would argue that this is only a rotation *on paper* and that what we hear and feel is not a rotation but an entirely new pattern, with very different properties. This relates to the concept of *symmetry breaking*, in which you break symmetry by applying a force to it, which then potentially causes a whole new symmetry to spontaneously form.[58]

Anthropologist Tim Ingold's view on notation, referring to Alfred Korzybski's famous statement "The map is not the territory,"[59] helps us understand this problem from the perspective of and mapmaking navigation:

> Do we say that a notation allows a musician to create a piece, as it was intended by a composer, "from the coals?" In the sense that the notation contains all the instructions to produce this piece? Or is the notation such that you can't understand it, unless you know how to play it already? Many notations are of that latter kind—they are maps which you can only read if you already know the territory.[60]

If music notation is a map for those who already know the territory, then perhaps live coders are live mapmakers of *unknown* territory. That is, a live coder is making a map-as-code, from which the computer generates a result, which the live coder then experiences as territory-as-sound. Having had this experience of the sound *territory*, they are able to read the code *map* they have written for the first time. From then on, each adjustment to the map in turn adjusts the territory, allowing a new reading of the map and a new adjustment and so on.

This generative relationship between a notation and what is notated is what drives creativity in the live coding field. The perceptual gap between notational map and generated territory allows the live coder to reach beyond their imagination, working with notation not to efficiently realize a ready-formed idea but to *follow* an idea to see where it takes them.[61] Rotating or reversing a rhythm might be a simple transformation on paper that when actually played out becomes a transformation of a complex whole, with the phenomenon of syncopation resulting in a rhythm with a completely different feel. In enacting such transformations, the live coder is in a perpetual state of anticipation, with each edit a hypothesis that might be confounded but nonetheless informs the next edit, allowing the live coder to guide a performance into the unknown.

What we then arrive at is the idea of a live coder who is simultaneously both theorist and practitioner. They are not beholden to established music or choreographic theory (except perhaps theory embedded in the live coding language they use) but instead continually develop, test, and share new theories. Each edit is a prescription for a method that is part of a wider holistic process that encompasses the human perception of rhythmic, kinetic, visual, tonal, and/or timbral relationships. As Klee put it:

> Already at the very beginning of the productive act, shortly after the initial motion to create, occurs the first counter motion, the initial movement of receptivity. This means: the creator controls whether what he [sic] has produced so far is good. The work as human action (genesis) is productive as well as receptive. It is *continuity*.[62]

Holistic Prescription

The distinction between holistic and prescriptive forces in live coding can be further clarified from metallurgist and research physicist Ursula Franklin's conception of the "real world of technology."[63] For Franklin, a holistic technology is exemplified by the craft of an artisan who is in control of their own creation process and where every piece they make is therefore unique. Prescriptive technology, on the other hand, concerns a creation process that is broken down into tasks, each well defined and reproducible. Here Franklin explicitly considers *technology* as *practice* and therefore discusses

technology not in terms of *what* is done but *how* it is done. Holistic technologies follow a growth model, in which the artisan makes decisions as they go, crucially including the decision of when to stop before the work becomes *over*grown. By contrast, prescriptive technologies follow a production model in order to support division of labor and mass production, whereby makers do not assert control over what they are doing and instead are fully compliant in following their assigned subtask.

This distinction again confronts us with an apparent conflict at the heart of live coding. On one hand the prescriptive "breaking down of a process into well-defined tasks" is what all computer programmers do through the decomposition of a problem into more easily solvable tasks. On the other hand, the liveness in live coding pushes a holistic role for notation, in which the coder is a craftsperson working with existing programming environments at different layers of abstraction and responding to their code as the material of creative constraints. The unambiguity of code, and its use in prescribing a deterministic process, can blind us to the wider, fundamentally human creative process at play. What a live coder unambiguously prescribes is action, but where that action creates results beyond their imagination, grounded in the creative responses of our perception, we arrive at a holistic process open to unintended consequences and surprise.

An alternative view of the live coder is of an artist who is "at one" with their tools, to the extent that they know the result of every action in advance and anticipate everything their software does. This is a live coder as a virtuoso, channeling art from the Platonic world of ideas into an imperfect world. Notation is then a matter of efficiency of expression, of getting what is in the coder's mind into the world in the most expedient way possible. One problem with this view is that if a live coder has full control over what their notation produces, then in terms of its creative influence, notation is neutralized and sidelined. Rather than allowing for an exploration of language with all its generative capabilities, live coding is then reduced to getting a result already predefined by the coder. In this case, perhaps, they would be better with a system like a digital audio workstation (DAW) or a sequencer, designed to allow the direct manipulation of every note. In practice, however, live coding exists between these extremes. The language is always in dialogue with the live coder, its affordances and constraints presenting themselves through live action. A live coder might well arrive at a performance with some particular ideas to express while leaving space for new ideas to emerge.

In some cases, the live coder might be the only person onstage, but we should not forget that there are always other people involved in setting the scene. As live coding has developed, naturally most now perform using languages created by people other than themselves. These live coding languages might be Turing-equivalent and therefore universal, in that any process can be described using them, but nonetheless

they are epistemic tools that offer particular creative constraints and affordances put there by the language author.[64] As Roland Barthes wrote in his essay "The Death of the Author,"[65] it is language that speaks, language that performs. In a sense, then, the live-programming environment prescribes a particular world of possibilities, and hopefully a rich one, allowing the live coder to creatively explore and push against those constraints as well as define their own.

Space in Notation

Another dichotomy that is core to the design of live coding notations is between *visual* and *textual* programming. This distinction *seems* clear at first, wherein visual programming languages build upon a visual layout and graphic elements, and textual languages are based on arrays of discrete symbols. When we look more closely at textual and visual languages, however, we see that this distinction stands on shaky ground.

Figure 4.2 shows the Sonic Pi live coding environment using one of its default themes. The performer has placed a webcam image underneath for this online livestream, but otherwise this is a standard presentation of the software. Sonic Pi is very much a textual live coding environment (based on the industrial Ruby programming language), but in this screenshot we see that its text both lives within and is supported by the visual

Figure 4.2
Melody Loveless performing as part of the New York DigiAna stream, September 12, 2020.

domain. The text is arranged within a two-dimensional grid, and furthermore, text is visuospatially placed *within* text through indentation, with alignment accentuated by vertical lines, creating a visual representation of embeddedness. Color visualizes syntactic elements. Adjacency visualizes connectedness. Time proceeds downward and loops within horizontal levels of indentation. These are all visual relationships.

The visuality of text is clearer still in figure 4.3, which shows the Orca live coding environment. In conventional programming languages, control flow proceeds downward, but in Orca, control flows can travel up, down, left, or right, triggering effects (including change of direction) indicated by single-letter (ideographic) commands. Control flow is itself visualized as highlights moving around the text and may self-modify instructions as it travels around. Orca has a great deal in common with the older Befunge programming language; the only real difference being that Befunge was created as an "esoteric" language not intended for "serious" use, whereas Orca is a practical, and increasingly popular, way to make music. Each letter is treated as an ideographic symbol rather than being composed into words, but it is still undeniable that this is a text-based language, which includes both visual syntax and semantics.

Figure 4.3
Orca live coding environment.
Source: Screenshot by Alex McLean, generated using Orca software by Devine Lu Linvega.

If we look at familiar visual languages such as Scratch, Pure Data, and Max, we find that all involve text but have alternative means to visualize syntactic connectedness. In earlier generations of textual programming languages, local syntactic connectedness is determined by the sequence of symbols, just as with the English-language text you are reading. In Scratch, the local sequence is visualized as jigsaw-like blocks, while with Pure Data and Max connectedness can be indicated over greater distances by a line drawn between text labels, each contained in a rectangle. So, in a very real sense, visual programming is textual, and text-based programming is visual. The specialist research communities in visual programming languages and diagrams continue to explore new forms of these text/graphic hybrids, with theoreticians further problematizing any naive graphic/linguistic distinction.[66]

Several live coding environments use the ambiguity and interdependence between textual and visual representation to create hybrid interfaces, combining visualization and a graphical user interface (GUI) with text. Some of these environments take a game-like form, such as Griffiths' work based on his live coding game engine Fluxus.[67] Others keep the appearance of a standard text editor but are augmented with GUI elements. The web browser–based Gibber live coding environment, created by Charlie Roberts, has been a particularly active and influential platform for experimentation in live code annotations and visualizations.[68] Graphic elements allow the end user to associate the sounds they hear with the text that caused it, with active elements highlighted and continuous signals visualized. Furthermore, individual values can be interacted with and adjusted with a mouse. As with Orca, these features are strikingly unusual yet also highly practical in bringing live text into a whole audiovisual experience.

This visualization of control flow in the code that notates it amounts to a conflation of space and time in the text editor. Earlier environments have explored this too. Magnusson's ixi lang, for example, has turned code lines into notation of rhythmic time, where symbols represent musical events, and spaces between the symbols then signify musical "rests."[69] Ixi lang has functions that operate on the code as data, where the code invokes a process for editing itself. We return to the representation of time in live coding environments in chapter 6.

Notation and Authenticity

With notation comes the possibility of assigned authorship and, by extension, authenticity. How does this apply to live coding practices? Nelson Goodman's 1976 treatise *Languages of Art* distinguished two fundamental categories of artistic work.[70] An *autographic* work, like a written signature, retains traces from the body that made it. When

viewing an autographic work such as an oil painting or sculpture, we see substance that has been shaped by the hands of the artist. There is a chain of material action connecting the viewer to the original performance—an act of expressive making. Although it is possible to copy such a work, reproducing that original performance with greater or lesser fidelity, we feel obliged to distinguish between such activities and the original work. One might attempt to pass off a copy as if it were the original, but this would be a different kind of expressive performance—an act of live forgery, not live creativity. Goodman's second category is that of *allographic* works. Unlike an autographic work, an allographic work can be reproduced without changing its nature. If I own a printed copy of the novel *Sense and Sensibility* and I see another copy in a shop, that copy is just as much the work of Jane Austen as my own. Making another copy is not a forgery of a novel or a score. In the case of allographic works, there is no fundamental difference between copies, and the essence of the work is the information that is encoded in every one of the copies. Reproduction of code is not forgery—it is not even live, in the sense that it can be achieved wholly mechanically.

Goodman labels the fine art practice of painting as autographic and the process of producing a musical score as allographic, but as a technique live coding can be applied both to making paintings and making music. So on which side of this distinction does live coding sit as a field, and what could it mean to make an "authentic" live coding performance? When Goodman writes about music, he has an orchestral performance in mind, with musicians reading from a score. It is less clear where music improvisation would fall, but the comparison between live coding and orchestral performance is still interesting since Western classical music is "two stage" in that there is the notation and its execution. Live coding brings notation and execution together, taking place at the same time in response to one another.

When a live coder works as a live improviser, sharing their screen, this would seem to be autographic—the body can be seen to make the text in the process of generating live performance outcomes. Perhaps the authenticity is then in the nonrepeatability of the performance. Has the live coder rigidly practiced every edit and keystroke in order to reproduce a work? If we view live coding as an allographic practice, then this is an authentic reproduction of the piece, but if we view it as autographic, then this is a "fake" improvisation! In reality, these are two extremes at opposite ends of a spectrum, where a given performer is likely to move between preprepared and more improvised sections at will. In the same live coding event, we might see one performer recalling and executing preprepared code, the next writing everything from scratch, designed in and for the moment, and a third taking a hybrid approach. We can say then that the live coding community supports both autographic or allographic approaches, celebrating

the former for its open sharing of creativity and risk and the latter for its slick control of a well-prepared composition.

In practice, the notions of allographic and autographic works are as interwoven as the notions of analog and digital, and the problems of seeing them as separate have been laid bare by the rise of digital media.[71] We call an MP3 file "digital" because it represents sound using discrete mathematics, stored as numbers. However, ultimately, the MP3 file represents analog movements of air pressure; the file is digital, but the outcome is very much analog. This is a layering of analog movement represented in a digital file, which in turn is held within the analog form of a silicon circuit. This layering allows an autographic work to be mass produced perfectly without the requirement of an original. The distinction between allographic versus autographic is similarly difficult to make in oral culture. The discrete, digital elements in a song—the words and notes—are handed from person to person as living memory, changing with use. The words and notes are specific, able to be transcribed and recorded as digital media, but an exact copy has less value than the next performance, which carries the autographic signature of the performer on to the next one.

John Cage alludes to the mass production of algorithmic music as an escape from the questions of authorship that underlie the distinction between allographic and autographic works: "Computers're bringing about a situation that's like the invention of harmony. Sub-routines are like chords. No one would think of keeping a chord to himself. You'd give it to anyone who wanted it. You'd welcome alterations of it. Sub-routines are altered by a single punch. We're getting music made by man himself: not just one man."[72] Both chords and subroutines are digital in nature in that both consist of discrete, countable elements. The discrete symbols used in live coding are similarly caught up in a life of continuous change, the digital mixing with the analog. A live coder works in a digital world of formal language, but that code ultimately describes continuous movements, which the coder experiences both as discrete events and continuous fluctuations.[73] Similarly, we find it hard to describe a printed novel as being a digital artwork; it may exist as a list of discrete alphabetical symbols, but when read, the experience is neither analog nor digital but an amalgamation of both.

Digital media has problematized autographic artwork, reflected in the ongoing debates over copyright ownership and commercial distribution. However, the nature of allographic works is even more significantly modified by digital media. The classical allographic work was a script or score, in which the encoded work itself is distinct and definitive, but the code specifies performances that may vary from each other. However, any digital work can be regarded as a score, specifying the action to be taken by a computer. When rendered via digital processes, the coded specifications of an

artwork seem to be not so much performance scores but computer programs. A computer program, like a script or score, specifies a sequence of actions to be rendered in "performance" when the program is executed. Computer programs, like scripts and scores, are written with specialized notational conventions designed to be unambiguous, compact, and expressive of the intended performance. Their purpose is to describe events that should take place in the future.

However, digital scores are also able to capture and preserve live performance. The distinction between specifying performance and recording has often been problematic in the performing arts. Laban dance notation is used to summarize, abstract, encode, and transcribe body movements. Despite that capability, when a dancer needs to learn a work, they more often learn it either by instruction from a choreographer, by transmission from other dancers who are already familiar with the piece, or from recorded video. Likewise, choreographers seldom construct traditional notation as a prescriptive score, preferring to demonstrate their intentions directly with their own body or that of a dancer. Nevertheless, the notion of notation (with all of its problems and potentialities) remains a focus of interest for many in the field of dance.[74] Just as a musical performance of a notated score in the Western tradition is an interpretation, so these notated recordings can be used to interpret and represent performing actions.

We Are All Live Coders

Every element viewed on a computer screen is a notated representation, either encoding and recording an action that the user has taken or specifying an action that the machine should take in future. These actions might include playing sounds, sending messages over a network, or even controlling machinery, but more than anything, the computer operates to modify itself. The internal state of the machine memory is an immense catalog of notation—recorded actions and planned behaviors. The notation of the screen is only one view, a window into this world of internal representations. Even more than the printing press, the media industry, or bureaucratic structures of government, the computer is a representation machine. Operating a computer is a constant manipulation of notational representations, and every computer user has the opportunity to think of their actions in terms of mathematical abstractions, structuring and adjusting the state of digital memory.

The modern GUI of icons and menus blurs the boundaries between data and programming language. Originally designed at Xerox PARC as part of the Smalltalk programming language, emerging from the Kiddikomp proposal for children to make their own art and music, the GUI has evolved into a universal diagrammatic notation—a visual

language combining a lexicon of pictorial words with a syntax of lines, shades, borders, and typographic design cues. Every computer user constantly learns to speak new notational languages, each of them offering a semiotically mediated conversation with an application designer who has offered possible behavioral functions via that user interface. To some extent, every computer user is a programmer—manipulating abstractions, combining software components, and modifying the future behavior of the computer. We read, interpret, consider, and redraw. When we use these machines as reflective abstract tools, perhaps we are all live coders, all the time.

While traditional art forms have conventionalized and internalized their notations, to the extent that a musician may experience a direct connection from the page to the keys of an instrument, these digital notations are in a constant flux of innovation. In a conventional musical score, the distinction between, say, the key signature (nonnegotiable) and performance markings (open to negotiation/interpretation by performers) is conventionalized and seldom highlighted as problematic. But when a new notation is invented, the correspondence between the graphic marks and the intended interpretation must be negotiated between the software designer, the system user, and the changing state of the application itself. Linguistic analyses such as Jacques Bertin's *Semiologie Graphique* and Yuri Engelhardt's "The Language of Graphics" offer a variety of modes of correspondence,[75] potentially determined by geometric constraints, symbolic conventions, or novel metaphorical interpretation.

The algorithmic interpretation of formal notation elements is often supplemented by *secondary notation*—remarks intended for a human reader that escape the constraints of the formal computational scheme. In a performance context, these may be notes for the performer, a side channel of commentary to the audience, or a resource for gestural control. In all of these cases, we might reflect on the questions raised by Goodman. Is the live coder allographically specifying a distinct machine state or autographically shaping artistic material? Is the computer recording, duplicating, or interpreting? Are the diagrammatic elements symbols selected from a discrete vocabulary or infinitely expressive visual markings?

These distinctions become increasingly unstable in virtual reality and in tangible and embodied interaction contexts. Much of the above analysis remains applicable. Digital control representations are still diagrammatic notations, even when disguised to resemble imaginary objects or environments. The correspondence from virtual appearance to expected behavior may become more surprising or baroque but will continue to be constrained by basic principles of geometry and visual perception. The relationship between recorded data and specified behavior becomes increasingly hard to disentangle when machine-learning and program-synthesis techniques derive programs from

observations. Increasingly, digital instruments resemble live coding languages, with the sound-processing variants of the loop pedal and harmonizer offering a resource for the algorithmic automation and augmentation of every action.

Dynamics of Machine Notation

Sheet music stays put on the page. The content of the page has been determined by the composer, editors, and engravers, and their work has ended when the music starts. Exceptions, such as a composer at a musical premiere crawling between orchestra desks to make last-minute changes to the copied parts, are memorable for their rarity. Even more open works—graphic scores, or textual instruction pieces for avant-garde happenings—take the printed page as a boundary object that allographically structures the relationship between composition and performance.

But when we place the notation on a screen, it becomes potentially mutable, permeable, ephemeral. As we've seen, live coding environments such as ixi lang, feedback.pl, betablocker, and Orca change themselves—manipulating the source code of the program itself like any other data. The familiar diagrammatic notations of the GUI desktop or mobile phone screen are conventionally static, but even this constraint is adopted purely for the convenience and comfort of the user. In many systems, the visual notation results from the underlying data, rather than determining them.

Heritage performing technologies, such as the violin or tabla, carry out a kind of conversation, or perhaps mutual oscillation, with the performer, offering tactile feedback through the hands and body. The performer constantly attends to these signals, shaping the sound through a collaborative accommodation of expressive intentions to mechanical constraints. Although *hybrid live coding* is becoming an active field of study,[76] we have yet to discover the full potential of such conversations for the live coding performer. A dynamic notation can respond to the instructions of the author. Trivially, this might be to express a constraint, such as a syntax error or runtime bug. Modern software-engineering tools offer a variety of more interventionist opportunities. Improvising programmers make extensive use of autocomplete functionality, in which the program editor anticipates the likely intention of the programmer and suggests the next fragment of code.

When a computer interprets source code, it becomes another reader, in addition to the live coder and audience. Whereas a score often presumes expressive interpretation by the performer, the live interpretation of the code to produce a dynamic visual or aural performance is carried out by the computer that executes the program. A central point is the sharing of agency between the person writing code and the machine executing it. Live coders often introduce variation through the use of random or stochastic

functions that at the level of notes and phrases reduce predictability. This might involve varying a continuous parameter according to a statistical distribution around a mean or shuffling the order of sounds and events. Over longer time frames, such decisions made using random number generators quickly lose their impact because they are arbitrary and thus predictable in their unpredictability. However, as explored earlier in the section on algorithmic pattern, unanticipated patterns and symmetries arise naturally from the combination or transformation of elements. Such patterns may unfold over multiple scales, giving longer form structure to performance.

Pattern Language of Lively Architecture

We can reflect on the attributes of notational space, and the experiences of those inhabiting it, through analogy to architectural theory. The work of architect Christopher Alexander has been influential in computer science, particularly for his work on pattern language.[77] Alexander's work focuses solely on the physical architecture of buildings, but it has been imported into software engineering in the form of a well-known set of object-oriented design techniques.

Of course, something has been lost in translation. For Alexander, dwellings and cities born from contemporary architecture lack life because they are now designed by distant architects, not designed and continuously modified by the people who live in them. Alexander's pattern language aims to provide a set of transformations for use in architectural design to solve problems in buildings and make them more lively and nurturing. Here his notion of lively architecture seems closely analogous to the motivation for live code. Indeed, as Alexander noted in a keynote lecture to computer scientists,[78] while the problem-solving aspect of his pattern language has been successfully brought to computer programming, the moral dimension has not. While Alexander was optimistic in his 1996 lecture that computer science could save the world where architects have failed, from our perspective in 2022 optimism for this view is in short supply—it seems we are still waiting for software engineers to take on the moral capacity to generate the coherent, living wholes that Alexander advocates.

Nonetheless, a direct reading of Alexander's work helps us reflect on the attributes of code as notational space and the experiences of those inhabiting it.[79] Alan Blackwell and Sally Fincher offer a pattern language of notational systems as a systematic description similar to work in notational spaces. These patterns of user experience are derived from Green's "cognitive dimensions of notations,"[80] which have previously been used to analyze usability of sequencers,[81] historical manuscript typesetting,[82] DAW,[83] and novel graphic scores.[84]

Working within a virtual notational space is unavoidably dynamic, resulting in patterns of experience that might be characteristic of reading, transcription, modification, or exploratory improvisation. As we construct and enhance new notations, a design pattern language of this kind draws attention to the potential for new modes of interaction, as well as opportunities to recognize the underlying cause of frustrations or loss of fluidity. Unlike conventional musical instruments, whose limitations and constraints are familiar to the expert performer, every innovation in a live coding language navigates an abstract space of design trade-offs.[85]

Social Relations Expressed through Notation

The role of notational systems in culture is now under scrutiny given our increased dependency on scripts, scores, and algorithms, which shape our decisions and behavior. Trying to understand the underlying logic behind them becomes urgent for those who are able to read and write them. This is especially important when algorithms work on big data at scales that are hard to conceptualize, but there is a longer connection to politics that we briefly touch upon here and elaborate on further in chapter 7.

A frequent reference for the role of scores in culture is the music theory of Theodor Adorno and his scathing views on jazz and "popular" music as standardized commercial form. In his 1938 essay "Über den Fetischcharakter in der Musik und die Regression des Hörens" (On the Fetish Character in Music and the Regression of Listening), he considers music to be a by-product of the musical score, which represents a purer form associated with production.[86] Once the score is performed, the listener becomes a consumer of the commodity form of music—the commodity fetishism of music, in other words.

In contrast to Adorno's view, live coding traverses some of these relations between notational practices and performance. Of course, there is little new in the romantic idea that live music somehow breaks out of commodification—with the various slogans to "keep it live"—but live coding is both notational practice and performance at the same time, allowing for new critical potential. The production processes are open to view as changes to the code are made public as part of the performance itself.

Related examples might help to establish this point, especially when notation is considered to be a social project. There are numerous historical references to alternative notation systems and improvisation techniques, as the previous section outlined, but the experiments of Cornelius Cardew and the Scratch Orchestra emphasize the political potential of notation. Simon Yuill, in his essay "All Problems of Notation Will Be Solved by the Masses,"[87] makes the further connection between experimental

notations and free software development, as well as the practice of live coding as an instantiation of making source code available and modifiable in real time. Each of these examples attempts to break out of standardized commodity forms of software development and electronic music performance, respectively.

The Scratch Orchestra emerged out of various critical energies of the late 1960s and managed to develop a collective form for the sharing of resources, self-organization, and peer critique. The orchestra was open to all, regardless of musical training or ability, under the principles of free improvisation. Notes, or "scratches" as they were called, were performed and developed into larger collage forms, similar to the ways in which source code is shared and distributed, open to further modification, and performed under "copyleft" principles. Their works played with organizational forms and hierarchies, as in the following instruction piece cited by Yuill: "Each person entering the performance space receives a number in order. Anyone can give an order (imperatively obeyed) to a higher number and must obey orders given him by a lower number." This score resembles the comparisons in a *bubblesort* algorithm and exemplifies the command and control structures of computational systems and the parallels between

Figure 4.4
"Keep Live Coding Live" sticker.
Source: Design by Alex McLean.

technical and social systems. Cardew attacked the conservatism of musical notation and announced that "all problems of notation will be solved by the masses."[88]

This comes back to the rejection of end product or commodity form in performance. The political philosopher Paolo Virno, also cited by Yuill, develops this in relation to the idea of "virtuosity"—reworked from Aristotle via Arendt and Marx—to indicate the "special capabilities of a performing artist."[89] For Virno, what characterizes the "work of the performing artist" is that their "actions have no extrinsic goal. They don't create a lasting product since they aim only at their own occurrence. They don't create new objects, but rather a contingent and singular event. . . . The purpose of their activity coincides entirely with its own execution."[90] Virno is drawing upon Hannah Arendt's observation that the performing arts have a strong affinity to politics and that both operate in real time and exhibit their own sense of purpose embedded in their form. The problem is that the score has been appropriated to particular ends, whereas it should remain without end, as "virtuosity without a script, or rather, based on the premise of a script that coincides with pure and simple dynamics, with pure and simple potential."[91] Virno's discussion on virtuosity also offers a different slant on the relation between live performance and its reproduction. It is this lack of an end product—or at least one that is indistinguishable from the performance itself—that enables performing arts to be conceived of as a species of political action. Perhaps one should simply conclude that the script, score, and code might be held open to change and modification at all times and in the public realm. The slogan to "Keep music live" (figure 4.4) takes on an urgency that might be applied to further notational forms, and live coding seems to offer radical potential in this regard. That live coding is notation and execution at the same time provides this potential.

5 Live Coding's Liveness(es)

The liveness of live coding is exemplified by the *just-in-time* or *on-the-fly* nature of its improvisatory extemporizing—its performing and showing of live *thinking-in-action*[1] differentiating it from certain kinds of notation-dependent forms of (musical) performance and generative approaches to audiovisual performance that are both scripted or coded in advance of being *played*. While chapter 4 addresses different notation and writing systems more explicitly, this chapter explores how such abstracted understandings might become reembodied and enlivened. However, the intent is not to valorize or fetishize the liveness of live coding as evidence of its supposed authenticity or originality but to address how diverse live coding practices[2]—improvisational and compositional—enrich a wider theoretical debate on the issue of liveness.

Expanding upon Philip Auslander's examination of live performance within mediatized culture,[3] the human-machine entanglement at the heart of live coding offers a highly complex, hybridized, and yet still undertheorized model of liveness.[4] What are the implications of live coding for our understanding of the concept of liveness? What kinds of liveness are being produced, and with what effects? What does this indicate about the relations between technology, performance, and even "life" that live coding suggests? How might live coding relate to, as well as contrast with, other live art forms and even potentially oppose their appraisal of immediacy and openness?

While the liveness of live coding remains a distinguishing feature, it has been shaped by different genealogies of ideas and practices, both philosophical and technological. The interdisciplinary nature of live coding—emerging between the lines of various scientific and artistic disciplines—requires that its very liveness be understood from more than one epistemological and ontological perspective. That live coding's liveness is predicated on mediatization and mediation through technology complicates any neat distinction between live and digital entities or phenomena. Indeed, within live coding, liveness refers both to nonhuman "machine liveness" (or "degrees

of liveness," articulated by computer scientist Steven Tanimoto as the increased immediacy of semantic feedback and real-time character of computational processes enabled through technological advancement[5]) and to the contingencies and vitalities of embodied human experience.

The previous chapters establish much of the historical background of live coding and its intersection with the development of particular programming languages that enable interaction with a running system that does not stop while waiting for new program statements. This allows the code to run immediately as it is executed, with the performer able to adjust and respond accordingly. In 2004 the Changing Grammars symposium indicated a shift in the use of programming language from a tool for "generating" sound to code conceived as a "conversational practice" in which the "grammar of sounds" could be improvised from within the code as part of the live performance itself. For some, live coding operates in resistance, critique, or as an alternative to the prevalence of generative processes within computer-based performance where algorithms that have been coded in advance are activated live and then left to run their course. Rather than giving over responsibility to the unfolding of an algorithm's logic, within live coding the performer consciously adopts a medial position, actively maintaining the conditions that will keep the action dynamic. Certainly, our aim in emphasizing the liveness of live coding is not to undervalue or underestimate the pre-gramming and practicing that happens "behind the scenes" and in advance of a live coding performance but rather to draw attention to a specificity of liveness operative and activated in and through the real-time actuality of live coding performance itself.[6]

A live coder might write (as code) a sequence of notes or other algorithmic structures, with the *live* performance involving the modification of intensity, volume, and speed. Admittedly, here there is a danger in representing live coding as sequencing one note after the other like in a score, for a live coder need not concern themselves with individual notes at all, instead having those generated from a higher-order process. For other live coders, the promise of increased liveness brings the possibility for greater improvisation and collaboration, and the code content itself is programmed as *real-time composition* as a live event.[7] Here, live coding advocates the agency of the computer alongside that of the performer, with technical constraints and machinic resistance forming a key part of live coding's collaborative and performative texture. The human-computer interaction within live coding foregrounds a more complex, nuanced, or even entangled relation. In this case, technology is not so much put to use as a mindless production tool kit but rather is worked with, the process unfolding through attending to or even collaborating with the resistances and affordances exerted by the technology.

For some performers, live coding involves the bricolage of preexisting or prerecorded samples and prescripted sequences brought together as a live event. These samples and sequences are effectively precomposed anterior to the situation and then modified and reconfigured through live performance, with the capacity even to be recorded and reworked and perhaps even named or titled.[8] For others, especially some of live coding's early pioneers, the practice of *live writing* coding is underpinned by a heuristic principle that works without a predetermined plan, including the possibility of starting from scratch. For example, live coding ensemble Benoît and the Mandelbrots describe their approach to *zero prepared code* as "hour-long musical conversations, starting by zero" while at the same time recognizing, "We have already a lot of prepared functions given to us by the programme, and we are reorganizing them live for our purpose."[9] For live coder Rangga Aji, live coding from scratch is a way that "I can learn how to directly or slowly decide what kind of musical structure that I want to build without depending on any prepared code."[10] ALGOBABEZ (Shelly Knotts and Joanne Armitage) state that they "rejected the use of prewritten code and structures" in favor of "acting in the moment, responding to context . . . developing a structure as we work, continually creating and resolving tensions."[11] Indeed, for some live coders, nothing is saved, recorded, or archived in support of future replaying: the performance both begins and ends with the blank screen/slate.[12]

These diverging approaches and attitudes to the liveness of live coding have given rise to different expectations and aspirations for both live coding's live performance and developments within its technology. On the one hand, within the live coding community there is a call for improved media technologies that enable greater immediacy of feedback, a shift toward predictive coding (explored later in the chapter) modeled on previous patterns and habits that support a faster, more fluid—perhaps even virtuoso—species of programming *comprovisation* (composed improvisation or improvisation with a composed structure).[13] On the other hand, there remains interest in a mode of improvisational performativity that harnesses the unpredictable, the unexpected, or the as yet unknown, where live coding is conceived as a vital site for experimental *per*-forming (the prefix *per*- meaning through, so *through-forming*), with new content arising in and through the very forming of the live performance itself. Rather than regard these tendencies in antagonistic relation, this chapter explores how different notions of liveness—indeed different degrees of liveness, alongside *a*liveness and undeadness—are negotiated within live coding and, moreover, how the development of intelligent machines might better facilitate live coding's liveness without eradicating the critical intervals and in-between spaces necessary for improvisatory invention and intervention. This chapter highlights the different livenesses that live coding seeks

to harness, where the immediacy of near real-time programming languages enabled through technical advancement meets the embodied heuristic of coding live.

The Ontology of Liveness

Within media culture and performance studies, the concept of liveness has been much debated and contested, inflected at different historical junctures in relation to wider questions of presence and absence; mediation, recording, and documentation; eventness and now-ness; ephemerality, temporality, and contemporaneity. While issues of temporality are addressed more fully in chapter 6, some theoretical coordinates around liveness are offered here as a way of identifying a conceptual terrain into which live coding intervenes and adds new understanding. Though it has been some decades now since their original publication, performance theorist Peggy Phelan's *Unmarked: The Politics of Performance* (1993) and media theorist Philip Auslander's *Liveness: Performance in Mediatized Culture* (1999) remain oft-cited references in the continued debate on what constitutes the ontology—indeed the ideology—of liveness. Phelan's account of the ontology of live performance argues that

> performance's only life is in the present. Performance cannot be saved, recorded, documented, or otherwise participate in the circulation of representations of representations: once it does so, it becomes something other than performance. To the degree that performance attempts to enter the economy of reproduction it betrays and lessens the promise of its own ontology.[14]

Auslander formulates a counterargument to Phelan's construction of performance as "representation without reproduction" and the assumption therein that its unmediated liveness is somehow more *real* than mediated events. He demonstrates how the concept of liveness itself is a product of *mediatization* and that since the early twentieth century *live performance* has been mutually entangled with and has coexisted alongside recordings, nonlive media, and various forms of technological reproduction.[15] Auslander asserts that the very concept of liveness emerges in and through the relation with its perceived opposite, mediatization, rather than having any preceding ontological condition or existence.

For Auslander, life itself is in performance but is also in technology. He explains that while live and mediatized events may be distinct in terms of their position in the cultural economy, this is not as a consequence of their intrinsic characteristics but is more a result of the sociopolitical conditions within which they operate.[16] Auslander refers to Jean Baudrillard's notion of *mediatization* to indicate how media are instruments of wider sociopolitical processes administered by a "single code."[17] An interesting aspect

of the politics of live performance has been its apparent ability to resist commodity forces and the hegemony of dominant culture by its immateriality and nonobject status (e.g., through happenings and other conceptual art traditions). But this position is unsubstantiated according to Auslander, as no clear-cut ontological distinctions can be made between live and mediatized events. The concern remains with the changing character of performance in a situation in which human performances are entangled with media performances, and we must reject the simplistic notion of live events as unmediated or *real* as if outside representation.[18]

Auslander's seminal text provides an important backdrop to an understanding of the complex relations between live and recorded media but is a work very much of its time. Although he outlines how mediatized performance has been traditionally granted authority through its reference to the live or real event, liveness has now been even more fully incorporated into its mediatized forms, and performance is less and less outside of its technological conditions. Live coding extends the ontological condition of liveness in ways that media studies and performance studies have not yet conceptualized. Indeed, as Auslander acknowledges, "Liveness is not a stable ontological condition but a historically contingent concept, a moving target that is continuously redefined in relation to the possibilities afforded by emergent technologies of reproduction."[19] So how do the different registers of liveness operating in live coding offer insights into the live(d) experience of our digitized, mediatized, streamed, and increasingly "mixed-reality" world? That is, as sociologist Nick Couldry suggests, how are they shaped by the ever-new modes of technologically mediated liveness—*online liveness*, *group liveness*—that challenge notions of spatiotemporal (co)presence and proximity in relation to what constitutes the live?[20]

The Experience of Liveness

Performance scholars Matthew Reason and Anja Mølle Lindelof argue for a shift in focus from liveness to multiple and shifting "liveness-es" and to the pluralities of "experiencing live," acknowledging the different meaning and value that liveness holds across different disciplines, including music, performance, and media studies.[21] For example, they note how "bodily co-presence between audience and performances is central to performance studies. . . . Music studies have typically engaged with liveness in relation to recording techniques and sound ideals. . . . Within media studies liveness has been discussed in relation to transmission technology."[22] Live coding is a practice that operates at the interstices of these disciplinary domains, in turn activating their different attitudes to liveness. Reason and Lindelof call for a reexamination of the concept of

liveness in contemporary performance by moving beyond the contested questions of ontological difference and the relationship between the live and the mediated to focus on liveness in terms of processes of experiencing, processes of making, and processes of audiencing.[23] Accordingly, this chapter shifts from the sociotechnical, ontological perspective of Auslander to explore how liveness operates and is experienced within live coding, attending to both the embodied nature of coding from the mutually interwoven perspective of human performer and audience as well as to the "degrees of liveness" functioning within the nonhuman processes of the machine.

More than a purely conceptual procedure, live coding involves a sense of embodied awareness in which principles of knowing *how* and knowing *when* are as privileged as knowing *what*. Rather than reducing the role of the human operator—an accusation levied at some forms of computer-generated performance—live coding requires heightened levels of dexterity, attention, cognitive agility, and tactical intelligence. It is a practice of timing and timeliness, of biding one's time and knowing when to act—that is, a practice of *tact*. Indeed, live coding does not just involve the logical manipulation of code language but rather unfolds as much through the complex embodied relation of rhythm, repetition, and response. While code is abstract, mathematical, and seemingly disembodied, live coding—as a performance—draws us back to the body of the performer. The computer itself tends to deny the body, reducing touch to a single pointing finger and sense to a symbolic eye.[24] Computer scientists, anxious in affairs of the flesh, strive to avoid it—witnessed in the advocacy of NUI, a natural user interface that aims to eradicate the last vestige of touch.[25] Yet, for all that computing neglects—those bodies hunched over keyboards and mice, at their desk-and-chair sets in the offices of the world—the live coding performer is unavoidably embodied ("made flesh").

Certainly, there is an inherent kinetic, even *kinaesthetic*,[26] dimension to the live writing of code involving direct physical engagement with the machine: a sensorimotor movement vocabulary of microadjustments, changes, and shifts performed in the frantic keystrokes, in the shuttling of the cursor around the screen, in the flash points of activation and execution. Analogous to the pulsing live body within other forms of performance, the cursor marks the point of decision-making within the live programming of code, the movement of the coder's thinking as it oscillates between sensemaking through the discontinuous, abstract notational form of code and the continuous—even sensuous—experience of coding as a lived experience. Live coding deviates a linguistic-numerical computational logic—algorithmic thinking—toward artistic application, involving not only a musical-rhythmic intelligence or sensibility but also the more intuitive knowledge(s) commonly associated with creative, embodied thinking.[27] This *know-how* is arguably of a more tacit kind, involving the tactility of active exploration

or haptic perception that psychologist James Gibson describes as "the sensibility of the individual to the world adjacent to his body by use of his body."[28] While chapter 7 further elaborates the epistemological implications of live coding's *embodied knowledge*, this chapter considers its embodiment through the prism of liveness.

Over the past decade, a number of research projects and symposia have attended to the live interactions between body and machine, to the navigation of various human and nonhuman forces and flows, and to the specificity of the liveness of embodied thinking-in-action within live coding. In 2014 the University of Sussex's Emute Lab in the UK hosted a symposium titled Live Coding and the Body to address this burgeoning field of practice and to expand ideas about what live coding is. The symposium raised questions concerning the interaction between live coding and the body, such as: How can live programming contribute to a better understanding of the body, language, and notation in live performances that use digital technologies? To what extent is the coding integrated into the practice of performing arts?[29] Consequently, as the field expands so, too, does the frame of reference and conceptual ground, with the issue of liveness rethought through the prism of somatic practices and affect and embodiment theory drawn from choreographic studies. This perhaps reflects a wider *choreographic turn* within contemporary culture where concepts of embodiment, performativity, corporeality, and choreopolitics, alongside philosophies of movement originating in dance, have increasingly entered the expanded interdisciplinary field.[30]

Indeed, for over a decade, live coding has extended beyond the performance of computer-generated music and projected visual effects, expanding rapidly to embrace practices—especially from live art, performance, and choreography—that foreground the potential of code in explicit association with the live performing of the body. For example, live coder Kate Sicchio uses the umbrella term *hacking choreography* for describing live coding performance scores for dancers performing choreography "where a choreographic score would be changed live in a performance setting."[31] Since 2011 Sicchio has been involved in an ongoing performance research collaboration with Camille Baker called Hacking the Body and HTB 2.0, involving *hacking* the data from the body to create new forms of choreography.[32] Since 2016, transdisciplinary coder Joana Chicau has been

> investigating diverse notation systems from both dance and web programming, which I then merge into a hybrid form of algorithmic composition: a "choreo-graphic-code." . . . The liveness of code writing became a way to activate the choreo-graphic-code, exposing various processes and dynamics of web computing while enhancing the physicality of the body—the body that is in constant friction between the constative (reality describing) and performative (reality producing). Engaging with different forms of choreographic thinking has been a way to bridge and enhance the somatic and semantic within coding.[33]

The research project Live Notation: Transforming Matters of Performance (introduced in chapter 4) focused on liveness as a connecting principle for exploring the relation between live coding (performing with programming languages) and live art (performing with actions). This project privileged the durational, embodied, nonrepeatable moment of performance, drawing attention to an improvisatory or even *kairotic* species of liveness rather than the live reactivation of a preexisting script or score that is rehearsed or planned in advance (the concept of *kairotic coding* is explored further in chapter 6). Focusing on the vitality and embodied materiality—the liveliness or even aliveness—within live coding opens up the exploration of liveness to these wider theoretical orientations.

The Vitality of Liveness

Psychologist Daniel Stern uses the term *vitality* to describe qualitatively the "manifestation of life, of being alive."[34] He examines how vitality, and vitality affect, manifest within everyday life, psychology, and the performing arts (as distinct from the domains of emotion, sensation, and cognition). For Stern, "Movement, and its proprioception, is the primary manifestation of being animate and provides the primary sense of aliveness."[35] Additionally, Stern states, "Vitality dynamics refer mainly to the shifts in forces felt to be acting during an event in motion, and thus focus more on the dynamic qualities of the experience, in particular the profile of the fluctuations in excitement, interest, and aliveness."[36] He argues that dynamic forms of vitality "concern the 'How,' the manner, and the style, not the 'What' or the 'Why.'"[37] Here, the knowing *how* to which Stern refers is of a qualitative kind rather than a type concerned with the imperative technics and techniques of production as such. His focus on *how* addresses the modulating changes in affect and attention as they occur within the liveness of action. The vitality dynamics of *how-ness* that Stern describes have a specific "temporal contour," or profile, a sense of processual directionality, intentionality, and movement vector.[38]

While Stern focuses on performing and time-based arts such as dance and music—practices that take place in real time—it is worth noting that the forms of vitality he describes are not considered to be exclusively the domain of improvisatory practices. Indeed, live performance offers no guarantee of vibrancy or vitality—its experience might be on occasion more akin to "deadliness,"[39] and composed or scored composition has the capacity to be *more* vital (alive) than improvisation (whose "live" is not always experientially enlivened). The question of how to reinvest composition with vitality or a sense of liveness therefore remains a perennial challenge across diverse performing arts. Here, as theorist Erin Manning argues:

The "how" of the work as it is replayed across settings and environments is its commanding form. This "how" is emergent each time anew and is always a complex mixture of technique and technicity. Technique to keep the piece rigorous, to give it the subtlety and nuance and precision it requires. Technicity to make the work outdo itself, to make the work.[40]

Significantly, for Manning, this foregrounding of the *how* involves a radical "letting go" of the original in order to refind it again, where "to begin is to begin again, differently, impossibly, impractically."[41] This is not simply the repetition of what is already rehearsed and ready in waiting. As Manning elaborates, "No movement can be cued, aligned to, or performed in exactly the same way twice. . . . What emerges as a dance of attention cannot be replicated."[42]

Increasingly interdisciplinary in its scope, live coding provides a frame for sharing and debating the overlapping and divergent conceptualizations of issues such as real time, liveness, and embodiment within diverse performance practices. However, this turn toward embodiment is not a turn away from the machine but rather a way to address the anthropocentric privileging of the human body and its capacities alone. Indeed, for literary critic N. Katherine Hayles, the posthuman is an embodied mode of being where information and materiality are not conceived as separate entities.[43] Expanding the interdisciplinary frame beyond the performing arts to include textile and weaving practices, the Weaving Codes/Coding Weaves project (discussed in chapter 4) provided a context for exploring the specificity of thinking-in-action while improvising within a live running code and how it might relate to the embodied *thought-in-motion* while working on the loom.[44] Central to the project was an attempt to dislodge the dominant model of working out, wherein an idea is conceived in advance and applied to material, in favor of a process of feeling one's way, in which various levels of operation and cognition are activated live. The concerns of the project resonate with Tim Ingold's writing on "being alive," alongside his conceptualization of the "textility of making," which integrates aspects of embodiment, material properties, and agency to address the movement and processes of negotiation between material and human action and between materials and forces.[45]

The immanent and embodied experience of liveness within live coding might be conceived in terms of *flow* or *flow state*. Flow describes a hyperfocused state of optimal experience—or mental state—conceptualized by psychologist Mihály Csíkszentmihályi as "full absorption," immersion, or "total involvement" in the process of an activity. Csíkszentmihályi argues that flow states involve an experiential transformation of time, alongside the merging of action and awareness: actions become spontaneous, even automatic—intrinsically rather than extrinsically meaningful. Live coding—like many other improvisatory practices—involves states of heightened concentration and

temporal disorientation in which an intrinsic value is placed on the process in and of itself. For Csíkszentmihályi, flow is also "based on a concrete experience of close interaction with some Other, an interaction that produces a rare sense of unity with these usually foreign entities."[46] It is perhaps in this sense that the live coder collaborates with their technology through a process of interaction in a system of action that is greater than the intentions of the individual self, that involves letting go of some control while *also* maintaining a heightened sense of mental activity and the activation of one's skill commensurate to the challenge.[47]

The optimal experience of flow depends on achieving the sweet spot of desirable difficulty between the nature of the challenge and one's available skill, between one's intention and capacity. For Csíkszentmihályi, to achieve a state of flow there should be a focused sense of intention that still allows one to gauge "Yes, this works; no, this doesn't."[48] However, in order to activate these microdecisions from "in the zone" of flow it is necessary to receive immediate feedback. Herein lies the challenge for the improvisatory live coder, for while live coding is described as a mode of real-time composition, in reality there is a lag (or delay) between the writing of code and its execution, which further complicates the issue of the *liveness* within live coding.[49] The live coder might be working on code that has not yet been executed (a preparatory step) but that is nonetheless visible as part of the "live performance" through the projection of the screen. In the case of the live coding of music, the live actions of the musician-coder might not necessarily correspond with the sound heard by either coder or audience in the moment. What the coder is witnessed doing live is not always coterminous with the sound that is experienced live. There is a disjunction (for both audience and coder) between what is seen onscreen as being worked on live and what is heard in the present moment of the live performance itself.

Unlike other forms of live composition, the relationship between a performer's actions and the resulting effects can be *asynchronous*. Or, rather, there are parallel threads of *arrhythmic* liveness: the live (yet arguably no longer live) unfolding of the effects generated through the event of coding and the live event of writing code itself, both of which are simultaneously experienced by the coder-performer and audience. The live coding performance evolves through continual feedback—the coder expresses the code that expresses sound back to the coder, which allows them to understand the code that they have expressed and to modify it. The live coder writes code in preparation for the future, for the next change, which is then executed when the time is right through the "gesture-sound event" of activating the code. Indeed, it is the potential of *minimized latency* in the execution of code that has enabled live coding, with improved media technologies allowing for greater immediacy or timeliness of execution feedback,

effectively making the performance more real time, increasing the perception of its liveness.[50] Accordingly, we now look briefly at the evolution of minimized latency and its implications for the liveness(es) of live coding.

Degrees of Liveness

Steven Tanimoto articulates the technical evolution of minimized latency in terms of "degrees of liveness." Tanimoto developed a hierarchical system initially for describing the four different degrees of liveness within programming: Level 1 (informative), in which no semantic feedback about a program is provided. He argues that this first level involves the four separate phases of edit, compile, link, and run. In liveness level 2 (informative and significant), semantic feedback is available on demand for a selected component: "The programmer would do something, would ask for a response, and some time later, the computer would respond."[51] In level 3 (informative, significant, and responsive), incremental semantic feedback is automatically provided with an incremental program edit: "The computer would wait and sometime after the programmer did something, would respond."[52] In level 4 (informative, significant, responsive, and live), incremental semantic feedback is automatically provided for other data events such as mouse clicks or exceptions: "The computer wouldn't wait but would keep running the program, modifying the behavior as specified by the programmer as soon as changes were made."[53]

Tanimoto has since elaborated two further levels of liveness, which in addition to swifter feedback response involve tactical and strategic prediction. Made feasible through the use of machine-learning technology, statistical analysis of programmer behavior, and "logical reasoning about meaningful choices," Tanimoto argues that in the new liveness level 5 (tactically predictive), "The computer not only runs the program and responds, but also predicts the next programmer action.... Instead of the environment lagging behind, or just keeping up with the programmer, it stays a step ahead of the programmer."[54] Level 6 would involve further "intelligent inference of the programmer's intentions or desires."[55] For Tanimoto, the "intelligence required to make such predictions into the system is an incorporation of one kind of agency—the ability to act autonomously. Agency is commonly associated with life and liveness. One might argue that here, liveness has spread from the coding process to the tool itself."[56] These technical developments promise improved human-machine interfaces and improvisation with predictive coding (modeled on previous habits) supported by faster response and processing times, seemingly maximizing the potential for flow, for increased spontaneity, and for more immediate coding on the fly. Rather than a passive tool, the computer is afforded a degree of decision-making responsibility based on its

capacity to second-guess, preempt, or predict the next step within a creative flow of action as it learns more about a performer's preferences and tendencies.

Certainly, improvements in semantic feedback and the development of tactical prediction and autocompletion could enable greater possibilities for live improvising "in the moment" or "in the zone."[57] However, such technological advances might not necessarily give rise to new forms of improvisatory liveness conceived as a mode of live thinking-in-action, of real invention and intervention. Indeed, the *pressure to perform*—even entertain—within our contemporary reputation economy places high demands on the performer. Under these conditions, technical developments might serve the betterment or even efficiency of a given performance—that is, become instrumentalized at the service of technical virtuosity through reducing the potential for error alongside increasing the performer's capacity for repetition of complex sequences of coding.[58] Here, the intrinsic motivation associated with flow states (heightened value on the process and its challenges) gives way to a form of extrinsic motivation dependent on external factors, including the success of the performance product, which becomes measured according to the normative criteria of acceleration and immediacy: the eradication of error and delay in favor of more easily attainable complexity and precision, speed and efficiency, and productivity and repeatability.[59] Certainly, speed and immediacy can easily become mistaken for liveness, which in turn can result in less risk. Indeed, rather than measuring the success of human-computer improvisation based on how effectively technologies facilitate the process of *creative flow*, the collaborative potential of improvising with computers might also recognize the critical value—even a different sense of computer agency—within moments of delay and technical resistance.

Although liveness refers to the higher levels of immediacy or even efficiency within increasingly real-time computational processes—in response to the demand for ever-faster transactions and instantaneous feedback—it also speaks of the potential for the unpredictable within performance, the capacity for risk, error, and serendipity.[60] Indeed, some live coders might even introduce errors and crashes on purpose, whether by coperformers interfering with each other's code, by ixi lang's "suicide" function (which causes the process to shut down at a random moment), or just by closing their laptop to abruptly stop the sound. So how might technological innovation increase the potential for the liveness of live coding, where a heightened level of collaboration or coimprovisation with machines allows for the emergence of the unexpected by combining increased performance capacity with a continued embrace of risk and uncertainty, even the affirmative potential of error and failure? Indeed, has the fetishization of liveness been replaced with that of immediacy—the conditions of contemporary life marked by the loss of reflection space and intervals?[61] How can the relation between liveness,

immediacy, and efficiency be uncoupled? How might predictive technologies—perhaps counterintuitively—enable that which cannot be predicted in advance, a truly experimental or surprising mode of liveness made possible through a more intuitive collaboration between human and nonhuman? For example, live coder Elizabeth Wilson describes being

> drawn to the idea of being able to share creative responsibilities with the computer. I've wanted to avoid the constraints of gestural control that comes with most musical interfaces. I found that by automating processes that previously required manual skills leaves more mental capacity for traversing unexplored areas of creative space and uncovering new territories of ideas.[62]

Within live coding, code is conceived neither as a *passive tool* nor an *autonomous predictive process* but rather as a material (or even collaborator) that the coder works with and can be surprised by. Indeed, the liveness of creative flow refers less to the quantitative speed of action or immediacy of feedback and more to the quality of its creative interactions. For musicologist Marc Leman, interactive flow is facilitated through embodied cognition involving dynamic, prereflective processes—whether playing an instrument, dancing, listening, or using new interactive technologies—in which one grasps the situation even before one is fully aware of it and responds on the fly. His "expressive moment" resonates with the notion of kairotic timeliness previously discussed (in chapter 4 and then elaborated in chapter 6), in contrast to the timeliness of machinic immediacy promised by real-time feedback.[63]

The Performativity of Live Coding

These different modes of liveness—liveness as the immediacy of execution between the writing of code and its effects, liveness as a dynamic process involving the interaction of unpredictable forces, liveness as a coemergent process—can be further elaborated with reference to the concept of performativity. Or, rather, different species of liveness become foregrounded through reference to different conceptualizations of performativity since this concept—like liveness itself—has varying meanings and values within different disciplinary and cultural contexts. The intent, however, is not to rehearse a comprehensive survey of performativity but rather to point to different lineages of thinking that offer alternative perspectives on the liveness of live coding. On the one hand, the performativity of live coding can be conceived through the prism of *speech act theory*, derived originally from J. L. Austin's much-referenced *How to Do Things with Words*, from 1955.[64] In contrast to *constative language* (descriptive language that can only be verified as true or false), Austin argued that a performative utterance (provided it is uttered in a "felicitous context") does what it says.[65] Additionally, beyond simply

enacting what it says, performative language actively creates: it is operative in the sense that it brings something into existence. It not only makes a statement but also performs an action. In these terms, live coding's programming languages can be said to be operative—they do what they say; moreover, they do what they say at the moment of saying it.[66] Austin's conceptualization of performativity emphasizes the executive function of language, and live coding arguably exemplifies this species of performativity. In these terms, the performativity of code is maximized by minimizing the gap or latency between utterance and its effect, between code's *speech act* and its resulting action.

Working in the tradition of science and technology studies, sociologist Adrian Mackenzie argues that the "performativity of code" offers a challenge to the commercial imperative of software development and also the social relations associated with it.[67] His example is the Linux operating system, the most pervasive example of free/open-source software development, not least through the enforcement of its GNU General Public License. Like the work it does, the coding performance disrupts the normative relations associated with work, what code does when it runs, and who benefits from this. Any sense of agency assigned to code—that Tanimoto identifies, for instance—relies on the relation of "code's existence as both expression and process."[68] It is inherently performative in this sense, and in the case of live coding, the performative act of coding becomes a prototype for its further action—rehearsal and performance at once, a score performing itself.[69]

Although this operative aspect of software is clearly one of its key attributes, many thinkers working in the software studies tradition have attempted to problematize the understanding of coding according to Austin's model of performativity. In "Language Wants to Be Overlooked: On Software and Ideology," writer and computer programmer Alexander R. Galloway makes the assertion that code differentiates itself from writing by doing what it says it will do but calls for an understanding of code in its own terms rather than anthropomorphizing it as speech or performance.[70] In contrast, taking issue with what she considers to be the inevitable anthropomorphism in Galloway's essay and drawing upon her background in both literature and systems engineering, Wendy Hui Kyong Chun asks: "How can code/language want—or more revealingly say—anything? How exactly does code 'cause' changes in machine behavior? What mediations are necessary for this insightful yet limiting notion of code as inherently executable, as conflating meaning and action?"[71] Her point, in drawing attention to the mistake of separating instruction from execution, is that code does not always do what it says but does things in a "crafty, speculative manner in which meaning and action are both created."[72] She is interested in how a whole series of operations produce something we refer to as source code and in how this in itself is something imprecise.

Indeed, to claim something as *source* appears essentialist since it is not a thing but rather a set of relations. There is a temporal complexity to this: it becomes source only after the action has taken place—"Source code only becomes a source after the fact."[73]

More to the point, Chun argues that source code becomes a substitute for a range of other operations and signals. Drawing on the work of Jacques Derrida, she asserts that "source code becomes a source only through its destruction, through its simultaneous nonpresence and presence.[74] . . . It is neither dead repetition nor living speech; nor is it a machine that erases the difference between the two."[75] It is undead writing. Live coding appears like an instantiation of this state of undeadness, as coders and codes call up preexisting code and layers of code to make them self-evidently *live*, oscillating between what is understood to be readable, writable, and executable. Chun conjures up the undeadness of information as well as its relation to the commodity fetishism and the undead labor of technology as a "ghostly abstraction" that comes to haunt all technologies.[76] Thus, coding practices can be seen to be acts of "sourcery," full of imaginative potential based on the (undead) logic of programmability, what Chun refers to as "'programmed visions' which seek to shape and to predict—indeed to embody—a future based on past data."[77] Live coding might also be understood in this way as an attempt to reanimate dead materials—both in terms of coders and codes—highlighting the potential to draw together meaning and action across multiple layers of operation. Live coding is both live and *a*live (where the prefix "a" here indicates neutrality), its code immediately executable and also capable of being put on hold, suspended in animation until an auspicious point is reached for bringing it back to life.

Codes operate in oscillation and with the impossibility of dealing with a fixed state. The performativity of live coding effectively exposes its own *mediality*, as a means to another state, without closure—with reference to philosopher Giorgio Agamben's writing, as *gesture*. If gesture is generally something that is considered to be lost in contemporary culture—as Agamben thinks—then live coding perhaps recovers some of its dynamics. For Agamben, "The gesture is the exhibition of a mediality: it is the process of making a means visible as such. It allows the emergence of the being-in-a-medium of human beings and thus it opens the ethical dimension for them."[78] He argues that the event of language is political inasmuch as it relates to the free use of "pure means," as "politics is the sphere neither of an end in itself nor of means subordinated to an end; rather, it is the sphere of a pure mediality without end intended as the field of human action and of human thought."[79]

Perhaps, as Virno argues, "what really counts is the act of enunciating and not the text of the enunciation."[80] This can be understood to relate to theorist Dieter Mersch's assertion that "aesthetics focus on the singular, on this-here or something that can

be shown. Yet it is never clear what (*quid*) it is, only that (*quod*) it is."[81] He argues that "we are dealing with 'showings' that in equal measure reveal something and show themselves while in showing, hold themselves back. . . . Their métier is not representation, but presence."[82] Here, the communicability of live coding exceeds language (code conceived only as performative utterance in Austin's terms): its performativity operates *with*, *in*, and *through* the materiality and mediality of the performance itself, through "surrender(ing) to the event and its experience."[83] Following such reflections, the performative act of showing the screen within live coding might be considered less a device for communicating what or how code is unfolding at the level of linguistic or methodological reasoning and more a device to show only that *something* is unfolding live.

Certainly, the idea of performativity is an expanded—and indeed expanding—concept in which the original Austinian conceptualization (with its various Anglo-American derivations, extensions, and critiques) has been deviated within a performance studies context to refer more broadly to the mattering of a performance's performance.[84] Alternatively, within a Germanic context the notion of performativity is untethered from the Austinian emphasis on speech, communication, and linguistic sensemaking and from the overtly pragmatic—even utilitarian—idea of enunciative execution that seeks to achieve a subject's (pre)intended effect and is approached instead through ideas of embodiment, eventhood, and cocreation. Theorist Erika Fischer-Lichte identifies a parallel "performative turn," activated in Germany in the 1960s through the work of literary historian and theorist Max Herrmann, which resists the privileging of text and semiotics by foregrounding the social dynamics of the performance event. Fischer-Lichte elaborates the idea of an "aesthetics of the performative" and the transformative potential therein to address the performativity of performance as one of *autopoiesis*: the self-producing operations of a living system.[85]

For Fischer-Lichte, the "continually operating feedback loop provided in any performance event by the ongoing interactions of performers and audiences" offers an exemplary system of autopoiesis.[86] The "self-organizing system" that Fischer-Lichte identifies within performance-as-event is marked by a sense of contingency. She states, "Contingency became a central aspect of performance with the performative turn of the 1960s. . . . The feedback loop as a self-referential, autopoietic system enabling a fundamentally open, unpredictable process emerged as the defining principle."[87] Significantly, while Fischer-Lichte emphasizes the importance of bodily copresence within this model (between performer and audience and also between spectators themselves), it is for enabling a feedback loop of coproduction or coemergence rather than for acting as a marker of liveness in and of itself. Or rather, this feedback loop *is* the marker of autopoietic liveness within performance.

While Fischer-Lichte is referring more broadly to theatrical performance, her conceptualization of liveness predicated on the feedback loop of autopoiesis resonates with live coding practice. Or rather, live coding complicates Fischer-Lichte's conceptualization since she argues that mediatized performances "sever the co-existence of production and reception. Mediatized performance invalidates the feedback loop."[88] Live coding, in fact, activates a feedback loop between the live performer and the machine, between live and mediatized, establishing the parameters for live modification where both human and computer edit the same script.[89] Feminist theorist Donna J. Haraway argues that what is required is the conceptualization of *sympoiesis*, or "making with," rather than autopoiesis, or self-making.[90] Indeed, live coding necessitates a radical rethinking of the concept of performativity, providing concrete examples of practice that reflect the wider conceptual "turn" from the anthropocentric as emerging within various theoretical orientations, including new materialism, vital materialism, agential realism, and *actor-network theory*.[91] Writing from the perspective of feminist new materialism, Karen Barad proposes "a specifically posthuman notion of performativity—one that incorporates important material and discursive, social and scientific, human and nonhuman, and natural and cultural factors. A posthumanist account calls into question the givenness of the differential categories of 'human' and 'nonhuman,' examining the practices through which these differential boundaries are stabilized and destabilized."[92] Barad argues for relational coconstitutive *intra-actions* between humans and nonhumans, stating that "on an agential realist account, agency is cut loose from its traditional humanist orbit. Agency is not aligned with human intentionality or subjectivity. . . . Agency is the enactment of iterative changes to particular practices through the dynamics of intra-activity."[93] Live coding provides material examples of this intra-activity, the entanglement of human and nonhuman agencies active in a process of collaborative coconstitution.

Live coding sets up an important tension between the human-centeredness of creative action and nonhuman agents that presents new ways of understanding and acting in the world—that exceed what is knowable by the programmer. This also means that a program cannot be reduced to its functional aspects or understood as a tool either. Instead it is a dynamic construction process of description and performance at the same time. Additionally, while live coding performers and audiences might share the same time-space, live coding is not reliant on spatial-geographical proximity for its liveness. Indeed, some live coding performances take place with the performers themselves operating remotely from different geographical locations yet still collaborating within a feedback loop of coproduction.[94]

Relational Liveness

Although agreement on the ontological constitution of liveness arguably remains at a stubborn impasse, Fischer-Lichte's model of performativity does enable a rethinking of what Reason and Lindelof call the "processes of audiencing," the experiencing of liveness and the sociopolitical implications therein. For Fischer-Lichte, a model of performativity based on the notion of "self-generation involves the participation of everyone, yet without any single individual being able to plan, control, or produce it alone. It thus becomes difficult to speak of producers and recipients."[95] In a conventional (entertainment) model of performance-as-product, a performance may well have been crafted and rehearsed in advance or else is dependent on the singular skill and agility of the performer: the audience members are not actively engaged or implicated in the performance; they are merely its recipients, its consumers. Significantly, performative self-generation involving the feedback loop of coproduction or coemergence (as outlined by Fischer-Lichte and described in the previous paragraphs) subverts a model of virtuoso performance—here meaning technical prowess, finesse, or mastery—that all too easily renders the audience awestruck by the aura of the performer, as passive spectators of staged spectacle. This transmissive mode of performance could be conceived in terms of Marxist educator and philosopher Paulo Freire's critique of transmissive education, the unidirectional flow of knowledge from the expert to the ignorant that ultimately serves to oppress, stifle curiosity, and disempower.[96] Drawing on the writing of philosopher Martin Buber, Reason and Lindelof argue that liveness involves the potential for "mutual surprises," echoing the dialogic interplay of a conversation that for Buber is "not one whose individual parts have been preconcerted, but one which is completely spontaneous, in which each speaks directly to his partner and calls forth his unpredictable reply."[97] The sense of dialogic liveness within live coding—coding conceived as a *conversational practice*—refers to both the relation between coder and computer and between collaborating coders and their respective machine, as well as between performer and audience.

Live coding performances have also become open to wider contingencies, such as variances in flows of electricity and other environmental factors that affect performance, where entities coexist in a strange and entangled ecology. Here, *Life Coding* is artist Martin Howse's term to describe some of the practices of live coding to open hardware and broader ecological concerns, thus extending the action of coding to the idea of the world itself as a potential operating system, opening up the wider connections of coding to materialist and environmental concerns. For example, Howse's *Earthboot* (2012–2014) boots computers using electricity drawn from the earth, with

variance in underground currents interpreted directly as code by the microprocessor-based device.[98] In this way both energy and operating system are drawn from the local terrain. This follows a media archaeological perspective and broader ecologies relating to matter—from the extractive use of minerals to broader infrastructures—that have real effects on life systems.[99]

Live coding's performativity involves a complex entanglement of exchanges and feedback loops between different human and nonhuman forces. Yet, beyond the making of mutual surprises, its mode of liveness creates the aesthetic and sociopolitical conditions for the formation of an emergent community inaugurated in and through the shared experience of the unfolding performance.[100] Curator-writer Miwon Kwon uses the term *temporary invented community* to describe those specific social configurations that are "newly constituted and rendered operational through the coordination of the art work itself,"[101] produced through a form of "collective artistic praxis."[102] Here, beyond the making of the performance itself, the shared experience of live performance can involve the constitution of a *public*. In these terms, performance *precedes* public, or rather, it is that which brings its community into being. Anthropologist Christopher Kelty nuances this idea as a "recursive public . . . a public that is constituted by a shared concern for maintaining the means of association through which they come together as a public."[103] Taking his example from free and open-source software development, the idea of a recursive public operates in a dual sense "first, in order to signal that this kind of public includes the activities of making, maintaining, and modifying software and networks, as well as the more conventional discourse that is thereby enabled."[104] Second, he argues, the use of the term is to "suggest the recursive 'depth' of the public, the series of technical and legal layers—from applications to protocols to the physical infrastructures of waves and wires—that are the subject of this making, maintaining, and modifying."[105] For Kelty, what makes recursive publics distinctive is the capacity to create infrastructure as an "activity of being public or contesting control" without this becoming sovereign, alongside the "ability to 'recurse' through the layers of that infrastructure, maintaining its publicness at each level without making it into an unchanging, static, unmodifiable thing."[106] The practice of live coding creates and maintains the recursive conditions of its own coming into being through the inauguration of an entire living ecology.

Like free and open-source software development in general, live coding is performed in public in multiple ways—at live coding public performances, of course, but also through the ongoing collective and collaborative processes of its production and distribution—challenging some of the normative social relations of production as discussed elsewhere in this book. For live coder Iris Saladino, "Communities operate by decentralizing and horizontalizing information, processes, events, and decisions with respect for others as

the core of all interactions. We aim for collaboration and we mistrust competition."[107] Live coding performances and festivals are often staged over long durations, interwoven with ad hoc workshops with, as artist-programmer Simon Yuill notes, "participants learning and adapting the tools of the performance as they take place."[108] As live coder Abhinay Khoparzi states, "Performances themselves become mini-workshops where one-on-one and one-to-many interactions with audience members can develop into a learning space."[109] For Yuill, live coding's emphasis on practice over end product can be conceived as the "virtues of practice," where it "is practice that is consciously linked to, and helps define, particular practitioner communities: groups defined not by a common aesthetic, style, nor common collection of cultural references, therefore, but by commitments to shared practices."[110] Live (living) coding environments are produced, structured, and circulated through lived communities, code repositories, and software distributions (such as in the case of the communities around SuperCollider, Sonic Pi, TidalCycles, ixi lang, or Hydra). Clearly, there is a further relation to other community formations (such as hacklabs and maker spaces), but again the real-time aspects and its potential for fast prototyping and distribution distinguishes the practice of live coding as a recursive public in Kelty's sense, integrating what Yuill describes as "the distribution of the knowledge of how to produce into that which it produces."[111]

Strongly held copyleft and creative commons principles underpin live coding as a community in "common." Indeed, within live coding the principle of making visible its process extends beyond what might usually be considered the performance itself. The audience often witnesses the processes of preparation as much as what might conventionally be considered the performance. Referring to Andrew Sorensen's live coding practice, Stephen Ramsay states that what we witness at the start of the live coding performance "is the equivalent of watching a symphony warm up."[112] Arguably, there is something more radical at play, where the revelation of preparation is less akin to the symphonic process of tuning in or up (which might be witnessed *ceremoniously* in theaters but is still not considered part of the performance). Instead, for many live coders the back(stage) and front(stage) of the process are indivisible.[113] Within some live coding performances, there is no concealment of preparation or setting up, no cuts to be made after the fact—all is visible, all part of the work, an apparatus laid bare. Preparation becomes folded into the practice itself; it is part of (and not prior to) the performance.

This *showing* of the backstage of the performance process (the activities of warming up, of setting up the parameters of one's environment, of the defining of functions), alongside the revelation of the script (as it is being modified synchronous to its execution or actualization), differentiates live coding as a critical practice engaged in the interrogation and exposition of its own means of production and working processes.

For Yuill, "Live code is unashamed to expose the bare materiality of its production ... akin to revealing the stage machinery in a Brecht play. It creates a virtue by exposing something that is normally concealed."[114] In so doing, the live ecology of live coding practices appears to resist or refuse the conventional idea of the virtuoso performer, the *auratic* authority of the individual coder demonstrating *mastery* of their art.[115] In these terms one might also situate live coding within a wider lineage of post-1960s performance practices that reject virtuosity (and its willful concealment of the practice or effort), instead exposing the mechanisms of production, including the incorporation of rehearsal and preparation into the space-time of the performance itself.[116] Here, as curator Catherine Wood asserts, "The 'making' of the work is simultaneous with and dependent upon its 'doing' as performance; it is process *and* action. Tautologically, the work (of art) is simultaneous with the work (effort) of its execution."[117] Or, as Yuill asserts, live coding involves the "presentation of the 'work' itself as an open-ended mutable piece of code rather than as a static discrete artefact."[118]

This chapter has drawn on different theoretical ideas of liveness and performativity to demonstrate that live coding does not sit easily within any singular theoretical framework: its liveness is to be apprehended from multiple interdisciplinary perspectives, in which the *hierarchy of liveness* conceived in computational terms collides with a wider discourse on embodiment, vitality, and performativity. Certainly, the liveness of live coding is enabled by technical advancements that make the real-time nature of its live performance possible. However, this significant shift in programming capability is more than technological: the liveness(es) operative within live coding open(s) up new reflections on the ontological and ideological questions of what constitutes liveness, where live and mediatized modes of performance interweave, and where human and nonhuman livenesses become entangled. Indeed, the mixed livenesses of live coding—oscillating between states of liveness, *a*liveness, and undeadness, and between machine and human liveness—invite further investigation of its multi- and microtemporal states, extending beyond the issue of liveness to that of live coding's *time criticality*, which becomes the focus of chapter 6.

6 Time Criticality in Live Coding

Although *time critical* is a term used in computer engineering,[1] this chapter explores how live coding presents a direct challenge to the conventional understanding of the contemporary experience of time in the digital domain. On the one hand, the programmer-subject has often been too absent from accounts of digital experience, dwelling in an engineering dreamtime, a metalevel of narratives prior, beyond, and above the experiences of the user. On the other hand, the computer itself also manipulates time, as the system clock and program counter play out the sequential logic of the Turing machine's tape. In live coding, these time regimes are coupled, human and machine times become entangled, and conceptual configurations are situated in the moment of their interpretation, subverting the mechanical determinism of the clock and introducing other temporal registers. In what follows in this chapter, live coding can be understood to operate both *in* and *out* of what we conventionally understand as time, expressing different rhythms, experiences, and epistemological registers and exemplifying the "coming together" of multiple and different temporalities.[2]

In the first section of the chapter, we introduce temporal complexity and begin to explore how live coding practices manipulate these processes of temporalization with a number of concrete examples. Following this, we further discuss the disjunction between algorithmic or machine time and the performer's embodied experience of lived time and, of course, how live coding operates across these objective and subjective registers as a practice that appears—anachronistically—both in time and out of time. The elasticity here is important because it points to disjunctions that challenge any received notion of a unified present. Live coding is thus to be understood as a complex multitemporal human and more-than-human experience. The time criticality we speak of points to this inherent processuality of the computer and programming to express dynamic operations: it is both critical on a technical level and on a conceptual level and moves toward "criticality" in the sense that we place emphasis on practices that actualize potentialities in real time.[3]

Live coding is clearly a practice of time: it takes place in time and appears to be of its time, both *extemporary* (prepared, but somewhat improvised) and *contemporary* (as if occurring in the present). It seems commonsensical to say that live coding operates in and expresses the present, but we might seek more detail on how live coding enacts a very particular sense of the "present present."[4] The work of philosopher Peter Osborne informs our initial understanding of the complexities here and provides some clarity in distinguishing not a single present but a multiplicity of complex presents. In his words this increasing temporal complexity expresses the

> distinctive conceptual grammar of con-temporaneity, a coming together not simply "in" time, but "of" times: we do not just live or exist together "in time" with our contemporaries—as if time itself is indifferent to this existing together—but rather the present is increasingly characterized by a coming together of different but equally "present" temporalities or "times," a temporal unity in disjunction, or a disjunctive unity of present times.[5]

The passage describes the more complex and layered problem of different kinds of time existing simultaneously across different spaces, as part of really existing global capitalism in which real-time technologies play an increasingly significant role in reproducing our experience of time. Osborne would insist that we are increasingly subject to the conditions of a *global contemporaneity*, underpinned by more general economic and sociotechnological processes, which makes contemporary practices such as live coding possible at all and, we would add, that makes live coding appear symptomatic of temporal complexity as well as a means through which it might be better understood as disjunctive.

When the philosopher Giorgio Agamben asked, "What is the contemporary?," he was referring to the contemporary not as mere coming together in time but as the "untimely."[6] In other words, he interpreted the contemporary as an experience of disconnection, or a disjunctive relationship with our own time, and as such a precondition for being able to act upon it and against it.[7] We speculate that live coding might similarly offer insight into our disjunctive experience of time in which humans and machines run in—and out of—synchronous time and where temporal complexity is actualized and made available to experience. Furthermore, if politics necessarily involves struggles over the experience of time, as Osborne suggests, then further discussion becomes important in developing a critical technical practice that negotiates and expands our ways of being in time, of understanding it more fully, and of even being able to somewhat shape it.

Building on chapter 5, the discussion of so-called real time provides a concrete example of the coming together of different temporal registers and encapsulates the demand for ever-faster transactions and instantaneous feedback. Real-time computation

underpins this cultural logic, as well as the wider applications of just-in-time economic production, yet there is little attention paid to this concept in art history or cultural criticism—aside from the *real-time systems aesthetics* of Jack Burnham from the late 1960s perhaps—to understanding how real time influences aesthetic practices outside of the register of liveness or performativity.[8] In changing rules at runtime, live coding seems to actualize these real-time dynamics. Put simply, the phrase *real time* refers to the effect of information being delivered seemingly as it arises. In computing it serves to describe the actual time elapsed in the performance of a computation by a computer, where the operation appears to be immediate and able to correspond instantaneously to the distinct operations of an external process—as, for example, with the fluctuations of financial markets, where accuracy and predictability is critical. But there is no such thing as *real* time to the computer, only degrees of delay.[9] This is a central discussion in terms of the emergent aesthetics and potential to offer time criticality, in which the term *criticality* offers technical and epistemic insights. We follow writer and theorist Irit Rogoff on this point, in her emphasis on criticality to challenge "the underlying assumptions that might allow something to appear as a convincing logic" and move to "an emphasis on the present, of living out a situation, of understanding culture as a series of effects rather than of causes, of the possibilities of actualising some of its potential rather than revealing its faults."[10] We would like to argue that live coding is deeply implicated in these operational dynamics in ways that reflect the intensity and disjunctive experience of time more widely.

Representing Time

In chapter 4 we noted that different live coding languages embody different technical and indeed philosophical understandings of the creators of those systems, and this is particularly true of temporal relationships between coder, code, and outcome. Live coding language developers themselves have often reflected on the nature of time within their computational formalisms, as well as technical documentation and the languages themselves to compare the different representations of time at play.

One approach to live coding language is *agent based*; some process unfolds over time, which the live coder guides by making declarative statements to create "agents" that tell them what to do. This is a social view of time, focused on the actions and interactions of agents within a space. An example is Al-Jazari by Dave Griffiths, one of several experimental gamelike live coding systems he created using his Fluxus game engine.[11] The live coder/gamer issues instructions as discrete steps, including movement and sensing, in this case to live code music as a form of cellular automata. A more overt

likeness to classic cellular automata systems is the Orca system introduced in chapter 4, where the live coder works with agents moving around a two-dimensional array of instructions. Another instructional approach is Magnusson's Threnoscope, where statements create tones moving around a surround-sound multispeaker array. One interesting aspect of the Threnoscope is the extent to which the visualization becomes part of the music, allowing the audience to anticipate sound events at very long timescales so that extended periods of silence can be incorporated into a performance as an exemplar of *slow coding* (which we return to later in this chapter). Here the coder takes an external view of time, taking a godlike position of watching agents work while telling them what to do.

In conventional imperative computer programming, an algorithm is specified in terms of step-by-step sequences of instructions organized into loops, conditional *if* statements, and named procedures. These procedures are often grouped together as *classes* that are then associated with data sets as *objects*, but within procedures, the logic of time has largely stayed the same since the introduction of ALGOL in the late 1950s. In such systems, time is not always considered to be part of the logic of a program but is always present, as a step within a sequence always takes time to process. Being able to decompose a given problem into conditional statements and loops is therefore seen as core to computational thinking in the computer science education agenda. This can be seen in the venerable and still very widely used Scratch system, which supports live coding and where word blocks can be arranged into loops and conditions using a mouse.[12]

The same structures of loops and conditionals can be seen in Aaron's Sonic Pi live coding system first developed in 2012 in a successful effort to meet the resurgent computer science curriculum in UK schools at that time. Interestingly, though, Sonic Pi takes these abstract, imperative structures and makes them concrete and declarative. This is done through the introduction of accurate timing, where *sleep* instructions are added as imperative steps, marking out time and rhythm in the resulting music. Therefore, what matters in a Sonic Pi procedure is not *what* it outputs (as with imperative programming), but exactly *when* and *how* that outcome unfolds. Rather than using loop constructions to solve problems through iteration, a Sonic Pi programmer uses them to directly represent a *musical* loop. This exposes an interesting aspect of live coding—it appears to be a form of software engineering, but on closer examination, the practices are very different.

The 2011 Extempore system and its 2005 precursor Impromptu, both by Andrew Sorensen, are similar in that music is declaratively represented, using step-by-step structures associated with imperative programming.[13] A core feature of Extempore is *temporal recursion*, in which a function calls itself with a particular time delay. This uses

what is known as *tail recursion*, in which the final step in a function is the recursive call to itself. Temporal recursion is Extempore's solution to a problem that every live coding environment has to face: How can a program be interpreted while it is itself undergoing change? A temporally recursive function always runs to the end, but if it is replaced in the meantime, it then recursively calls this new version of itself. Temporal recursion therefore manages both change and time.

That change needs to be managed in such a way follows from a fundamental *incommensurability* lying at the heart of live coding, as media theorist and live coder Julian Rohrhuber has pointed out.[14] This is the sense that the ideal of live coding—changing rules as they are followed—is in some sense impossible. Rules are followed over time, which implies that a process is dependent on its history, and it is a matter of causality that it is not possible to change what has already happened. In practical terms, in order to respond to code changes compromises must then be made in the design of a live coding environment: Does it attempt to continue with the state left behind by the previous version of the code, or does it recalculate the history of the process as though the code had always been as it is now? Rohrhuber refers to these as the *state* and *causal* pictures, respectively, as complementary but incommensurable approaches to change.

The aforementioned Extempore and Sonic Pi systems maintain a state picture, but several systems apply an alternative, causal picture to live coding system design by taking a *pure functional* approach to the representation of time. This is particularly true of live coding systems for sound synthesis, such as, to a large extent, the SuperCollider sound engine, but is also true of TidalCycles, which is oriented around pattern. The problem with a causal picture is that changes to code cause an immediate switch from one version of history to another, creating a discontinuity, which in the case of sound synthesis results in an audible *click*. One workaround for this problem is to run both the previous and new versions of the code at the same time, adding an audio cross-fade between them. This approach, taken by Rohrhuber's Just-In-Time library for SuperCollider, works very well but has a clear aesthetic impact on the musical results, especially when interferences between the old and new create a momentary chord or polyrhythm during the transition. Alternatively, some live coders switch this feature off and embrace the discontinuous click as an aesthetic choice.

TidalCycles instead maintains a causal picture and is unusual for representing pattern as a pure function of time, as opposed to working with stateful operations over sequences or lists. *Pure* here is a technical term for describing a function that is not able to *do* anything apart from calculate an output based on its input. From this tight constraint comes great flexibility; because a TidalCyles pattern has no *side effects*, its timeline is untethered and may be manipulated freely—for example, reversed, chopped

up, rearranged, shifted, and compressed—or indeed manipulated in many combinations and at multiple scales.

Olivia Jack's Hydra live coding system applies a similar causal picture in synthesizing video rather than sonic patterns,[15] specifying GLSL shaders as a function that takes time and pixel position as input and returns a color for that pixel as output. In other words, the main renderer is a pure function that has no internal representation of time, aside from taking time as input. The live coder may then build their own representation of time to work with—for example, by working with sequences over time or with oscillators with time as input. What breaks this purity is Hydra's ability to take itself as an input source, allowing video feedback effects similar to the classic analog video synthesizers that inspired Jack to create Hydra.

With all these systems, the live coder might have the impression that the program is unfolding over *physical time*. However, if that were true, then all the time-consuming operations of interpreting and executing code would be perceivable in the music as delay, continuously varying and resulting in off-kilter stutters. With few exceptions,[16] live coding systems therefore differentiate *logical* and *physical* time in order to achieve metronomic accuracy. Calculations then work ahead of time, working out when things *should* happen and then introducing delays so they happen at exactly the right moment.[17] These calculations must be continually adjusted to stay accurate with physical time, as measured against a system clock. The temporal reference point for physical time is itself physically manifest, in the form of an oscillating crystal located within the circuitry of a CPU or sound module. Although computer programmers work many levels of abstraction away from these crystals, they are still required to keep the whole computer in coordinated self-oscillation so that it can usefully function. Here we can take a moment to consider the vast sociotechnical enterprise of a whole operating system, consisting of the encoded thoughts of many thousands of systems programmers working together in networked, coordinated sympathy with this shared clock.

In Time/s

The above examples from live coding inform our understanding of the contemporary experience of time, marked by its temporal complexity, multiplicity, elasticity, fragmentation, and unevenness. With its questions of latency, just-in-time programming, and collaboration in time, real-time media makes the contemporary experience of time ever more complex in ways different from the past. However, before expanding further on the implications of real-time media on the experience of time, we offer some reflections on how the human experience of temporality has *always* been shaped by different

and often competing—even contradictory—rhythms, regulations, and philosophical rhetoric.

Time is "out of joint," as Hamlet once announced.[18] Indeed, for cultural geographers Jon May and Nigel Thrift, our sense of time—especially *social time*—has been influenced by numerous factors, including the consideration of natural timetables and rhythms, through social rituals, through our relationship to various instruments and devices that mark the passage of time, and through new conceptualizations of time itself. Consequently, they argue that social time is not—and perhaps never has been—uniform or singular but rather is marked by a "radical unevenness in . . . nature and quality" in which "the (already partial and uneven) networks that constitute one domain connect (or fail to connect) with the (partial and uneven) networks constituting another."[19] Likewise, and although rather anthropocentric in tone, performance theory would tend to assert that time is "not a given, natural, objective phenomenon, but a condition and product of processes of human activity" involving "processes of temporalization . . . of perception, measure, experience and worlding."[20]

Yet, while this uneven, heterogeneous experience of time, of temporality, and even of the various processes of temporalization might feel tangible at the level of lived reality, the common means through which we articulate time—specifically through the standardized scientific model of machine time or clock time—does not account for these vagaries or for how machines might produce their own sense of time outside of human experience. So how might the practice of live coding contribute toward new understanding about our contemporary temporal experience?[21] How might live coding reveal and reflect the heterogeneous and contradictory temporalities that we negotiate within our daily lives? Moreover, how might live coding itself temporalize and actively produce—activate, intervene in, invent, and reorganize—as much as *reflect* different experiential temporalities? What different modalities of time, timing, and temporality does live coding give rise to?

In one sense, of course, live coding is a practice that actively works with temporalizing technologies: it harnesses the algorithmic logic of computer programming using those computational technologies, digital devices, and instruments so inseparable from the contemporary networked conditions of global capitalism. That temporalizing technologies radically (re)shape human temporal experience can be seen in relation to social practices that have attempted to standardize our understanding of time as, for example, the clock in relation to the process of industrialization and the regulation of the labor force. The claim can be extended to the way that contemporary digital technologies—through their privileging of velocity, speed, and immediacy—serve to both *accelerate* and simultaneously *compress* our experience of time (and space).

Arguably, one consequence of recent technological developments is the way in which those different means through which social time has been historically organized have been collapsed, or rather subsumed by, a rather more precarious temporality, a contemporary experience that sociologist Zygmunt Bauman has called *liquid times*. Liquid times refers to the "passage from 'solid' to 'liquid' modernity,"[22] the shift from a sense of a *chrono-normative* existence in which social forms and institutions provide a specific stable framework for the organization of human life toward an increased and somewhat pervasive sense of temporal uncertainty and instability.[23]

For art critic Amelia Groom, "The delocalization and non-fixity of networked digital space is both a symptom and catalyst of the broken, multifarious time that we find ourselves in."[24] Technological progress (under the influence of modernism and in turn neoliberalism) has given rise to a culture of twenty-four seven access and availability,[25] a work-life indeterminacy that exposes us to a heightened pressure to perform and a state of perpetual readiness supported by an ethos of just-in-time productivity.[26] In this sense, live coding could be seen as an exemplar of our contemporary liquid times, a precarious practice that utilizes the temporalizing technologies of our algorithmic age toward the generation of on-the-fly performance work. Here, live coding could be conceived as entirely *in time* with the conditions of its own emergence: the perfect product *of its time*. Its performativity could be seen as one of making tangible or explicit the temporal conditions of our "liquid life,"[27] at worst simply replicating, representing, and even reifying that which Capital already knows to exist.[28] However, while contemporary life might indeed appear to be organized (perhaps even disorganized) through the specifically algorithmic temporalizing technologies of neoliberalism, other temporal modalities still remain as a somewhat stubborn palimpsest. Perhaps, then, it is this temporal palimpsest (or disjunction), which Capital seeks to conceal or deny, that the practice of live coding reveals.

In the enactment of the coming together of different times, live coding enables the performer to exhibit some sense of agency over these processes of temporalization to generate and execute a specific output (sound, visual image, or movement) through algorithmic manipulation across these layers. Rhythms can be transformed at multiple scales (beyond human capabilities alone) through the modification of functions and parameters in real time. When generating an output, the live coder is required to understand these different registers of time—how code execution unfolds in time as well as how the live intervention of the coder might change its course—which all require sensitivity to timing. Specifically, the live coder has to decide *when* as much as *how* to intervene in the performance. The success—and indeed risk—within a live coding performance thus relates to degrees of control over these processes of temporalization, in particular the

Time Criticality in Live Coding

timely organization of edits into transitions and shifts and into more stable sections of focused development of form (such as a rhythmic, melodic, or timbral theme) emerging from an algorithmic combination of functions or transformative steps.

The use of clock time or measured time remains an important part of this. It functions as a way of structuring time in performance practices, as choreographer and performance scholar Jodie McNeilly states: "Time used as a system of counts (time-as-timing) is a useful tool for structuring choices in the construction and composition.... Time-as-timing sets rhythm and pace and provides a precise measure for the structural segmentation of a performance event."[29] Indeed, some live coders perform using the time signatures and temporal constraints that are familiar within more conventional (musical) performance composition, counting as a means to decide when to shift key or change tempo. For example, when live coding in an algorave context (discussed in other chapters), the coder might draw explicitly on the signature structures of dance music, an underlying or grounding rhythm based on powers of two (e.g., four, eight, sixteen, thirty-two, or sixty-four beats). Significantly, the performer must *feel* the relation of the surface rhythms of musical performance to the underpinning pulse of beat or meter. Indeed, while computer time is metric, rhythm is something perceived rather than notated in language or written down.[30] Here, some live coders report working more intuitively, deciding to make a change or shift based on time and timing felt, rather than necessarily counted. In these terms, the code itself does not express the whole experience of live coding (and indeed this question of what cannot be articulated through code language—including the live act of listening and responding—is explored in the previous chapters on liveness and notation). Live coding performance emerges through a negotiation between the prescriptive *what* of the notation and the experiential *how* of the passage of time.

In order to effect a change at the next metric cycle, the coder has to pace their speed of typing according to this metric deadline, and if this opportunity is missed, then they might well wait until the next metric cycle to initiate the change (or for the effects to take place). However, once an algorithm is set to run it does take time: time is thus a material part of the process, with the running time of the algorithm itself structured into the live coding performance. Live coding thus involves the play of different temporal rhythms: this process involves live negotiation between the coder's desire for a change or transition and the time that typing takes (with its potential for mistakes and errors), alongside the time of execution (with its technical latency and buffering).[31] The coder has to gauge how much time is enough—the optimal time needed for both human and nonhuman operations so as not to interfere with the flow of rhythm—giving it enough time so that you don't hear how much it takes. Some live coding

systems are designed such that the delay of execution is minimal, perhaps impossible, to perceive. In others it may be longer, a delay that the live coder internalizes in each act of preparation in anticipation of the next change. Such technical delays are directly comparable to playing other instruments, such as that experienced by a church organist when a pipe takes time to sound.

In most cases, and under normal conditions, the time that it takes for simple procedural code to be parsed and executed by a computer is minimal, and the timeline of an algorithm running is practically identical to the timeline in which its immediate effects can be heard. However, this execution time does have the capacity to be creatively exploited. For some live coders, the deliberate overloading of the computer can be deployed critically, exposing the inherent rhythms of machine processing by pushing it to its limits.[32] Execution takes longer under these pressured conditions, creating glitches or pops as the computer switches between tasks, missing samples in the absence of adequate time for generating enough audio. As the computer misses deadlines, you start to hear the time that the processing is taking, giving tangibility to a largely imperceptible (operational) level of computational infra-activity. It is not uncommon for live coders to use this to finish a performance, adding more and more layers of processing until the software, and therefore the music, stutters to a halt.

Time Felt and Temporal Elasticity

Within live coding, algorithmic time is blurred with both clock time and musical-rhythmic timing. In the performance of live coding, the unfolding of algorithmic or machine time meets with the performer's embodied experience of lived time, and the seemingly objective temporality of measured time—the beats per minute of clock time—is shaped and modified according to the *felt time* of a more subjective register.

Live coding operates at the interstices between what might be described as objective and subjective temporalities, with the potential to contribute new knowledge with regard to "the problem of time experience and time perception (how we experience time passing co-relative to measured time)."[33] The discrepancy or seeming incompatibility between these two approaches to time, temporality, and temporalization—between "the irreconcilability of the apparent elasticities in the experience of time and the rigidity of its objective measure"[34]—has long been a preoccupation within both philosophical and artistic thinking. Feminist scholar Elizabeth Grosz identifies various thinkers (such as Friedrich Nietzsche, Henri Bergson, and Gilles Deleuze), alongside "philosophers of becoming" (among them Martin Heidegger, Maurice Merleau-Ponty, Jacques Derrida, Michel Foucault, Pierre Klossowski, and Luce Irigaray), whose respective writing

has attempted to challenge some of the temporal "assumptions provided by everyday and scientific concepts of directionality, progress, development, accumulation and lineage."[35] Or, more specifically, for Grosz these various thinkers can be united through their affirmation of "time as an open-ended and fundamentally active force—a materializing if not material force—whose movements and operations have an inherent element of surprise, unpredictability, or newness."[36]

In the context of performance studies, too, what underpins the attempt to conceptualize a more embodied, affective, experiential understanding of time is a general sense of "suspicion of abstracted, measured, objective time" in which the aim is to develop a "multi-temporal understanding of time grounded in human experience, perception and performance."[37] Central to this endeavor is a critique of, or challenge to, the dominance of deterministic clock time as the means through which time and temporality are commonly understood (in Western culture at least). For Grosz, "What is significant about clock time is that it homogenizes and measures all modes of passing insensitively, with no reference to or respect for the particularity of duration of events and processes. It imposes rather than extracts unity and wholeness through homogenization and reduction."[38]

In this section we also address this balance by briefly highlighting *different* models for conceptualizing lived time (extending the concerns of the chapter 5 on liveness), in which temporality is experienced through its duration rather than its spatial abstraction and the potential elasticity or stretchiness within temporal experience becomes foregrounded. However, it should be clear that in addition to these aspects, we consider nonhuman elements such as machines and code—although not the focus here—to be crucially important for an articulation of time criticality, and we return to this later in the chapter. Live coding invites reflection on the lived and embodied aspects of computer programming while encouraging an understanding of time and temporality beyond anthropocentrism.

While a comprehensive exposition on the different philosophical standpoints of *lived time* is beyond the scope of this book, some elaboration is useful in the context of live coding. One, and admittedly limited, approach to this issue is through a Western tradition of philosophical thinking drawing on the work of, for example, Bergson, Husserl, and Heidegger. Writing at the turn of the twentieth century—a period marked by profound shifts toward the automation and standardization of lived experience—Bergson's philosophy of *pure duration* presents an important attempt to think of time in ways other than through the abstract spatialization of clock time. Against the logic of mathematical time—a measurable duration divided into a sequence of distinct, discontinuous instants or units—Bergson proposes the idea of pure time or even real time, the inner experience of *time felt* in its ceaseless and indivisible continuity, as incessant flux.

For Bergson, the present moment does not refer to "a mathematic instant" but rather "the real, concrete, live present . . . occupies a duration."[39] He argues that the duration of the present moment "has one foot in my past and another in my future. . . . The psychical state then, that I call 'my present,' must be both a perception of the immediate past and a determination of the immediate future."[40] Here, as Grosz clarifies: "Time is a mode of stretching, protraction, which provides the very conditions of becoming. . . . Time is the hiccoughing that expands itself, encompassing past and present into a kind of simultaneity."[41]

This elasticity of the present moment is also explored in the writing of Husserl, whose phenomenology of lived time is articulated through a three-part present: "A present-of-the-present moment (not so different from the present instance of *chronos*, the passing point of moving time)" (impression), a "past-of-the-present moment" (retention), and a "future-of-the-present moment" (protention).[42] Within this conceptual model, as psychologist Daniel Stern asserts, the "future-of-the-present moment is part of the experience of the felt present moment because its foreshadow, even if vague, is acting at the present instant to give directionality and, at times, a sense of what is about to unfold."[43] In the philosophy of Heidegger, too, time is conceived beyond the model of *common time* or *vulgar time* (measurable by clocks, for instance) and even *scientific time* (associated with mathematics and physics, or even computer science). In advance of this model of common time, Heidegger proposes a state of original temporality (*ekstasis*) as the basic structure of presence or being there (Dasein),[44] conceptualized through a unity of three temporal phases that significantly do not refer to a linear chronological sequence of past (no longer), present (now), and future (not yet). As Heidegger states, "Temporalizing does not mean a 'succession' of the ecstasies. The future is *not later* than the having-been, and the having-been is *not earlier* than the present. Temporality temporalizes itself as a future that makes present, in the process of having been."[45] Rather, as McNeilly observes, "Past and futural events following this structure are inextricable from the present; both the having-been-ness and not-yet-now are always expressed in the now of enpresenting."[46]

This cursory glance at philosophies of the lived present is intended primarily to point toward a different temporality beyond that of common time toward a sense of lived time's inherent elasticity. Without going deeper into a phenomenology of time as such (which is beyond our scope here), our intention is to indicate how live coding also challenges the common understandings of time in ways that are experientially tangible in the encounter with the practice itself. Live coding is not so much performed in the singular temporal present; rather, it is an experimental practice capable of extending, expanding, and even stretching the sense of how the present is experienced. Live coding's temporality involves more than the mathematical time of computation.

It unfolds through the lived present and pure duration experienced by the living, embodied performer *and* the audience alike and is especially evident in the case of musical performance in the present. Indeed, the phenomenologist Alfred Schutz has defined music as "sharing of the other's flux of experiences in inner time, this living through a vivid present in common."[47] However, in the case of live coding, unlike some conventional forms of musical performance, the live actions of the performer are not entirely synchronous with what is heard; the relation between the performer's action and output might well be asynchronous (or indeed disjunctive).

The present moment of live coding's performance involves the felt *being in time* with the live, unfolding flux of a sensorial experience (whether sound, image, or movement) at the same time as the writing—or witnessing the writing—of the code itself occurs. This is an action performed in the present but future oriented, conceived in relation to a present moment yet to come. Within the live and present moment of coding, the coder is both attending to and improvising in the moment (an experience perhaps synonymous with the flow states discussed in chapter 5) while also setting up the conditions for what will come next once the code is executed. Moreover, live coders are often engaged in the production of preparation or scaffolding, code written in the present that will be activated at a future point. This preparation is what takes the most time, whereas its later activation takes an instant. In the context of programming languages, programs promise to do something—for instance, when one part of the program communicates to another. This is one of numerous mechanisms for coordinating between parallel threads or processes. In the case of live coding, we might speculate further that the promise becomes a part of the temporal relationship between the algorithm, performer, and audience.[48]

Following this it could be argued that live coding performances give expression to the promise of the three-part present, where the performer's attention appears split between the present-of-the-present moment (the *as is*) and a future-of-the-present moment (the *yet to come*). Moreover, while improvising in the present-present and planning for a future-present, the coder is also attentive to the past-of-the-present moment through backtracking and reactivating code lines already written but presently inactive. Indeed, while the live coding audience experiences the durational lived present of an unfolding performance (in time), the performer seemingly occupies an altogether more ambiguous time zone, attending in time to something as it is happening live in the continuous present while also working *out of time* or *ahead of time* on code that may or may not be executed at some point in the future. For example, the visible frame of the live coding performance—the projected screen—has the capacity to show both the temporal continuum of the working timeline—the running command

line of the executable program—and code material that is either not yet or else no longer part of that timeline. The live coder might be working on something that exists outside of the timeline of the unfolding sound to be introduced at some later point in the performance. To give an example of a specific system, Dave Griffiths's Scheme Bricks allows the live coder to drag, drop, and plug together programs rather than typing. Unwanted sections are pulled out of the program and set aside rather than being deleted, accumulating around the program as spare parts that are often later recycled by being pulled back into another section. Here, unwanted sections of code have the capacity to be pulled out of the timeline as well as pulled back in. Within different live coding systems, fragments of code can be prepared in advance in order to then be built upon or modified during the performance. The timeline of execution has a sense of temporal continuity, yet this can be stretched or contracted through the addition or removal of discrete code sequences or even code events that have their own temporal structure independent of the timeline.[49]

Different live coding systems contain different solutions as to how musical events are scheduled in time, often offering original solutions. For example, within Thor Magnusson's ixi lang system alphabetical characters are used to represent events (either numbers for notes or letters for sounds), and the spaces between them are noneventful or silent. The code thus gets a graphic, spatial, and score-like representation of the music. The temporality of code is represented by its color. Grayed-out code is not active, active code is green, yellow code is being executed, and when code is rewriting itself, it flashes white. The ixi lang typically encourages the user to work with beats, polyrhythms, and agents of varied tempi. However, a conscious effort has been made to lessen this event-based focus of ixi lang—for example, with the concrete mode and the morphing of samples in the rhythmic mode. Alternatively, Magnusson's Threnoscope system emphasizes notes of indefinite length (drones), harmonic waveforms that can be instantiated anywhere on the system's circular interface, where waveforms move in cyclical space, crossing lines that represent speaker locations in space and whose parameters can be controlled through a textual interface. Refraining from a linear representation of time, the work is underpinned by a circular temporal structure without a clearly definable beginning or end, invoking a sense of timelessness, even the eternal.[50] McLean's TidalCycles system allows both periodic and linear patterns to be represented, allowing for the temporal duality of having repeating rhythmic structures that nonetheless progress linearly. Time can be conceptualized either as linear change with forward order of succession or as a repeating cycle where the end is also the beginning of the next repetition.

In these terms, live coding systems such as TidalCycles and Threnoscope invite a consideration of time criticality beyond a Western-centric perspective—whether

Time Criticality in Live Coding

philosophical or scientific—embracing the influence of non-Western thinking including, for instance, Indian conceptualizations of time and its relation to music. Here, as ethnomusicologist Martin Clayton observes, Indian cyclical time is not the "philosophy of sheer recurrence" with cycles of events that repeat themselves exactly. Clayton argues that Indian music "unfolds in a process of continuous development and does not repeat exactly, but this development takes place largely within the context of a cyclically repeating temporal structure—the tāl."[51]

An Indian conception of time can be seen most clearly in the venerable Bol Processor system for algorithmic music, created by computer scientist Bernard Bel from work on notating tabla rhythms and developed over forty years. Drawing from Indian classical music, it includes an expressive approach to time setting that seems unique to the algorithmic music field,[52] in which sound events are organized in terms of interrelationships before being mapped to physical time. Although not a live coding system itself, it has been heavily influential on the design of the TidalCycles system, particularly its embedded "mininotation" language for describing rhythm in the Bo Processor and more generally its representation of music based not on the duration of events (as in staff notation) but on the duration of cycles.

This focus on cycles rather than notes is in keeping with the longer-term focus on structure over events in live coding. In a cyclic structure, the live coder is placed in a situation in which the past is also the future, inviting a trancelike state, again comparable with the flow states discussed earlier. However, there is rarely just one cycle at play, giving the possibility of multiple cycles running at different speeds or at the same speed at different lengths, creating an interference pattern between elements, also known as polyrhythm and polymeter. A particular code state therefore may or may not produce an outcome that repeats before the next edit is executed, and the loop transforms into the next unfolding state.

Live coding is thus performed as a complex multitemporal, more-than-human experience where time can be revealed not only as a continuous, indivisible flux or flows but also as discontinuous breaks, enabling the possibility of temporal zones seemingly outside the continuum of an unfolding present and thus exposing time's inherent elasticity.

Out-of-Timeness

Live coding offers an intriguing model for reflecting on these various temporal conceptualizations since it is a practice that appears to be simultaneously in and out of time, occupying a disjunctive between space that exposes different temporal zones

of experience. Indeed, and following Agamben, we might take this to be a precondition for perceiving one's own time through anachrony.[53]

Some further elaboration of the untimely is developed in this section. Drawing on the ethnographic work of Arnold Van Gennep, anthropologist Victor Turner elaborates on the *liminal* quality of *out-of-timeness* as "an interval, however brief, of margin or *limen*, when the past is momentarily negated, suspended, or abrogated and the future has not yet begun, an instant of pure potentiality where everything, as it were trembles in the balance."[54] For Turner, liminality refers to a time-space of transition and transformation, a "between times" experienced at a temporal threshold "betwixt and between" that is simultaneously "no longer and not yet" where it is possible for those inhabiting this time-space to momentarily free themselves from structural time and to access a state of pure potentiality.[55]

For feminist philosopher Catherine Clément, this radical out-of-timeness, or emphasis on discontinuity, relates to the rapturous experience of *syncope* (the omission of sounds or letters from within a word), when "suddenly, time falters."[56] She further explains that although physical time never stops, "syncope seems to accomplish a miraculous suspension. Dance, music, and poetry traffic in time, manipulate it, and even the body manages to do that by an extraordinary short circuit."[57] Clément further reflects on the model of syncope in music described by Jean-Jacques Rousseau: "Syncope: prolongation on the strong [beat] of a sound begun of the weak [beat]; wherefore, every syncopated note is in counter time, and every collection of syncopated notes is a movement in counter time."[58] She elaborates on this movement in counter time further, drawing on Bergson's distinction between time and duration: one closed, static, and inalterable and the other open to transformation and rupture.[59]

Significantly, the model of syncopated out-of-timeness described by Bergson and Clément enables the possibility of a critical perspective on *structural time* predicated on the rupture or destabilization of established *structural values*—indeed, practiced through sudden jumps and jolts rather than through a unified continuity. Therefore, we can assert that syncope—literally, *syn* (with) and *kopto* (cut)—is borne of discontinuity; a missing beat or break in rhythm, out of sync with what came before. In these terms, the out-of-timeness within syncopation neither involves an attempt to escape time nor describes the absent-minded forgetting or loss of time; rather, it refers to a critical practice intent on accessing a different quality of temporal experience predicated on both criticality or rupture. While referencing these accounts of renouncing time is not to suggest that live coders are necessarily "liminal personae" engaged in the ritual transformation of temporal experience, there is evidently a quality of temporal indeterminacy or even suspended atemporality within the practice of live coding where the

liminal condition of *no longer and not yet* leans future oriented toward the opening of other potentialities.

Live coding—like many other improvisatory practices—involves experiential grounding in a temporal present while remaining alert and receptive to the opportunities of the temporal future. Indeed, within live coding performance it is possible to identify different models of possible future states—for example, between a model of the future as *foreseen* (a future-possible that is already planned and scripted in advance of its occurrence) and an ever-emergent future that is endlessly seized and inhabited through improvisatory practice (the near and *living* instant of an emerging future).[60] We hope it is clear by now that we consider live coding to be an emergent force in this way through its ability to rupture the continuity of the linear score and the smooth running of the script. So rather than imagining the future as already existing (somehow *prescripted* and simply waiting passively to be executed), live coding points toward an unforeseeable future borne more of disjuncture, discontinuity, and invention.

In this sense, live coding can be conceived as a kairotic practice based on principles of timing and timeliness, of invention and intervention.[61] The ancient Greek term *kairos* does not refer to an abstract measure of time passing (*chronos*) but rather is often taken to mean the "right time," a decisive moment whose fleeting opportunity must be grasped before it passes. Etymologically related to the Greek word *keirein*—"to cut"— kairos can be conceived as a temporal "opening" or critical moment (a "nick" in time). Here, according to rhetoric scholar Eric Charles White, "Instead of viewing the present occasion as continuous with a causally related sequence of events, *kairos* regards the present as unprecedented, as a moment of decision" where "the flow of time is understood as a succession of discontinuous occasions rather than as duration or historical continuity."[62] He asserts that "kairos stands for a radical principle of occasionality," an improvisational capacity that is "contemporary with itself, alert and able to adapt to the present occasion" where the "subject must always be in the act of creating itself anew."[63] For White, "Understood as a principle of invention . . . kairos therefore counsels thought to act always, as it were, on the spur of the moment."[64] Likewise for Stern, kairos refers to "the coming into being of a new state of things, and it happens in a moment of awareness."[65] He turns to the concept in response to the question: "So, what is to be done with the *now* while life is actually being experienced—while the present is still unfolding?"[66] A kairotic practice is thus critically attentive to the live circumstances or *occasionality* of its own production, capable of creating the conditions *for* while simultaneously responding *to* the contingencies within its own emergence. For us, this comes close to an understanding of live coding and the ways performers tweak their programs as they perform: live coding is a kairotic practice in this very sense.

A further conception of these emergent qualities can be found in the work of political philosopher Antonio Negri, who uses the term *kairòs* (the opportune moment) to describe a mode of immanent (and imminent) invention taking place at the limit of being: "*Kairòs* is the modality of time through which being opens itself, attracted by the void at the limit of time, and it thus decides to fill that void."[67] For Negri,

> *Kairòs* is an exemplary temporal point, because Being is opening up in time; and at each instant that it opens up it must be invented—it must invent itself. *Kairòs* is just this: the moment when the arrow of Being is shot, the moment of opening, the invention of Being on the edge of time.[68]

The future that kairos ushers in is less the not-yet of the future conceived as a continuation of the present as a radical discontinuity. For artist-theorist Simon O'Sullivan, Negri's kairòs can be pictured "as an oblique line—a 'disjunctive synthesis' to use Deleuze and Guattari's terminology—away from the present (but, not, as it were, to an already determined future)."[69] Within this model, "language is creative and future orientated, an exploratory probe of sorts . . . a leap into the *to-come*."[70]

Certainly, these different modalities of future-oriented imagination can be recognized within the field of live coding: for some, the imperative is toward an increasingly predictive future where decisions are anticipated (in advance) to support efficiency, immediacy, and speed within performance, while for others the futurity that live coding seeks to harness is oriented toward a model closer to kairòs, the practice of leaning into the void of the to-come where the unfolding future of the performance emerges simultaneously with its activation. In the latter situation, the live coder introduces individual elements that they understand perfectly but which on execution interact and interfere with each other in ways and at scales that the coder is unable to precalculate and anticipate. This creates a sense of chance that is unlike rolling dice but more like purposefully breaking one symmetry in order to create a new, unexpected symmetry.[71] Approaching live coding through the prism of kairos foregrounds the centrality of attending to an expanded sense of the present therein, emphasizing the flow of real-time action, the criticality of the present moment, alongside both the risk *and* skillfulness required in engaging with the as yet unknown. Drawing on these different conceptualizations of kairotic occasionality, the potential for invention is clear in the sense that the future cannot be prepared for in advance; rather, it *happens*, meaning both that it comes to pass and that it unfolds not through planning or prediction but rather by *hap* (by accident or chance).

For Grosz, too, a future-oriented approach to time foregrounds the attributes of "chance, randomness, openendedness, and becoming."[72] She continues, "Only if we open ourselves up to a time in which the future plays a structuring role in the value

and effectivity of the past and present can we revel in the indeterminacy, the becoming, of time itself."[73] This is perhaps all the more urgent when we seem to have lost an imaginative sense of the future to come, and it is therefore unsurprising that our ability to conceive of change and transformation has become constrained by contemporary forces that lock us into an inert *presentism*, with no recognized past and no real future either.[74] In one sense it could be tempting to imagine the modality of these future-oriented, transformative temporalities as one of acceleration and velocity and moreover, to conceive of the just-in-time nature of live coding's decision-making processes as one that is necessarily connected to the speed of action urgent in the now of the present as it is seized. Indeed, kairos does describe the radical temporality of the very moment of something new coming into being that is unique to that very moment. However, the performativity of timing and timeliness within kairos relies on the *dual principles* of slowness (even hesitancy) practiced alongside speed, the double maneuver of biding one's time and knowing when to act. Paradoxically, perhaps, the critical opportunity within the opening of kairos (ready to be seized) might only be discerned through a slowing down of habitual flows and rhythms, thereby producing the necessary quality of attention in order to act critically. Moreover, as O'Sullivan states, it is this "'affective-gap,' or 'hesitancy' as Bergson understood it, between stimulus and response, which in itself allows creativity to arise."[75]

In these terms, against the too-easy privileging of real-time performance—and the narrowing of the feedback loop between coding and its execution—one could advocate a critical value for the gaps and lags (moments of inaction, sitting back, listening, waiting, and enforced delays) within live coding performance as necessary reflective intervals within which one bides one's time before deciding when to act.[76] In this sense, slow practices are often conceived as a critique of, in resistance to, or perhaps even as the manifestation of *chronophobic* anxiety resulting from the accelerated temporalities of contemporary life. Making explicit reference to the slow-food movement, *slow coding* thus emphasizes the epistemological advantage: "To know code, is to slow code."[77] Experimenting beyond objective measure in such a way evokes durational performances and other modes that attempt to warp time.[78]

Live coding is an experimental practice operating in and out of time. It involves the bringing into relation of seemingly incompatible temporalities: timeliness alongside untimeliness; a sense of temporal continuum (akin to Bergson's durée) alongside the radical discontinuity of kairos; on-the-fly acceleration alongside the biding of time and *organic* time (the subjective sense of lived time) with *inorganic* time (nonhuman clock time, algorithmic *machine time*). Alongside its revelation of the writing of code, live coding reveals and activates the potential of the polyrhythmic, polytemporal, partial,

and uneven microtemporalities operating between, beneath, and below the more readable temporal dynamics of contemporary life. Moreover, it is a practice that harnesses the temporalizing capacity of computer technology as the means through which to conduct its experiments.

The Problem of Ending

Central to this ability to operate both in and out of time—and what we refer to as time criticality—is the challenge to the dominance of deterministic clock time as the means through which time and temporality are commonly understood, especially in technical disciplines and in anthropocentrist thinking. In this final section of the chapter, we explore these ideas by paying more attention to the machine and the ways in which the temporalities of computation challenge many of our precepts of how we consider time to be structured, and even constituted, in technical systems. It is already clear that machine time operates at a different register—for instance, in the way that system time indicates the computer system's notion of the passing of time. In "The Computer as Time-Critical Medium,"[79] Wolfgang Ernst clarifies the ontological importance of time to the computer's operations and networks, from the scheduler to regulate time for computations to the network protocol for coordinating packet switching. He points to key issues of programmability, feedback, and recursion at the level of programming languages as well as the temporal gap between the computer and programmer that is crucial for an understanding of live coding.[80] Precise technical detail is important for the argument—as is, for instance, the flip-flop time of binary switching and the specifics of the clock signal to emphasize that "time counts," as he puts it. For the practice of live coding, timing is clearly paramount and expressed through real-time operations and recursions. Ernst's concept of microtemporality is useful as well to draw attention to time in terms of signals, counting, and calculation.[81] These are some of the complex layers of temporality at play.

If we start from the broad premise that the humanities have tended to overlook technical details, we might draw attention to the way that discussions around live coding have tended to privilege the agency of the human programmer-performer and that other operative nonhuman agents are not sufficiently considered as part of the way in which time is produced and manipulated. Sound synthesis makes a good example, and Ernst refers to the SuperCollider programming environment in particular by quoting Julian Rohrhuber asking: Does "an algorithm for sound synthesis refer to a sonic event or to the machine that created it?"[82] Our larger claim here is that technologies are not simply tools that shape meaning but rather are constitutive of meaning (rather like

philosopher Bernard Stiegler's point that our relation to time is constituted, or "mediated," by the technical means through which it is apprehended[83]). Put simply, we want to insist that the technologies are operative too: that the technical apparatus is both performed and performs as part of any live coding performance.[84] This is what Ernst neatly refers to as "epistemological reverse engineering" to account for the active contribution of machines to knowledge production and how an archaeology of knowledge thereby extends beyond the human sensory apparatus,[85] and what is perceptible, to informatics and the nondiscursive realm of computer programs and technical infrastructures.[86] Although it is the time-critical aspect of Ernst's work that concerns us here, the epistemological implications are significant and something chapter 7 develops in more detail.

Live coding, and in particular its real-time operations, the use of iteration and recursion, offers alternative epistemological perspectives and imaginaries. In his conference paper "... Else Loop Forever," Ernst develops this discussion in relation to untimeliness in a rather different way to that which we have discussed so far.[87] His starting point is not the philosophy of time but a fundamental technical concept: namely, the infamous *halting problem* that underpins Turing computation and refers to the problem of whether a computer program, given all possible inputs, will finish running or continue to run forever. In the 1936/1937 essay "On Computable Numbers, with an Application to the Entscheidundsproblem," it was Alan Turing's assertion that a general algorithm to solve the halting problem was not possible. This led to the mathematical definition of a computer and a program, which became known as a Turing machine.[88] This "problem of decision," or "ending," as Ernst puts it, underscores broader notions of algorithmic time and the way the computer forever anticipates its own sense of never ending in an endless loop. That there can be "no happy ending," as Ernst suggests, allows him to elaborate on new temporal structures that no longer align with traditional narrative structures or the terminal logic of the "end of history."[89] In keeping with our earlier discussion, he asserts that kairos is privileged over chronos, and as we have argued, the practice of live coding would seem to emphasize the opportune moment, the point at which invention takes place, which is quite different from the linear steps a computer follows when it executes an instruction in machine time.

Also referring to the decision or halting problem to highlight the unknowability that is inherent in algorithmic music despite, and indeed due, to its deterministic means, Julian Rohrhuber portrays the live coder as working through "multiple alternative trajectories of causality" as a "search for rationality with the means of rationality."[90] As discussed earlier, Rohrhuber points to two ways in which a process can respond to code edits: by responding to state (continuing where the previous version left off) or cause

(recalculating history). Here he notes that these points of decision within loops or recursions also tend to be the points at which timing mechanisms are placed, as with Sorensen's temporal recursions discussed earlier; whether the process loops or recurses is then a time-critical relation of whether the clock drives the reckoner or the reckoner drives the clock.

Temporal complexity is further developed by referring back to Turing's speculation on artificial intelligence and whether a finite-state machine can be aware of its conscious state at a given time and whether a sense of ending is necessary in order to be functional. It is clear that finite-state machines are procedural, in that they produce linear sequences of discrete events in time like a complex clockwork, but as Ernst reminds us: "There is no automatic procedure which can decide for any program, if it contains an endless loop or not."[91] Contrary to the traditional musical performance—with a beginning, middle, and end—Ernst points out that the computational musical recording can be replayed endlessly. Live coding performances also occupy an ambiguous space in this relation because they seem to oscillate between states and thus seem to be most suitable for time-critical analysis. Indeed, the manipulation of time/s is key to this—live coding as the performance of the medium of time itself—where discrete events usually ordered into a sequence for a defined duration are instead open to nonlinearity and entropy. Making reference to Heidegger's "being-in-time" and the knowledge of the inevitable end of life that inscribes a temporal sense of what it means to be a human being, Ernst says: "Humans live with the implicit awareness that their death is already future in the past."[92] This deferral of ending is ontologically exacerbated with computation, unfolding the ending of being as a time-critical condition for both humans and machines alike.

The importance of these ideas for understanding the time criticality in live coding relates to how live coding can be said to activate the present in all its complexity. As indicated by our adoption of the term *time criticality*, we can acknowledge that time plays a crucial role in live coding in terms of the unfolding of time in its performance—as in a timeline or score—as well as in demonstrating how time can be manipulated, and indeed produced, programmatically. If we are to consider programming, the development of Smalltalk, an agile, reflective, object-oriented programming language started in 1971, makes one obvious further reference.[93] What is distinctive about Smalltalk is how it allows for programming with dynamic qualities or, in more technical terms, for interaction with a running system that is not stopped while waiting for new program statements. We look a little closer at Smalltalk in chapter 7, but for now the example helps to establish how a processual practice operates its own particular kind of liveness and temporality that is unique to its technical form and

presents ways to conceptualize how software exists not only in lived time but as actually constitutive of it. This also allows us to shift our attention to both human time and machine time—or rather opens up a tension between cultural and technical registers or that of signs and signals—and, for the critical technical practice of live coding, opens up the tension between musical content and the poetics of the temporal processes in operation. This performative potential of code, beyond its formal logic, is what media/design scholar and experimental media designer Shintaro Miyazaki has drawn attention to in his wordplay *algorhythmics*, referring, on the one hand, to a finite sequence of instructions (algorithm) as a procedure for solving a problem and,[94] on the other, a temporal ordering of infinite movement of matter, bodies, and signals (rhythm).[95] It is not simply the programmer who performs in a live coding performance but a whole suite of technical processes that involve the intricacies of calculation, storage, transmission, and processing in time. These algorhythmic aspects are something that the concept of algoraves further invokes with its reference to the inherent temporal and rhythmic structures of computation and the affective dimensions of bodies moving in space. These algorhythmic interventions draw attention to the complex materialities and microtemporal registers at work in our soundscapes and remind us that machines are running particular sequences and processes that are orchestrated in time.

The concept of time criticality is important, we think, as it articulates some of the ways we experience a multiplicity of presents and presences made operative through the live coding performance. The understanding of criticality we introduced at the beginning of the chapter plays no small part in our argument by drawing attention to the present and to the possibility of actualizing some of its potential.[96] Looping back to the beginning of the chapter, we might go as far as to say that live coding allows for a better understanding of the coming together of different but equally present temporalities and thereby how computation plays a critical role in our ordering and experience of the world—not only how we perceive it but also how it is open to transformation. The attention to computation is important to establish more clearly that time is out of joint, like the crackle of the phonograph that unsettles the distinction between surface and depth and reminds us of the means by which the manipulation of time was made possible in the first place.[97] Live coding points to these more-than-human entanglements and perhaps begins to draw together human and machine registers of time in ways that are not reductive to either.

7 What Does Live Coding Know?

Live coding can be considered a specifically technical practice, arising from, engaged with, and resulting in technological tools, infrastructure, and ways of thinking. In these terms, live coding is fundamentally reliant on a certain level of technical knowledge. However, live coding is not only a technical practice—as a creative endeavor it both draws on and expands the fields of knowledge and ways of thinking within craft, design, and artistic processes, practices, and research. In asking "What does live coding know?," we invoke different possibilities of the meaning of *technē*—referring to technology, to the art of making or doing, to productive knowledge, and even to rhetorical strategy.[1] Accordingly, this chapter explores the engineering contexts in which the necessary technical knowledge has been generated and applied and the contexts of creativity in which know-how from several perspectives crosses the boundaries of computer science, craft practices, and artistic research. The intention is to explore beyond the knowledge needed to practice live coding, extending to the knowledge that is acquired or that emerges in and through that practice.

The interdisciplinary nature of live coding—or rather its transdisciplinary (even *un*disciplinary) character, emerging as it does between the lines of different scientific and artistic disciplines—requires that the question of what it *knows* must be approached from more than one epistemological perspective. As with the discussion on the liveness of live coding in chapter 5 and on the temporal, temporalizing, and time-critical dimension of live coding in chapter 6, it becomes clear that the question of what live coding knows is a highly complex and layered issue that does not sit comfortably within any singular theoretical framework or school of thought. Live coding forces different epistemological registers into proximity, where they become negotiated in and through its specific practice. This chapter attempts to create conversations between the different ways of thinking and knowing operative within live coding to ask: What forms of knowledge are prerequisites for live coding? What forms of knowledge are produced—or even cultivated—in and through live coding (including technical knowledge as well

as the human capacities of agile thinking and resourceful tact)? What does live coding know; moreover, how can this be shared? What is the epistemological contribution of live coding within a wider interdisciplinary discourse, whether in relation to computer engineering, musical composition, or artistic performance? Demonstrating a multimodal model of sensemaking emerging between the lines of different disciplinary demarcations, how might live coding offer insight into the commonalities, complementarity, and differences between ways of knowing within the sciences and the arts? How might it register uncertainty in this respect, *not knowing*—along with a desire to know?[2] So, across this chapter, we move from engineering and craft perspectives to the epistemic insights of artistic research, opening up discussion on uncertainty and in turn the indeterminacy that defines the limits of computation and computational aesthetics.[3]

In asking "What does live coding know?," the intention is also to expand beyond an anthropocentric understanding of knowledge. Here, what live coding knows is not synonymous with what the live coder knows but rather refers to the epistemological potential of the practice itself, including the knowledges arising in and through the collaboration between human and machine sensemaking. The technologies worked with in the practice of live coding are not only a result or outcome of human technical knowledge but also enable and mediate epistemological advances and are constitutive of knowledge and meaning.[4] As such, and as with previous chapters, the question of knowledge within live coding necessarily engages with the complexity of human and more-than-human entanglement.[5]

Critical Technical Practice

Live coding comprises artistic and technical as well as philosophical inquiry—for not only does it draw on and from specific fields of knowledge but as a practice also asks specific epistemological questions. Here, we draw again on Agre's notion of *critical technical practice* to demonstrate how critical and cultural theories can intervene in engineering practices.[6] Agre was concerned specifically with the conduct of artificial intelligence (AI) research and with the relationship between AI as a critical pursuit and its engineering methods. In his notes on trying to reform AI, he observes that it is necessary to be competent in both technological and critical discourses in order to understand the new kinds of knowledge being produced since these span the conventional separation of engineering and philosophy.[7]

Live coding also leads us to liminal regions in the conventional separation of engineering and philosophy, as well as art. Might we consider speculative AI experiments as

a kind of art-music within the software industry? The Turing test, the singularity, and epic human-machine contests in chess and Go are performances of virtuosic imagination only tenuously related to the mundane statistical operation of search engines and data mining. At the same time, performance notations, most familiarly music notation, should be understood as a kind of software that can be instantiated (performed) in multiple contexts and involves a theory that the maker brings to bear—exploratory questions, concepts of how the hearer will receive it, and a kind of autonomy or agency that results from its own internal logic.

Engineering Know-How

To address the question of *what* (and perhaps even *how*) live coding knows, it is useful to identify some historical and contextual coordinates, examining how live coding both extends (and also deviates) from earlier practices and conceptions of coding and programming. In one sense, this mapping of the historical coordinates that enable the emergence of live coding can be seen in relation to chapter 2. However, while the emphasis of that chapter is on the specific living narrative of live coding's many histories (the evolution of its specific practices, networks, and communities), the focus here is more on a wider sense of technical prerequisites, conditions, and epistemological shifts that have enabled creative, experimental practices such as live coding to emerge.

The scientific-industrial origins of coding since the 1940s seem far away from the notion of coding as craft,[8] as a creative or even artistic, performance-based practice. For the first half century of the computer industry, most coding was embedded within highly structured business and organizational environments. Computers and computer time were expensive, as was the labor of experienced programmers. Far from being "live," much effort was devoted to constraining and controlling the work that programmers did in order to ensure that their time was productively applied and that the results justified the investment. As a consequence, most practices of software engineering, in both technical and commercial applications, became formal processes of bureaucratic translation through which contractual specifications were systematically converted into program code. Analogies to industrial processes and mass production resulted in project management structures such as the structured systems analysis and design method (SSADM), in which business analysts or system designers rather than programmers were responsible for the creative work of invention, to be embodied in plans and specification documents.[9]

Within these industrial and bureaucratic environments, the conversion of business process inventions into mundane code eventually became the job of relatively

low-skilled labor, minimizing the time commitments from technical specialists to an extent that the role of programmers could be recast by analogy to construction site or factory workers expected faithfully to follow the instructions of software "architects" or "designers."[10] Within such environments, the suggestion that software development could be a craft process, with autonomy for the programmers, was vigorously opposed. In constructing an expensive and apparently fragile advanced technology, the expertise of the software project manager rested in understanding, predicting, and repeatedly controlling as many aspects of the process as possible.[11] In an industrial-bureaucratic context, the contingency, uncertainty, and variability of craft activity (qualities that are often positively associated with live coding) were associated with amateurism and inefficient preindustrial modes of organizing production and thus were to be eradicated wherever possible rather than nurtured.

Two critical factors have come together to radically change this situation in recent decades, opening up possibilities for coding as an experimental practice. The first was the steadily falling cost of hobbyist and educational computer hardware, to an extent that the capital resources necessary for software development now appear to be approaching zero. In contrast to the small number of wealthy geeks who could afford to build or buy their own home computers in the 1970s, almost all adults in developed nations now carry computers (mobile phones) in their pockets, and children and hobbyists can acquire low-cost (practically disposable) computers, such as the Raspberry Pi Zero, that are perfectly adequate for creative experimentation.[12] Access to technical hardware—that had been available only within certain industries or for a privileged few—has now become widespread. The tools and technologies needed for coding practices are now more democratically obtainable.

The second factor in opening up the potential of coding as an experimental, creative practice is a transformed understanding of the practice of programming, which has developed alongside these democratized technical resources. The context for this transformation was a vision of enhancing human experience, set within a characteristically West Coast 1960s counterculture,[13] that led to systems in which the mode of operation was understood to be dynamic experimentation, rather than rigidly controlled and defined behaviors. Two projects in California were in the vanguard of changing attitudes toward programming—the Augmentation Research Center, founded by electrical engineer Douglas Engelbart at Stanford in the 1960s for developing and experimenting with new tools and techniques for collaboration and information processing, and computer scientist Alan Kay's KiddiComp concept (1968) and DynaBook proposal (1972), in conjunction with the agenda of Xerox PARC. Kay and his colleagues sought to produce a "personal computer for children of all ages."[14]

Kay's Smalltalk language for the Dynabook—the software component of his research proposal—in particular set out to offer capabilities through which children could create and modify their own artistic tools. The Smalltalk programmer goes about their work by literally *changing* the language, editors, and operating system as they work, inspecting and modifying parts of the running code, and experimenting with new features or alternatives by replacing them within the running system. Of course, Kay's ambition to deliver these technical capabilities to children was particularly challenging, and Smalltalk became far more influential on adults than children.[15] Nevertheless, the desire to make such capabilities accessible to relatively untrained individuals resulted in many of the graphical user interface (GUI) innovations that we take for granted in software tools today, including dialog windows and the earliest uses of the icon.[16] As mentioned in chapter 4, Kay's more far-reaching aims continue to inspire those looking to meet his vision, such as the global ambitions of the One Laptop Per Child Foundation, or the more recent DynamicLand Foundation, which aims to "enable universal literacy in a humane computational medium."[17]

At the time that these early personal computers were being developed, the distinction between *programming* a computer and *using* a computer was not quite as clear-cut as it is today—indeed, the GUI was interpreted by at least one influential researcher at the time as being a "step beyond" programming.[18] But the surface appearance of the Macintosh and other GUI products, relinquishing the command line that had been familiar to small business and home users until then, became associated with restricted technical capabilities and exclusion from the power of code.[19] Meanwhile, although Smalltalk had been created specifically with an agenda of creative empowerment, Xerox did not itself recognize the market opportunity that might arise from live programming in their machines.[20] On the contrary, Xerox was the archetypal enabler of bureaucracy, supplying the photocopiers by which all those other documents—memos, contracts, specifications, and forms—would be duplicated to support formal and professionalized software development. It would be some time (almost three decades) before live coding practices emerged in the early twenty-first century to truly seize the opportunities enabled by the increased accessibility and availability of hardware, alongside the experimental potential for creating and modifying programming languages.[21] Indeed, it is interesting that live coding eschews the restricted technical capabilities and exclusion from code (associated with the development of Macintosh and other GUI products) by often explicitly retaining rather than relinquishing the command line.

Companies such as Xerox could not be expected to recognize or support the ambitions of live coding. Nevertheless, the broader community associated with the Smalltalk language and its successors has continued to develop practices and concerns for

software development that are distinct from previously established software-engineering or business practices. These practices include the alternative characterization of design processes in the form of *agile* programming; the approach to documenting software in the wiki, and the characterization of ways of programming as a pattern language. Each of these reflects forms of liveness in software engineering and provides a further context from which to consider live coding.

Agile programming is a relatively live approach to professional software development work that treats the construction of the technical artifact as a performance of craft and is potentially undertaken in the presence of software users (so that they can direct or comment on the work in progress).[22] In the agile practice of *pair programming*, this performance becomes a duet, or perhaps pas de deux, in which a driver and navigator both sit at the same computer, jointly improvising the construction of a shared artifact. In agile software development, a full specification is not written in advance. Instead, the system evolves in a more emergent manner, with system users contributing stories about the way they would like the system to work and programmers responding in sprints to create new code to create the new capabilities that will enable those stories.

Wiki-editing software is another live practice that has arisen from the Smalltalk community.[23] Now best known as the basis for Wikipedia, the first wiki (or WikiWikiWeb) was another outcome of the agile development community.[24] In the Smalltalk language, everything is there to be changed. However, if other programmers or users are expected to use a constantly changing system, the documents describing the software must also be changed. In the agile development context, it is not only the software that is performatively created and shaped in front of the customer and users but also the software documentation, texts, or illustrations that accompany software or are embedded in the source code. This has to happen quickly—*wiki*, in the Hawaiian phrase that named the system.

Finally, the experience of live modification of software in the Smalltalk environment drew attention to the ways that different aspects or parts of a software system are more or less modifiable (or amenable to understanding by others after modifications have been made). The research community inventing these new practices drew on the work of architect Christopher Alexander, whose pattern language theory described the built environment in terms structured by the experiences of those who lived there.[25] The live development practices of the Smalltalk programmer inspired an analogy by which the Smalltalk environment became the place in which they lived—a virtual environment that might have pattern languages of its own. The resulting development of *design patterns* has become a fundamental of software-engineering practice and education, despite the fact that its original philosophical intentions have now become rather obscured.[26]

In addition to Smalltalk, its tools, and its descendents, practitioners of live programming also draw on the traditions of a far older language and associated tools—the Lisp environment. Although most computer programming tools through the 1960s and 1970s were shaped and constrained by the high costs of computer time, a small number of programmers worked in relatively wealthy AI research laboratories, such as that at MIT, where the Lisp language had been developed to exploit the luxury of direct access to powerful machines. As with Smalltalk (and Forth, as discussed in chapter 2), Lisp programmers are able to change aspects of the language itself, modifying the system through an interactive interpreter. The core of the language is the famous read-eval-print loop, often called REPL, in which the primary task of the system is to continually *read* the command the programmer has just typed, *evaluate* that command to change the system state, *print* out the result, and then simply (perhaps recursively) *loop* through those four steps indefinitely. As with Smalltalk, commands presented to the REPL can be used to define or redefine new functionality or even modify parts of the Lisp system (including the read, eval, or print statements themselves).

Just as the alternative styles of programming enabled by the Smalltalk environment led to distinctive craft and social practices, the earlier Lisp language was also associated with critical developments that ultimately set the conditions for the open-source software revolution. Lisp programs were conventionally distributed as source code, which could be loaded directly for evaluation to recover a previous system state—sometimes as sophisticated macro packages that transformed the nature and capabilities of the language itself. The Lisp philosophy formed the basis of the Emacs editor—an interactive programming environment largely written in Lisp and indeed often used for writing Lisp programs—whether for other research purposes or just for enhancing Emacs to become an email client, system command shell, directory utility, newsreader, or anything else that might occur to the user. This fundamental extensibility resembled the way Smalltalk programmers could modify the features of the editor itself, changing its behavior while using it. Because the REPL philosophy of Lisp assumed that the program continued to run as it was being modified, the programmer could work in the editor to change the editor—an everyday live performance in which every keystroke or Command key that the user might type was immediately translated to interpreted code, immediately useful, and also modifiable on the fly.

The author of the most popular version of Emacs, Richard Stallman, extended these live customization practices into a political philosophy, advocating free software that could always be modified by its users, with the intention that no software user need have constraints placed on them by another. The longer-term goal of Stallman and the Free Software Foundation was to produce a complete operating system based on free

software principles,[27] although stalled by slow progress on their equivalent to the *kernel* at the very core of Unix-style operating systems. This set the scene for Linus Torvalds to develop his Linux kernel and build a complete operating system using tools from Stallman's GNU (GNU's Not Unix!) project. While few GNU/Linux tools offer the degree of live extensibility that Emacs allowed, the principle of operation of the Unix shell, flexibly combining small tools via the Command line, itself amounts to an advanced and highly capable live coding environment.[28] The resulting free/open-source system software underpins much of the public infrastructure of the internet today, despite the fact that, as one might expect, few businesses or other institutions embrace the idea of the free and flexible modification of such crucial software to the extent that would have been typical when Stallman started his work as a researcher in the MIT AI Lab.

In the cases of both Lisp and Smalltalk, the flexible practices of research environments encouraged tools that are mutable and able to be reconfigured by creative engineers who engage in craft practices of modifying the tools they use for their own work. In both cases these languages have resulted in sets of social practices that reconfigure business and media contexts where they are applied—democratizing and decentralizing. Open-source commentator Eric Raymond has drawn a distinction between the traditional structures of software production and these live and open practices, calling them the "Cathedral and the Bazaar."[29] The software engineering research community itself, while traditionally aligned with the systematic and predictable processes of large-scale software production, has responded to changing industry practices of agile programming, design patterns, informal documentation, and open software by developing its own specialist series of LIVE workshops,[30] distinct from the art and media practices that are the main focus of this book but developed with an element of dialogue and overlap between the software-engineering and live coding communities.

Craft and Making

As stated at the outset of this chapter, live coding is a technical practice, a specific type of craft and approach to artistic process, practice, and research. Yet in what ways can live coding be considered a craft, a material practice? Indeed, the tension between the materiality and immateriality of code constantly challenges the ways in which we understand it. Code, as observed by architect and design scholar Daniel Cardoso-Llach,[31] often carries metaphorical associations of weightlessness. It appears mathematical, platonic, abstract, insubstantial—the stuff that dreams are made of. Codes encode information—they are ciphers, disembodied languages, rather than physical machinery. Code is pure knowledge, pure calculation, and pure control.

Yet code impinges on the material world—programs are also rule systems and orderings, specifying regularities over the everyday world of substance and phenomena. In this respect, live coding exists within a wider context of the software industry and indeed the whole enterprise of technology, whose purpose, it might be argued, is to bring order to the world. As an abstract mechanism of control, code has traditionally been an instrument of government, relieving the military-industrial complex from the uncertainty of human workers and replacing fallible or undisciplined human hands with the precisely replicable actions of machines. Moreover, although software is conceptually abstract, the computers in which these codes are constructed, executed, and observed are complex and costly assemblages often incorporating rare minerals and/or the products of sweatshop labor.[32] Their operation depends on a material infrastructure of communications, power networks, server farms, and processor clusters spanning the globe.

In chapter 8, we explore some of the tensions between, on one hand, the ways in which contemporary life is increasingly determined and constrained by the algorithmic rules of bureaucratic systems, commerce, and government, and, on the other, the *unruly* potential of live coding. Live coding cannot be dislocated from the wider enterprise of technology and the systems of control and exploitation therein. However, for live coders, code is not an instrument of control for imposing order on a chaotic world. It is quite the opposite: an activity that generates chaos in a highly technical world. Indeed, the practice of live coding could not be further from the military-industrial use of code for control of human life. Its use of code is creative rather than regulative.

In one sense, live coding as an artistic practice could be seen as another way of creating order from matter—perhaps inviting an analogy in terms of the way that the sculptor's chisel extracts form from stone or wood or the painter's brush arranges form from pigment. Yet this analogy soon collapses under the pressure of examination: Should one conceive of code as the chisel (tool) or as the wood (material)? Such analogous comparisons are complicated by the practice of live coding—no neat equivalent can be applied. Here, our own analysis elaborates on problematics that were already apparent to the authors of the TOPLAP live coding manifesto in 2004. The manifesto statement that "programs are instruments that can change themselves" highlights the problematically material mutability of the tool within live coding.[33] It goes on to claim that "live coding is not about tools. Algorithms are thoughts. Chainsaws are tools. That's why algorithms are sometimes harder to notice than chainsaws."[34] It is clear that live coding complicates the distinction between tool and material. Yet this complication does not invite resolution through any attempt to achieve new or definitive reinterpretations of *tool, material, form, practice,* or *craft* that could adequately capture the challenges posed by live coding to any of these terms. Live coding provokes reflection

on the potential of a new ontology of code by refusing to be contained by existing categories and definitions.

There is much to learn from this new ontology of code—both in relation to the nature of technology and in relation to the nature of material practice. This change is also occurring as those parts of the software industry concerned with user experience and interaction design have had their attention drawn away from the traditional office workstation, with its visual display screen and typewriter keyboard, to the many forms and contexts in which digital processors are now found.[35] Where software was once separate from the materiality of everyday life, sustaining a kind of technological mind-body dualism through the separation of the (middle-class) home and (white-collar) office or the traditionally remote and white-coated abstraction of the mainframe server room, we have now become thoroughly entangled with computers that are in our pockets, cars, and homes; embedded in our clothing, chest cavities, and skulls;[36] in our pets;[37] or attached to our wrists and faces. Interaction designers for this tangible, embodied, and embedded world of computation are thus reengaging with materials and craft practices in order to embody their interactive metal, wooden, or cloth prototypes. Once they lose their screens and keyboards, embedded computers become tangible user interfaces,[38] joining the rematerialized Internet of Things.

Rather than working with the "pure digital,"[39] these software and interaction designers can be conceived as craft makers, "reflective practitioners" (in design theorist Donald Schön's terms) engaged in creative design research work that draws attention to the resultant conversation with materials.[40] The user experience research literature delights in this turn to a new materiality because of the way that it offers insights from more established branches of design research.[41] Unsurprisingly, this research engagement with newfound material practices has also led to a concern with the materiality of code itself for those researchers who see code as a site of human interaction rather than simply a mathematical abstraction.[42] Not all writers take the analogy this far, but many interaction designers perceive their experiences with the software of their prototypes as having a great deal in common with their rediscovered experiences of hardware. They feel that, even when they turn from their workbench back to their laptop keyboard, they are still having a conversation with a material in which the code resists their intentions,[43] disrupting their pure theoretical conceptualizations via the "mangle of practice," to use sociologist and philosopher Andrew Pickering's phrase.[44]

Certainly, code often seems to be resistant to the intentions and desires of the coder—experienced, some argue, in much the same way as when physical materials resist craft labor. Engineering scientist Malcolm McCullogh's celebration of the "practiced digital

hand" describes a "master" user of computer-aided design tools engaged with coaxing reluctant or recalcitrant digital materials.[45] Gross, Bardzell, and Bardzell draw on painter and early computer artist Harold Cohen's theory of artistic media, from the perspective of interaction design,[46] to explain why this very recalcitrance becomes a media resource for performance and exhibition wherein audiences appreciate the virtuosity that has been exhibited in the struggle with a "viscous" medium. But if code is a material, it would appear to be a surprisingly immaterial one.[47] Interaction design theorists persist in the argument that software is material and that where there is a material, there must be a craft. Even social critic Richard Sennett describes open-source software development as a "public craft."[48] Programming is persistently described by programmers themselves as a craft skill, with practitioners writing manifestos for "software carpentry" or "software craftsmanship."[49] Yet the use of exclusive terms such as *craftsman* when describing craft expertise raises further challenges for the live coding community since both craft and coding traditions have privileged a particular gendered sense of skillfulness and agency, along with the hierarchical and gendered notion of *mastery*, which many live coders seek to resist and reject.

Just as the pure algorithmic code of theoretical computer science is actually embodied and embedded in the large material infrastructure of computer hardware and networks, so, too, are craft practices physically embodied in the craftsperson and socially embedded in communities of practice. One such long-standing community of practice is the demoscene, an antecedent of the live coding community that shares many common concerns with live coders.[50] Demoscene participants create virtuoso technical artworks, which they present to their peers in competition and performance events. Hansen, Nørgård, and Halskov undertook an ethnographic study of the demoscene community, from which they developed a theory of craft practice as observed among these code artists.[51] They see a relationship between the rhythmic elements of the realized artworks and the rhythmic practice of the artist tweaking and refining code. In their analysis this material practice results in a distinctive craft skill, molding the practitioner at the same time as the material.

An alternative conception of craft knowledge is offered by anthropologist Tim Ingold,[52] in which there is no repetition (only machines repeat mindlessly) but rather one step after another, along a journeying path. The craftsperson's tool seeks and responds to the grain of a material in a process of accommodation and understanding rather than imposing form on an inert substance. Ingold foregrounds the importance of a "conversation with materials" or even of the "correspondence" (to use his term) between sentient practitioner and active material.[53] He emphasizes an "art of inquiry"

in which the way of the craftsperson is "to allow knowledge to grow from the crucible of our practical and observational engagements with the beings and things around us."[54] Here, Ingold states:

> Every work is an experiment: not in the natural scientific sense of testing a preconceived hypothesis, or of engineering and confrontation between ideas "in the head" and facts "on the ground," but in the sense of prising an opening and following where it leads. You try things out and see what happens.[55]

Material should be considered as "matter-flow," in flux rather than stable, and the craftsperson *follows* the material, in a manner (Ingold argues) that Gilles Deleuze and Félix Guattari have described as *itineration*, rather than iteration.[56] The craftsperson is thus an itinerant wayfarer whose practice is one of journeying with the material. Ingold's work on what he calls textility provides one of the most productive perspectives in the contemporary discussion of materiality and offers an ideal analytic perspective for the live coding situation.[57] He applies social anthropologist Alfred Gell's work on *Art and Agency* in identifying a kind of mistaken belief in which an object is taken to be the starting point for an inquiry that traces backward from the object to find the conditions and creative agent that caused it to exist.[58] The object becomes a static index of a prior causal chain, rather than a thing unfolding through the interaction of a maker via the flows and forces of material.

The alternative process-oriented perspective of flow and unfolding is unfamiliar to many technologists but more than familiar to the contemporary artist, as expressed in artist Paul Klee's classic evocation of drawing as "taking a line for a walk,"[59] or indeed in La Monte Young's aforementioned "Draw a straight line and follow it."[60] The process-oriented sense of "taking a line for a walk" resonates equally well with the experience of the live coder, who is engaged in a process of programming with no intention to create a finalized software product. Ingold himself observes how different these material craft practices are from the conventional world of technology. He describes technology itself as being an ontological claim. The claim of technology is that things come into being through the application of rules and rational processes and that objects are thus formed out of inert and undifferentiated substances. Indeed, there are many computer scientists who resist the suggestion that computing might be a craft rather than an objectively mathematical science.[61] The tension is so long-standing that the mathematician Charles Babbage engaged in a long-running dispute with Joseph Clement, the engineer building his Difference Engine who claimed that he, rather than Babbage, should be recognized as its inventor.[62]

In subsequent generations, true computer science has often been advocated as a more appropriate domain for the refined academic rather than the mechanical engineer,

where the highest aspiration of theoretical computer science is to prove the correctness of its products in the manner of a mathematical theorem.[63] Indeed, foundational theoreticians of the discipline, such as Edsger Dijkstra, have publicly regretted the tendency for software development to be treated as a craft rather than an automated and repeatable scientific discipline.[64] There are many challenges in drawing the appropriate analogies between our traditional understanding of craft and materials and the experiences of making software, and these alternative and competing conceptions are acknowledged in the conflicting implications of the statements made in the TOPLAP manifesto.

Whatever the theoretical and idealized ambitions of computer scientists, the everyday professional practices of agile software development, like the creative practices of the live coder, seem far more fluid than a desire for rigorous formality might suggest. Agile developers respond to events rather than simply following a specification plan. Their practice—just as Lucy Suchman's research on situated cognition reflects[65]—demonstrates the contingency of rational action, in which the rational agent improvises and adapts to the world rather than imposing order on it. In practice, code seldom attains the mathematical standards that theoretical computer scientists aspire to. The practice of live coding, in which code is a process to be experienced rather than an intermediate specification accounting for an indexical product, is indeed a craft. Metallurgist and research physicist Ursula Franklin offers additional support to this view in recognizing that the world of technology includes such craft activities, as opposed to activities of mass production.[66]

While theorists of materiality in interaction design have argued that software is a design material like their other materials and that where there is a material there must be a craft,[67] a perspective from live coding follows those assertions in the reverse direction. Following the analyses of Ingold, Sennett, and Franklin, live coding *is* a craft—and given this craft, it seems that code must be its material despite the claims to immateriality made in its manifesto. Through code, it seems that we have made a linguistic tool into a material even though this material remains insubstantial.[68] Furthermore, the "conversation with materials" already observed in craft and design practice by theorists such as Sennett and Schön now becomes a more literal conversation through the medium of a programming language and thus composed of *linguistic* (or at least notational) exchanges. The regularities and explicit observability of code notations mean that we can more readily understand the patterns of experience inherent in such craft, reflecting on those experiences in the form of pattern language.[69] We can also appreciate a diversity of craft practices, extending beyond live coding to other communities of practice and other practices of programming.[70]

Creative Know-How and No-How

Within live coding, advances in technical and engineering knowledge meet with a sense of "knowing in practice" or even "practice of knowing,"[71] a practical form of "intelligent doing" or know-how perhaps more commonly (though certainly not exclusively) associated with craft-based practices and artistic practices.[72] The question of what live coding knows, or even how live coding thinks, draws the practice of live coding into closer proximity with the burgeoning field of artistic research. Indeed, artistic research offers a further framework to draw attention to the way that the practice of live coding is not fixed or foreclosed by a particular knowledge domain (such as computer science, electronic music or computer music, or even artistic practice). For some advocates of artistic research, its modes of thinking and knowing can be differentiated through emphasis on the nonpropositional or nonconceptual dimension of its sensemaking practices.[73] In parallel, attempts have been made to address the commonalities between artistic research and scientific research, drawing attention to reflexive practitioners operating at the boundaries between the arts, science, and technology, thereby unsettling some of the established assumptions of and about art and scientific research.[74]

For research scholar Robin Nelson, the multimodal epistemological model for research in and through artistic practice (or even arts praxis) involves a triangulation of *know-how* (comprising "insider close-up knowing"; experiential, haptic knowing; performative knowing, tacit knowledge, and embodied knowledge) and *know-what* (tacit knowledge made explicit through critical reflection), combined with the *know-that* of cognitive propositional knowledge.[75] His framing of know-how draws on Schön's (previously mentioned) work on the "reflective practitioner" and "knowing-in-action,"[76] philosopher and polymath Michael Polanyi's writing on the tacit dimension of knowledge,[77] and enactivist accounts of embodied knowledge (for example, the work of philosophers Francisco Varela and Alva Noë[78]), which for Nelson demonstrate that "cognition is not the representation of a pre-given world by a pre-given mind but it is rather the enactment of a world and a mind."[79]

Of specific interest for this publication is the way in which live coding operates at the threshold of different species of knowledge, troubling easy classification. Indeed, as scholars Dorothy Leonard and Sylvia Sensiper state:

> Knowledge exists on a spectrum. At one extreme, it is almost completely tacit, that is semiconscious and unconscious knowledge held in people's heads and bodies. At the other end of the spectrum, knowledge is almost completely explicit or codified, structured and accessible to people other than individuals originating it. Most knowledge of course exists between these extremes.[80]

Live coding not only exists *between* these extremes but also demonstrates the coexistence, cooperation, and even complementarity between seemingly divergent knowledge paradigms.

Live coding is a distinctly hybrid practice, operating at a critical interstice between different disciplines and oscillating between a problem-solving approach (often associated with design-based practices) and a problem-finding, questioning,[81] even obstacle-generating tendency (often part of the research impetus for artistic inquiry).[82] Live coding brings computational knowledge into dialogue with those (alternative) forms of knowledge—tacit knowledge, sensuous knowledge modeled on experienced continuity of process rather than discontinuous abstraction; not knowing, the value of trial and error and of "feeling one's way"; and technē, conceived as a practical or even tactical knowledge underpinned by kairotic and mêtic intelligence as much as a craft[83]—that have been habitually eclipsed or even marginalized within a knowledge hierarchy that favors a form of abstract, rational logic.

Live coding pressures the *if-then* thinking of computational logic toward the *what-if* of speculative experimentation. Within live coding, neither the programmer nor program makes finite choices or decisions as such; rather, each becomes mutually part of an open-ended and contingent process of both problem generation and problem-solving. Live coding is conceived as a live practice for testing the possibilities of *this* or *this* or *this* or *this* for exploring the potential of what if. For philosophers Erin Manning and Brian Massumi, "Potential is not of the if-then. Potential is allied to what-if."[84] They assert that performing in the key of what-if "is never a question of formally working something out in advance" but rather "a movement precise with training but still open to regeneration."[85] This "see what happens" or "what-if" approach appears as a central modus operandi for many live coders.

Although many live coders acknowledge some formal training in computing, music, or artistic methods, the knowledge of the process required for live coding emerges often through experimentation, through the accumulation of trial and error, and through innumerable versions and iterations, tests, and attempts. The etymology of the word *experiment* refers to a species of practical knowledge based on experience, with origins in *experiri*, "to try, test"; from *ex-*, "out of," and from *peritus*, "experienced, tested." Experiential knowledge is gained through trial and error, through the process of doing and undoing, and through the repeated labor of trying something out again and again. However, theorist Dieter Mersch differentiates between the role of the experiment within art and science: "The scientific system is the medium *through* which experiments are first constituted. . . . In the arts, this relation is turned around; it is the *experiri* of

the *experimentum* that is the medium *through* which artistic research takes place."[86] He identifies the characteristics of "experimentality" within aesthetic research thus:

> First, it follows the original meaning of *empeiría*, "to open to risks" and "make visible" (*exponere*) that which binds and allows for ex-perience.... Second, self-referentiality or self-reflexivity is the main access to as well as pull of the "esoteric" of such a wealth of experience, so that it is at the same time an experimental experience and an experiencing (itself) in the experimental.[87]

Live coding is seemingly underpinned by these same principles: an openness to risk (the potential for the unpredictable, for chance and error related both to live coding's liveness as well as the loss of authorial agency through working with algorithmic processes) and to "making visible" the process of its own procedural unfolding, often involving self-reflexivity and self-criticality.

Live coding performances actively disclose to an audience their moments of not knowing, of trial and error, and of testing something out (through endless subtractive and additive procedures, the testing of constants and variables); moreover, the promise of not knowing (and the risk, uncertainty, and sometimes even messiness therein) is arguably part of live coding's improvisational performativity. The *showing of the screen* within many live coding performances makes visible not only the unfolding code—the liveness of the *working out*—but also has a capacity for showing a level of self-reflexivity through the inclusion of live annotation, commentary, notes, and marginalia (reflecting during the live performance) embedded within the textual frame of the code. The making visible of thinking within live coding practice sheds light on the nature of knowledge production and the mode of intelligence operative therein, generating insights into this habitually unseen aspect of creative endeavor. However, the exposition of process (within live coding) is not always concerned with explication; it also has the capacity for adding layers of complexity, further enriching the work itself. Indeed, within live coding (and artistic inquiry more broadly) the process of making visible one's reasoning is not always about creating transparency but sometimes about furthering opacity, desirable confusion, and bewilderment (or even sometimes a humorous effect).

The making visible of the operational thinking and working out within live coding thus seems predicated less on a model of *how to* (apply logical, algorithmic thinking within practice). It is not so much about direct explanation or instruction, an approach based on the pedagogical transmission of a specific method, or its technics and techniques. Rather, the revelation and live reworking of digital code through its performance is inherently advocatory, even political, involving showing and sharing the unfolding logic of a language so instrumental to contemporary life but in which still so few are fluent. The live coding performance thus has a constitutional function, helping augment and inaugurate a community of existing and future live coders (a community

of practice, to echo the earlier discussion in relation to the demoscene) through the revelation of a shared or common performance language.[88] Live coding makes visible its process of thinking so that others might then modify, build upon, and creatively develop this further still, reinforcing the importance of sharing code and *commoning* within this community, referred to earlier in relation to a free/open-source ethos as well as through comparison with the oral culture explored in chapter 4.

For technical know-how to be detoured—or even *détourned*, to borrow the situationist term for the "rerouting" or "hijacking" of an existing practice or artifact, especially the software practices and products of digital capitalism, toward a new subversive meaning[89]—in the direction of live coding's experimental performance, a prerequisite level of technical knowledge is undoubtedly needed. Indeed, many live coders report a commitment made over time to the preparatory practicing of programming for developing the high levels of familiarity, process fluency, and agility needed for live coding, both in terms of mental cognition and physical dexterity. However, live coding performance is not one of simply showing one's knowledge (as rehearsed and scripted in advance). It also seeks to create the germinal conditions wherein something unplanned for or unanticipated might arise.

Reflecting on the artistic journey into the "unforeseen" or "unforeseeable," writer-curator Sarat Maharaj differentiates between innovation (conceived as the "improvement and incremental adding to what is already there") and a species of creativity that is "about discontinuity, about rupture, about production and emergence, and the spasmic appearance of something entirely unexpected and new."[90] Indeed, receptivity to the experience of not knowing is as necessary for invention and intervention within artistic inquiry as it is within practice-based craft research. For curator Elizabeth Fisher and artist Rebecca Fortnum, "Artists often begin something without knowing how it will turn out. In practice, this translates as thinking through doing."[91] They argue that this mode of thinking through doing is often associated with a "largely negative lexicon" (the uncertain, invisible, incomprehensible). At other times, "not knowing is not only to be overcome, but sought, explored and savored; where failure, boredom, frustration and getting lost are constructively deployed."[92] The not knowing of live coding seems inseparable, then, from the question "What does live coding know?," and the notion of uncertainty is addressed further through the specific lens of indeterminacy later in this chapter.

In parallel, the on-the-fly improvisatory quality of live coding invites further reflection on the relation between improvisation and cognition, on the nature of improvisatory thinking, and on the kinds of knowledges generated in and through improvisation.[93] The improvisatory approach of live coding embraces a sense of play

within its process of experimentation. For sociologist Roger Caillois, play is an inherently "uncertain activity. Doubt must remain until the end.... An outcome known in advance, with no possibility of error or surprise, clearly leading to an inescapable result, is incompatible with the nature of play."[94] Live coders appropriate and redirect (hack) a specific form of technical knowledge and language, which is then played with. Understood as a form of artistic experimentation or perhaps even aesthetic play, live coding is inherently without function or purpose (beyond itself)—it is willfully *autotelic*. Indeed, play refuses to be coerced into the service of something else. As Caillois states, "A characteristic of play, in fact, is that it creates no wealth or goods.... At the end of the game, all can and must start over again at the same point. Nothing has been harvested or manufactured, no masterpiece has been created, no capital has been accrued."[95] A different way of looking at the playful excess of live coding is by returning to a point partly developed in chapter 4 (referring to Mark Fisher's take on *red plenty*), which argues that the pressures of capitalism are not about creating wealth but necessarily *restricting* wealth. Live coding then is not about producing *nothing* but producing overwhelming plenty.[96]

For philosopher and semiologist Paolo Virno, what characterizes the "work of the performing artist" is that their "actions have no extrinsic goal. They don't create a lasting product since they aim only at their own occurrence. They don't create new objects, but rather a contingent and singular event.... The purpose of their activity coincides entirely with its own execution."[97] As Mersch argues, "Art always begins anew. There is no finality in the art, no satisfying closure, state of peace, or generalizable result."[98] For Mersch, art does not "lead to cognitive gains and their supposed truths, but rather to a break in or destabilization of the reigning codes of knowledge."[99] Mersch foregrounds the question "How does art know?" by asking whether we can conceive of a specific mode of "aesthetic thinking" or of "art as theōria."[100] For him, this is a question of "what kind of thought artistic praxis generates and to what extent it can be conceived of as a particular, even singular form of thought, in contrast to a notion of thought linked to linguistics"—that is, thought "based on a 'propositional act.'"[101] Indeed, in these terms the question of live coding's knowledge is related not only to how technical computational knowledge is deployed therein but also to the specificity of live coding's "art *as* a thinking process."[102] Here, modifying the question of "What does live coding know?" to that of "How does live coding *think*?" mirrors a wider interest within other disciplines concerned with understanding the specificity of their thinking in and through the doing of practice.

For Mersch, the challenge is one of differentiating an artistic or even aesthetic mode of thought beyond both the vocabulary of linguistic discursivity and process methodology,

where the specificity—even alterity—of an aesthetic epistemology is made explicit. He argues that *discursiveness*—"making a statement or formulating an 'argument' in the form of sentences"[103]—and *methodology* based upon a "scientific, i.e. methodological, research process" have "advanced to become the main criteria for the production of episteme," neither of which, he claims, are "particularly suited to artistic practice."[104] Significantly, Mersch is keen to avoid "favouring tacit knowledge as is the trend in science studies and the history of science."[105] Instead, he asks what "thought in other media" might mean, where "thought is understood as a practice, as acting *with* materials, *in* materials, or *through* materials . . . or *with* media, *in* media or *through* media."[106] He argues that artistic thought "reveals itself in the form of those practices that 'work in the work,' the 'becoming' of the processes themselves."[107] According to Mersch, the process of artistic thought involves "the stimulation of effects or leaps rather than directional intentions or calculated efforts that follow a precise plan and aim for closure in a manner imagined at the work's inception."[108] Moreover, it is through the act of "showing" rather than "saying" that "aesthetic knowledges" communicate their distinctiveness. Following Mersch, then, the thinking of live coding is perhaps best expressed when it is shown at work *with*, *in*, and *through* the materiality and mediality of its performance through "surrender(ing) to the event and its experience."[109]

According to Manning and Massumi, "Every practice is a mode of thought, already in the act. To dance: a thinking in movement. To paint: a thinking through color. . . . the practice in question will be construed as a mode of thought *creatively* in the act."[110] They conceive this mode of thought variously as "thinkings-in-the-act" or as "thought-in-the-act."[111] How then, is live coding's "thought in the act"? Connections have been made between the thought in the act of live coding and that of weaving, especially preindustrial loom weaving. Certainly, live coding's thinking-knowing resonates with the embodied thought-in-motion or loom-thinking activated while working on the loom:[112] both require heightened alertness to the live circumstances of their own production, a form of live or even kairotic thinking-in-action immanent to the process itself rather than conceived in advance.[113] The research project Weaving Codes, Coding Weaves (which we discussed in chapter 4 in relation to notation and in chapter 5 in relation to liveness) involved a radical recuperation of a largely ignored relation between ancient handweaving (as a mode of thought-in-motion) and the thinking that takes place within the practice of coding. The project attempted to retrieve a sense of lost or buried connections between coding and weaving by disrupting or dislodging the privileged position of the Jacquard loom in the historical conceptualization of these practices, arguing that the ancient warp-weighted loom prefigured the dyadic or Pythagorean arithmetic necessary for computational logic.[114] Rather than conceive the

connection between weaving and coding through the prism of machinic mass production and its privileged concepts of optimization, efficiency, productivity, and standardization, the research emphasis of this project was on technical processes that resist the standard template and that require the interweaving of multiple methods not possible to accommodate within standard mass production design: techniques involving the complex collaboration and cooperation between human and machine that, moreover, are predicated on the activation of embodied knowledge.

Weaving Codes, Coding Weaves focused on the points of resonance between two (temporally disconnected) practices to explore how an engagement with the past (the historical practice of ancient weaving) might open up new ways of thinking about the future (of live coding). These research concerns have since been expanded within the frame of the five-year project PENELOPE: A Study of Weaving as Technical Mode of Existence.[115] The research aim of the PENELOPE project is to integrate ancient weaving into the history of science and technology, especially digital technology, toward a better understanding of the textility of the processes of making and also thinking. The project encompasses an investigation of ancient sources as well as the practices and technological principles of ancient weaving, unfolding within a Penelopean laboratory for exploring the models and topologies of weaves and developing codes to make them virtually explorable. Both ancient weaving and live coding involve a live, embodied process of decision-making and knowledge activation that operates in excess of or *between the lines* of conventional notational systems. How might we account for the cognitive and bodily intelligences activated at the point where abstract algorithm meets with the lived experience of the weaver-coder?

Within live coding, the challenge seems less one of responding with learned behavior or an already rehearsed script than of how to harness the potential unique to every contingent situation. However, this is not about placing faith in a form of tacit knowledge if this describes an already embodied know-how. Instead, what is activated is a *known-not* knowledge closer perhaps to Maharaj's articulation of the flux of *no-how*, "distinct from the circuits of know-how that run on clearly spelled out methodological steel tracks. It is the rather unpredictable surge and ebb of potentialities and propensities. ... No-how embodies indeterminacy, an 'any space whatever' that brews up, spreads, inspissates."[116] Live coding involves a mode of knowing that is activated in response to uncertainties of the situation and that alone is adequate to the task of responding to that situation.

Live coding offers a transdisciplinary challenge to some of the assumptions of what constitutes knowledge and how it might be articulated in ways in which the outcomes are less certain or prescribed. Our suggestion is that the nontraditional methods of

live coding, inclusive of the live interactions of programmer, program code, and the practice of coding, further expand the range of possibilities for knowledge production. To put this in the context of artistic research means to place live coding within a more general critique of epistemological paradigms and the possibilities for alternative forms to reshape what we know and how we know it and to redefine some of the limits of knowledge and what escapes its confines (in the realm of alternative knowledges or nonknowledge).[117] Likewise, a productive context for considering the alternative knowledges of live coding is the expanded perspective of postcognitivist approaches to thinking, including situated, embodied, enactivist, extended, and distributed modes of cognition that have developed in resistance to the computational theory of mind that is central to the development of cognitive science.[118] It becomes clear that formal epistemologies are inherently paradoxical and that alternative paradigms (such as live coding understood as artistic research or in relation to the broader context of postcognitivism) might help to reshape how and what we know about how knowledge is produced through real-time operations and recursive feedback loops.

Uncertainty

Live coding presents a further challenge to the conventions of research practices in its embrace of uncertainty and what live coding *could* know, including those methods that attempt to incorporate practice as a mode of research to destabilize expectations or goal-oriented approaches to research design. The embrace of uncertainty and not knowing within practice is often conceptualized (in relatively anthropocentric terms) from the perspective of the practitioner. However, the uncertainty referred to in this last section draws on a sense of indeterminacy that takes its cue from the decision problem that helps to define the limits of computation. As discussed in chapter 6, and according to Alan Turing's 1936 paper "On Computable Numbers, with an Application to the Entscheidungsproblem (Decision Problem),"[119] some things are incapable of being computed, including problems that are well defined and understood. Computation contains its own inner paradoxes, and every Turing-complete language carries the potential for undecidable effects. It is not logically possible to write a computer program that can reliably distinguish between those programs that halt and those that loop forever. The decision problem unsettles certainties about what computers are capable of and what they can and cannot do. Yet, at the same time, decision-making processes become ever more automated and pervasive (especially in the era of post-truth), and it is possible to speak of a kind of "algorithmic decisionism" that values quick decisions more than correct ones.[120] Here we see the instrumental reasoning of the machine (especially the AI

machine) take form, and as such it seems important to question how to "think in terms of the means through which error, indeterminacy, randomness, and unknowns in general have become part of technoscientific knowledge and the reasoning of machines."[121] Live coding might be considered to operate in terms of decision-making in the way the uncertainty of outcomes is made evident through the introduction of further live and improvised actions outside the computer. All decisions are revealed to be contingent and subject to internal and external forces that render the performance itself undecidable and the broader apparatus an active participant. It becomes clear that research practices, methodologies, and infrastructures of all kinds are part of wider material-discursive apparatuses through which emergent forms of human and nonhuman knowledge are produced and circulated.

With reference to philosopher Foucault's *Archaeology of Knowledge*,[122] this contingent aspect is already well established, and thereby what constitutes knowledge is necessarily open to question and to alternative forms of knowledge or nonknowledge. To reiterate the point, it becomes necessary to conceptualize knowledge that is less human-centered to include ways of understanding and acting in the world that exceed what is rendered knowable through exclusively human sensing and sensemaking.[123] Live coding provides a good example of how the epistemic aspects of computational processes and technological infrastructures might be revealed through such means—for instance, in the sharing of code and screens and other sensemaking phenomena. Building on the discussions in the previous section around artistic research, we might then ask what live coding knows in itself.[124] The question helps to further establish how live coding is able to unsettle some of the certainties around how knowledge is produced. By referring to the notion of *onto-epistemology*, we invoke the feminist new materialism of Karen Barad,[125] who draws together epistemology (the theory of knowing) and ontology (the theory of being) into an ethical framework that she calls "apparatus" (after Foucault[126]). Her interest is in how apparatuses and subject/objects mutually create and define each other and as such are thoroughly active and "productive of (and part of) phenomena."[127]

If we apply this to live coding, we take our departure from an anthropocentric tendency to situate the programmer as the one who introduces uncertainty (as, for instance, through artistic intention or human error.[128]) Instead we suggest a more nuanced understanding to take into account the wider apparatuses in which human/nonhuman subjects/objects cocreate and establish outcomes together. In other words, the making, doing, and becoming of live code, coding, and coders are materialized through what Barad would call a complex intra-action of elements. As we hope is clear by now, our intention here is to demonstrate the potential of live coding to unsettle

some of the knowledge regimes through which it circulates—across various domains and networks of practice (performance, experimental computer music, computational practice, artistic, and so on). The potential to undermine expectations and introduce uncertainty is particularly important, we think, in the wider context of closed and opaque coded systems that do not provide access to any understanding of their inner operations, let alone encourage the manipulation of them at the level of writing or reading code or through the questioning of how live coding operates as part of a wider network or relations. One of the challenges then, we would argue, is to identify code as an integral part of coding practices such that it can be understood for what it is, how it is produced, and what it might become. This is arguably part of the criticality of live coding: to expose the conditions of possibility or, in other words, to remain attentive to the uncertainty of what constitutes knowledge in contested fields of practice and to demonstrate modes of uncertainty in what otherwise would seem to be determinate processes.

It is this condition of uncertainty that makes it important to us, related to the theory of probability, to stress that there is an indeterminism between human and nonhuman knowledge that comes close to the *uncertainty principle*.[129] Things are evidently known and unknown at the same time, and this is clearly the case in live coding. Events and processes are constantly renegotiated without recourse to any preexisting notion of space and time according to Barad, who is referring to both the uncertainty principle that asserts the trade-off between knowing or not knowing about position and momentum and physicist Niels Bohr's *complementarity principle* to understand how individual things have their own independent sets of determinate properties that exclude other properties.[130] This is not a consequence of the design of the experiment or the will of the scientist—or the composition of the live coding performance or intentionality of the programmer—but results from the material conditions in which the apparatus operates. According to Bohr's epistemological framework, an object is not independent of its scientific observation but is a "phenomena" and thus a condition for the way scientific knowledge is produced.[131]

Here Bohr's notion of apparatus comes close to Foucault's more complex formulation that extends the apparatus into a far wider relational network. Barad draws together these ideas—from Foucault and Bohr—to challenge the "epistemological and ontological inseparability of the apparatus from the objects and the subjects it helps to produce; and produces new understandings of materiality, discursivity, agency, causality, space, and time."[132] Her contention is that a more dynamic conception of materiality is required to take account of all bodies—human and nonhuman—that more fully describes the contemporary relation between power, knowledge, and bodies. As a result, there is not only the realization that uncertainties exist over space and time

but also the realization that apparatuses do not simply change in time but materialize through time. It is an open temporal (even time-critical) process that is not deterministic or straightforwardly causal in activating the movement from cause to effect. Rather, it can be argued that material-discursive apparatuses are constituted through constant intra-actions and that they are performative and necessarily open-ended in their production of bodies and meanings. The consequence is that spaces and times are more open to other possibilities of critical-political practice where indeterminacy and contingency coexist with causality and determinacy.

Machines, including computers, are already epistemological technologies if we follow these arguments and are not simply determined by human intentions or pre-existing scripts. The live coding performance demonstrates the point really well that determinism and indeterminism coexist in their mutual and iterative performativity. This takes place across various spaces and temporalities and also at different scales that link together the various elements to provide connections and complementarities. Drawing on the new materialism of Barad in this way allows us to assert that it is simply not possible to generate knowledge outside of the material and ontological substrate through which it is mediated. Thus, the interrelation of epistemology and the ontological dimension of the materials, technologies, program codes, and bodies can be established as active and constitutive parts of knowledge. Live coding offers a useful paradigm in which to establish how the know-how of code is exposed in order to more fully understand how code subjects and objects mutually create and define each other.

Without this know-how, we would simply miss the detail on how various effects are produced and circulated, how human-nonhuman relations are coconstituted, and how codes are embedded in wider systems of control. We might further speculate on what it means for machines to know—especially in the context of machine learning, which produces its own distinctive form of know-how as "reasoning through and with uncertainty."[133] All this helps to establish the uncertainties of live coding along with the indeterminacy of computation. More expansive conceptions and diverse forms that emerge in the complementarity between certainties and uncertainties in coding and live performances become part of the critical potential of live coding: to expose the conditions of possibility and to speculate on the emergent forms of human and nonhuman knowledge that challenge humanist traditions of thinking. The need to approach these questions from a decolonial perspective is further explored in chapter 8, where we highlight the necessity of a more pluriversal approach that challenges Western epistemological frameworks, including many of those relied on in this chapter and within this book more broadly.

8 What Does Live Coding Want?

In this final chapter of the book, we shift our attention from what live coding does or knows to the question of what it wants.[1] In characterizing the discussion this way—as if live coding were a living entity with its own desires—we extend the various threads across the chapters relating to human and nonhuman agency and how live coding might provide insights into its own future development. The question of what it wants is in keeping with our acknowledgment of the performativity of code but also with its underlying sense of purpose in the world. In this way, throughout various chapters we have tried to allow live coding to speak for itself. Initially, we included other voices from the live coding community, and subsequently, we addressed the expressive performativity of code itself—its livenesses and time criticality. To put it in Barad's terms, performativity takes place across the space and time of live coding and at different scales that link together its various intra-active elements.[2] As such, we think that live coding can help to reveal some of the details and significance of these relations (or entanglements), as well as demonstrate its potential to invent new forms of practice.

This last chapter speculates about some of these possible futures but also attempts to address some of the issues that we think merit further reflection as the practice of live coding develops. What is broadly at stake is a deeper exploration into the ways that space and time are constructed when live coding, especially in the context of corporate data repositories, increasing levels of automation, and global digital infrastructure. One thing that live coding helps to establish is that algorithms, increasingly seen to manipulate and control our social systems, are themselves recipients of live updates. Neither humans nor algorithms operate autonomously. They do so in relation to other entities and as part of larger sociotechnical assemblages and infrastructures that are constantly evolving and subject to changing conditions. In other words, both humans and algorithms do things in the world, but it is necessary to understand them as part of broader ecologies in order to comprehend their sense of agency (and environmental consequences), as well as their coconstituted agency when they perform together.

In the context of live coding, the phenomenon of the algorave resonates with this description, as an unruly event in which people are encouraged to dance to music generated from algorithms.[3] The implications of manipulating algorithms in the context of dance culture take on political significance. Dance culture, outside of its formal versions, is often considered to be a site of resistance to dominant forms of language, public assembly, and social behavior (dancing in the street as a form of protest, for instance). The UK rave scene, emanating from electronic dance music genres of house, acid house, and techno in the late 1980s, developed a countercultural reputation for the use of illegal drugs (such as LSD and ecstasy) and for subversively convening parties at unauthorized venues.[4] The algorave seems somewhat distant from these anarchist impulses and the sociopolitical movements behind Chicago house and Detroit techno, for example,[5] and yet implicitly holds on to some of the subcultural spirit in messing with normative behavior and rules at the level of the algorithm—in terms of the experience of ecstasy as alternative reality. In other words, dancing to different "algorhythms"[6] can be extended to broader imaginaries and instances of power.

The politics of live coding is there to be further performed, not least in the context of developments in machine learning and its predictive capacity. Here, again our starting question is pertinent: Adrian Mackenzie asks what machine learning wants.[7] The anthropomorphism of the machine in this sense—although problematic in other ways—draws attention to the underlying sense of purpose in these algorithmic procedures. If the machine could answer the question about what it wants, what would it say?[8] Mackenzie's point is that these predictive techniques demonstrate "operational power" that "generate statements and prompt actions in relation to instances of individual desire."[9] The techniques indicate something about how machine learning is generalized and how it produces subjectivities and the desire to predict particular things generated from data sets that are already ideologically determined. Machine learning is *found wanting*.

A tension emerges around the divisions of creative labor here—between programmers and machines and how they program together and apart. Rather than the work of traditional programming, what becomes even more challenging is the way in which automation has taken new forms in the field of artificial intelligence (AI) and in the subfield of machine learning, where it becomes far harder to differentiate what and who is doing what.[10] Given that machine learning is derived from the logic of calculation,[11] the perceived power of algorithms rests on an understanding of how they operate, which is made clear in Mackenzie's book *Machine Learners*, in which he examines specific algorithms and data practices to understand the particularity of human-machine relations and their transformations.

The assumption, as Mackenzie also points out, is that everything that exists becomes reducible to stable and distinct categorization.[12] Live coding is a practice that operates in a rather different register and troubles classification in multiple ways, refusing to be easily fixed, defined, or generalized. As we have outlined in earlier chapters, live coding opens up new ways of thinking about notation, liveness, and temporality. It also involves the misdirection of technological know-how, with human and nonhuman agencies engaging in a collaborative and coemergent process of experimental performance that embraces uncertainty and failure, risk, and surprise. Live coding thus emerges as a radically open aesthetic practice capable of destabilizing and disrupting the instrumentality and determinism of algorithms and data structures and of subversively undermining some of the more insidious infrastructural and ideological values inherent to computational culture.

In the following we outline some of these political challenges for live coding and suggest that it can help to mobilize an engagement with social justice in the face of algorithmic corporate regimes and governmentality that threaten to undermine freedom of thought and action. As a dynamically creative and generative practice, live coding offers a means of appropriating the algorithm for different ends or even to stress *means without end*.[13] Its potential politics comes from its ability to expose the differentials of power, materiality, subjectivity, agency, and so on and how meanings are produced through reconfigured human-machine relations. Although we have tried to pay attention to some of these grand challenges in terms of intersectional politics and postcolonial, minority ethnic, and disadvantaged narratives, clearly there is far more work to be done.

This final chapter does not offer solutions but further develops the problems in the spirit of criticality: first, situating live coding in the broader context of data structures and developments in machine learning; second, addressing the colonial legacies and inherent exclusions of algorithmic culture; and finally, returning to the title of the book to stress that live coding is about people interacting with the world, and each other, and about social relations and their transformation. As we have already stated, the liveness of live coding invites reflection on what it means to be alive—to have bodies and to interact with other humans and nonhumans, including machines. We stress that live coding is neither deterministic nor universalist in this way and how, by its very nature, it is process driven, endlessly subject to revision and modification—like this book, which remains open to further development through the use of creative commons licenses—offering a means for thinking and doing in the world that is not constrained or prescriptive in its direction or purpose. These bold statements need further unpacking, of course, so first we address the broader context of data infrastructures

and automation and how live coding helps to establish that algorithms are not as fixed or as deterministic as they might first appear. What live coding wants, then, can only be uncovered by engaging more fully with the sociotechnical conditions in which it arises.

Data Structures and Algorithms

Live code drills down and digs into the logic of digital systems.[14] It presents them for inspection and offers an alternate universe in which artists attempt to take control. Two fundamentals of computer science are, first, data structures—data organized in a certain way—and, second, algorithms, or rules for manipulating that data.[15] The two are often permeable or interdependent, with rules defining structure and structure establishing the rules for action. However, as argued by theorist Andrew Goffey, it is important to remember that algorithms are also culturally situated as linguistic sites for pragmatic action.[16] It may once have been the case, in classic cybernetic systems, that the programmed goal state would (in principle) be open to inspection. But a broader understanding of algorithms leads us to ask about the ways in which rules and structures work together and how they might be manipulated.

For anthropologist and anarchist activist David Graeber, the algorithmic rules from which society constructs bureaucratic systems are a form of *structural violence*, fundamentally opposed to the freedom that is both allowed and celebrated in human play.[17] Whether by left- or right-wing politicians or by Libertarian Silicon Valley corporations, human words and actions are structured into algorithmic courses and categories. Modern markets and democracies supposedly act in the interests of the public—but this so-called public is itself a structural artifact, brought into existence by the infrastructural mechanics of electoral systems, opinion polls, and media channels. Now in the early 2020s, disclosures of covert political influence wielded via social media platforms, such as Facebook,[18] generate widespread anxiety over the continued rise of extreme far-right populism while newspaper headlines state "Why 'Ditch the Algorithm' Is the Future of Political Protest,"[19] in relation to systems of educational quantification disrupted by the COVID-19 pandemic.[20]

Live coding, in this analysis, is not simply a poetic or performative allusion to the hacking of cybernetic infrastructure. As well argued by Jacques Attali,[21] music, through its abstract form, is able to explore and experiment with structures that are later adopted in the economic and social domains. Here, live coding brings into being new kinds of rules in which the structures being made are intended to be transient—an invitation to play, not to build. Live coding is a political demonstration of restructuring, not purely

deconstructing. Live coding projects such as Rodrigo Velasco's on-the-fly code poetry and Kate Sicchio's Terpsicode make this clear when they step outside the conventional digital realm, producing rules for the dancing body, for tangled threads, for theoretical texts, or for social processes.[22] These instantaneous bureaucracies are generative, producing new experiences rather than being subjected to existing structures. Could there be a world in which artists make the rules? Graeber contrasts the structural violence of bureaucratic systems with the creative freedom of the anarchist or artist. He claims that the true spirit of the Left is not to be found in a Socialist state but in the liberty of playful expression. The play of making new rules, new algorithms, and new structures is indeed a technological speech act, but one that brings into existence new kinds of social relations, as well as human-machine relations. Consider the weeklong, nonstop online live coding events featuring hundreds of live streamed performances coordinated by Argentinian artist and developer Damián Silvani's muxy software,[23] or the features built into the Hydra live coding platform that allow live coders to submit and receive code patches as a kind of social networking through code. Such software extends live coding systems outward, in order to organize new social practices.

Infrastructural Monopolism and Craft Resistance

Behind these operations, and largely invisible, is the infrastructure of big data, in which data and services are delivered from a massive, intentionally obscured *cloud* of server farms across global fiber-optic networks.[24] Global corporations compete to exploit this infrastructure, each working to recruit customer users into its own proprietary ecosystem: consumer devices that harvest data from the user's home or pocket, archives of every action and utterance the customer makes, and software that sells these data to advertising agencies or back to the customer themselves as new services. The proprietary ecosystem architectures are designed to lock in the user as a loyal citizen of Apple, Google, Facebook, or Amazon, through which the corporation gains maximal rights to the resulting data. Programmers are increasingly reliant on code produced by these companies, particularly for the machine-learning libraries at the core of data-driven business. Statistical pattern analysis allows companies not only to monitor every action of their users but also to predict those actions in a dynamic now recognized as *surveillance capitalism*.[25] However, users constantly experience disconcerting tensions between conveniently intelligent prediction and creative action or decisions. The everyday dynamic of predictive text means that whether writing in love or in condolence, a user's devices are intervening to assist, brushing aside any poetry with the statistical recommendation of familiar words they have used before.

This substitution of archived platitudes for creative expression is the real business model of big data. When a user struggles to express an original query for Google, the browser leaps to offer the same question that ten thousand other people have already asked, ideally directing them to a product linked to specific Ad Words. Even when avoiding invitations to purchase, "free" answers involve, at best, delivering an article that the PageRank algorithm has judged to be most popular or the carefully anodyne compromise of a hundred Wikipedia editors. Individual authorship is neither needed nor wanted. Whether celebrated as open source or creative commons, the reality is that nobody gets paid for the work that was done, other than Google, which acts as the "rentier of cognitive capitalism," in the analysis of media philosopher Matteo Pasquinelli,[26] or even engages in "institutional plagiarism," as suggested by Alan Blackwell.[27]

In contrast to these algorithmically mechanized and statistically standardized online experiences, live performance confronts the audience with a real, embodied person on the stage. Live coding reverses the homogenization of creative technology, particularly music technology where intelligent beat trackers, arpeggiators, autotuners, mastering tools, or harmonizers present music that has been algorithmically averaged to meet audience expectations. Whereas algorithmic assistance might encourage performers to abdicate from the elementary creative decisions of each moment and newer generations of machine-learning systems engage in institutionalized plagiarism through the processing of anonymized training data for the automated pastiche of *style transfer*, live coders are able to define the terms on which remixing will proceed. In live coding, the structural components of the sound are openly acknowledged in the code that produces it and, as a result, are made more visible.

Perhaps the question, then, is whether the live coder can escape the infrastructural supply chain of the music industry, whether iTunes, YouTube, or Spotify.[28] Put simply, just as the industrial revolution delivered all surplus value to the bank accounts of the capitalist landowners, so, too, has the big-data revolution been extracting value from creative work to enrich those who own the infrastructure. Live coders could look to Luddism as one way out. The Luddites formed a prototypical union movement that, not unlike live coders, stood for craft practices and against full automation.[29] Despite their modern-day image, the Luddites were not against technology in general; rather, their radical, distributed, and at times successful campaigns were to protect the livelihoods of artisans who were accomplished users of their own technologies. Indeed it is plausible that software engineers will in the future find many elements of their own industry replaced by AI automation (as hinted by GitHub's AI copilot), just as handweavers found their livelihoods undermined by machine automation. Power looms stand not only for the automation of weaving but also for limits on the possibilities

of weaving. The algorithmic patterns intrinsic to weaving handcraft were dehumanized and creatively constrained within the grids of Jacquard's punch cards. Just as weavers sit at handlooms, live coders sit at computers, humans and machines working together in ways that suggest alternative, potentially more social and sustainable forms of control.[30]

The Live Coding *Other*

As has been established, live coding tends to be presented as a practice in which the coder is in relative control of the machine, a scenario in which the machine is a passive receiver of instructions and follower of commands, executing according to script. However, computational systems need not be so submissive. As we saw in chapter 4, live coders have from the beginning explored models of programming in which ideas of actors, interactive objects, conversational programming, or machine learning become more overtly constitutive in the relationship between the coder and the machine.[31]

The prospect of the live coding language learning about the coder is both enticing and disturbing to the narrative of taking back control. Reflecting continued advances such as code completion, templating, and automated refactoring in software-engineering tools, and even the generation of novel code,[32] the live coding language might suggest, predict, comment, or correct code that is being created in real time. These systems might learn from more than one user, gathering data from the crowd in a manner similar to how data analytics is increasingly applied in commercial music technology contexts to track user behavior, perhaps even identifying new music genres as they emerge. The live coding alternative is interesting in this context given that most, if not all, live coding systems are committed to open-source principles of collaboration—not least that the code is projected to the audience. In an open-source and open-access world, live code data analytics could allow participants to become more aware of and connected to wider cultural movements.

In principle, the definition of neural network architectures for machine learning could also be live coded. What might not be so open to the audience, or publicly projected, would be the statistical outcome of the training or the model structure in which pretrained networks are used. This is a problem studied in the MIMIC research project, which puts machine learning, particularly its Sema live coding language, into the hands of creative coders and aims to support *small-data* machine learning, real-time initiation, and training, all as part of the live performance.[33] Relatedly, the artist-driven Patterns in between Intelligences project opens up AI through dance and live coding. This performance approaches intelligence in terms of oscillatory processes in the brain, which it extends into oscillatory processes between live coders, live dancers,

interactive etextiles, and pattern-recognition and pattern-generation algorithms.[34] The explorative, critical, and questioning principles of live coding apply here as well: if the commercial companies are feeding artists and audiences precooked tools for musical creativity, live coding can still represent a locale where users are able to experiment, learn, develop, communicate, and share through a critical relationship with emerging technologies. It might well be that the public understanding and experience of machine learning and AI will be through live coding and creative coding—that is, areas where programming is used for human expression and where the concepts of sharing and communicating are still prioritized over commodification and datafication.

It is likely that many technological devices will increasingly adapt to their users in the future. A smart refrigerator (a perennial example in the imaginaries of future consumption[35]) should ideally learn the behavior of each fridge owner, ordering (or recommending) what each person needs rather than forcing predefined and standardized food consumption on all. The same is happening across the Internet of Things in models of cars, sporting appliances, smart watches, game controllers, and, potentially, musical instruments. With the latter we might imagine a situation in which two physical musical interface controllers come with the same default mapping (gestures-to-sound) from the factory, but each user might then train the instrument such that it adapts to their musical needs and habits. Two users who bought the same musical instrument in the shop might, after a few months, have trained two quite distinct instruments. The training would have derived from the use and supervision of the owner. The two users might even swap training data (since the data would simply be a file on the device), creating a sense of alienation and estrangement with the instrument.[36] Such experiences are familiar in other performance contexts; for example, violinists often remark that if they lend an instrument to someone else to play, it feels slightly different after being returned.[37]

Now an interesting question is whether the same type of programming instructions might be interpreted differently by differently trained program interpreters or programming editors. Might the system learn features of its user—for example, in terms of sounds (types of synthesis, such as FM or subtractive), effects (distortion, reverb), rhythmic preference (strict, swing), mix (volume of individual instruments, mastering effects, such as compression). In the future, could live coded notation be interpreted differently by instances of the live coding language, just like notated music is interpreted differently by every performer who plays it? Just as natural human languages change through use, systems will learn and cybernetically adapt to their user's behavior, and there is no reason to think that this won't happen with live coding systems, or that this is necessarily a problem. The cultural importance of the systems described here is that they will be open, trained, explored, and presented in real time such that

users of technology will still be able to yield control, understand, peek under the hood, develop, participate, and change, as people have always done with the technologies they make and use. Lisanne Bainbridge noted that one irony of automation is that an automated system requires an expert to supervise it and step in when it goes awry, but it is difficult to maintain this human expertise in an automated task they are disassociated from.[38] Live coding offers a way to keep humans engaged as authors rather than supervisors of automation.

The continuing concerns over developments in machine learning are also plain to see whenever predictive algorithms, or predictive analytics techniques, are applied in the broader context of the creative economy. Even critical practices that employ machine-learning techniques run the danger of perpetuating the same logic—whether intentionally or not—because they are necessarily aligned to the capitalist production underpinning their infrastructure. In other words, there are some serious worries about the forms of creativity produced through machine learning, given the broader political context in which it arises. Yet, despite these worries, practices can also emerge that engage with the claims of machine learning and the ways in which it produces knowledge and forms of creativity through reconfigured human-machine relations. What other technologies can live coders bring back from the world of mass production and control to the world of craft?[39] What alternative practices might emerge that take account of, but are not reducible to, the capitalist creative economy? We might refer once again to Agre's "critical technical practice" to stress the importance of social and political aspects of technical fields such as AI.[40] He asserts that AI becomes a discursive practice through the way the technical terminology offers intellectual generativity, developing analogies between otherwise disparate technical and critical activities and intellectual traditions. In addition, we would suggest the need to look beyond creative, technological, and critical traditions that are rooted in colonialist and extractivist worldviews. The ways in which we have conceptualized human-machine relations may have become less stable in the case of live coding and be grounds for reinvention, but they are still rooted in Western cosmology.[41] We hope the examples in chapter 3 demonstrate how contemporary live coding is responding to some of these challenges through diverse practices.

Live Coding in a Globalized Context

Previous chapters have discussed the imaginaries opened up by live coding, but it is important to consider what practical boundaries might remain, even if adopting the liberating ideals of movements such as free/libre open-source Software (F/L/OSS).

The F/L/OSS movement, in which "'free software' is a matter of liberty, not price" was becoming a mainstream feature of contemporary arts and data activism by the time the TOPLAP manifesto was written. As noted by Christopher Kelty in 2004, F/L/OSS had "broken free of its connection to software and become common among artists, writers, scientists, NGOs, and activists."[42] The once liberating ideals shared by this nexus of media artists, policy advocates, and open-source hackers established a zeitgeist for the arts in the early twenty-first century. And yet this critical tradition that takes as its focus the ability to have access to code (and sharing screens) is not particularly revealing or effective unless it is understood as part of the larger set of sociotechnical relations within which it operates. When it comes to machine learning, for instance, as Mackenzie explains, the code logic is different, as the learning does not rely on symbolic logic alone. The further point is that there is more than code here, situated as it is in open-source platforms and communities of interest that help to shape the ways in which power and knowledge are expressed.[43] This is both inclusive and exclusive of others.[44] The problem is that there was little acknowledgment at the time these movements were founded and thrived in the Global North, where the advocates and interventionists were White and male by a large majority. Just as the free software community excluded women to a far greater extent than the (already male-centric) computing industry,[45] it seemed that attention to software as a moral enterprise in itself could often draw attention away from the individual activist's own privilege and participation in systems of oppression.

The ideals of openness are easily co-opted for purposes of oppression. As explained by Linda Tuhiwai Smith in relation to Indigenous peoples:

> Multinational companies have been given transnational freedoms that enable them ultimately to move labor across borders (importing and exporting people for the labor market), to foster an intellectual property regime that has few ethical limits, to shape national laws and values at the expense of national identities, and to develop themselves in competition with governments.[46]

Similarly, the supposedly open, but still Western, infrastructure of the scientific knowledge economy means that the scholars of Africa become subject to scientific extraversion and are oriented away from their own countries.[47] Movements that are associated, in the Global North, with inclusion and consultation are similarly co-opted for other purposes in the South. The agile software movement (as mentioned in chapter 7), with its origins among liberal thinkers of Portland, Oregon, has subsequently become another source of asymmetric relations in global outsourcing.[48]

If we establish some critical distance from the moral enterprises that have defined ethically oriented movements such as open science, free software, or indeed live

coding, might there be any obligation to distance live coding itself from global infrastructure, as a necessary element of its liberating agenda? We should first be clear that, while observing how live coding is indeed implicated in global systems of inequity constructed through the legacy of colonialism, addressing the problems of live coding is not an adequate redress. We do not wish "to focus on decolonizing the mind, or the cultivation of critical consciousness, as if it were the sole activity of decolonization; to allow conscientization to stand in for the more uncomfortable task of relinquishing stolen land."[49] Similarly, we would not wish to claim a "postcolonial" viewpoint from which to avoid complicity in these systems. As Aborigine activist Bobbi Sykes observed: "What? Post-colonialism? Have they left?"[50]

Nevertheless, commentators on the software industry, drawing on theoretical discussions of decolonization and postcolonialism, have identified useful warnings and precautions that are relevant to live coding. As proposed by Lilly Irani and others, "Postcolonial computing, then, is not a project of making better design for 'other' cultures or places. It is a project of understanding how all design research and practice is culturally located and power laden, even if considered fairly general."[51] Similarly, Geoffrey C. Bowker and Susan Leigh Star's argument in *Sorting Things Out*, on classification and how we structure our world through language and design, clearly implies that systems designed in the Global North might not fit so well to work patterns elsewhere in the world.[52] In response, what is suggested is "a bag of tools" for critical reappraisal of computing technologies.[53] Drawing on these ideas, we are reminded once more of the *long networks* in which live coding participates and on which it depends. These extend beyond open-source software components and communities of support to networks, servers, manufacturing facilities, and mineral extraction. As compellingly diagrammed by Kate Crawford and Vladen Joler in their *Anatomy of an AI System*,[54] and subsequently evidenced at length in Crawford's *Atlas of AI*,[55] the abstractions of contemporary computational culture remain founded in material realities of colonial oppression and exploitation.

These unwelcome realities of our contemporary situation seem entrenched in ways that live coding would struggle to challenge or modify. Nevertheless, as indicated above, there are tactics that can be applied in sites of innovation—and live coding is fundamentally enacted as a practice of innovation and creation. Many live coders, for example, attend to the *coalescing regime* of the community, asking what work has been placed outside its bounds. For example, why has live coding not been widely welcomed by hip-hop, grime, or drill producers as a tool for vocal performance and social critique? When listening to the impressive transcriptions of Fela Kuti compositions that artist and programmer Evans Augustt created in Sonic Pi,[56] one might ask

how remediation via code could develop the political activism central to the origins of Afrobeat. As with the Afrofuturism of Sun Ra and Black Panther, or indeed the sanctification of Marcus Garvey in reggae music, the harder implications of pan-Africanism in relation to systematic racism and injustice warn their audiences against the trivial appropriation of exotic samples or dance rhythms. Many of these commercial musical practices have been established within, and constrained by, the capabilities of digital audio technology. Live coding could certainly be a tool for the disruption of such boundaries, for which we look to follow examples being set by the growing live coding communities in Latin America, from the Colectivo de Live Coders in Argentina to the birth of Algorumba in Medellín, and the grounding in living heritage, such as through the Neokhipukamayoq manifesto (discussed in chapter 2).

It may be necessary to be more alert to the implications of live coding's own generous intentions, more clearly articulating a developmental "theory of change" in association with the global ambitions for live coding.[57] Maybe this is something live coding wants—to simply be useful.

Conditions of Use

As stated in chapter 1, the title of this book borrows from Georges Perec's novel *Life: A User's Manual*.[58] The original French title, *La Vie mode d'emploi*, makes clear a relation between the terms *use* or *user* and the notion of employment, with *use* meaning "to employ for a purpose," "to make use of," "take advantage of," or "to consume." Indeed, a user's manual (a *mode d'emploi*) is often something to be used—to be put into action or to be applied in practice. It could be easy to conceive of use only as the capacity of a commodified object to serve a useful purpose or satisfy some extrinsic and existing demand, need, or want. Rather than focusing on the usefulness of live coding (and how it might serve an external purpose or want), how can we look beyond the utilitarian to really consider what live coding itself might want? Indeed, the etymology of the term *employ*, "to entangle," from the Latin *implicare*, meaning "to enfold," "to involve," "to be connected with, associate or else unite," also complicates any narrowly utilitarian or even instrumentalized application. In these terms, this book is not so much a *mode d'emploi* or user's manual *on* or *about* live coding as an attempt to explore live coding *as* a user's manual or guide.

We return to the title of the book, *Live Coding: A User's Manual*, to underscore that live coding is about people interacting with *life*—with the world and with others—with social relations. Or rather, by returning to the title, we again foreground the significance of the term *user*—and of the user's interaction with both computer technology

and an increasingly technologized world. We refer once again to artist Olia Lialina's lamentation on the disappearance of the user and the critical implications therein. As Lialina observes, the evolution of digital technologies has in part involved an evolution of alienation, the "alienation of users from their computers."[59] She states that "the denial of the word 'user' in favor of 'people' becomes dangerous. Being a User is the last reminder that there is, whether visible or not, a computer, a programmed system you use."[60] Counter to the notion of the "invisible user,"[61] live coding can be seen as part of a wider movement of resistance, which epitomizes in Lialina's terms a certain mindset or mode of interaction with hardware and software that "makes the user visible, most importantly to themselves."[62] Live coding's practice and politics of making the screen visible are also gestures of making visible the possibility and potential of a user, or a multitude of users who might otherwise be rendered invisible. It is a practice for making visible the symbiotic relationship between human and machine, as well as the broader infrastructures that support it. The potential of a *critical-technical user* is that they are not simply implicated or complicit within an increasingly technologized "society of control,"[63] which they can neither fully understand nor begin to resist but retain or reclaim some capacity to act within—or even to complicate—that system.

Indeed, live coding can be conceived of as a practice of *complication*. Throughout this book, live coding is shown as a practice that complicates and exceeds easy categorization or containment within any singular system—whether of notation, of liveness, of temporality, of epistemology, or of coding itself. Live coding willfully undoes—disrupting and unraveling established categories and ways of thinking while weaving a more complex relation and collaboration between the sciences and the arts and between human and nonhuman forces. From *implication* and *complicity* to *complication*—etymologically, these terms each contain the Latin *plicare*, meaning "to fold, weave." *Complicate* then means to fold or weave together. In these terms, live coding's practice of complication is not one of making things difficult nor only of destabilizing certain (binary) definitions and demarcations of making strange. Affirmatively, it has the capacity to reveal or make visible something of the complexity of posthuman entanglement and intrarelating.[64]

At times, writing this book has also been a complicated undertaking. It has evolved through a process of gradual development—its work has taken time. For all of its just-in-time immediacy and liveness, our attempts to engage with the complexity of live coding as a practice have required a slow approach. As Michelle Boulous Walker reminds in *Slow Philosophy*, "Honouring the rhythms and temporality of deep and careful thought—thought that is threatened by speed, efficiency and interchangeability—means, perhaps, honouring the importance of a slow engagement with the work that

we do."[65] Our own slowness attests to the challenges that we have encountered during the process of our collaborative writing as we have attempted to *write with* live coding rather than necessarily write *about it*; as we have explored ways for bringing different and diverging ideas and perspectives on live coding into dialogue without homogenizing them within a single authorial view; as we have tried to reflect on both the practical and conceptual implications of live coding as a critical technical practice.

In the early stages of the process, our approach had distinctly experimental ambition, willfully playing with various rules and constraints and striving for a form in which the writing itself remained close to the practice of live coding and in which the different authorial styles were more amplified and clearly evident. As the book evolved, the differentiation of individual authorial voice became more complicated (woven together) through the collaborative process of coproduction and reciprocal *thinking with*. Likewise, though we conceived the structure of the book as broadly bipartite—the first part more practice oriented, the second part more speculative and conceptual in its register—we hope that the reader will navigate between, complicating any neat separation of practice and theory.

During the period of writing this book, we watched live coding continue to evolve as a practice and as a community in ways that could not have been predicted at its inception. It has now been over twenty years since the specific term *live coding* first appeared (around the year 2000), and considerable time has passed since the TOPLAP manifesto was first drafted in 2004. Indeed, in so many ways the state of the world feels very different to those millennial years. As outlined already, live coding emerged in relation to the coming together and culmination of very specific conditions: the influence of critical precedents and forerunners; significant technical developments enabling greater access to and availability of computers, as well as increased capacity for real-time programming; higher educational institutions receptive to experimentation and the genuine risk of transdisciplinary collaboration; the existence of cultural venues open to new possibilities of practice; the techno-optimism of people who embraced the global digital network as a liberating force, often driven by companies that promised not to be "evil";[66] international festivals and symposia that enabled the cross-pollination of ideas and practice to create a live context for conversations and collaborations, for experiencing live coding *together*. Writing this chapter in 2021 against the wider context of ever-increasing global precarity—economic, environmental, political, and social—and indeed from the perspective of numerous lockdowns and widespread losses experienced during the current coronavirus pandemic, the fragility and interconnectedness of various ecologies of life and practice become ever-clearer. The task of confronting racial inequalities and dismantling the colonial edifice of White privilege gained a heightened sense of urgency in

the wake of the police murder of George Floyd in May 2020 and the subsequent Black Lives Matter protests. In parallel, the implications of the current climate emergency for all forms of life are a live crisis that no field of practice can afford to ignore.

We don't yet know how live coding will respond to these new challenges. It could be tempting to see conditions of practice as something given, something outside of one's influence or control. Although life will always be unpredictable, certain conditions of practice can be created as much as awaited and actively produced rather than lamented, resisted, or simply reacted to. Live coding exists in a technical ecosystem, and when new languages, techniques, and technologies emerge—be it haptic interfaces, a new language, or libraries for AI, for example—live coders are likely to pull them into their practice, critically evaluating and contextualizing them in the performative setting. It is perhaps easy to forget that live coding did not just emerge in response to certain conditions but also created the conditions for its own emergence. Many first-generation live coders were actively inventing the various programming languages and live coding environments that are now used by live coders all over the world. Many live coders create and curate, as well as perform at, the various festivals, symposia, workshops, seminars, and algoraves through which the practice of live coding is shared and evolved and are core members of academic and research programs. How might live coding retain the liveliness of its instituting while resisting institutionalization? This question has also been very present in the writing of this book. Certainly, there are new communities of live coding coming into being all over the world that retain a sense of the urgency, even insurgency, of those initial instituting moments of live coding and that continue to invent and reinvent the conditions of and for practice. Still, the evolution of the practice and community of live coding has involved a broad shift from the conditions of necessity and urgency (when the means did not yet exist so had to be invented) to one of *plenty*, to a plethora of technological options and choices for the prospective live coder.[67] However, technology (and indeed live coding) is something that you *do*, not something that you simply consume or own.

Tracing the trajectories of live coding's evolution is not an exercise of nostalgia nor a gesture of retrospectively looking back. Rather, this book attempts to reinvigorate the critical questions that drove live coding practice in its inception while anticipating the possibilities of live coding's future still yet to be written and still remaining in potential. Live coding is not a progressive practice in conventional terms—it is not concerned with the normative teleology of development, improvement, and growth. Live coding wants to be undone, unraveled, unwoven, and rewoven anew.

Notes

Chapter 1

1. For example, users can be exploited through their apparent inclusion, as with the so-called sharing economy. We return to a positive application of the term *user* later in this chapter with reference to artist Olia Lialina's essay "Turing Complete User," 2012, accessed March 11, 2022, in which she argues for the continuing usefulness of the term: http://contemporary-home-computing.org/turing-complete-user/.

2. The utility of traditional user manuals for any purpose is problematized in the body of work on *minimal documentation*, which offers complementary evidence for the value of live action and experience as an approach to instruction and learning, rather than reading books. See John M. Carroll, *Minimalism beyond the Nurnberg Funnel* (Cambridge, MA: MIT Press, 1990).

3. See David Ogborn's exposition in chapter 3.

4. The notion of real time is explored further in chapters 5 and 6.

5. Command-line interfaces are essentially live coding interfaces, presented in Douglas Engelbart's 1968 "Mother of All Demos" as a form of augmented intelligence, that are still present in modern operating systems.

6. Of course, live coding also references a variety of alternative practices, including hacking, prototyping, code bending and demo-ing, that are already recognized or understood to some degree. For example, see Iias Bergström and Alan F. Blackwell, "The Practices of Programming" (paper presented at IEEE Visual Languages and Human-Centric Computing (VL/HCC) 2016, Cambridge), https://www.researchgate.net/publication/308540044_The_Practices_of_Programming.

7. See Sarah Groff Hennigh-Palermo's exposition in chapter 3; see also her "Seven Points for a Computer Critical Computer Art," n.d., http://art.sarahghp.com/seven-points/.

8. The term *defamiliarization* was introduced by Viktor Shklovsky in his (1917) essay "Art as Device" (sometimes translated as "Art as Technique") in *Theory of Prose* (1925; repr., Elmwood Park, IL: Dalkey Archive Press, 1990). For more on this concept and Russian formalism, see, for instance, Fredric Jameson, *The Prison-House of Language: A Critical Account of Structuralism and Russian Formalism*, vol. 332 (Princeton, NJ: Princeton University Press, 1974).

9. In making software strange, we echo the slogan of the ReadMe festival curated by Olga Goriunova and Alexei Shulgin (organized between 2002 and 2005, with events in Moscow, Helsinki, Aarhus, and Dortmund): "People doing strange things with software" (which is itself a reworking of the "doing strange things with electricity" used in Dorkbot events). For more on this, see Read Me, last modified April 11, 2017, https://monoskop.org/Readme.

10. By *open work*, we refer to philosopher and semiotician Umberto Eco's oft-cited *The Open Work* (Cambridge, MA: Harvard University Press, 1989) to emphasize how live coding is open to, and further completed by, the performer, viewer, reader, or audience.

11. To be more specific, interface design becomes experience design under this (not-open) logic, and this has always been a reductive (behaviorist) notion that experience itself can be designed.

12. For example, the European Disappearing Computer research program. See Norbert Streitz and Paddy Nixon, "The Disappearing Computer-Introduction," special issue, *Communications of the ACM: The Disappearing Computer* 48, no. 3 (2005): 32–35.

13. Lialina, "Turing Complete User."

14. By Big Tech we refer to the monopolistic practices of the four or five largest and most dominant companies in the information technology industry: Amazon, Apple, Google, Facebook, and Microsoft. Here we also invoke Douglas Rushkoff's *Program or Be Programmed: Ten Commands for a Digital Age* (Berkeley, CA: Soft Skull Press, 2011) and the more overt notion of *mass deception* in Theodor Adorno and Max Horkheimer, "The Culture Industry: Enlightenment as Mass Deception," in *Dialectic of Enlightenment* (1944; repr., London: Verso 1997).

15. Writing on human computer interaction, Christine Satchell and Paul Dourish explore "not using computers—ways not to use them, aspects of not using them, what not using them might mean, and what we might learn by examining non-use as seriously as we examine use." Their point is not simply about "not using" but about exploring the varieties of not-using and how this relates to social relations (e.g., disenfranchisement as it is related to disability, socioeconomic status, geographical factors, and more). It is clear that certain kinds of users tend to remain invisible. See Christine Satchell and Paul Dourish, "Beyond the User: Use and Non-use in HCI," in *OZCHI '09—Proceedings of the 21st Annual Conference of the Australian Computer-Human Interaction Special Interest Group: Design: Open 24/7* (Australian Computer-Human Interaction Special Interest Group) (New York: Association for Computing Machinery), 9–16.

16. Lialina, "Turing Complete User."

17. Georges Perec, *Life: A User's Manual*, trans. David Bellos (London: Harvill Press, 1996); originally published in 1978, in French, with the title *La Vie mode d'emploi*.

18. Raymond Queneau, cited in Warren F. Motte Jr., ed., *OuLiPo: A Primer of Potential Literature*, trans. Warren F. Motte (Funks Grove, IL: Dalkey Archive Press, 1998), 38.

19. For example, we have worked alongside each other within the framework of the AHRC Digital Transformation research projects Live Notation: Matters of Performance (2012) and Weaving Codes/Coding Weaves (2014–2016), as well as through many meetings of the International Conference on Live Coding (since 2015 and ongoing).

20. This etymological relation is explored further by Tim Ingold in *Lines: A Brief History* (London: Routledge, 2016).

21. We draw reference here from poet Kenneth Goldsmith, who has argued that writers today are beginning to resemble programmers—working with writing machines to generate and execute texts. See Kenneth Goldsmith, *Uncreative Writing* (New York: Columbia University Press, 2011), 1. In *Uncreative Writing*, Goldsmith makes clear his desire not to produce ever more new texts but instead to manage, organize, and distribute them in divergent ways.

22. Our method was to draw freely on the affordances of technologies to *render* our thoughts and conversation in a written form that is nevertheless embedded in technical infrastructure—of wikis, word processors, and collaborative writing platforms. We endeavored to stay attentive to the literary and technological form as a "writing machine," as literary critic N. Katherine Hayles has put it. To further clarify, Hayles explains: "When a literary work interrogates the inscription technology that produces it, it mobilizes reflexive loops between its imaginative world and the material apparatus embodying that creation as a physical presence." N. Katherine Hayles, *Writing Machines* (Cambridge, MA: MIT Press, 2002), 25. An account of some of these writing experiments can be found in Alan Blackwell, Geoff Cox, and Sang Won Lee, "Live Writing the Live Coding Book" (paper presented at the International Conference on Live Coding 2016, McMaster University, Hamilton, Canada). See http://iclc.toplap.org/2016/papers.html.

23. Here we align our views with Walter Benjamin's "The Author as Producer" in saying: "The reader is always prepared to become a writer, in the sense of being one who describes or prescribes. . . . And writing about work makes up part of the skill necessary to perform it. Authority to write is no longer founded in a specialist training but in a polytechnical one, and so becomes common property." See Walter Benjamin, "The Author as Producer," 1934, in Vol. 2, *Selected Writings, 1931–1934*, ed. Howard Eiland, Michael W. Jennings, and Gary Smith (Cambridge, MA: Belknap Press of Harvard University Press, 2005), 90.

24. The temporal lag of writing operates as a "strange loop" in this sense. Consider the following example: "The sentence I am now writing is the sentence you are now reading." The example is from Douglas Hofstadter, *Gödel, Escher, Bach: An Eternal Golden Braid* (1979; repr., New York: Basic Books, 2000), 495. See also Douglas Hofstadter, *I Am a Strange Loop* (New York: Basic Books, 2007).

25. Across these two parts of the book, the idea is to gradually expose live coding to be a "critical technical practice." See Philip E. Agre, "Toward a Critical Technical Practice: Lessons Learned in Trying to Reform AI," in *Bridging the Great Divide: Social Science, Technical Systems, and Cooperative Work*, ed. Geof Bowker, Les Gasser, Leigh Star, and Bill Turner (Hillsdale, NJ: Erlbaum, 1997), 131–157. In referring to aesthetics in terms of *sensing* and *sensemaking*, across the arts and science and concerning human and nonhuman entities, we invoke Matthew Fuller and Eyal Weizman, "Aesthetics," in *Investigative Aesthetics: Conflicts and Commons in the Politics of Truth* (London: Verso, 2021), 43–55.

On "aesthetic practice" and "practices of aesthetic thinking," see also Dieter Mersch, *Epistemologies of Aesthetics* (Zurich: Think Art Diapanes, 2015) and "Aesthetic Thinking: Art as Theōria," in *Aesthetic Theory*, ed. Dieter Mersch, Sylvia Sasse, and Sandro Zanetti, trans. Brian Alkire (Zurich: Think Art Diaphanes, 2019), 219–236.

26. See TOPLAP Wiki, "Manifesto Draft," last modified September 3, 2020, https://toplap.org/wiki/ManifestoDraft.

27. For more on TOPLAP, see https://toplap.org/about/.

28. See Michael Schwab and Henk Borgdorff, introduction to *The Exposition of Artistic Research: Publishing Art in Academia* (Leiden, the Netherlands: Leiden University Press, 2014), 9–20.

29. Agre, "Toward a Critical Technical Practice," 131–157.

30. Following Karen Barad, we prefer the term *intra-action*—as opposed to *interaction*—to stress agency as not an inherent property of an individual or human to be exercised but as a dynamism of forces. See Karen Barad, *Meeting the Universe Halfway: Quantum Physics and the Entanglement of Matter and Meaning* (Durham, NC: Duke University Press, 2007), 141.

31. Karen Barad makes a similar point in her preface and acknowledgments to *Meeting the Universe Halfway*: "In an important sense, it is not so much that I have written this book, as that it has written me. Or rather, 'we' have 'intra-actively' written each other ('intra-actively' rather than the usual 'interactively' since writing is not a unidirectional practice of creation that flows from author to page, but rather the practice of writing is an iterative and mutually constitutive working out, and reworking, of 'book' and 'author')." See Barad, *Meeting the Universe Halfway*, ix–x. This is also cited in the acknowledgments of Janneke Adema's *Living Books* (Cambridge, MA: MIT Press 2021).

32. This is a reference to Michel Foucault's idea of writing with a "shaky hand," rejecting the notion of a writer with a solid identity, from his introduction to *The Archaeology of Knowledge and the Discourse of Language* (New York: Pantheon Books, 1972). See Thor Magnusson and Kate Sicchio, "Writing with Shaky Hands," *International Journal of Performance Art and Digital Media* 12, no. 2 (2016): 99–101, https://toplap.org/special-issue-on-live-coding-in-ijpadm/.

33. Our intention is that aspects of this book—specifically chapters 2 and 3—can be added to and amended in the future. In this sense this publication is conceived of not as a final product but rather more like a momentary *snapshot* of live coding as it appears at a particular moment in time.

Chapter 2

1. Rather than being bound to the limitations of historical narrative, things are both historical *and* performative; history thereby is not only heard, as Ernst has characterized it, but, we would add, *live coded*. See Wolfgang Ernst, "Toward a Media Archaeology of Sonic Articulations," in *Digital Memory and the Archive*, ed. Jussi Parikka, Electronic Mediations no. 39 (Minneapolis: University of Minnesota Press, 2013). See also chapters 5 and 6 in this book.

2. Donna Haraway, "Situated Knowledges: The Science Question in Feminism and the Privilege of Partial Perspective," *Feminist Studies* 14 (1988): 575–599.

3. To be clear, *live* does not necessarily mean ahistorical, and we might learn from some of the past practices of live coding here. While live coding often privileges live improvisation over recording,

and clearly a recording falls short of the experience of a live event, there have been experiments in combining the two. To be specific, we can benefit here from users of Alberto de Campo's "History" class within the SuperCollider language, which records the code whenever it is executed. The Powerbooks_Unplugged laptop ensemble has recorded a great number of performance sessions in this way. Somewhat in this spirit, it might be said that we offer a "history unplugged" in this chapter.

4. Moreover, we recognize that *all* history is contested. Indeed, the perceived difficulty of writing this chapter is not only in dealing with what might be considered facts but also in writing a history of something that is by its nature "live" and that resists being recorded at all. Our approach perhaps owes more to the oral history tradition than any grand (canonical) narrativizing of significant events and people. We are thinking here of the work of Raphael Samuel and the History Workshop movement that developed "history from below." See "Samuel, Professor Raphael Elkan," Making History, accessed March 12, 2022, https://archives.history.ac.uk/makinghistory/historians/samuel_raphael.html.

5. The interviews themselves, although experimental in format and conduct, followed the social science research convention of the semistructured interview. Our research team (the authors of this volume) initially agreed on a set of questions designed to elicit both historical detail and personal reflection. Each interview included these prepared questions but explored topics in further detail (or ignored them) as determined in collaboration by the interests of both the interviewer and interviewee. These explorations and responses included a range of experiments with the collaborative real-time editor PiratePad, and also drew liberally on other technical media. And yet the history that we report remains (somewhat) conventional in style and falls short of representing the diversity of interpretations among the editors of this volume, let alone the voices of those who were interviewed. A further reflection on the ephemerality and provisionality of live technologies is that PiratePad itself was decommissioned in the course of our work, meaning the "live" record of the interviews (which we had intended to publish as an open and editable dynamic text) has disappeared. This fate, although disappointing, is unremarkable when considered in the context of other live-coded performances.

6. Note that the British Nick Collins (b. 1975), known as a pioneering figure in live coding, is not the same person as the American (b. 1954) Nicolas ("Nic") Collins, electronic music composer and writer.

7. Further reflections on diversity are included later in this chapter, and broader questions of settler-colonialism and the legacies of slavery that have resulted in racialized oppression, and in minority status for ethnic groups within technologized society, are addressed and explored in chapter 8.

8. Named in honor of Max Mathews, who in 1957, when working at Bell Labs, developed the original MUSIC program (later called MUSIC-1) that commenced the MUSIC-N series.

9. The sound engine of Pure Data was later incorporated into the Max software written by Puckette years earlier, which became Max/MSP, with *MSP* standing for "Miller S. Puckette."

10. Several interviewees reported the influence of techno/dance music, especially Aphex Twin and Autechre.

11. The VJ, or video jockey, is responsible for assembling and mixing projected video material, usually alongside a DJ.

12. Although this is broadly true, it is also the case that many practitioners have embraced the creative constraints of the eight-bit era.

13. The situation has not fully changed. As DO said, "I think we're still orienting youth towards the boring computing of the present rather than the fantastic utopian monstrous computing of the near future."

14. Our use of the term *geek* is very deliberate here to point to creative expression outside of the artistic frame. See Matthew Fuller's *How to Be a Geek: Essays on the Culture of Software* (Cambridge: Polity Press, 2017). The Read_me festival was set up on similar principles in that creativity is not simply the privilege of the creative class and has become distributed to other fields of nonarts practice. See the Read_me festival, curated by Olga Goriunova and Alexei Shulgin, Moscow, Helsinki, Aarhus, and Dortmund, 2002–2005, at "ReadMe," Monoskop, last modified April 11, 2017, https://monoskop.org/Readme. For more on geek cultures, see, for instance, Ellen Ullman's *Close to the Machine: Technophilia and Its Discontents* (London: Picador, 2012).

15. Some entered the creative sector, in sound engineering or the nascent video game industry. The less fortunate faced mundane futures: AM headed toward a practical career studying programming with a "bog-standard" computing diploma and degree, where he wasn't allowed to use the fancy Macs on the media arts course, while SA was frustrated by the boring assignments for his computer science degree, as he already knew more programming than they taught. Some did try to follow both interests. AA registered for a double major in music and computing, but on the first day she was advised to keep the music (which she loved) and drop the computing (assumed to have been her father's idea). DO started to learn both music and programming at the age of seven, but it was years before he realized they could be combined in "computer music."

16. This project predates AW's later and well-known Auto-Illustrator, which similarly parodied Adobe's commercial software. AW also produced numerous generative sound experiments, released through his company Signwave, exploring the performativity of code. This led to the development of his live coding. See Adrian Ward, Wikipedia, last modified January 21, 2022, https://en.wikipedia.org/wiki/Adrian_Ward_(artist).

17. See https://transmediale.de/content/auto-illustrator and https://transmediale.de/content/forkbombpl, respectively. Both works also featured as part of the 2002 touring exhibition *Generator*, curated by Geoff Cox and Tom Trevor, https://web.archive.org/web/20190220044143/http://generative.net/generator/.

18. The name *slub* signaled the meeting point of McLean's slab.org and Ward's stub.org websites.

19. See NTK Now, June 16, 2000, http://www.ntk.net/2000/06/16/?l=120#l.

20. See Public Life, last modified 2019, http://www.publiclife.org/text1.htm.

21. See Read_Me 2004 report, August 2004, http://www.m-cult.org/read_me/report.htm.

Notes to Chapter 2

22. The fourth and final Read_me was held in Dortmund in 2005; see http://readme.runme.org/.

23. Ge Wang and Perry R. Cook, "On-the-Fly Programming: Using Code as an Expressive Musical Instrument," in *Proceedings of New Interfaces for Musical Expression*, Hamamatsu Shizuoka, Japan June 3-5, 2004, 138–143. Singapore: National University of Singapore, 2004.

24. See Labomedia Ressources, February 2004. Accessed March 23, 2022: https://raw.githubusercontent.com/yaxu/unravelling/master/livecodemlarchive.txt.

25. Hence the elaborate cautions that we presented at the start of this chapter with regard to the problems of taking a historical stance in relation to an avowedly ephemeral endeavor.

26. For a view on the development of the TOPLAP manifesto, see Christopher Haworth, "Algorithmic Music and the Social," in *The Oxford Handbook of Algorithmic Music*, ed. Alex McLean and Roger Dean (Oxford: Oxford University Press, 2018), 557–581.

27. See "Manifesto Draft," TOPLAP, last modified September 3, 2020, http://toplap.org/wiki/ManifestoDraft.

28. "Show Us Your Screens" is also the title of a short documentary film made by Louis McCallum and Davy Smith, 2011. See https://vimeo.com/20241649.

29. Aside from the various manifestos associated with the modernist period, such as those of surrealism and Dada, numerous other examples point to the belief that art and technology might facilitate radical change. *The Futurist Manifesto* written by F. T. Marinetti in 1909 famously espouses the glorification of war, speed, and misogyny. More in keeping with our views, we would point to its reworking in Franco Bifo Berardi's *Post-Futurist Manifesto* of 2009, which argues that the aspirations of the avant-garde and the dominant order they hoped to overthrow have collapsed into what has become known as the *creative economy*. See *The Post-Futurist Manifesto* by Franco Bifo Berardi, February 2009, http://www.generation-online.org/p/fp_bifo5.htm. There is more to be said about live coding as a counterpoint to the creative and knowledge economies, and we return to this in chapter 8.

30. Author Blackwell recalls creating a real-time executive for machine control in Forth as his undergraduate dissertation at the University of Auckland in 1982. (His original plan to create a sampling synthesizer was considered infeasible because the department could not afford to buy that much RAM!)

31. Douglas J. Collinge, "MOXIE: A Language for Computer Music Performance," in *Proceedings of the International Conference on Computer Music*, Institut de Recherche et Coordination Acoustique/Musique (IRCAM) Paris, France, October 19–23, 1984, 217–220. San Francisco, CA: International Computer Music Association, 1984, https://quod.lib.umich.edu/cgi/p/pod/dod-idx/moxie-a-language-for-computer-music-performance.pdf?c=icmc;idno=bbp2372.1984.030;format=pdf.

32. Roger B. Dannenberg, "Software Design for Interactive Multimedia Performance," *Interface—Journal of New Music Research* 22, no. 3 (August 1993): 213–228.

33. Scott Wilson, David Cottle, and Nick Collins, *The SuperCollider Book* (Cambridge, MA: MIT Press, 2011).

34. Smalltalk is an object-oriented, dynamically typed reflective programming language designed and created in part for educational use at the Learning Research Group of Xerox PARC by Alan Kay, Dan Ingalls, Adele Goldberg, Ted Kaehler, Diana Merry, Scott Wallace, and others during the 1970s. Connections to the software-engineering industry, including Smalltalk, are discussed further in chapter 7. Some discussion of the research questions related to language design can be found in Brian Burg, Adrian Kuhn, and Chris Parnin, "1st International Workshop on Live Programming (LIVE 2013)," in *35th International Conference on Software Engineering* (Piscataway, NJ: Institute of Electrical and Electronics Engineers, 2013), 1529–1530; and Juraj Kubelka, Romain Robbes, and Alexandre Bergel, "The Road to Live Programming: Insights from the Practice," in *2018 IEEE/ACM 40th International Conference on Software Engineering* (Piscataway, NJ: Institute of Electrical and Electronics Engineers, 2013), 1090–1101.

35. As noted earlier, Fabrice Mogini, Nick Collins, and John Eacott had a band called 3play around 2002 whose performances involved live coding.

36. Powerbooks_UnPlugged members have included Alberto de Campo, Echo Ho, Hannes Hoelzl, Jan-Kees van Kampen, Julian Rohrhuber, and Renate Wieser. See https://pbup.net/, accessed March 12, 2022.

37. See, for example, Seminaris Sonors, 2011, https://web.archive.org/web/20180218022134/https://lullcec.org/2011/workshops/seminaris-sonors-2011/.

38. Alan F. Blackwell, "Patterns of User Experience in Performance Programming," in *Proceedings of the First International Conference on Live Coding (ICLC)*, University of Leeds, UK, July 13–15, 2015, Geneva, Switzerland: Zenodo/CERN, http://doi.org/10.5281/zenodo.19315.

39. Featuring JR, Oliver Wittchow (cf. nanoloop), Raffaello Minuzzi, and the Hamburg artist Sebastian Burdach (d. 2021).

40. See Georgina Born and Kyle Devine, "Music Technology, Gender, and Class: Digitization, Educational and Social Change in Britain," *Twentieth-Century Music* 12, no. 2 (August 2015): 135–172; and Joanne Armitage, "Spaces to Fail In: Negotiating Gender, Community and Technology in Algorave," in *Dancecult: Journal of Electronic Dance Music Culture* 10, no. 1 (2018), https://dj.dancecult.net/index.php/dancecult/article/view/1032. Armitage refers to research that has explored issues of gender and participation in these fields, including Tami Gadir, "Resistance or Reiteration? Rethinking Gender in DJ Cultures," *Contemporary Music Review* 35, no. 1 (2016): 115–129, http://dx.doi.org/10.1080/07494467.2016.1176767; and Anna Vitores and Adriana Gil-Juárez, "The Trouble with 'Women in Computing': A Critical Examination of the Deployment of Research on the Gender Gap in Computer Science," *Journal of Gender Studies* 25, no. 6 (2015): 1–15, http://dx.doi.org/10.1080/09589236.2015.1087309.

41. JA reports an interview with a female live coder who said, "It is the reactions of some men that will create an invisible barrier that says to women 'you don't belong here in the way that I do.'" Armitage, "Spaces to Fail In," 41.

42. JA states that "despite the promises of both the community and the technology, the performative nature of live coding and performing algorave events deeply genders their experiences." Armitage, "Spaces to Fail In," 33.

43. See, for example, Freida Abtan, "Where Is She? Finding the Women in Electronic Music Culture," *Contemporary Music Review* 35, no. 1 (2016): 53–60.

44. Georgina Born and Kyle Devine, "Gender, Creativity and Education in Digital Musics and Sound Art," *Contemporary Music Review* 35, no. 1 (2016): 1–20, http://doi.org/10.1080/07494467.2016.1177255.

45. See workshop for Yorkshire Sound Women Network (YWSN), December 2015, presented by Joanne Armitage and Shelly Knotts. Accessed March 23, 2022, https://www.youtube.com/watch?v=PboSZGllzsU; also https://yorkshiresoundwomen.com/.

46. See Northern Sound Collective, "Automation and Me: Living an Algorithmic Life," May 8–9, 2019. Accessed March 23, 2022, https://northernsc.wordpress.com/open-call/.

47. Armitage, "Spaces to Fail In," 39.

48. Armitage, "Spaces to Fail In," 40. More broadly, it is worth adding a further layer of critique here in the work of the Feminist Software Foundation. See, for instance, their C+= manifesto: "Booleans are banned for imposing a binary view of true and false. C+= operates paralogically and transcends the trappings of Patriarchal binary logic." "C-Plus Equality," Feminist Software Foundation, accessed April 13, 2018, https://github.com/ErisBlastar/cplusequality/blob/master/README.md.

49. See https://livecode.slack.com. JA notes that this chat forum has recently moved from Slack to https://talk.lurk.org/home, accessed May 8, 2018.

50. Armitage, "Spaces to Fail In," 42.

51. Algorave guidelines, 2022: https://github.com/Algorave/guidelines.

52. Diversity has also been addressed through the common practice of artists engaging with underserved communities—for example, Melody Loveless working with young people with learning difficulties, as she relates in her exposition in chapter 3.

53. See (Algo|Afro) futures, April–June 2021. Accessed March 23, 2022, https://algo-afro-futures.lurk.org/artists/.

54. Amy Alexander, "At the Margins: A Look at Marginal Approaches to Coding, Art and Performance" (paper presented at the International Conference of Live Coding, Hamilton, Canada, October 12–15, 2016). The event also included the panel "Equity, Inclusion and the Growth of the Live Coding Community." See http://iclc.toplap.org/2016/.

55. Hakan Erdogmus, Nenad Medvidović, and Frances Paulisch, "0 Years of Software Engineering," *IEEE Software* 35, no. 5 (2018): 20–24.

56. For example, see both the introduction and contents of Born and Devine, "Gender, Creativity and Education in Digital Musics and Sound Art," 1–20.

57. Quoted from a Facebook post in Michelle Knotts ("Shelly"—interviewee SK), "Social Systems for Improvisation in Live Computer Music" (PhD diss., Durham University, UK, 2018), 54.

58. Armitage, "Spaces to Fail In."

59. See Sadie Plant, "The Future Looms: Weaving Women and Cybernetics," *Body and Society* 1, no. 3–4 (1995): 46. Several recent projects have drawn *threads* between the work of Bauhaus weaver Anni Albers (1899–1994) and coding—for example, Conductive Coding, an etextiles weaving workshop led by Emilie Giles and Sarah Wiseman at Tate Modern (2019) in response to Albers's retrospective of the same year. See also Anni Albers, *On Weaving* (Middletown, CT: Wesleyan University Press, 1965). A metaphorical connection between the performance practice of live coding and weaving was made by Emma Cocker during the AHRC-funded Live Notation project (led by Hester Reeve and Alex McLean). See Emma Cocker, "Live Notation: Reflections on a Kairotic Practice," *Performance Research Journal: On Writing and Digital Media* 18, no. 5 (2013): 69–76.

60. This project is discussed elsewhere in chapters 4, 5, and 7 in relation to embodied knowledge and notation; on *loom-thinking*, see Janis Jeffries, "Textiles: What Can She Know?," in *Feminist Visual Culture*, ed. Fiona Carson and Claire Pajaczkowska (New York: Routledge, 2001), 189–207.

61. The Neokhipukamayoq manifesto was launched by Paola Torres Núñez del Prado at Ars Electronica 2021 with Patricia Cavidad through a live performance titled *Khipumancy*, using augmented *Khipu* as interfaces for sound. The manifesto is available at https://khipumantes.github.io/ (2021). Accessed March 23, 2022.

62. Michelle Boulous Walker reflects on how instituting moments eventually become instituted structures (for her, in relation to philosophy) in *Slow Philosophy: Reading against the Institution* (London: Bloomsbury, 2017).

63. Alan F. Blackwell, Alex McLean, James Noble, and Julian Rohrhuber, eds., in collaboration with Jochen Arne Otto, "Collaboration and Learning through Live Coding," *Dagstuhl Reports* 3, no. 9 (2014): 130–168, http://drops.dagstuhl.de/opus/volltexte/2014/4420/.

64. Following Leeds in 2015, the conference was hosted at McMaster University, Canada, in 2016; in Morelia, Mexico, in 2017; in Madrid, Spain, in 2019; in Limerick, Ireland, in 2020; and in Chile in 2021.

65. The First International Workshop on Live Programming was held in conjunction with the International Conference on Software Engineering (ICSE 2013), a second workshop at the European Conference on Object-Oriented Programming (ECOOP 2016), and four times subsequently at the ACM SIGPLAN Conference on Systems, Programming, Languages, and Applications: Software for Humanity (SPLASH). A series archive is maintained at http://liveprog.org (2013–2021). Accessed March 23, 2022.

66. For the current list of TOPLAP nodes, see TOPLAP site, (2004–2021). Accessed March 23, 2022, https://toplap.org/nodes/.

67. Tom Cheshire, "Hacking Meets Clubbing with the 'Algorave,'" *Wired*, September 2013, https://www.wired.co.uk/article/algorave.

68. It's amusing to note that since live coding emerged in 2000, *Wired* magazine published pieces dubbing it the future of electronic music in 2006 ("Real DJs Code Live"), 2013 ("Hacking Meets Clubbing with the 'Algorave'"), and 2019 ("DJs of the Future Don't Spin Records, They Write Code"). We anticipate the next prediction in 2025.

69. See Algorave, 2022. Accessed March 23, 2022, https://algorave.com/; and also Algorave guidelines, https://github.com/Algorave/guidelines.

70. Thor Magnusson, "Herding Cats: Observing Live Coding in the Wild," *Computer Music Journal* 38, no. 1 (2014): 8–16.

71. The most complete list of live coding links currently shows around fifty live coding environments (https://github.com/toplap/awesome-livecoding), with thirty geographically centered communities adding themselves to the list of TOPLAP nodes: https://toplap.org/nodes/.

72. New live coders are constantly arriving. There are undoubtedly some whom we should have invited and did not and others who were invited but not able to respond. We plan to maintain this part of the book as an open online resource for continued development and expansion after the published manuscript is complete.

73. We take the term *exposition* from the context of artistic research: Henk Borgdorff and Michael Schwab, eds., *The Exposition of Artistic Research: Publishing in Academia* (Leiden: Leiden University Press, 2014).

Chapter 3

1. https://youtu.be/hMdkb8pvA8g; accessed April 12, 2022.

2. https://www.instagram.com/mariaaristya/; see Abhinay Khoparzi's exposition in this chapter.

3. Open Source Shakespeare, accessed March 12, 2022, https://www.opensourceshakespeare.org/views/plays/play_view.php?WorkID=henry6p2&Act=4&Scene=7&Scope=scene&LineHighlight=2721#2721.

4. July 27, 2012, https://vimeo.com/195936508.

5. TOPLAP, last modified May 28, 2009, https://toplap.org/wiki/Some_thoughts.

6. Stack Exchange, accessed March 12, 2022, https://english.stackexchange.com/questions/196489/did-sir-arthur-conan-doyle-coin-the-proverb-a-change-is-as-good-as-a-rest.

7. https://composerprogrammer.com/research/collectedrewritings.pdf t.

8. In *The Language of the New Media* (Cambridge, MA: MIT Press, 2000), Lev Manovich offers the first rigorous and systematic theory of new media, framing it in the history of the media and visual cultures of the last centuries.

9. P is for Personal, Private, Popular, Poetic, Pretty, Playful, Pleasant, Peaceful, Primary, Proto, Post, Potential, Pseudo, Portable, Programming, Physical, Paper . . .

10. "Live coding is not about tools. Algorithms are thoughts." TOPLAP manifesto draft.

11. Ramos Ana, "The Anarchive: A Language Nomadism, the Way of the Anarchive," unpublished manuscript, 2018.

12. Nahuatl is a Uto-Aztecan language spoken by approximately 1.5 million people in Mexico. Most speakers live in central Mexico, including in Puebla, Veracruz, Hidalgo, San Luis Potosí, Guerrero, Mexico City (Distrito Federal), Tlaxcala, Morelos, and Oaxaca. There are fewer speakers of Nahuatl in the rest of Mexico, in El Salvador, and in parts of the United States.

13. http://sro.sussex.ac.uk/id/eprint/46861/1/Magnusson.pdf; accessed April 12, 2022.

Chapter 4

1. The Live Notation project was funded by the Arts and Humanities Research Council and led by coinvestigators Hester Reeve and Alex McLean, working in dialogue with an international network of artists, coders, and theorists, including Sam Aaron, Maria Chatzichristodoulou, Geoff Cox, Yuen Fong Ling, Dave Griffiths, Thor Magnusson, Brigid McLeer, Kate Sicchio, Andre Stitt, and Wrongheaded, who collectively composed the Live Notation Unit. Emma Cocker observed as an interlocutor, leading to the published outcome: Emma Cocker, "Live Notation—Reflections on a Kairotic Practice," *Performance Research Journal* 18, no. 5 (January 2014): 69–76.

2. On July 27, 2012, at the Live Notation Unit, the project participants staged a symposium and a series of performances at Arnolfini (an international arts center) in Bristol, UK, to test and question what the phrase *live notation* signifies. More details of the presentations at Arnolfini in July 2012 can be found at http://livenotation.lurk.org/. See also Alex McLean and Hester Reeve, "Live Notation: Acoustic Resonance?," Paper presented at the *International Computer Music Conference* (ICMC), Ljubljana, Slovenia, September 9–14, 2012.

3. See Cocker, "Live Notation."

4. John Hall, *13 Ways of Talking about Performance Writing* (Plymouth, UK: Plymouth College of Art Press, 2007).

5. See Geoff Cox and Alex McLean, *Speaking Code, Coding as Aesthetic and Political Expression* (Cambridge, MA: MIT Press, 2013). They refer to Florian Cramer's "Concepts, Notations, Software, Art," Netzliteratur, March 23, 2002, https://www.netzliteratur.net/cramer/concepts_notations_software_art.html.

6. Weaving Codes, Coding Weaves (2014–2016) was an interdisciplinary research project funded by an Arts and Humanities Research Council Digital Transformations Amplification Award, led by principal investigator Alex McLean and international coinvestigator Ellen Harlizius-Klück, with collaborative developer Dave Griffiths and coinvestigator Kia Ng. See Weaving codes – coding weaves, http://kairotic.org/, accessed April 16, 2022. See also Ellen Harlizius-Klück, in collaboration with Alex McLean, eds., "Weaving Codes, Coding Weaves," special issue, *Textile: Journal of Cloth and Culture* 15 (2017). For a project account, see Alex McLean, Ellen Harlizius-Klück, and Janis Jefferies, "Introduction: Weaving Codes, Coding Weaves," 118–123 and Emma Cocker, "Weaving Codes/Coding Weaves: Penelopean Mêtis and the Weaver-Coder's Kairos," 124–141. Concrete examples of exploring weave and code include Julian Rohrhuber and David Griffiths, "Coding with Knots," 142–157, which explores pre-Colombian *Khipus* using both visual and sonic interpretations, and David Griffiths and Alex McLean, "Textility of Code: A Catalogue of

Errors," 198–214. This collaboration has continued through the European Research Council–funded PENELOPE project (2016–2021).

7. See Simone Boria et al., eds., *On Turtles and Dragons and the Dangerous Quest for a Media Art Notation System* (Linz: Times Up Press, 2012), 7.

8. Boria et al., *On Turtles and Dragons*, 9.

9. Boria et al., *On Turtles and Dragons*, 9.

10. Boria et al., *On Turtles and Dragons*, 16–25.

11. He also invented two other systems that are relevant to live coding: a system for algorithmic composition, in which consonants are given pitch values according to generative rules, and the Guidonian hand, an improvisational conducting system that a conductor operates by pointing to parts of their hand, thus defining the next note. This can be used in live composition and serves well as a methodological predecessor to what we today call *soundpainting*, which live coder Julio D'Escrivan uses to live code musical ensembles. Thor Magnusson, *Sonic Writing: Technologies of Material, Symbolic and Signal Inscriptions* (London: Bloomsbury, 2019).

12. Documentation of *Code Music Notation*, including video of the performance with Greta Eacott, is available at https://github.com/thormagnusson/cmn, accessed April 16, 2022.

13. John Eacott has produced staff notation on the fly for instrumental ensembles to play using his live notation system, although it was produced by generative processes working on live tide data rather than directly live coded. John Eacott, "Instant Music? Just Add Water," *AI and Society* 27, no. 2 (May 2012): 287–288, https://doi.org/10.1007/s00146-011-0350-6.

14. In conversation, Mark Fell and Rian Treanor offer a controversial comparison between algorithmic and score-based music. Mark Fell and Rian Treanor, "The Musical Score Is the Worst Thing in the History of Music," *Wire* magazine, January 2021, https://www.thewire.co.uk/in-writing/interviews/the-musical-score-is-the-worst-thing-that-ever-happened-in-the-history-of-music-mark-fell-.

15. Thomas W. Patteson, "Player Piano," *Oxford Handbooks Online*, November 2014, 10.1093/oxfordhb/9780199935321.013.16.

16. Rebecca Wolf, *Spielen und bedienen: Das selbstspielende Klavier als virtuose Maschine. Spiel (mit) der Maschine: Musikalische Medienpraxis in der Frühzeit von Phonographie, Selbstspielklavier, Film und Radio* (Bielefeld, Germany: Transcript Verlag, 2016).

17. We should note the influence of Conlon Nancarrow's experimental compositions for player piano on algorithmic music. For a continuation of his ideas in the live coding community, see Diego Villaseñor de Cortina and Alejandro Franco Briones, "Nanc-in-a-Can Canon Generator: SuperCollider Code Capable of Generating and Visualizing Temporal Canons Critically and Algorithmically," in *Proceedings of the Fourth International Conference on Live Coding* (Madrid: Medialab Prado/Madrid Destino, 2019), https://doi.org/10.5281/zenodo.3946192.

18. This dance is still performed by Caroline Radcliffe (as taught to her by Pat Tracey as part of the Camden Clog dance group), who in collaboration with composer Sarah Angliss relates

it to the sounds of call centers as the modern-day equivalent to the mills of the industrial era. See Caroline Radcliffe and Sarah Angliss, "Revolution: Challenging the Automaton: Repetitive Labour and Dance in the Industrial Workspace," *Performance Research* 17, no. 6 (December 2012): 40–47, https://doi.org/10.1080/13528165.2013.775758.

19. These are commonly known as *Mozart's dice games*, although none are believed to have been published in his name. See also George Brecht, John Cage, and La Monte Young, *An Anthology of Chance Operations, Concept Art, Anti-art, Indeterminancy, Improvisation, Meaningless Work, Natural Disasters* (Munich: Heiner Friedrich, 1970).

20. Luigi Russolo, *The Art of Noise (Futurist Manifesto, 1913)*, trans. Robert Filliou, A Great Bear Pamphlet (New York: Something Else Press, 1967), http://www.artype.de/Sammlung/pdf/russolo_noise.pdf.

21. Theresa Sauer, *Notations 21* (New York: Mark Batty, 2009).

22. Sol LeWitt, "Paragraphs on Conceptual Art," *Artforum* 5, no. 10 (1967): 79–83.

23. Twenty-four code-based implementations of "Draw a straight line and follow it" are archived at https://web.archive.org/web/20080825030910/http://instructionset.org/instruction/4/, accessed April 16, 2022.

24. http://www.geocities.ws/lasaltersjr/anthonybraxtoninterviews.htm, accessed April 16, 2022.

25. Live coding is often associated with grid-based music, but this does not always apply. Sound synthesis is often free-flowing, and the TidalCycles system has a rational representation of time focused on metric cycles rather than discrete beat units. Alex McLean, "Making Programming Languages to Dance To: Live Coding with Tidal," in *Proceedings of the 2nd ACM SIGPLAN International Workshop on Functional Art, Music, Modeling and Design* (New York: Association for Computing Machinery, 2014), https://doi.org/10.1145/2633638.2633647.

26. Kate Sicchio, Zeshan Wang, and Marissa Forbes, "Live Coding Tools for Choreography: Creating Terpsicode," in *Proceedings of the 2020 International Conference on Live Coding* (Limerick, Ireland: University of Limerick), https://doi.org/10.5281/zenodo.3939135.

27. We compare different conceptions of time embedded in different live coding systems in chapter 6.

28. Clive is an environment for live coding in the C language and is impressive for the timbral and musical complexity of its short programs, at least in the hands of its creator Claude Heiland-Allen. See, accessed March 15, 2022, https://mathr.co.uk/clive/.

29. Mark Fell discusses the tendency of algorithmic musicians to define their own tight constraints in an article in the *Wire*, January 2013, https://www.thewire.co.uk/in-writing/essays/collateral-damage-mark-fell.

30. Chris Kiefer and Thor Magnusson, "Live Coding Machine Learning and Machine Listening: A Survey on the Design of Languages and Environments for Live Coding," in *Proceedings of the Fourth International Conference on Live Coding* (Madrid: Medialab Prado/Madrid Destino, 2019).

31. Steve Tanimoto's ideas about levels of liveness are discussed in chapter 5.

32. The title "Future of Programming" is ironic in that the video addresses ideas from the past that have not yet been realized, including the early work of Douglas Engelbart. See Bret Victor, "Future of Programming," July 2013, https://vimeo.com/71278954.

33. Kay's accomplishments include Smalltalk, briefly introduced in chapter 2 and further described in chapters 6 and 7.

34. Thor Magnusson and Alex McLean, "Performing with Patterns of Time," in *Oxford Handbook of Algorithmic Music*, ed. Roger T. Dean and Alex McLean (Oxford: Oxford University Press, 2018), https://doi.org/10.5281/zenodo.1193251.

35. Computer music can be represented as data, which pattern operations are applied to, or as functions, where pattern operations are directly combined into more complex behaviors. See Alex McLean, "Algorithmic Pattern," in *Proceedings of the 20th Conference on New Interfaces for Musical Expression* (Birmingham UK, 2020), Geneva, Switzerland: Zenodo/CERN, https://zenodo.org/record/4299661.

36. Laurie Spiegel, "Manipulations of Musical Patterns," in *Proceedings of the Symposium on Small Computers and the Arts* (Los Alamitos: IEEE Computer Society Press, 1981), 19–22.

37. David Griffiths, "Computation Is Woven," January 28, 2021, Zenodo, http://doi.org/10.5281/zenodo.4476811.

38. In an unpublished 2018 talk in IRCAM (Institut de Recherche et Coordination Acoustique/Musique), Andrew Hugill notes the very different responses that mathematicians, designers, and composers have to pattern, recounted in his blog *Shifting Meanings: The Fate of Words in Transdisciplinary Academia*, January 2020, http://www.andrewhugill.com/blog/?p=3159; private emails with Laurie Spiegel reveal that her mother was a keen weaver, suggesting her own conception of pattern could owe as much to her exposure to textiles as her experience as a foundational composer, music technologist, and software developer.

39. Spiegel, "Manipulations of Musical Patterns," 19–22.

40. Bernard Bel, "Rationalizing Musical Time: Syntactic and Symbolic-Numeric Approaches," in The Ratio Book, ed. Clarence Barlow, Feedback Papers 43 (Cologne: Feedback Studio, 2001), 86–101.

41. Joanne Armitage, "Spaces to Fail In: Negotiating Gender, Community and Technology in Algorave," *Dancecult: Journal of Electronic Dance Music Culture* 10 (November 2018): 31–45, https://doi.org/10.12801/1947-5403.2018.10.01.02.

42. Tanimoto's levels of liveness are explored further in relation to notions of liveness in chapter 5. Cf. Steven Tanimoto, "A Perspective on the Evolution of Live Programming," *LIVE '13, Proceedings of the 1st International Workshop on Live Programming* (Los Alamitos: IEEE Computer Society, 2013), 31–34.

43. Alex McLean, "Improvising with Synthesised Vocables, with Analysis towards Computational Creativity" (Master's thesis, Goldsmiths College, University of London, 2007).

44. McLean, "Making Programming Languages to Dance To."

45. Jeremy Stewart, Shawn Lawson, Mike Hodnick, and Ben Gold, "Cibo v2: Realtime Livecoding A.I. Agent," in *Proceedings of the 2020 International Conference on Live Coding* (Limerick, Ireland: University of Limerick), https://doi.org/10.5281/zenodo.3939174.

46. Simon Hickinbotham and Susan Stepney, "Augmenting Live Coding with Evolved Patterns," in *Evolutionary and Biologically Inspired Music, Sound, Art and Design*, ed. Colin Johnson, Vic Ciesielski, João Correia, and Penousal Machado, 31–46, Lecture Notes in Computer Science (Cham, Switzerland: Springer International, 2016), https://doi.org/10.1007/978-3-319-31008-4_3.

47. Francisco Bernardo, Chris Kiefer, and Thor Magnusson, "Designing for a Pluralist and User-Friendly Live Code Language Ecosystem with Sema," in *Proceedings of the 2020 International Conference on Live Coding* (Limerick, Ireland: University of Limerick), 41–58.

48. We discuss this relation in terms of the "map" and "territory" later in this chapter.

49. C. Pair, "Programming, Programming Languages and Programming Methods," in *Psychology of Programming*, ed. J.-M. Hoc, T. R. G. Green, R. Samurçay, and D. J. Gilmore (Cambridge, MA: Academic Press, 1990), 11.

50. Ryan Kirkbride, "Troop: A Collaborative Tool for Live Coding" (paper presented at the 14th Sound and Music Computing Conference, Espoo, Finland, July 5–8, 2017), https://doi.org/10.5281/zenodo.1401895; FeedForward is a custom live coding editor for TidalCycles created by Alex McLean—see https://github.com/yaxu/feedforward/.

51. As mentioned previously, we also experimented with this approach in writing this book. See Alan Blackwell, Geoff Cox, and Sang Won Lee, "Live Writing the Live Coding Book" (paper presented at the International Conference on Live Coding 2016, McMaster University, Hamilton, Canada), http://iclc.toplap.org/2016/papers.html.

52. Mark Fisher, *K-PUNK* (blog), May 11, 2015, http://k-punk.org/abandon-hope-summer-is-coming/. See Mark Fisher, *K-punk: The Collected and Unpublished Writings of Mark Fisher (2004–2016)*, ed. Darren Ambrose (London: Repeater, 2018).

53. Contesting Derrida's notion that writing exceeds speech, literary critic N. Katherine Hayles has argued that code exceeds both speech and writing in its address to both humans and machines. See N. Katherine Hayles, *My Mother Was a Computer* (Chicago: University of Chicago Press, 2005), 40.

54. This difficulty of "printing out" live code has been a challenge for this book, and we encourage the reader to explore the videos on our accompanying website.

55. Kofi Agawu, "Structural Analysis or Cultural Analysis? Competing Perspectives on the 'Standard Pattern' of West African Rhythm," *Journal of the American Musicological Society* 59, no. 1 (April 2006): 1–46, https://doi.org/10.1525/jams.2006.59.1.1.

56. This tension between code that looks good but may do something unexpected (or even crash!) in practice brings exciting moments often celebrated by audiences.

57. Godfried Toussaint, "The Euclidean Algorithm Generates Traditional Musical Rhythms," in *Proceedings of BRIDGES:Mathematical Connections in Art, Music and Science* (Banff, Alberta: Banff Centre, 2005), 47–56, http://citeseerx.ist.psu.edu/viewdoc/summary?doi=10.1.1.62.231.

58. Philip Ball explains symmetry breaking with the example of heating oil in a pan, causing the perfect symmetry of a circle to be broken and replaced with a new pattern with hexagonal symmetry. Philip Ball, *The Self-Made Tapestry: Pattern Formation in Nature* (Oxford: Oxford University Press, 2001).

59. Alfred Korzybski, *Science and Sanity: An Introduction to Non-Aristotelian Systems and General Semantics* (International Non-Aristotelian Library, 1933).

60. Transcribed from the Weaving Codes research seminar, October 21, 2014, Leeds, UK.

61. This notion of "following" is expanded in chapter 7 with regard to the way that the live coder as "craftsperson" follows their materials.

62. Paul Klee, *Pedagogical Sketchbook* (New York: Frederick A. Praeger, 1953); emphasis in original.

63. Ursula Franklin, *The Real World of Technology*, 2nd ed. (Toronto: House of Anansi Press, 1999).

64. Thor Magnusson, "Epistemic Tools: The Phenomenology of Digital Musical Instruments" (PhD thesis, University of Sussex, 2009), http://sro.sussex.ac.uk/id/eprint/83540/.

65. Roland Barthes, "Death of the Author," in *Image-Music-Text* (New York: Fontana, 1978), 142–148.

66. Atsushi Shimojima, "The Graphic-Linguistic Distinction Exploring Alternatives," *Artificial Intelligence Review* 13, no. 4 (1999): 313–335.

67. For a review of Griffiths's work and other aspects of visualization in live coding environments, see Alex McLean, Dave Griffiths, Nick Collins, and Geraint Wiggins, "Visualisation of Live Code," in *Proceedings of Electronic Visualisation and the Arts London 2010* (Swindon, UK: British Computer Society, 2010), 26–30.

68. Roberts has published an excellent interactive (live codable) demonstration of his work on live code annotations and visualizations at https://charlieroberts.github.io/annotationsAndVisualizations/, last modified November 17, 2018. For a more traditional academic paper, see Charles Roberts, Matthew Wright, and JoAnn Kuchera-Morin, "Beyond Editing: Extended Interaction with Textual Code Fragments," in *Proceedings of the International Conference on New Interfaces for Musical Expression* (Baton Rouge: School of Music and the Center for Computation and Technology, Louisiana State University, 2015), 126–131.

69. Thor Magnusson, "Ixi Lang: A SuperCollider Parasite for Live Coding," in *Proceedings of International Computer Music Conference 2011* (Ann Arbor: Michigan Publishing, 2011), 503–506.

70. Nelson Goodman, *Languages of Art: An Approach to a Theory of Symbols* (Indianapolis: Hackett, 1976).

71. This is even so, if we consider the notion of the *post-digital*, in which the distinctions between "old" and "new" media are no longer considered useful. Cramer's examples are the typewriter

and piano keys, notionally analog but in a strictly technical sense both digital systems. See Florian Cramer, "What Is Post-Digital?," *APRJA* 3, no. 1 (2014), https://doi.org/10.7146/aprja.v3i1.116068.

72. John Cage, "Art and Technology," in *John Cage: Writer* (New York: Cooper Square Press, 1969).

73. For an account of this dual coding of perception in the context of live coding, see chapter 2 of Alex McLean's "Artist-Programmers and Programming Languages for the Arts" (PhD thesis, Department of Computing, Goldsmiths, University of London, 2011), https://slab.org/thesis/.

74. See, for example, Gabriele Brandstetter, *Notationen und Choreographisches Denken* (Freiburg, Germany: Rombach, 2010); Scott deLahunta and Norah Zuniga Shaw, "Constructing Memories: Creation of the Choreographic Resource," *Performance Research* 11, no. 4 (2006): 53–62; and for historic contrast and variety in choreographic notation, Ann Hutchinson Guest, *Choreographics: A Comparison of Dance Notation Systems from the Fifteenth Century to the Present* (London: Routledge, 2014) and Laurence Louppe, *Traces of Dance: Drawings and Notations of Choreographers* (Paris: Editions Dis Voir, 1994). See also Lilia Mestre and Elke Van Campenhout, eds., *Writing Scores in Process* (Brussels: a.pass, 2015); Raphael Gygax and Heike Munder, eds., *Between Zones: On the Representation of the Performative and the Notation of Movement* (Zurich: JRP; Manchester: Ringier, 2010); and Scott deLahunta, Kim Vincs, and Sarah Whatley, eds., "On An/Notations," *Performance Research* 20, no. 6 (2015): 1–2.

75. Jacques Bertin, *Semiology of Graphics: Diagrams, Networks, Maps* (Redlands, CA: ESRI Press, 2010), first published in French in 1968; Yuri Engelhardt, "The Language of Graphics: A Framework for the Analysis of Syntax and Meaning in Maps, Charts and Diagrams: (PhD diss., University of Amsterdam, 2002).

76. For example, the Hybrid Live Coding workshop convened in 2020 explored interdisciplinary perspectives on tactile and haptic interfaces incorporating live coding. See, accessed March 15, 2022, https://hybrid-livecode.pubpub.org/workshop2020.

77. Christopher Alexander, *A Pattern Language: Towns, Buildings, Construction* (Oxford: Oxford University Press, 1977).

78. A transcript of Alexander's talk is available at Pattern Language, accessed March 15, 2022, http://www.patternlanguage.com/archive/ieee.html.

79. Alan F. Blackwell and Sally Fincher, "PUX: Patterns of User Experience," *Interactions* 17 (2010): 27–31.

80. Thomas R. G. Green, "Cognitive Dimensions of Notations," *People and Computers* 5 (1989): 443–460.

81. Alan F. Blackwell, Thomas R. G. Green, and Douglas J. E. Nunn, "Cognitive Dimensions and Musical Notation Systems," Paper presented at *International Computer Music Conference Workshop on Notation and Music Information Retrieval in the Computer Age*, Berlin Germany, August 27–September 1, 2000.

82. Alan F. Blackwell and Thomas R. G. Green, "A Cognitive Dimensions Questionnaire Optimised for Users," in *Proceedings of the Twelfth Annual Meeting of the Psychology of Programming Interest Group*, ed. Alan F. Blackwell and E. Bilotta, (Cosenza, Italy: Edizioni Memoria, 2000), 137–152.

83. Matthew Duignan, James Noble, and Robert Biddle, "Abstraction and Activity in Computer-Mediated Music Production," *Computer Music Journal* 34, no. 4 (2010): 22–33.

84. Tom Hall and Alan F. Blackwell, "Sharing Digital Performance Notation with the Audience," in *Proceedings of the 9th Conference on Interdisciplinary Musicology–CIM14*, Berlin: Staatliches Institut für Musikforschung, 2014.

85. Alan F. Blackwell, "Patterns of User Experience in Performance Programming," in *Proceedings of First International Conference on Live Coding*, 2015, Geneva, Switzerland: Zenodo/CERN, http://doi.org/10.5281/zenodo.19315.

86. Theodor W. Adorno, "On the Fetish Character in Music and the Regression of Listening," in *The Culture Industry: Selected Essays on Mass Culture*, ed. J. M. Bernstein (London: Routledge, 1981).

87. Simon Yuill, "All Problems of Notation Will Be Solved by the Masses: Free Open Form Performance, Free/Libre Open Source Software, and Distributive Practice," *Mute* 2, no. 8 (May 2008), https://www.metamute.org/editorial/articles/all-problems-notation-will-be-solved-masses. These ideas have also been explored in Geoff Cox and Morten Riis, "(Micro) Politics of Algorithmic Music: Towards a Tactical Media Archaeology," in *The Oxford Handbook on Algorithmic Music*, ed. Alex McLean and Roger Dean (Oxford: Oxford University Press, 2018).

88. In this statement, which also provides the title of Yuill's essay, Cardew is making an explicit political allegiance to Marxism (not least as a founding member of the Revolutionary Communist Party in the UK). Like many other utopian projects, the Scratch Orchestra collapsed, which was explained by Yuill as a consequence of its overreliance on notation as a determining factor for change and the inherent contradiction that in legislating for nonconformity it operated its own form of authoritarianism. This can be further explained, perhaps, by its lack of ability to modify its own notational form on an ongoing basis.

89. Paolo Virno, *A Grammar of the Multitude: For an Analysis of Contemporary Forms of Life* (Los Angeles: Semiotext(e), 2004), 52.

90. Paolo Virno, *When the Word Becomes Flesh: Language and Human Nature* (South Pasadena, CA: Semiotext(e), 2015), 22.

91. Virno, *Grammar of the Multitude*, 66.

Chapter 5

1. This chapter draws on Emma Cocker's articles "Performing Thinking in Action: The Meletē of Live Coding," *International Journal of Performance Arts and Digital Media* 12, no. 2 (2016): 102–116 and "What Now, What Next—Kairotic Coding and the Unfolding Future Seized," in

"Improvisational Creativity," ed. Jon McCormack, Toby Gifford, and Shelly Knotts, special issue, *Journal of Digital Creativity* 29, no. 1 (2018): 82–95.

2. Theorist and philosopher Mark Fisher argues that in music there has been a symptomatic privileging of liveness and a consequent lack of engagement with recorded and sampled forms (such as dub or hip-hop), and the technology through which they are served, as well as the materiality of the sounds themselves. See Mark Fisher, "The Metaphysics of Crackle: Afro-futurism and Hauntology," *Dancecult: Journal of Electronic Dance Music Culture* 5, no. 2 (2013): 42–55.

3. Philip Auslander, *Liveness: Performance in a Mediatized Culture* (London: Routledge, 1999).

4. This point of departure echoes that taken by artist-researcher Winnie Soon in "Executing Liveness: An Examination of the Live Dimension of Code Inter-actions in Software (Art) Practice" (PhD thesis, Aarhus University, Denmark, 2016).

5. See Steven Tanimoto, "VIVA: A Visual Language for Image Processing," *Journal of Visual Languages and Computing* 1, no. 2 (1990): 127–139; Tanimoto, "A Perspective on the Evolution of Live Programming," in *Proceedings of the 1st International Workshop on Live Programming*, 2013, 31–34, https://liveprogramming.github.io/2013/papers/liveness.pdf. IEEE Press (Institute of Electrical and Electronics Engineers), San Francisco, California. However, note that Tanimoto writes from a computer science and software-engineering perspective, rather than wishing to characterize the experiences of artistic performance.

6. The notion of *pre-gramming* is discussed in chapter 4. As Thor Magnusson and Kate Sicchio note, "Live coders programme, they write in public (Greek: *pro-graphein*)—but they also *pre-gramme*, that is, their algorithmic writing is conditioned by a system that has already been designed with careful considerations of expressivity, constraints, interface, and other concerns of human-machine interaction and performer-audience communication." Thor Magnusson and Kate Sicchio, "Writing with Shaky Hands," *International Journal of Performance Arts and Digital Media* 12, no. 2 (2016): 99–101. Indeed, live coding further complicates the relation between *pre-gramming* and *programming* (indeed, between activity *behind the scenes* and *onstage*) since many live coders share (and even livestream) their preparatory practicing and pre-gramming activity, including the making of new functions directly online (for example, by sharing on GitHub) for others to engage with and comment on. See, for example, Tidalcycles, January 2021, https://club.tidalcycles.org/t/ply-and-chords/2724/11?u=yaxu.

7. Later in the chapter, we discuss the notion of real-time composition in relation to the increased immediacy enabled by minimizing the technical latency between the writing and the execution of code with reference to Steven Tanimoto's hierarchy of degrees of liveness. However, for choreographer João Fiadeiro, real-time composition (RTC) is a theoretical-practical tool for problematizing the experience of improvisation and composition where the performer is invited to "let go" their role as "creator"—along with the "interference" of habits and patterns of behavior—to become the "facilitator" or "mediator" of "what happens," conceived as a coemergent process. See João Fiadeiro, "If You Don't Know, Why Do You Ask? An Introduction to the Method of Real-Time Composition," in *Knowledge in Motion: Perspectives of Artistic and Scientific Research in Dance*,

ed. Sabine Gehm, Pirkko Husemann, and Katharina von Wilcke (Bielefeld, Germany: Transcript, 2007), 101–110. The notion of real time is further explored in chapter 6.

8. See also Mark J. Butler, *Playing with Something That Runs: Technology, Improvisation and Composition in DJ and Laptop Performance* (Oxford: Oxford University Press, 2014). The repeatability and recording of live coding performances raises complex questions regarding issues of copyright, around which there is currently little consensus within the live coding community.

9. Benoît and the Mandelbrots (Holger Ballweg, Patrick Borgeat, Juan A. Romero, Matthias Schneiderbanger), interview by Emma Cocker, July 11, 2016.

10. See Rangga Aji's exposition in chapter 3.

11. See the ALGOBABEZ (Shelly Knotts and Joanne Armitage) exposition in chapter 3.

12. The blank slate is always bound to be a relative concept. For example, a blank slate using ixi lang is impregnated with more musical sounds and patterns than the blank slate of SuperCollider, which in turn is more pregnant than C/C++. This reflects the system's hierarchy of code: ixi lang is written in SuperCollider, which is written in C/C++. Live coders have always used their own libraries and convenience classes to make live coding faster and less of an inventing-the-wheel-in-front-of-a-live-audience process. Increasingly, people package these systems as self-standing live coding environments, a unique system derived from that person's coding style. Specific systems such as LOLC, Gibber, Al-Jazari, Scheme Bricks, or Texture are all good examples of constrained and limited systems that explore a particular idea yet provide a wide scope for general musical expression.

13. See Richard Dudas, "Comprovisation: The Various Facets of Composed Improvisation within Interactive Performance Systems," *Leonardo Music Journal* 20 (2010): 29–31, https://openmusiclibrary.org/article/4662/.

14. Peggy Phelan, *Unmarked: The Politics of Performance* (London: Routledge, 1993), 146.

15. Auslander, *Liveness*.

16. Auslander, *Liveness*, 11.

17. Auslander, *Liveness*, 5. Auslander refers to Jean Baudrillard's *For a Critique of the Political Economy of the Sign*, trans. Charles Levin (St. Louis: Telos Press, 1981), 175–176.

18. Auslander, *Liveness*, 3.

19. Philip Auslander, "Afterword: So Close and Yet So Far Away, the Proxemics of Liveness," in *Experiencing Liveness in Contemporary Performance: Interdisciplinary Perspectives*, ed. Matthew Reason and Anja Mølle Lindelof, Routledge Advances in Theatre and Performance Studies (London: Routledge, 2017), 296. See also Auslander, "Digital Liveness: A Historic-Philosophical Perspective," *PAJ: A Journal of Performance and Art* 34, no. 3 (2012): 3–11.

20. Nick Couldry, "Liveness, Reality, and the Mediated Habitus from Television to the Mobile Phone," *Communication Review* 7 (2004): 353–361. The experience of technologically mediated

liveness has been unexpectedly foregrounded since 2020 (during the final years of writing this book) as a consequence of the COVID-19 pandemic, with a rise in streamed performances and zoom events. For example, Eulerroom Equinox 2020 (March 2020) was a live discussion by the TOPLAP community, originally planned as a physically situated event, that resulted in a stream of 117 performances. See YouTube video, https://www.youtube.com/watch?v=qcE_a8IXk8o &list=PLMBIpibV-wQLUXxRDiwz5JhoIf2CX_uM6.

21. Reason and Lindelof, *Experiencing Liveness in Contemporary Performance*, 6.

22. Reason and Lindelof, *Experiencing Liveness in Contemporary Performance*, 7–8.

23. Reason and Lindelof, *Experiencing Liveness in Contemporary Performance*.

24. See Alan F. Blackwell, "The Dark Side of Metaphor: Fetish in User Interfaces" (paper presented at the Conference on Human Factors in Computing Systems, April 10–15, 2010, Atlanta), https://www.cl.cam.ac.uk/events/experiencingcriticaltheory/Blackwell-DarkSide.pdf.

25. See Kenton O'Hara, Richard Harper, Helena Mentis, Abigail Sellen, and Alex Taylor, "On the Naturalness of Touchless: Putting the 'Interaction' Back into NUI," *ACM Transactions on Computer-Human Interaction* 20, no. 1 (April 2013): article 5.

26. Choreographer and philosopher Maxine Sheets-Johnson uses the term *kinesthetic memory* to address the question of "how we do what we do." Maxine Sheets-Johnson, *The Corporeal Turn: An Interdisciplinary Reader* (Exeter, UK: Imprint Academic, 2009), 11. See also Sheets-Johnson, *The Primacy of Movement* (Amsterdam: John Benjamins, 1999) and Zeynep Çelik Alexander, *Kinaesthetic Knowing* (Chicago: University of Chicago Press, 2017).

27. These categories of "intelligence" are drawn from Howard Gardner's *Frames of Mind: The Theory of Multiple Intelligences* (New York: Basic Books, 1983). For example, on embodiment see Francisco J. Varela, Evan Thompson, and Eleanor Rosch, *The Embodied Mind* (Cambridge, MA: MIT Press, 1991).

28. James J. Gibson, *The Senses Considered as Perceptual Systems* (Boston: Houghton Mifflin, 1966), 97. See Michael Polyani, "Tacit Knowing: Its Bearing on Some Problems of Philosophy," *Review of Modern Physics* 34 (1962): 601–616 and Michael Polyani, *The Tacit Dimension* (1966; repr., Gloucester, MA: Peter Smith, 1983).

29. See also Thor Magnusson and Kate Sicchio, eds., "Live Coding in Performance Arts," special issue, *International Journal of Performance Arts and Digital Media* 12, no. 2 (2016).

30. See André Lepecki, ed., *Dance*, Documents of Contemporary Art (London: Whitechapel; Cambridge, MA: MIT Press, 2012). See also Sheets-Johnson, *Corporeal Turn*; Alva Noë, *Action in Perception* (Cambridge, MA: MIT Press, 2004); Noë, *Varieties of Presence* (Cambridge, MA: Harvard University Press, 2012).

31. See Kate Sicchio's exposition in chapter 3.

32. See Kate Sicchio's exposition in chapter 3.

33. See Joana Chicau's exposition in chapter 3.

34. Daniel Stern, *Forms of Vitality: Exploring Dynamic Experience in Psychology, the Arts, Psychotherapy, and Development* (Oxford: Oxford University Press, 2010), 3. In so doing, he departs from philosopher Henri Bergson's conceptualization of *élan vital*, conceived as a "vital force or impulse," an immanent creative principle continually developing and generating new forms.

35. Stern, *Forms of Vitality*, 9.

36. Stern, *Forms of Vitality*, 45.

37. Stern, *Forms of Vitality*, 8. This distinction connects with the "imperative how vs. declarative what" dichotomy in programming-language design. See C. Pair, "Programming, Programming Languages and Programming Methods," in *Psychology of Programming*, ed. J.-M. Hoc, T. R. G. Green, R. Samurçay, and D. J. Gilmore (London: Academic Press, 1990), 11.

38. Stern, *Forms of Vitality*, 4.

39. Reason and Lindelof use the term *deadliness* in reference to the writing of Brook, *Experiencing Liveness in Contemporary Performance*, 1. See also Peter Brook, *The Empty Stage* (London: Penguin, 1972).

40. Erin Manning, *Always More Than One: Individuation's Dance* (Durham, NC: Duke University Press, 2013), 139.

41. Manning, *Always More Than One*, 147.

42. Manning, *Always More Than One*, 142.

43. See N. Katherine Hayles, *How We Became Posthuman: Virtual Bodies in Cybernetics, Literature and Informatics* (Chicago: University of Chicago Press, 2010).

44. The notions of *thinking-in-action*, *thought-in-motion*, and *loom-thinking* are explored further in relation to live coding in chapter 7.

45. See Tim Ingold, "The Textility of Making," in *Being Alive: Essays on Movement, Knowledge and Description* (London: Routledge, 2011), 210–219. The epistemological implications of live coding's "textility" is explored further in chapter 7.

46. Mihaly Csíkszentmihályi, *Flow: The Classic Work on How to Achieve Happiness* (London: Rider, 2002), 64.

47. See also Chris Nash and Alan F. Blackwell, "Flow of Creative Interaction with Digital Music Notations," in *The Oxford Handbook of Interactive Audio*, ed. K. Collins, B. Kapralos, and H. Tessler (New York: Oxford University Press, 2014), 387–404.

48. Csíkszentmihályi, *Flow*, 56.

49. There is no such thing as real time or the present to the computer, only degrees of delay. See Wolfgang Ernst, *Delayed Present: Media-Induced Tempor(e)alities and Techno-Traumatic Irritations of "the Contemporary"*, ed. Geoff Cox and Jacob Lund (Berlin: Sternberg Press, 2017).

50. See also David M. Berry, "Real-Time Streams," in *The Philosophy of Software: Code and Mediation in the Digital Age* (London: Palgrave Macmillan, 2011), 142–169.

51. Tanimoto, "Perspective on the Evolution of Live Programming."

52. Tanimoto, "Perspective on the Evolution of Live Programming."

53. Tanimoto, "Perspective on the Evolution of Live Programming."

54. Tanimoto, "Perspective on the Evolution of Live Programming."

55. Tanimoto, "Perspective on the Evolution of Live Programming."

56. Tanimoto, "Perspective on the Evolution of Live Programming."

57. See Chris Nash, "Supporting Virtuosity and Flow in Computer Music" (PhD thesis, University of Cambridge, 2012), https://doi.org/10.17863/CAM.16375.

58. See also Rosa Menkman, *The Glitch Moment(um)* (Amsterdam: Institute of Network Cultures, 2011).

59. Alternatively, for some thinkers *acceleration* has radical critical potential, where certain technosocial processes could in fact be accelerated as a way of generating change. See Robin Mackay and Armen Avanessian, eds., *#Accelerate#: The Accelerationist Reader* (Falmouth, UK: Urbanomic, in association with Merve, 2014).

60. On failure within live coding, see Tom Johnson, *Failing: A Very Difficult Piece for String Bass* (Paris: Editions 75, 1975), and also Nick Collins, "Infinite Length Pieces: A User's Guide," in *Proceedings of MAXIS*, Sheffield, UK: Sheffield Hallam University, April 12–14, 2002, where it is unclear whether the (prototype) software has terminated or just crashed. See also Kim Cascone's "The Aesthetics of Failure: Post-Digital Tendencies in Contemporary Computer Music," *Computer Music Journal* 24, no. 4 (December 2000): 12–18.

61. On the loss of intervals in contemporary culture, see Byung-Chul Han, *The Scent of Time* (Cambridge: Polity Press, 2017).

62. See Elizabeth Wilson's exposition in chapter 3.

63. See Marc Leman, *The Expressive Moment: How Interaction (with Music) Shapes Human Empowerment* (Cambridge, MA: MIT Press, 2016) and Leman, *Embodied Music Cognition and Mediation Technology* (Cambridge, MA: MIT Press, 2007).

64. J. L. Austin, *How to Do Things with Words* (Cambridge, MA: Harvard University Press, 1975).

65. Austin later revised the opposition between constatives and performatives through the introduction of three categories: locutionary (e.g., the performance of an utterance), illocutionary (e.g., the force of the utterance, thus its real, intended meaning, such as a command or promise), and perlocutionary (e.g., its actual effect, whether intended or not).

66. See Geoff Cox and Alex McLean, "Vocable Speech," in *Speaking Code, Coding as Aesthetic and Political Expression* (Cambridge, MA: MIT Press, 2013), 35.

67. Adrian Mackenzie, *Cutting Code: Software and Sociality* (New York: Peter Lang, 2006), 141.

68. Mackenzie, *Cutting Code*, 141.

69. Florian Cramer has written more extensively about this in "Concepts, Notations, Software, Art," Netzliteratur. March 23, 2002, https://www.netzliteratur.net/cramer/concepts_notations_software_art.html.

70. Alexander R. Galloway, "Language Wants to Be Overlooked: On Software and Ideology," *Journal of Visual Culture* 5, no. 3 (2006): 315–331.

71. Wendy Hui Kyong Chun, *Programmed Visions: Software and Memory* (Cambridge, MA: MIT Press, 2011), 23. We also refer to the agency of live coding in the final chapter of this book and ask what it *wants*.

72. Chun, *Programmed Visions*, 24.

73. Chun, *Programmed Visions*, 24. See also chapter 4 for a discussion of how source code is like a map that you can only read once you know the territory that it generates.

74. In an echo of D. W. Winnicott's *object relations*, it becomes something through its destruction; see Winnicott, *Playing and Reality* (Abingdon: Taylor and Francis, 2005).

75. Chun, *Programmed Visions*, 25.

76. This phrase invokes Derrida's concept of *hauntology*. Furthermore, the unreliable separation of the living and dead is made clear by sound recording, according to Jason Stanyek and Benjamin Piekut in "Deadness, Technologies of the Intermundane," *Drama Review* 54, no. 1 (2010): 14–28.

77. Chun, *Programmed Visions*, xii.

78. Giorgio Agamben, "Notes on Gesture," in *Means without Ends: Notes on Politics*, trans. Vincenzo Binetti and Cesare Casarino (1992; repr., Minneapolis: University of Minnesota Press, 2000), 57.

79. Agamben, "Notes on Gesture," 116. He is referring to Aristotle's distinction between production (poiesis, which has an end other than itself) and action (praxis, which is itself an end) (56). Gesture disrupts the false distinction and presents means without end. See also Giorgio Agamben, "Language and Historical Categories in Benjamin's Thought," in *Potentialities* (Stanford, CA: Stanford University Press, 2007), 48–62, where he refers to Walter Benjamin's essay "On Language as Such and the Language of Man," in *One-Way Street, and Other Writings*, trans. Edmund Jephcott and Kingsley Shorter (London: New Left Books, 1979), 107–123. Agamben also draws on Walter Benjamin's idea of pure language—that is, a language operating beyond a mode of communication between subjects to become one of pure communicability.

80. Paolo Virno, *When the Word Becomes Flesh: Language and Human Nature* (South Pasadena, CA: Semiotext(e), 2015), 35.

81. Dieter Mersch, *Epistemologies of Aesthetics* (Zurich: Think Art Diaphanes, 2015), 118–119.

82. Mersch, *Epistemologies of Aesthetics*, 170.

83. Mersch, *Epistemologies of Aesthetics*, 52.

84. See Erika Fischer-Lichte, "Explaining Concepts," in *The Transformative Power of Performance: A New Aesthetics* (London: Routledge, 2008).

85. The notion of autopoiesis here draws on the work of Humberto Maturana and Francisco Varela—e.g., *Autopoiesis and Cognition: The Realization of the Living* (1980). See also Andy Clark and David J. Chalmers, "The Extended Mind: A Dynamical Systems Perspective," *Analysis* 58 (1998): 7–19.

86. Marvin Carlson, introduction to Fischer-Lichte, *Transformative Power of Performance*, 7.

87. Fischer-Lichte, *Transformative Power of Performance*, 39. See also Umberto Eco, *The Open Work* (Cambridge, MA: Harvard University Press, 1989).

88. Fischer-Lichte, *Transformative Power of Performance*, 68.

89. For example, see Thor Magnusson's ixi lang "shuffle," referred to in Jason Freeman and Akito Van Troyer, "Collaborative Textual Improvisation in a Laptop Ensemble," *Computer Music Journal* 35, no. 2 (Summer 2011): 8–21. Also, see the self-modifying live code editor feedback.pl, described in Adrian Ward et al., "Live Algorithm Programming and a Temporary Organisation for Its Promotion," in *Read_me: Software Art and Cultures*, ed. Olga Goriunova and Alexei Shulgin (Århus, Denmark: Digital Aesthetics Research Centre, University of Aarhus, 2004).

90. See Donna J. Haraway, *Staying with the Trouble: Making Kin in the Chthulucene*, Experimental Futures (Durham, NC: Duke University Press, 2016) and Donna J. Haraway, "Anthropocene, Capitalocene, Plantationocene, Chthulucene: Making Kin," *Environmental Humanities* 6, no. 1 (2015): 159–165, 160.

91. See Bruno Latour, *Reassembling the Social: An Introduction to Actor-Network-Theory* (Oxford: Oxford University Press, 2005). In *Vibrant Matter*, Jane Bennett explores the "capacity of things . . . not only to impede or block the will and designs of humans but also to act as quasi agents or forces with trajectories, propensities, or tendencies of their own." See Jane Bennett, *Vibrant Matter: A Political Ecology of Things* (Durham, NC: Duke University Press, 2010), viii.

92. Karen Barad, "Posthumanist Performativity: Toward an Understanding of How Matter Comes to Matter," new issue, *Signs: Gender and Science* 28, no. 3 (Spring 2003), 808. See also Karen Barad, *Meeting the Universe Halfway: Quantum Physics and the Entanglement of Matter and Meaning* (Durham, NC: Duke University Press, 2007).

93. Barad, "Posthumanist Performativity," 827.

94. As mentioned earlier, this geographical displacement has become even more foregrounded since 2020 as a consequence of the COVID-19 pandemic.

95. Fischer-Lichte, *Transformative Power of Performance*, 50.

96. Paulo Freire, *Pedagogy of the Oppressed* (New York: Seabury Press, 1968).

97. Reason and Lindelof, *Experiencing Liveness*, 2. See Martin Buber, *Between Man and Man* (London: Routledge, 2002), 241.

Notes to Chapter 5

98. Martin Howse, Earthcodes Project, September 17, 2014, http://www.1010.co.uk/org/earthcode.html.

99. See also Martin Howse, "Dark Interpreter," The Dark Interpreter, September 6, 2015, http://www.1010.co.uk/org/darkint.html.

100. See Fischer-Lichte, *Transformative Power of Performance*, 51–60.

101. Miwon Kwon, *One Place after Another: Site-Specific Art and Locational Identity* (Cambridge, MA: MIT Press, 2004), 126. See also Irit Rogoff, "WE: Collectivities, Mutualities, Participations," in *I Promise Its Political: Performativität in der Kunst*, ed. Dorothea Von Hantelmann and Marjorie Jongbloed (Cologne: Museum Ludwig, 2002).

102. Kwon, *One Place after Another*, 7.

103. Christopher Kelty, "Geeks and Recursive Publics," in *Two Bits: The Cultural Significance of Free Software* (Durham, NC: Duke University Press, 2008), 28.

104. Kelty, "Geeks and Recursive Publics," 29.

105. Kelty, "Geeks and Recursive Publics," 29.

106. Kelty, "Geeks and Recursive Publics," 62.

107. See Iris Saladino's exposition in chapter 3.

108. Simon Yuill, "All Problems of Notation Will Be Solved by the Masses: Free Open Form Performance, Free/Libre Open Source Software, and Distributive Practice," Mute 2, no. 8 (May 2008): 67, https://www.metamute.org/editorial/articles/all-problems-notation-will-be-solved-masses. Yuill provides the example of drumming circle performances in which "anyone can join in with their own algorithms and code, constructing and developing a collective rhythmic work, as well as performances that start from one piece of code that is rewritten by successive performers."

109. See Abhinay Khoparzi's exposition in chapter 3.

110. Yuill, "All Problems of Notation," 77.

111. Yuill, "All Problems of Notation," 67. To Yuill, live coding enacts many of the principles of free software development:

> Of all the artforms supported and enabled through FLOSS . . . "livecoding" has emerged as the one which most directly embodies the key principles of FLOSS production into the creation and experience of the work itself. . . . Livecoding emphasises the FLOSS principle of code-based production as a form of production that is itself "live" and living, that enables the possibility of production by others for their own purposes. (Yuill, "All Problems of Notation," 65)

112. Stephen Ramsay, *Algorithms Are Thoughts, Chainsaws Are Tools*, video, 2016, https://vimeo.com/699880166. Accessed 15 May 2016, in Cocker, "Performing Thinking in Action," 109.

113. For an analysis of the difference between frontstage and backstage performance in everyday life, see Irving Goffman, *The Presentation of Self in Everyday Life* (Woodstock, NY: Overlook, 1973).

114. Yuill, "All Problems of Notation," 66.

115. For a key historical touchstone text on "aura" and its relation to technology, see Walter Benjamin, "The Work of Art in the Age of Mechanical Reproduction," in *Illuminations*, ed. Hannah Arendt, trans. Harry Zohn (New York: Schocken Books, 1969).

116. The notion of virtuosity is addressed in chapter 4, where it is rescued from its association with the cult of the performer and recuperated as political action through the prism of Paolo Virno's writing.

117. Catherine Wood, *Yvonne Rainer: The Mind Is a Muscle* (London: Afterall, 2007), 27. Wood is specifically referring to Yvonne Rainer's choreographic performances from the 1960s onward. See also Rainer's *No Manifesto* (1965), which explicitly refuses virtuosity in the commonplace understanding.

118. Yuill, "All Problems of Notation," 67.

Chapter 6

1. A formal definition of the phrase *time critical* in a technical context, by analogy to systems properties such as *safety critical*, would refer to systems where the correctness of the program execution depended not only on the value of the outputs but also on the time at which those outputs were produced. A computer science response to this research question might involve mathematically verified guarantees that a particular event will occur at a particular moment in time—a proof procedure that can itself be applied to the programming languages used in live coding, as in Sam Aaron, Dominic Orchard, and Alan F. Blackwell, "Temporal Semantics for a Live Coding Language," in *Proceedings of the 2nd ACM SIGPLAN International Workshop on Functional Art, Music, Modeling and Design* (New York: Association for Computing Machinery, 2014), 37–47.

2. We paraphrase this from Peter Osborne, *Anywhere or Not at All: Philosophy of Contemporary Art* (London: Verso, 2013), 17.

3. Irit Rogoff describes a shift from criticism to critique to what she describes as "criticality." See Irit Rogoff, "From Criticism to Critique to Criticality," *Transversal*, January 2003, https://transversal.at/transversal/0806/rogoff1/en.

4. Here we paraphrase Geoff Cox and Jacob Lund's *The Contemporary Condition: Initial Thoughts on Contemporaneity and Contemporary Art* (Berlin: Sternberg Press, 2016), 9. The book is the first in an edited series related to the research project the Contemporary Condition at Aarhus University, led by Jacob Lund and Geoff Cox and funded by the Danish Council for Independent Research. See "The Contemporary Condition," Aarhus University, last modified May 10, 2021, http://contemporaneity.au.dk/.

5. Osborne, *Anywhere or Not at All*, 17.

6. Giorgio Agamben, "What Is the Contemporary?," in *What Is an Apparatus? and Other Essays* (Palo Alto, CA: Stanford Press, 2009), 39–55.

Notes to Chapter 6

7. In Agamben's words:

> Those who are truly contemporary, who belong to their time, are those who neither perfectly coincide with it nor adjust themselves to its demands. . . . But precisely because of this condition, precisely through this disconnection and this anachronism, they are more capable than others of perceiving and grasping their own time. ("What Is the Contemporary?," 40)

8. See Jack Burnham's "Systems Esthetics," *Artforum* 7, no. 1 (September 1968): 30–35 and "Real Time Systems," *Artforum* 8, no. 1 (September 1969): 49–55.

9. See Wolfgang Ernst's *Delayed Present* (Berlin: Sternberg Press, 2017). For instance, a stream of data produces differences due to the influence of all things that are executing and running in real time, making the stream decidedly unpredictable. The alternative phrase *near real time* is commonly used in technical circles to describe this delay between the occurrence of an event and the use of the processed data, exemplified by the buffering effects when streaming heavy audio or video data from the internet.

10. Rogoff, "From Criticism to Critique to Criticality."

11. Alex McLean, Dave Griffiths, Nick Collins, and Geraint Wiggins, "Visualisation of Live Code," in *Proceedings of Electronic Visualisation and the Arts*, London, 2010. Swindon, BCS Learning & Development Ltd., 2010: 26–30.

12. Scratch also has some features that are less conventional in contemporary terms, such as a message-passing model that has only relatively recently been supplemented with support for conventional named procedures.

13. See also Andrew Sorensen and Henry J. Gardner, "Programming with Time: Cyber-Physical Programming with Impromptu." In *Proceedings of the 25th Annual ACM SIGPLAN Conference on Object-Oriented Programming, Systems, Languages, and Applications (OOPSLA)*, Reno/Tahoe, Nevada, October 17-21, 2010 (New York: Association for Computing Machinery, 2010): 822–834.

14. Julian Rohrhuber, "Algorithmic Complementarity, or the Impossibility of 'Live' Coding," *Collaboration and Learning through Live Coding (Dagstuhl Seminar 13382)* 3, no. 9 (2014): 140–142, http://dx.doi.org/10.4230/DagRep.3.9.130.

15. Olivia Jack, "Hydra: Live Coding Networked Visuals," in *Proceedings of the Fourth International Conference on Live Coding*, Medialab Prado / Madrid Destino, Madrid, Spain, 16-18 January 2019. Geneva, Switzerland: Zenodo/CERN, 353-354. https://doi.org/10.5281/zenodo.3946269. See also https://hydra.ojack.xyz/.

16. The aforementioned Scratch does not account for logical time, so although it has functionality to make sound and introduce pauses to create rhythm, timing inaccuracies lead to any music produced with it having a pronounced shuffling feel.

17. Depending on the system's sample rate but in terms of digital sound, a *moment* often lasts for 1/44,100th of a second, with 44.1 kilohertz the standard sample rate used by audio compact discs.

18. To adopt a phrase also repeated by poststructuralist thinkers such as Gilles Deleuze (in *Difference and Repetition*) and Jacques Derrida (in *Spectres of Marx*) to indicate how lived time is

experienced as a kind of illusion. See Jack Reynolds, *Understanding Existentialism* (London: Routledge, 2014), 101.

19. Jon May and Nigel Thrift, eds., *Timespace: Geographies of Temporality* (London: Routledge, 2007), 4–5.

20. Stuart Grant, Jodie McNeilly, and Maeva Veerapen, eds., *Performance and Temporalisation: Time Happens* (Basingstoke, UK: Palgrave Macmillan, 2014), 1, 3.

21. See also Julian Rohrhuber, "Algorithmic Music and the Philosophy of Time," in *The Oxford Handbook of Algorithmic Music*, ed. Alex McLean and Roger T. Dean (Oxford: Oxford University Press, 2018), https://zenodo.org/record/2596675#.YBFtRpP7QW4.

22. Zygmunt Bauman, *Liquid Times: Living in an Age of Uncertainty* (Cambridge: Polity Press, 2007), 1.

23. Michael Hardt and Antonio Negri go even further in their account of globally networked late capitalism, in which they claim that "all *times* have been subsumed in a general *non-place*," which could also arguably be conceived as a general non-time. Michael Hardt and Antonio Negri, *Empire* (Cambridge, MA: Harvard University Press, 2000), 353.

24. Amelia Groom, ed., *Time*, Documents of Contemporary Art (London: Whitechapel; Cambridge, MA: MIT Press, 2013), 13.

25. See Jonathan Crary, *24/7: Late Capitalism and the Ends of Sleep* (London: Verso, 2013) for a more detailed account of these conditions.

26. Michael Hardt and Antonio Negri would conceive of this as "total subsumption" to the logic of capital or empire. See Hardt and Negri, *Empire*, 2000.

27. Zygmunt Bauman, *Liquid Life* (Cambridge: Polity Press, 2005).

28. Indeed, conceived in these terms one could argue as the political philosopher Alain Badiou does: "It is better to do nothing than to contribute to the invention of formal ways of rendering visible that which Empire already recognises as existent." Alain Badiou, "Fifteen Theses on Contemporary Art," in *Performance Research* (London: Routledge, 2004).

29. Jodie McNeilly, "Temporalising Digital Performance," in Grant, McNeilly, and Veerapen, *Performance and Temporalisation*, 153.

30. Within music theory, meter is conceived as ground, and rhythm is the figure. In music tradition, time may be notated within discrete symbols, such as Western staff notation or Indian Bol syllables, but performed with subtle phrasing over continuous time.

31. The temporality of latency is discussed by Kristen Veel through its etymological roots (from the Latin *latentum*, meaning "hidden," "lurking," "concealing"), including how it prompts further thinking around invisibility and uncertainty. See Kristen Veel, "Latency," in *Uncertain Archives: Critical Keywords for Big Data*, ed. Nanna Bonde Thylstrup, Daniela Agostinho, Annie Ring, Catherine D'Ignazio, and Kristin Veel (Cambridge, MA: MIT Press, 2021), 313–319.

32. See Alex McLean, "Forkbomb.pl," July 4, 2001, https://slab.org/forkbomb-pl/, a short section of code that when executed gradually disables a computer system. Similarly, glitch is a musical genre in its own right in which musical instruments are pushed to their limits as a way to give audibility to things you are not *meant* to hear in conventional musical terms. See Rosa Menkman, *The Glitch Moment(um)* (Amsterdam: Institute of Network Cultures, 2011).

33. McNeilly, "Temporalising Digital Performance," 153.

34. Grant, McNeilly, and Veerapen, *Performance and Temporalisation*, 3.

35. Elizabeth Grosz, ed. *Becomings: Exploration in Time, Memory and Futures* (Ithaca, NY: Cornell University Press, 1999).

36. Grosz, *Becomings*, 4.

37. Grant, McNeilly, and Veerapen, *Performance and Temporalisation*, 6.

38. Grosz, *Becomings*, 18–19.

39. Henri Bergson, *Matter and Memory* (London: Dover, 1991), 137.

40. Bergson, *Matter and Memory*, 138.

41. Grosz, *Becomings*, 25.

42. Daniel Stern, *The Present Moment in Psychotherapy and Everyday Life* (New York: W. W. Norton, 2004), 27.

43. Stern, *Present Moment in Psychotherapy and Everyday Life*, 27. Here, perhaps, this future-of-the-present moment could be considered in relation to Erin Manning's writing on *preacceleration*. See Erin Manning, *Relationscapes: Movement, Art, Philosophy* (Cambridge, MA: MIT Press, 2009).

44. Martin Heidegger, *Being and Time* (1953; repr., Albany: State University of New York Press, 2010). The Greek word *ekstasis* (standing outside oneself) is used by Heidegger to indicate how Dasein (the experience of being) stands out from the past and projects itself toward a future by way of the present.

45. Heidegger, *Being and Time*, 334.

46. McNeilly, "Temporalising Digital Performance," 156.

47. Alfred Schutz, "Making Music Together: A Study in Social Relationship," in vol. 2, *A. Schutz, Collected Papers* (The Hague: Martinus Nijhoff, 1976), 159–179.

48. But, of course, it is important to recognize that the way in which words like *promise* are employed may or may not closely resemble human uses of the same word. For a discussion of this, see Alan F. Blackwell, "Metaphors We Program By: Space, Action and Society in Java," in Proceedings of the 18th Annual Workshop of the Psychology of Programming Interest Group, 7–21. Brighton, UK: University of Sussex, 2006.

49. A further example could be taken from a technical paper discussing the formal logic of temporality implemented in Sonic Pi. See Sam Aaron, Dominic Orchard, and Alan F. Blackwell, "Temporal Semantics for a Live Coding Language," 37–47.

50. See Thor Magnusson, "The Threnoscope: A Musical Work for Live Coding Performance" (paper presented at the First International Workshop on Live Programming in Conjunction with the 35th International Conference on Software Engineering, 2013, May 18–26, 2013, San Francisco).

51. Martin Clayton, *Time in Indian Music: Rhythm, Metre, and Form in North Indian Rāg Performance* (Oxford: Oxford University Press, 2000), 16.

52. Bernard Bel, "Rationalizing Musical Time: Syntactic and Symbolic-Numeric Approaches," in *The Ratio Book*, ed. Clarence Barlow, Feedback Papers 43 (Cologne: Feedback Studio, 2001), 86–101.

53. Here we paraphrase Agamben's notion of the contemporary once more, as an experience of disconnection in order to establish a disjunctive relationship with one's own time. See Agamben, "What Is the Contemporary?," 40.

54. Victor Turner, *From Ritual to Theatre: The Human Seriousness of Play* (New York: PAJ, 1982), 44.

55. See also Julian Rohrhuber, "Live Coding and the Self Alienation of Time," keynote lecture at the First International Conference on Live Coding, 2015, University of Leeds, UK.

56. Catherine Clément, *Syncope: The Philosophy of Rapture*, trans. Sally O'Driscoll and Deirdre M. Mahoney (Minneapolis: University of Minnesota Press, 1994), 1.

57. Clément, *Syncope*, 5.

58. Clément, *Syncope*, 254. The original reference is from Jean-Jacques Rousseau's article on syncope in *A Complete Dictionary of Music*, trans. William Waring (1779; repr., New York: AMS Press, 1975), 390–391. Significantly, in the original the word *time* was used instead of *beat* but has been changed in keeping with Clément's usage.

59. More specifically, she draws on Bergson's writing on the *syncopathic* figure of the *renunçiant* who leaves the village for the forest. Her argument is that Bergson uses the duality to point to a deeper division between time and duration: "In the village, time is homogenous and divisible. . . . In the forest, duration is heterogeneous and indivisible, is in continuous mutation." Clément, *Syncope*, 173.

60. Reflecting on the concept of *futurity*, writer Jean-Paul Martinon turns to the French language and identifies two different words for the future: *le futur* and *l'avenir*. The first, *le futur*, he states, "refers to something distant or remote, possible, or probable . . . *Le futur* supposes in fact the possibility of projection, predictions, and prophecies." While *le futur* is concerned with "what will or might be," *l'avenir*, as Martinon notes, is usually translated as "what is '*yet*-to-come.'" He differentiates the two modes thus: "One focuses on what the future does or what we do with the future [*l'avenir*] and the other concentrates on what the future *is* or holds [*le futur*]." Though different, both models refer to the future as a linear continuation of time. Against this logic, he positions the radical potential of a third term: *à-venir* (the expression of the "to-come"), which represents an "unhinging," a "spacing (and) temporizing" that "interrupts the present," "breaking up . . . the measurable linearity of space and time." Moreover, he asserts, "*À-venir* does not stem from the future, but *from itself*, from a 'self' that 'lies' between radical impossibility ('what has not yet streamed') and a future historically determined in advance." According to Martinon, "*À-venir*

surges between the foreseeable, 'projectable,' 'plannable,' and programmable *future present* and the radical future, that is . . . that which exceeds or is more than this future possibility." Jean-Paul Martinon, *On Futurity, Malabou, Nancy and Derrida* (London: Palgrave Macmillan, 2007), 1, 4–5, 7.

61. See Emma Cocker, "Live Notation: Reflections on a Kairotic Practice," *Performance Research* 18, no. 5 (2013): 69–76, where the concept of kairotic coding is coined to address the specific mode of timing and timeliness operating within the diverse live coding practices specifically encountered by Cocker within the Arts and Humanities Research Council–funded project Live Notation: Transforming Matters of Performance (2012), as previously discussed.

62. Eric Charles White, *Kaironomia: On the Will to Invent* (Ithaca, NY: Cornell University Press, 1987), 14.

63. White, *Kaironomia*, 54–55.

64. As White notes, *kairos* has its origins in two different sources: archery, where it describes "an opening . . . through which the archer's arrow has to pass" and weaving, where there is "a 'critical time' when the weaver must draw the yarn through a gap that momentarily opens in the warp of the cloth being woven." White, *Kaironomia*, 13.

65. Stern, *Present Moment in Psychotherapy and Everyday Life*, 7.

66. Stern, *Present Moment in Psychotherapy and Everyday Life*, 7.

67. Antonio Negri, *Time for Revolution* (New York: Continuum, 2003), 152.

68. Antonio Negri, *Negri on Negri: Antonio Negri in Conversation with Anne Dufourmantelle* (London: Routledge, 2004), 104.

69. Simon O'Sullivan, *Art Encounters: Deleuze and Guattari, Thought beyond Representation* (London: Palgrave, 2006), 119.

70. O'Sullivan, *Art Encounters*, 122.

71. For an introduction to symmetry breaking, see Ian Stewart, *Fearful Symmetry: Is God a Geometer?* (Mineola, NY: Dover, 2010).

72. Grosz, *Becomings*, 3.

73. Grosz, *Becomings*, 11.

74. See François Hartog, *Regimes of Historicity: Presentism and Experiences of Time* (New York: Columbia University Press, 2015).

75. O'Sullivan, *Art Encounters*, 37.

76. See Emma Cocker, "What Now, What Next—Kairotic Coding and the Unfolding Future Seized," in "Improvisational Creativity," special issue, *Digital Creativity* 29, no. 1 (2018): 82–95.

77. See Tom Hall, "Towards a Slow Code Manifesto," Ludions, April 2007, http://www.ludions.com/texts/2007a/. Tom Hall, Julian Rohrhuber, and Renate Wieser initially promoted slow

code ideals as members of the Elementary Music Ensemble and later the Slow Code Library for SuperCollider.

78. As Adrian Heathfield states, where "duration nearly always involves the collapse of objective measure. Whether it is long or short in 'clock time,' its passage will be marked by a sense of the warping of time." Adrian Heathfield, *Out of Time: The Lifeworks of Tehching Hseih* (Cambridge, MA: MIT Press, 2009), 22.

79. Wolfgang Ernst, *Chronopoetics: The Temporal Being and Operativity of Technological Media* (London: Rowman and Littlefield, 2016), 63–95.

80. Ernst, *Chronopoetics*, 63.

81. Cf. our earlier comment on *temporal semantics*, fn. 42.

82. Ernst, *Chronopoetics*, 89.

83. See Bernard Stiegler, *La technique et le temps*, 3 vols. (Paris: Éditions Galilée, 1994–2001).

84. For Ernst, the critical difference is that media do not produce (discursive) cultural signs but rather (nondiscursive) technical signals, and in this way media can be understood as active "archaeologists" of knowledge. It is important to explain that Ernst takes his cue from the writings of Michel Foucault and his *Archaeology of Knowledge* (1969; repr., London: Routledge 2002) and from the various strands of German media theory associated with Friedrich Kittler, who developed a critique of Foucault for not taking seriously enough the ways in which media produce knowledge. That Ernst was trained as a historian is important for an appreciation of his particular take on media archaeology and his preference for Foucauldian epistemic ruptures: "As an alternative way of writing—or rather not writing—media history." Anthony Enns, "Foreword: *Media History versus Media Archeology: German Media Theory and Wolfgang Ernst's* Chronopoetics," in Ernst, *Chronopoetics*, xviii.

85. Wolfgang Ernst, "Media Archaeography: Method and Machine versus History and Narrative of Media," in *Media Archaeology: Approaches, Applications and Implications*, ed. Erkki Huhtamo and Jussi Parikka (Berkeley: University of California Press, 2011), 239.

86. Ernst's example is Fourier analysis in which the machine can be considered to be a better cultural analyst (or archaeologist) than the human. This knowledge can then be presented back to humans to enhance their understanding. When processing signals, such as sound waves, Fourier analysis can isolate narrowband components of a compound waveform, concentrating them for easier detection or removal.

87. Wolfgang Ernst, "'. . . Else Loop Forever': The Untimeliness of Media" (paper presented at Humboldt University, Berlin, 2009, https://www.medientheorien.hu-berlin.de/de/medienwissenschaft/medientheorien/ernst-in-english/pdfs/medzeit-urbin-eng-ready.pdf. Here, we also refer to Winnie Soon and Geoff Cox, "Infinite Loops," in *Aesthetic Programming* (London: Open Humanities Press, 2020), 94–95.

88. Alan M. Turing, "On Computable Numbers, with an Application to the Entscheidungsproblem," *Proceedings of the London Mathematical Society* 42 (1936/1937): 230–265.

Notes to Chapter 7

89. "The end of history" is a concept that supposes that a particular political, economic, or social system may develop that would constitute the end point of human evolution and the final form of government. Among other references to Hegel and Marx, it is commonly associated with Francis Fukuyama's *The End of History and the Last Man* (New York: Free Press, 1992), which argued for the triumph of Western liberal democracy, and as such the end of history, after 1989 (marking the fall of communism). Like Ernst, we happily contest this on technological and political grounds.

90. Rohrhuber, "Algorithmic Music and the Philosophy of Time."

91. Ernst, "Else Loop Forever."

92. Ernst, "Else Loop Forever."

93. Alan C. Kay, "The Early History of Smalltalk" (New York: Association for Computing Machinery, 1993), http://gagne.homedns.org/~tgagne/contrib/EarlyHistoryST.html. Publicly released in 1980 and developed through numerous iterations since 1971 by Alan Kay, Dan Ingalls, Adele Goldberg, Ted Kaehler, Diana Merry, Scott Wallace, Peter Deutsch, and Xerox PARC, in the context of ARPA (Advanced Research Projects Agency) in the US, Smalltalk has since informed the development of many other popular languages, such as Java, Python, and Ruby.

94. Although see, for example, the section on algorithmic pattern in chapter 4 for a more nuanced treatment of the algorithm.

95. Shintaro Miyazaki, "Algorhythmics: Understanding Micro-temporality in Computational Cultures," *Computational Culture* 2 (2012), http://computationalculture.net/article/algorhythmics-understanding-micro-temporality-in-computational-cultures.

96. Rogoff, "From Criticism to Critique to Criticality." A key reference to the political potential of this can also be found in Walter Benjamin's "On the Concept of History," in vol. 4, *Selected Writings, 1938–1940*, ed. Howard Eiland and Michael W. Jennings (Cambridge, MA: Belknap Press, 1992).

97. Thus, to Fisher, we realize that we are listening not only to a "phonographic revenant, but also by introducing the technical frame, the material pre-condition of the recording, on the level of the content." Fisher, "The Metaphysics of Crackle," 49. Additionally, of course, this affords creative possibilities of working with the aesthetics of the crackle as a parallel to what we broadly argue is the case with live coding. The connection to temporary, or more specifically *contemporaneity*, has been developed in Geoff Cox, Ryan Nolan, and Andrew Prior, "The Crackle of Contemporaneity," in *Futures of the Contemporary: Contemporaneity, Untimeliness, and Artistic Research*, ed. Paulo de Assis and Michael Schwab (Leuven, Belgium: Orpheus Institute Series-Leuven University Press, 2019), 97–114.

Chapter 7

1. In "Nicomachean Ethics" Aristotle outlines different types of thought including *technē* (productive knowledge, craft, art), *episteme* (theoretical or scientific knowledge), and *phronesis* (prudence, practical wisdom), associating them, respectively, with the faculties of *poiesis* (making),

theoria (contemplation), and *praxis* (action). See "Nicomachean Ethics," book 6, in *Western Philosophy: An Anthology*, ed. and trans. John Cottingham (Oxford: Blackwell, 3rd Edition, 2021). Of course, the words in the previous parentheses are only the closest denominators for the ancient Greek terms; there is no one-to-one mapping because what we understand as craft, art, or scientific knowledge today had a different meaning twenty-five hundred years ago. It is from the term *technē* that we get the words *technical*, *technique*, and *technology*. Although tracing the philosophical lineage of contested terms such as *technē* is beyond the scope of this book, some specific references are offered that help to consider the term *technē* in relation to live coding. Thor Magnusson questions the historical division between *technē* and *episteme* through exploration of the relation of technology and knowledge in *Sonic Writing: Technologies of Material, Symbolic and Signal Inscriptions* (London: Bloomsbury, 2019). Emma Cocker explores technē as a subversive, tactical knowledge in relation to live coding in "Weaving Codes/Coding Weaves: Penelopean Mētis and the Weaver-Coder's Kairos," 140. Cocker refers specifically to the work rhetoric scholar Janet Atwill, who draws on Aristotelian thought to explore *technē* as a particular mode of "knowing" or art capable of responding to situations that are contingent, shifting, or unpredictable in order to effect a change of balance or power by steering the direction of events through wily means rather than through force. See Janet Atwill, *Rhetoric Reclaimed: Aristotle and the Liberal Arts Tradition* (Ithaca, NY: Cornell University Press, 1998). See also Ben Spatz, *What a Body Can Do: Technique as Knowledge, Practice as Research* (London: Routledge, 2015), especially the section "A Selective Genealogy of Technique" (26–28), for an exploration of technē and technique.

2. See Elizabeth Fisher and Rebecca Forthum, *On Not Knowing: How Artists Think* (London: Black Dog, 2013).

3. For more on this, see M. Beatrice Fazi, *Contingent Computation: Abstraction, Experience, and Indeterminacy in Computational Aesthetics* (Lanham, MD: Rowman and Littlefield, 2018).

4. This echoes the argument in chapter 6 that technologies are not simply tools that shape meaning; rather, they are constitutive of meaning, rather like philosopher Bernard Stiegler's point that our relation to time is constituted, or "mediated," by the technical means through which it is apprehended. See Bernard Stiegler, *La technique et le temps*, 3 vols. (Paris: Éditions Galilée, 1994–2001).

5. Karen Barad states: "To be entangled is not simply to be intertwined with another, as in the joining of separate entities, but to lack an independent, self-contained existence. Existence is not an individual affair. Individuals do not preexist their interactions; rather, individuals emerge through and as part of their entangled intra-relating." Barad, *Meeting the Universe Halfway: Quantum Physics and the Entanglement of Matter and Meaning* (Durham, NC: Duke University Press, 2007), ix.

6. Philip E. Agre, "Toward a Critical Technical Practice: Lessons Learned in Trying to Reform AI," in *Bridging the Great Divide: Social Science, Technical Systems, and Cooperative Work*, ed. Geof Bowker, Les Gasser, Leigh Star, and Bill Turner (Hillsdale, NJ: Erlbaum, 1997), 131–157.

7. For more on the relation between Agre and music technology, see Alan F. Blackwell, "Too Cool to Boogie: Craft, Culture and Critique in Computing," in *Sound Work: Composition as Critical*

Technical Practice, ed. Jonathan Impett (Leuven, Belgium: Orpheus Institute Series—Leuven University Press, 2021), 15-33 and Georgina Born, "Diversifying MIR: Knowledge and Real-World Challenges, and New Interdisciplinary Futures," *Transactions of the International Society for Music Information Retrieval* 3, no. 1 (2020): 193–204, https://doi.org/10.5334/tismir.5.

8. For instance, Herman Heine Goldstine and John Von Neumann, "Planning and Coding of Problems for an Electronic Computing Instrument" (Princeton, NJ: Institute for Advanced Study, 1947).

9. There are exceptions, of course; for example, Larry Cuba borrowed the Jet Propulsion Laboratory mainframe computer during the night when creating the computer graphic movie *First Fig* (1974). Cuba's methods were in many ways live coding practice, where code could be written in real-time with real-time results.

10. Michael A. Cusumano, "The Software Factory: A Historical Interpretation," *IEEE Software* 6, no. 2 (1989): 23–30, http://doi.org/10.1109/MS.1989.10017.

11. W. S. Humphrey, *Characterizing the Software Process: A Maturity Framework*. CMU/SEI-87-TR-11 (Pittsburgh: Carnegie Mellon University, Software Engineering Institute, 1987).

12. This disposability is indeed something that should be questioned in relation to the very large numbers of Raspberry Pi computers that were purchased out of enthusiasm for this UK success story but never used.

13. John Markoff, *What the Dormouse Said: How the 60s Counterculture Shaped the Personal Computer Industry* (London: Penguin, 2005). Markoff relates the work done in this lab to drug culture, psychedelic rock, and alternative spirituality. The title of Markoff's book is a reference to a Jefferson Airplane lyric: "Remember what the Dormouse said Feed your head Feed your head."

14. Alan C. Kay, "A Personal Computer for Children of All Ages," in vol. 1, *Proceedings of the ACM Annual Conference* (New York: Association for Computing Machinery, 1972).

15. As noted in chapter 2, Smalltalk was a key inspiration in the evolution of the SuperCollider language involved in many live coding environments for music, as was the Simula language that inspired Smalltalk itself. In Smalltalk, "everything is an object," including numbers, characters, or any other data types (e.g., musical notes or dance steps), and new methods can be created for any of these.

16. For the claimed invention of the icon, see David C. Smith, *Pygmalion: A Computer Program to Model and Stimulate Creative Thought* (Basel, Switzerland: Birkhauser, 1977). However, alternative claims have been made: see Alan F. Blackwell, "The Reification of Metaphor as a Design Tool," *ACM Transactions on Computer-Human Interaction* 13, no. 4 (2006): 490–530.

17. See DynamicLand Foundation narrative, accessed March 15, 2022, https://dynamicland.org/dynamicland-501c3-narrative.pdf.

18. Ben Shneiderman, "Direct Manipulation: A Step beyond Programming Languages," *Computer* 8 (1983): 57–69.

19. An illustrative example is the everyday use of wildcards in the IBM PC-DOS command line language. Most PC users were familiar with syntax such as "DEL *.BAK" to quickly remove large numbers of backup files—a quick and easy operation that otherwise requires tedious clicking and dragging to achieve the same effect in a GUI.

20. Douglas K. Smith and Robert C. Alexander, *Fumbling the Future: How Xerox Invented, Then Ignored, the First Personal Computer* (New York: William Morrow, 1988).

21. See chapter 4 for an account of the evolution of these various practices.

22. Kent Beck et al., *Manifesto for Agile Software Development*, 2001, http://www.agilemanifesto.org.

23. In fact, wiki was used in the early stages of live writing this book. See Alan Blackwell, Geoff Cox, and Sang Won Lee, "Live Writing the Live Coding Book" (paper presented at the International Conference on Live Coding 2016, McMaster University, Hamilton, Canada), http://iclc.toplap.org/2016/papers.html.

24. Bo Leuf and Ward Cunningham, *The Wiki Way: Quick Collaboration on the Web* (Boston: Addison-Wesley, 2001).

25. Christopher Alexander, *A Pattern Language: Towns, Buildings, Construction* (Oxford: Oxford University Press, 1977).

26. Alan F. Blackwell and Sally Fincher, "PUX: Patterns of User Experience," *Interactions* 17 (2010): 27–31.

27. Free Software Foundation (website), accessed March 12, 2022, https://www.fsf.org.

28. Performing music using the Linux bash shell was indeed a topic at the Changing Grammars symposium where TOPLAP was founded, as described in chapter 2.

29. Eric Raymond, "The Cathedral and the Bazaar," *Knowledge, Technology and Policy* 12 (1999): 23–49. Raymond refers to changes within the open-source movement, in which the "Cathedral" practitioners were the first generation of open-source campaigners, reflecting academic and institutional authority rather than what we now recognize as self-organizing online communities.

30. See LIVE: Workshop on Live programming, accessed March 15, 2022, http://liveprog.org and http://liveprogramming.github.io/2013/, for the series of workshops that followed an initial meeting in 2013.

31. Daniel Cardoso Llach, "Software Comes to Matter: Toward a Material History of Computational Design," *Design Issues* 31 (2015): 41–54.

32. Kate Crawford, *Atlas of AI* (New Haven, CT: Yale University Press, 2021); Kate Crawford and Vladan Joler, *Anatomy of an AI System: The Amazon Echo as an Anatomical Map of Human Labor, Data and Planetary Resources*, AI Now Institute and Share Lab, September 7, 2018, https://anatomyof.ai.

33. See chapter 2 for details on the TOPLAP manifesto (2004).

34. Alex McLean notes that this particular statement is likely to have been written by Julian Rohrhuber, following his contribution to the discussion around the drafting of the manifesto:

"I would suggest not to use tools at all, or not to see algorithms as tools at least." Julian Rohrhuber, TOPLAP mailing list, February 24, 2004, https://toplap.org/archive/livecode.txt.

35. Mikael Wiberg, "Methodology for Materiality: Interaction Design Research through a Material Lens," *Personal and Ubiquitous Computing* 18 (2013): 1–12.

36. In the form of cardiac pacemakers and cochlear implants. Many other devices are likely to follow.

37. For example, the dog microchip registration scheme mandated by the UK government.

38. Alan F. Blackwell et al., "Tangible User Interfaces in Context and Theory," In *CHI '07 Extended Abstracts on Human Factors in Computing Systems (CHI EA '07)*. (New York: Association for Computing Machinery, 2007), 2817–2820.

39. Nicolai B. Hansen, Rikke Toft Nørgård, and Kim Halskov, "Crafting Code at the Demo-Scene," in *Proceedings of the ACM Conference on Designing Interactive Systems* (New York: Association for Computing Machinery, 2014), 35–38.

40. Donald A. Schön, *The Reflective Practitioner: How Professionals Think in Action* (New York: Basic Books, 1983).

41. Shad Gross, Jeffrey Bardzell, and Shaowen Bardzell, "Structures, Forms, and Stuff: The Materiality and Medium of Interaction," *Personal and Ubiquitous Computing* 18, no. 3 (2014): 637–649. It can also be seen in relation to a wider material turn within the social sciences and humanities, reflected in the discourse of new materialism, object-oriented ontology, and speculative realism, for example, in the work of thinkers such as Tim Ingold ("Materials against Materiality," *Archaeological Dialogues* 14, no. 1 (2007): 1–16; Bruno Latour (actor-network theory); Jane Bennett (*Vibrant Matter: A Political Ecology of Things*, 2009), Graham Harman (*Object-Oriented Ontology: A New Theory of Everything*, 2018; *Speculative Realism: An Introduction*, 2018). See also Diana Coole and Samantha Frost, eds., *New Materialisms: Ontology, Agency, and Politics* (Durham, NC: Duke University Press, 2010).

42. Alan F. Blackwell, Marian Petre, and Luke Church, "Fifty Years of the Psychology of Programming," *International Journal of Human-Computer Studies* 131 (2019): 52–63.

43. Schön, *Reflective Practitioner*.

44. Andrew Pickering, *The Mangle of Practice: Time, Agency and Science* (Chicago: University of Chicago Press, 1995).

45. Malcolm McCullough, *Abstracting Craft: The Practiced Digital Hand* (Cambridge, MA: MIT Press, 1998).

46. Gross, Bardzell, and Bardzell, "Structures, Forms, and Stuff."

47. See also Graham Harmon, *Immaterialism: Objects and Social Theory* (Cambridge: Polity Press, 2016).

48. Richard Sennett, *The Craftsman* (New Haven, CT: Yale University Press, 2008).

49. See Software Carpentry, home page, accessed March 12, 2022, https://software-carpentry.org. This is a reference to the Software Craftsmanship Manifesto, 2009, http://manifesto.softwarecraftsmanship.org.

50. The demoscene and live coding communities have had surprisingly little overlap despite the former holding closely related activities of live coding "shader" competitions onstage and in front of very large audiences. A recent exception is the Parisian Cookie Collective, well known in the demoscene and actively hosting algoraves, although their events focus on live coding of video rather than music.

51. Hansen, Nørgård, and Halskov, "Crafting Code at the Demo-Scene," 35–38. Note that members of the community prefer the typography *demoscene*, and despite the title of the publication by Hansen et al., the text of that paper uses both forms. Here we use the form preferred by the community itself.

52. Tim Ingold, "The Textility of Making," *Cambridge Journal of Econometrics* 34 (2010): 91–102.

53. Tim Ingold, *Making: Anthropology, Archaeology, Art and Architecture* (London: Routledge, 2013).

54. Ingold, *Making*, 6.

55. Ingold, *Making*, 6–7.

56. Deleuze and Guattari state,

> A distinction must be made between two types of science, or scientific-procedures: one consists in "reproducing," the other in "following." The first involves reproduction, iteration and reiteration; the other, involving itineration, is the sum of the itinerant, ambulant sciences. Itineration is too readily reduced to a modality of technology, or of the application and verification of science. But this is not the case: following is no, at all the same thing as reproducing, and one never follows in order to reproduce. ("Treatise on Nomadology—the War Machine," in *A Thousand Plateaus: Capitalism and Schizophrenia*, trans. Brian Massumi (New York: Continuum, 1987), 372.

57. Ingold's notion of textility is also referred to in chapter 4.

58. See Ingold, "Materials against Materiality," 1–16. See also Alfred Gell, *Art and Agency: An Anthropological Theory* (Oxford: Oxford University Press, 1998).

59. Paul Klee, *Pedagogical Sketchbook* (New York: Frederick A. Praeger, 1953).

60. To Florian Cramer, La Monte Young's *Composition* (1961) provides an example of (noncomputer) software art in which the instruction is unambiguous enough to be executed by a machine. See Cramer's "Concepts, Notations, Software, Art," Netzliteratur, March 23, 2002, https://www.netzliteratur.net/cramer/concepts_notations_software_art.html. A number of 2008 code-based implementations of this work, including by early live coders Amy Alexander and Dave Griffiths, are archived under https://web.archive.org/web/20080825030910/http://instructionset.org/instruction/4/.

61. Rikard Lindell, "Crafting Interaction: The Epistemology of Modern Programming," *Personal and Ubiquitous Computing* 18 (2014): 613–624.

62. Simon Schaffer, "Babbage's Intelligence: Calculating Engines and the Factory System," *Critical Inquiry* 21, no. 1 (1994): 203–227.

63. Tony (C. A. R.) Hoare and Charles Antony Richard, "An Axiomatic Basis for Computer Programming," *Communications of the ACM* 12, no. 10 (1969): 576–580.

64. Edsger W. Dijkstra, "Programming: From Craft to Scientific Discipline," in *Proceedings of the International Computing Symposium*, 23–30 (Liege, Belgium, 1977). Amsterdam; New York: North-Holland, 1977.

65. See Lucy Suchman, *Human-Machine Reconfigurations: Plans and Situated Actions* (Cambridge: Cambridge University Press, 2007), as well as Paul Dourish, *Where the Action Is: The Foundations of Embodied Interaction* (Cambridge, MA: MIT Press, 2004).

66. Ursula Franklin, *The Real World of Technology*, 2nd ed. (Toronto: House of Anansi Press, 1999).

67. Lindell, "Crafting Interaction."

68. Perhaps this is completely appropriate in an information economy and media society where so many products and commodities have also become insubstantial—for example, audio streams, image files, and electronic books—and email has replaced records, photographs, books, and letters.

69. As discussed in chapter 4 in the section on "Dynamics of Machine Notations." See also Alan F. Blackwell, "Patterns of User Experience in Performance Programming," in *Proceedings of the First International Conference on Live Coding*, 2015, Geneva, Switzerland: Zenodo/CERN, http://doi.org/10.5281/zenodo.19315.

70. Ilias Bergström and Alan F. Blackwell, "The Practices of Programming," in *Proceedings of IEEE Visual Languages and Human-Centric Computing* (Piscataway, NJ: Institute of Electrical and Electronics Engineers), 190–198, https://www.researchgate.net/publication/308540044_The_Practices_of_Programming

71. See Bengt Molander, *The Practice of Knowing and Knowing in Practices* (Frankfurt: Peter Lang, 2015).

72. The difference between "knowing that" and "knowing how" is explored by Gilbert Ryle in *The Concept of the Mind* (1949; repr., Harmondsworth, UK: Penguin 1973), which was in turn preceded by Ryle's "Knowing How and Knowing That: The Presidential Address," in *Proceedings of the Aristotelian Society* (Oxford: Oxford University Press, 1945–1946). Ryle's formulation is re-evaluated, debated, and contested in John Bengson and Marc A. Moffett, eds., *Knowing How: Essays on Knowledge, Mind and Action* (New York: Oxford University Press, 2011). On "knowing how," see also Bengt Molander, *Practice of Knowing and Knowing in Practices*.

73. See Henk Borgdorff, "The Production of Knowledge in Artistic Research," in *The Conflict of the Faculties: Perspectives on Artistic Research and Academia* (Leiden: Leiden University Press, 2012), 140–173.

74. See Henk Borgdorff, Peter Peters, and Trevor Pinch, eds., *Dialogues between Artistic Research and Science and Technology Studies*, Routledge Advances in Art and Visual Studies (London: Routledge, 2019).

75. Robin Nelson, *Practice as Research in the Arts: Principles, Protocols, Pedagogies, Resistances* (New York: Palgrave Macmillan, 2013), 37.

76. Schön, *Reflective Practitioner*.

77. Michael Polanyi, *The Tacit Dimension* (Gloucester, MA: Peter Smith, 1983).

78. Francisco Varela, Evan Thompson, and Eleanor Rosch, *The Embodied Mind: Cognitive Science and Human Experience* (Cambridge, MA: MIT Press, 1993); Alva Noë, *Action in Perception* (Cambridge, MA: MIT Press, 2004).

79. Nelson, *Practice as Research*, 43.

80. Dorothy Leonard and Sylvia Sensiper, "The Role of Tacit Knowledge in Group Innovation," *California Management Review* 40 (1998): 113, cited in Nelson, *Practice as Research*, 38.

81. Bergström and Blackwell, "Practices of Programming."

82. See Jessica Jacobs, "Intersections in Design Thinking and Art Thinking: Towards Interdisciplinary Innovation," *Creativity: Theories, Research, Applications* 5, no. 1 (2018): 4–25.

83. Emma Cocker, "Weaving Codes/Coding Weaves: Penelopean Mêtis and the Weaver-coder's Kairos," *Textile: Journal of Cloth and Culture* 15, no. 2 (2017): 124–141.

84. Erin Manning and Brian Massumi, *Thought in the Act: Passages in the Ecology of Experience* (Minneapolis: University of Minnesota Press, 2014), 41.

85. Manning and Massumi, *Thought in the Act*, 43–44.

86. Dieter Mersch, *Epistemologies of Aesthetics*, trans. Laura Radosh (Zurich: Think Art Diaphanes, 2015), 52.

87. Mersch, *Epistemologies of Aesthetics*, 53–54.

88. See also chapter 5 for a discussion on how live coding performance has the capacity to inaugurate "temporary communities," to borrow Miwon Kwon's phrase.

89. *Détournement*, meaning "rerouting, hijacking," is a technique developed in the 1950s by the Letterist International and adapted by the Situationist International. The principle of *détournement* or of *détourning* involves appropriating or altering an existing practice or artifact (especially the practices and products of capitalism) to give it a new subversive meaning or revolutionary significance.

90. Sarat Maharaj, "Know-How and No-How: Stopgap Notes on 'Method' in Visual Art as Knowledge Production," *Art and Research* 2, no. 2 (2009), http://www.artandresearch.org.uk/v2n2/maharaj.html.

91. Elizabeth Fisher and Rebecca Fortnum, eds., *On Not Knowing: How Artists Think* (London: Black Dog, 2013), 7.

92. Fisher and Fortnum, *On Not Knowing*, 7. See also Emma Cocker, "Tactics for Not Knowing: Preparing for the Unexpected," in Fisher and Fortnum, *On Not Knowing*, 126–135.

93. The epistemological significance of improvisation has indeed been of long interest within many disciplines, especially within both music and choreography, two fields of practice that are

embraced by and have in turn contributed to and informed the development of live coding. See Ann Cooper-Albright and David Gere, eds., *Taken by Surprise: A Dance Improvisation Reader* (Middletown, CT: Wesleyan University Press, 2003) including the section "Improvising Body, Improvising Mind", 3–40. See also "Improvisational Creativity," special issue, *Journal of Digital Creativity* 29, no. 1 (2018); Mark J. Butler, *Playing with Something That Runs: Technology, Improvisation and Composition in DJ and Laptop Performance* (Oxford: Oxford University Press, 2014).

94. Roger Caillois, *Man, Play and Culture*, trans. Meyer Barash (1958; repr., Champaign: University of Illinois Press, 2001), 5–6. David Graeber's analysis of play is further explored in chapter 8. See David Graeber, *The Utopia of Rules: On Technology, Stupidity, and the Secret Joys of Bureaucracy* (Brooklyn, NY: Melville House, 2015).

95. Caillois, *Man, Play and Culture*, 5.

96. Instead of creating and preserving individual works, live coding continually produces new works, sharing them in the same way that love is shared: the more you share love, the more value it holds. Indeed, online live coding events are therefore not carefully curated for consumption but are open celebrations of production en masse. Anyone can perform during streamed events that can last over eighty hours nonstop, crossing the world's time zones. These events have left behind an archive of thousands of performances that would take many weeks to view, by which time a new event might well have taken place. See Mark Fisher, *K-PUNK* (blog), May 11, 2015, https://k-punk.org/abandon-hope-summer-is-coming/

97. Paolo Virno, *When the Word Becomes Flesh: Language and Human Nature* (South Pasadena, CA: Semiotext(e), 2015), 22.

98. Mersch, *Epistemologies of Aesthetics*, 26.

99. Mersch, *Epistemologies of Aesthetics*, 26

100. Dieter Mersch, "Aesthetic Thinking: Art as Theōria," in *Aesthetic Theory*, ed. Dieter Mersch, Sylvia Sasse, and Sandro Zanetti, trans. Brian Alkire (Zurich: Think Art Diaphanes, 2019), 219–236. See also the research project Practices of Aesthetic Thinking: A Sinergia project of the Swiss National Science Foundation, January 2, 2017–February 28, 2021, https://sinergia-pat.ch/. See also Alex Arteaga, "Embodied and Situated Aesthetics," *Artnodes*, (2017): 20–27, which is a reformulation of his lecture "Understanding: On the Cognitive Function of Aesthetic Practices" at the Questioning Aesthetics symposium, Art Research and Aesthetics, Barcelona, June 20–22, 2017.

101. Mersch, "Aesthetic Thinking," 219–220.

102. Mara Ambrožič and Angela Vettese, eds., *Art as a Thinking Process: Visual Forms of Knowledge Production* (Berlin: Sternberg Press, 2013), 8.

103. Mersch, *Epistemologies of Aesthetics*, 8.

104. Mersch, *Epistemologies of Aesthetics*, 9.

105. Mersch, *Epistemologies of Aesthetics*, 9–10.

106. Mersch, *Epistemologies of Aesthetics*, 9–10.

107. Mersch, *Epistemologies of Aesthetics*, 11.

108. Mersch, *Epistemologies of Aesthetics*, 11.

109. Mersch, *Epistemologies of Aesthetics*, 52.

110. Manning and Massumi, *Thought in the Act*, vii.

111. Manning and Massumi, *Thought in the Act*.

112. Debra Hawhee, *Bodily Arts: Rhetoric and Athletics in Ancient Greece* (Austin: University of Texas Press, 2004), 75. On *loom-thinking*, see Janis Jeffries, "Textiles: What Can She Know?," in *Feminist Visual Culture*, ed. Fiona Carson and Claire Pajaczkowska (New York: Routledge, 2001), 189–207. As stated in chapter 4, see Sadie Plant's statement, "The computer emerges out of the history of weaving. . . . The loom is the vanguard site of software development" and more in "The Future Looms: Weaving Women and Cybernetics," *Body and Society* 1, no. 3–4 (1995): 46. Several recent projects have drawn "threads" between the work of Bauhaus weaver Anni Albers (1899–1994) and coding—for example, Conductive Coding, an etextiles weaving workshop led by Emilie Giles and Sarah Wiseman at Tate Modern (2019) in response to the Albers's retrospective. See also Anni Albers, *On Weaving* (Middletown, CT: Wesleyan University Press, 1965).

113. Cocker, "Weaving Codes/Coding Weaves," 124–141.

114. For example, see Ellen Harlizius-Klück, "Weaving as Binary Art and the Algebra of Patterns," in Harlizius-Klück, Ellen, in collaboration with Alex McLean, eds., "Weaving Codes, Coding Weaves," special issue, *Textile: Journal of Cloth and Culture* 15, no. 2 (2017).

115. Led by Ellen Harlizius-Klück in collaboration with Alex McLean. For the project outline, see "A Study of Weaving as Technical Mode of Existence, Cordis, last modified December 27, 2021, https://cordis.europa.eu/project/rcn/206885/factsheet/es.

116. Maharaj, *Know-How and No-How*. See also Sarat Maharaj, "What the Thunder Said: Toward a Scouting Report on 'Art as a Thinking Process,'" in Ambrožič and Vettese, *Art as a Thinking Process*, 154–160.

117. See Michel Foucault, *Power/Knowledge* (New York: Pantheon, 1980).

118. For an overview of some of these postcognitivist approaches, see Simon Penny, *Making Sense, Cognition, Computing, Art and Embodiment* (Cambridge, MA: MIT Press, 2017).

119. Alan Turing, "On Computable Numbers, with an Application to the Entscheidungs Problem," *Proceedings of the London Mathematical Society* 2, no. 1 (1937): 230–265.

120. Luciana Parisi, "Reprogramming Decisionism," *e-flux* 85 (October 2017), https://www.e-flux.com/journal/85/155472/reprogramming-decisionism/.

121. Parisi, "Reprogramming Decisionism."

122. Michel Foucault, *Archaeology of Knowledge* (New York: Pantheon Books, 1972).

123. Wolfgang Ernst, *Digital Memory and the Archive*, ed. Jussi Parikka, Electronic Mediations no. 39 (Minneapolis: University of Minnesota Press, 2011), 239.

124. Geoff Cox, "What Does Live Coding Know?," in *Proceedings of the First International Conference on Live Coding* (Leeds: University of Leeds, 2015).

125. Barad, *Meeting the Universe Halfway*.

126. Foucault indicates that an apparatus (*dispositif* in French) is a network or system of relations between entities, such as "discourses, institutions, architectural forms, regulatory decisions, laws, administrative measures, scientific statements, philosophical, moral, and philanthropic propositions." Michel Foucault, "The Confession of the Flesh," in *Power/Knowledge: Selected Interviews and Other Writings*, ed. Colin Gordon (New York: Pantheon, 1980), 194–228.

127. Barad, *Meeting the Universe Halfway*, 98.

128. See Geoff Cox and Alex McLean, *Speaking Code, Coding as Aesthetic and Political Expression* (Cambridge, MA: MIT Press, 2013), 35.

129. To explain, in brief, Heisenberg's uncertainty principle asserts that one cannot precisely know both position *and* momentum, but position *or* momentum *can* be known.

130. Barad, *Meeting the Universe Halfway*, 19.

131. Barad, *Meeting the Universe Halfway*, 198–199.

132. Barad. *Meeting the Universe Halfway*, 200.

133. Parisi, "Reprogramming Decisionism." We might also refer, as Parisi does, to N. Katherine Hayles's *nonconscious cognition*, which challenges anthropocentrism in favor of a coevolutionary cognitive infrastructure where machines do not passively adapt to data retrieved but instead establish new patterns of meaning by aggregating, matching, and selecting data (they learn). See N. Katherine Hayles, *Unthought: The Power of the Cognitive Nonconscious* (Chicago: University of Chicago Press, 2017).

Chapter 8

1. Here we reference, for instance, Kevin Kelly, *What Technology Wants* (New York: Viking Press, 2010), in which he suggests technology is a living organism, although it is worth saying that artificial life is outside our scope of interest for this book. See also W. J. T. Mitchell, "What Do Pictures 'Really' Want?," *October* 77 (Summer 1996): 71–82.

2. Karen Barad, *Meeting the Universe Halfway: Quantum Physics and the Entanglement of Matter and Meaning* (Durham, NC: Duke University Press, 2007), ix.

3. See chapter 2 on the emergence of algorave; see also Iman Amrani, "Run the Code: Is Algorave the Future of Dance Music?," *Guardian*, November 30, 2017, https://www.theguardian.com/music/2017/nov/30/is-algorave-the-future-of-dance-music-sheffield-algomech-festival; and *Resident Advisor*'s "Algorave Generation," 2019, https://ra.co/features/3396.

4. The term *rave* is associated with the so-called acid movement developed through secret and underground venues and warehouse and street parties, as well as the use of pirate radio stations.

5. For more on the roots of rave, including the queer and Black politics underpinning Chicago house and Detroit techno, see Simon Reynolds, *Energy Flash* (London: Faber and Faber, 2013).

6. Shintaro Miyazaki, "Algorhythmics: Understanding Micro-temporality in Computational Cultures," *Computational Culture* 2 (2012), http://computationalculture.net/article/algorhythmics-understanding-micro-temporality-in-computational-cultures.

7. Adrian Mackenzie, "The Production of Prediction: What Does Machine Learning Want?," *European Journal of Cultural Studies* 18, no. 4–5 (2015): 429–445.

8. Here we are reminded of a passage in Marx's *Capital*, in which he asks what commodities would say if they could speak, which would be for them to emphasize their exchange value over use value. See "The Commodity," Marxists Internet Archive, n.d., https://www.marxists.org/archive/marx/works/1867-c1/commodity.htm; see also David Cunningham, "If Commodities Could Speak," Fotomuseum Winterthur, September 7, 2016, https://www.fotomuseum.ch/en/explore/still-searching/articles/29094_if_commodities_could_speak.

9. Mackenzie, "Production of Prediction," 431–432.

10. Mackenzie makes a useful intervention with regard to our understanding of the key terms: "We cannot conduct critical enquiry into how calculation will automate future decisions without putting the notions of calculation and automation into question." Adrian Mackenzie, *Machine Learners: Archaeology of a Data Practice* (Cambridge, MA: MIT Press 2017), 8.

11. Alan F. Blackwell, "Objective Functions: (In) Humanity and Inequity in Artificial Intelligence," *HAU: Journal of Ethnographic Theory* 9, no. 1 (2019): 137–146.

12. Mackenzie, "Production of Prediction," 433.

13. Echoing Giorgio Agamben's *Means without Ends: Notes on Politics* (Minneapolis: University of Minnesota Press, 2000). This was previously applied to live coding in Geoff Cox's "Means-End of Software," in *Interface Criticism: Aesthetics beyond Buttons*, ed. Christian Ulrik Andersen and Søren Pold (Aarhus, Denmark: Aarhus University Press, 2011), 145–161.

14. The metaphor of infrastructural undermining as a subversive cultural act might trace speculative connections from the event described in chapter 2, where Alex McLean and Adrian Ward shouted their "Generative Manifesto" over algorithmic beats at London's Institute of Contemporary Arts, to the notorious event at the same venue on January 3, 1984, when post-punk band Einstürzende Neubauten's performance of *Concerto for Voice and Machinery* saw the band drilling through the stage, supposedly to access a system of tunnels heading under the Mall to Buckingham Palace. The otherwise unexplained reference to chainsaws in the TOPLAP manifesto is perhaps an evocation of the destructive capacity that is inherent in powerful tools.

15. Niklaus Wirth's 1975 formulation that "algorithms+data structures=programs" is cited in Paul Dourish, "Algorithms and Their Others: Algorithmic Culture in Context," *Big Data and Society* 3, no. 2 (August 2016), https://journals.sagepub.com/doi/full/10.1177/2053951716665128.

Notes to Chapter 8

16. Andrew Goffey, "Algorithm," in *Software Studies: A Lexicon*, ed. Matthew Fuller (Cambridge, MA: MIT Press, 2008), 21–30.

17. David Graeber, *The Utopia of Rules: On Technology, Stupidity, and the Secret Joys of Bureaucracy* (Brooklyn, NY: Melville House, 2015).

18. A bellwether of this anxiety was the revelation of the personalized political campaigning associated with psychographic services company Cambridge Analytica in its contributions to the Libertarian maneuvering of the Trump election and Brexit campaigns.

19. A newspaper headline that appears to have been bowdlerized from the actual protest chant "Fuck the algorithm," as heard in video from the event uploaded to Twitter, August 16, 2020: https://twitter.com/i/status/1294985562106015750.

20. Louise Amoore, "Why 'Ditch the Algorithm' Is the Future of Political Protest," *Guardian*, August 19, 2020, https://www.theguardian.com/commentisfree/2020/aug/19/ditch-the-algorithm-generation-students-a-levels-politics.

21. Jacques Attali, *Noise: The Political Economy of Music* (Minneapolis: University of Minnesota Press, 1985).

22. Cargo Collective, accessed March 15, 2022, http://cargocollective.com/onfcopoe/; Kate Sicchio, Zeshan Wang, and Marissa Forbes, "Live Coding Tools for Choreography: Creating Terpsicode," in *Proceedings of the 2020 International Conference on Live Coding* (Limerick, Ireland: University of Limerick, 2020), https://doi.org/10.5281/zenodo.3939135.

23. See the multiday streams archived at Eulerroom, YouTube video, accessed March 15, 2022, https://www.youtube.com/c/Eulerroom/playlists and the muxy software developed to coordinate with them at GitHub, https://github.com/munshkr/muxy.

24. Alex Taylor, "Data, (Bio)sensing and (Other-)Worldly Stories from the Cycle Routes of London," in *Quantified: Biosensing in Everyday Life*, ed. Dawn Nafus (Cambridge, MA: MIT Press, 2016).

25. Shoshana Zuboff, *The Age of Surveillance Capitalism: The Fight for a Human Future at the New Frontier of Power* (New York: PublicAffairs, 2019).

26. Matteo Pasquinelli, "Google's PageRank Algorithm: A Diagram of Cognitive Capitalism and the Rentier of the Common Intellect," in *Deep Search*, ed. Konrad Becker and Felix Stalder (London: Transaction, 2009). For more on the politics of search, related to race in particular, see Safiya Umoja Noble, *Algorithms of Oppression: How Search Engines Reinforce Racism* (New York: New York University Press, 2018).

27. See Alan F. Blackwell, "Objective Functions: (In)humanity and Inequity in Artificial Intelligence," *HAU: Journal of Ethnographic Theory* 9, no. 1 (2019): 137–146.

28. Martin Scherzinger, "The Political Economy of Streaming," in *The Cambridge Companion to Music in Digital Culture*, ed. Nicholas Cook, Monique M. Ingalls, and David Trippett (Cambridge: Cambridge University Press, 2019), 274–297.

29. The contemporary interest in the Luddites comes as no surprise given the alienating effects of AI automation. See, for instance, Miriam A. Cherry's "The Future Encyclopedia of Luddism," *MIT Press Reader*, January 19, 2021, https://thereader.mitpress.mit.edu/the-future-encyclopedia-of-luddism/.

30. For further discussion of live coding as a Luddite movement, see Alex McLean, Giovanni Fanfani, and Ellen Harlizius-Klück, "Cyclic Patterns of Movement across Weaving, Epiplokē and Live Coding," *Dancecult: Journal of Electronic Dance Music Culture* 10, no. 1 (2018): 5–30, http://dx.doi.org/ 10.12801/1947-5403.2018.10.01.01.

31. Such conversational dynamics between coder and machine reach back to figures as diverse as Gordon Pask, David Tudor, Alan Kay, or Richard Stallman (in his original work on the Emacs editor). The reconfiguration of interactive computing and electronics, as the West emerged from the Cold War era, can be seen as a reaction against the adoption of cybernetic theory in the infrastructure, bureaucracies, and government apparatus of the military industrial complex.

32. See, for example, Jacob Austin et al., "Program Synthesis with Large Language Models," 2021, arXiv:2108.07732. These developing technologies correspond to the liveness levels 5 and 6 proposed by Steve Tanimoto and discussed earlier in chapter 5. See Steven L. Tanimoto, "A Perspective on the Evolution of Live Programming," in *Proceedings of the 1st International Workshop on Live Programming* (New York: Institute for Electrical and Electronics Engineers, 2013), 31–34.

33. See *Sema: A Playground for Livecoding Music and AI*, University of Sussex, 2021–2022, https://www.sema.codes.

34. This project was funded as part of the LINK Master's program in Germany during 2021 and 2022 and led by etextile artist and designer Mika Satomi, live coders Elizabeth Wilson and Alex McLean, choreographer Deva Schubert, and performance artist Juan Felipe Amaya Gonzalez, originally instigated with Berit Greinke.

35. Richard Harper, ed., *Inside the Smart Home* (Berlin: Springer, 2006).

36. This is the research focus of Magnusson's Intelligent Instruments research project at *Sonic Writing* (blog), December 9, 2020, http://www.sonicwriting.org/blog/intent. See also Intelligent Instruments Lab, Reykjavik, 2021–2022, http://www.iil.is.

37. Some of these experiences have been anticipated in configurable software systems such as the Emacs editor, which became notorious for the irritating experience of you sitting at another user's terminal to find that they had installed a "key-binding" configuration file different from your own habits, with the computer becoming unpredictable or even unusable as a result.

38. Lisanne Bainbridge, "Ironies of Automation," *Automatica* 19, no. 6 (1983): 775–779.

39. Here we again reference Franklin's dichotomy between prescriptive and holistic technology. Ursula Franklin, *The Real World of Technology*, 2nd ed. (Toronto: House of Anansi Press, 1999).

40. Philip E. Agre, "Toward a Critical Technical Practice: Lessons Learned in Trying to Reform AI," in *Bridging the Great Divide: Social Science, Technical Systems, and Cooperative Work*, ed. Geof Bowker, Les Gasser, Leigh Star, and Bill Turner (Hillsdale, NJ: Erlbaum, 1997), 131–157.

41. This is broadly what Walter Mignolo argues in his "Foreword: On Pluriversality and Multipolarity," in *Constructing the Pluriverse: The Geopolitics of Knowledge*, ed. Bernd Reiter (Durham, NC: Duke University Press, 2018), x: "Together, epistemology and hermeneutics prevent the possibility of pluriversality, with all its internal diversity, and close off ways of thinking and doing that are not grounded in Western cosmology." We already hinted at this at the end of chapter 7.

42. Christopher M. Kelty, "Culture's Open Sources: Software, Copyright, and Cultural Critique," *Anthropological Quarterly* 77, no. 3 (2004): 499–506. European public resistance to the corporate controls being introduced in the US Digital Millennium Copyright Act coalesced in events such as a 2001 conference, convened by the Arts Council of England with the Academia Europaea, on Collaboration and Ownership in the Digital Economy, at which Kelty was joined both by arts activists, such as Florian Cramer and Geert Lovink, alongside legal, policy, and business innovators James Boyle, Richard Stallman, Bruce Perens, and Rishab Ghosh. See Rishab A. Ghosh, ed., *Code: Collaborative Ownership and the Digital Economy* (Cambridge, MA: MIT Press, 2006).

43. Mackenzie, *Machine Learners*, 23, 27. His example is TensorFlow, accessed March 15, 2022, https://www.tensorflow.org/, originally developed by researchers and engineers from the Google Brain team within Google's AI organization, which comes with extensive support and has wide application across multiple domains and disciplines. We would cite examples from the live coding community that also have extensive communities built around them, such as TidalCycles and Sonic Pi.

44. See the paradoxical notion of *inclusive exclusion* in Giorgio Agamben, *Homo Sacer: Sovereign Power and Bare Life* (Stanford, CA: Stanford University Press, 1998).

45. Dawn Nafus, James Leach, and Bernhard Krieger, "Gender: Integrated Report of Findings," *FLOSSPOLS, Deliverable D* 16 (March 2006), https://www.researchgate.net/publication/264799720_FLOSSPOLS_Deliverable_D_16_Gender_Integrated_Report_of_Findings.

46. Linda Tuhiwai Smith, *Decolonizing Methodologies: Research and Indigenous Peoples* (London: Zed Books, 2012), 221.

47. Paulin J. Hountondji, "Scientific Dependence in Africa Today," *Research in African Literatures* 21, no. 3 (1990): 5–15.

48. Pernille Bjørn, Anne-Marie Søderberg, and S. Krishna, "Translocality in Global Software Development: The Dark Side of Global Agile," *Human-Computer Interaction* 34, no. 2 (2019): 174–203.

49. As so importantly observed in Eve Tuck and K. Wayne Yang, "Decolonization Is Not a Metaphor," *Decolonization: Indigeneity, Education and Society* 1, no. 1 (2012): 1–40.

50. Cited in Smith, *Decolonizing Methodologies*, 25.

51. Lilly Irani, Janet Vertesi, Paul Dourish, Kavita Philip, and Rebecca E. Grinter, "Postcolonial Computing: A Lens on Design and Development," in *Proceedings of the ACM SIGCHI Conference on Human Factors in Computing Systems (CHI)*, Atlanta, Georgia, April 10–15, 2010, 1311–1320. (New York: Association for Computing Machinery, 2010).

52. Geoffrey C. Bowker and Susan Leigh Star, *Sorting Things Out: Classification and Its Consequences* (Cambridge, MA: MIT Press), 1999.

53. Kavita Philip, Lilly Irani, and Paul Dourish, "Postcolonial Computing: A Tactical Survey," *Science, Technology and Human Values* 37, no. 1 (2012): 3–29.

54. Kate Crawford and Vladen Joler, "Anatomy of an AI System: The Amazon Echo as an Anatomical Map of Human Labor, Data and Planetary Resources," AI Now Institute and Share Lab, September 7, 2018, https://anatomyof.ai/.

55. Kate Crawford, *Atlas of AI: Power, Politics, and the Planetary Costs of Artificial Intelligence* (New Haven, CT: Yale University Press, 2021).

56. See Evans Augustt, YouTube channel, 2020–21, https://www.youtube.com/channel/UCVi-EuhS951316RirfLYwqg.

57. Danielle Stein and Craig Valters, "Understanding Theory of Change in International Development," JSRP Paper 1 (London: London School of Economics, 2012), http://eprints.lse.ac.uk/id/eprint/56359.

58. Georges Perec, *Life: A User's Manual*, trans. David Bellos (London: Harvill Press, 1996); originally published in 1978, in French, with the title La Vie mode d'emploi.

59. Lialina, "Turing Complete User."

60. Lialina, "Turing Complete User."

61. Lialina notes that "the notion of the Invisible User is pushed by influential user interface designers, specifically by Don Norman a guru of user friendly design and long time advocate of invisible computing. He can be actually called the father of Invisible Computing."

62. Lialina, "Turing Complete User."

63. Gilles Deleuze, "Postscript on Control Societies," *Negotiations* (New York: Columbia University Press, 1995), 177–182.

64. We again borrow the terms *entanglement* and *intrarelating* from Barad, *Meeting the Universe Halfway*.

65. Michelle Boulous Walker, *Slow Philosophy: Reading against the Institution* (London: Bloomsbury, 2017), xv.

66. "Don't be evil!" is Google's well-known company motto from 2000 and is subsequently in their corporate code of conduct, indicative of the moral confusion between lines of individual and corporate responsibility. See Matthew Fuller and Andrew Goffey, *Evil Media* (Cambridge, MA: MIT Press, 2012) for a (Nietzschean) discussion of media morality beyond good and evil.

67. Again, how might live coding generate something of the "red plenty" that Mark Fisher argues for (as we discuss in chapter 4), which exceeds the pressure of capitalism (which is concerned with necessarily *restricting* wealth rather than creating it) by producing or even accelerating overwhelming plenty? See Mark Fisher, *K-PUNK* (blog), May 11, 2015, https://k-punk.org/abandon-hope-summer-is-coming/.

Bibliography

Aarhus University. "The Contemporary Condition." Last modified May 10, 2021. http://contemporaneity.au.dk/.

Aaron, Sam, Alan F. Blackwell, and Pamela Burnard. "The Development of Sonic Pi and Its Use in Educational Partnerships: Co-creating Pedagogies for Learning Computer Programming." *Journal of Music, Technology and Education* 9 (2016): 75–94.

Aaron, Sam, Dominic Orchard, and Alan F. Blackwell. "Temporal Semantics for a Live Coding Language." In *Proceedings of the 2nd ACM SIGPLAN International Workshop on Functional Art, Music, Modeling and Design*, 37–47. New York: Association for Computing Machinery, 2014.

Abtan, Freida. "Where Is She? Finding the Women in Electronic Music Culture." *Contemporary Music Review* 35, no. 1: 53–60.

Adema, Janneke. *Living Books*. Cambridge, MA: MIT Press, 2021.

Adorno, Theodor W. "On the Fetish Character in Music and the Regression of Listening." In *The Culture Industry: Selected Essays on Mass Culture*, edited by J. M. Bernstein, 270–299. London: Routledge, 1981.

Adorno, Theodor W., and Max Horkheimer. "The Culture Industry: Enlightenment as Mass Deception." In *Dialectic of Enlightenment*. 1944. Reprint, London: Verso 1997.

Agamben, Giorgio. *Homo Sacer: Sovereign Power and Bare Life*. Stanford, CA: Stanford University Press, 1998.

Agamben, Giorgio. "Language and Historical Categories in Benjamin's Thought." In *Potentialities*. Stanford, CA: Stanford University Press, 2007.

Agamben, Giorgio. *Means without Ends: Notes on Politics*. Translated by Vincenzo Binetti and Cesare Casarino. 1992. Reprint, Minneapolis: University of Minnesota Press, 2000.

Agamben, Giorgio. "What Is the Contemporary?" In *What Is an Apparatus? and Other Essays*, 39–55. Palo Alto, CA: Stanford University Press, 2009.

Agawu, Kofi. "Structural Analysis or Cultural Analysis? Competing Perspectives on the 'Standard Pattern' of West African Rhythm." *Journal of the American Musicological Society* 59, no. 1 (April 2006): 1–46. https://doi.org/10.1525/jams.2006.59.1.1.

Agre, Philip E. "Toward a Critical Technical Practice: Lessons Learned in Trying to Reform AI." In *Bridging the Great Divide: Social Science, Technical Systems, and Cooperative Work*, edited by Geof Bowker, Les Gasser, Leigh Star, and Bill Turner, 131–157. Hillsdale, NJ: Lawrence Erlbaum, 1997.

Albers, Anni. *On Weaving*. Middletown, CT: Wesleyan University Press, 1965.

Alexander, Amy. "At the Margins: A Look at Marginal Approaches to Coding, Art and Performance." Paper presented at the International Conference of Live Coding, Hamilton, Canada, October 12–15, 2016. https://iclc.toplap.org/2016/.

Alexander, Christopher. *A Pattern Language: Towns, Buildings, Construction*. Oxford: Oxford University Press, 1977.

Ambrožič, Mara, and Angela Vettese, eds. *Art as a Thinking Process: Visual Forms of Knowledge Production*. Berlin: Sternberg Press, 2013.

Amoore, Louise. "Why 'Ditch the Algorithm' Is the Future of Political Protest." *Guardian*, August 19, 2020. https://www.theguardian.com/commentisfree/2020/aug/19/ditch-the-algorithm-generation-students-a-levels-politics.

Arendt, Hannah. *The Human Condition*. 1958. Reprint, Chicago: University of Chicago Press, 1998.

Aristotle. "Nicomachean Ethics." [*Ethika Nikomacheia*] In *Western Philosophy: An Anthology*, edited and translated by John Cottingham, 3rd Edition, 518–521. Oxford: Blackwell, 2021.

Armitage, Joanne. "Spaces to Fail In: Negotiating Gender, Community and Technology in Algorave." *Dancecult: Journal of Electronic Dance Music Culture* 10, no. 1 (2018). https://dj.dancecult.net/index.php/dancecult/article/view/1032.

Arteaga, Alex. "Embodied and Situated Aesthetics," *Artnodes* (2017): 20–27.

Attali, Jacques. *Noise: The Political Economy of Music*. Minneapolis: University of Minnesota Press, 1985.

Atwill, Janet. *Rhetoric Reclaimed: Aristotle and the Liberal Arts Tradition*. Ithaca, NY: Cornell University Press, 1998.

Augustt, Evans. YouTube channel, 2020–21. https://www.youtube.com/channel/UCVi-EuhS951316RirfLYwqg.

Auslander, Philip. "Afterword: So Close and Yet So Far Away, the Proxemics of Liveness." In *Experiencing Liveness in Contemporary Performance: Interdisciplinary Perspectives*, edited by Matthew Reason and Anja Mølle Lindelof. Routledge Advances in Theatre and Performance Studies, 295–298. London: Routledge, 2017.

Auslander, Philip. "Digital Liveness: A Historic-Philosophical Perspective." *PAJ: A Journal of Performance and Art* 34, no. 3 (2012): 3–11.

Auslander, Philip. *Liveness: Performance in a Mediatized Culture*. London: Routledge, 1999.

Austin, J. L. *How to Do Things with Words*. Cambridge, MA: Harvard University Press, 1975.

Babbitt, Bill, Dan Lyles, and Ron Eglash. "From Ethnomathematics to Ethnocomputing." *Alternative Forms of Knowing (in) Mathematics* 10 (2012): 205–219. https://doi.org/10.1007/978-94-6091-921-3_10.

Badiou, Alain. "Fifteen Theses on Contemporary Art." *Performance Research* 9, no. 4 (2004): 86.

Bainbridge, Lisanne. "Ironies of Automation." *Automatica* 19, no. 6 (1983): 775–779.

Ball, Philip. *The Self-Made Tapestry: Pattern Formation in Nature*. Oxford: Oxford University Press, 2001.

Barad, Karen. *Meeting the Universe Halfway: Quantum Physics and the Entanglement of Matter and Meaning*. Durham, NC: Duke University Press, 2007.

Barad, Karen. "Posthumanist Performativity: Toward an Understanding of How Matter Comes to Matter." New issue, *Signs: Gender and Science* 28, no. 3, (Spring 2003): 801–831.

Barber, Lynn. *Demon Barber*. London: Penguin, 1998.

Barthes, Roland. "Death of the Author." In *Image-Music-Text*, 142–148. New York: Hill and Wang, 1978.

Baudrillard, Jean. *For a Critique of the Political Economy of the Sign*. Translated by Charles Levin. St. Louis: Telos Press, 1981.

Bauman, Zygmunt. *Liquid Life*. Cambridge: Polity Press, 2005.

Bauman, Zygmunt. *Liquid Times: Living in an Age of Uncertainty*. Cambridge: Polity Press, 2007.

Beck, Kent, et al. "Manifesto for Agile Software Development," 2001. http://agilemanifesto.org.

Bel, Bernard. "Rationalizing Musical Time: Syntactic and Symbolic-Numeric Approaches." In *The Ratio Book*, edited by Clarence Barlow, 86–101. Cologne: Feedback Studio, 2001.

Bengson, John, and Marc A. Moffett, eds. *Knowing How: Essays on Knowledge, Mind and Action*. New York: Oxford University Press, 2011.

Benjamin, Walter. "The Author as Producer." In Vol. 2, *Selected Writings, 1931–1934*, edited by Howard Eiland, Michael W. Jennings, and Gary Smith, 768–782. Cambridge, MA: Belknap Press of Harvard University Press, 2005.

Benjamin, Walter. "On Language as Such and the Language of Man." In *One-Way Street, and Other Writings*, 107–123. Translated by Edmund Jephcott and Kingsley Shorter. London: New Left Books, 1979.

Benjamin, Walter. "On the Concept of History." In Vol. 4, *Selected Writings, 1938–1940*, edited by Howard Eiland and Michael W. Jennings, 389–400. Cambridge, MA: Belknap Press, 1992.

Benjamin, Walter. "The Work of Art in the Age of Mechanical Reproduction." In *Illuminations*, edited by Hannah Arendt and translated by Harry Zohn, 217–252. New York: Schocken Books, 1969.

Bennett, Jane. *Vibrant Matter: A Political Ecology of Things*. Durham, NC: Duke University Press, 2010.

Bense, Max. "The Projects of Generative Aesthetics." In *Cybernetics, Art and Ideas*, edited by Jasia Reichart, 57–60. London: Studio Vista, 1971.

Bergson, Henri. *Matter and Memory*. Translated by Arthur Mitchell. London: Dover, 1991.

Bergson, Henri. *Time and Free Will: An Essay on the Immediate Data of Consciousness*. Translated by F. L. Pogson. 1889. Reprint, Mineola, NY: Dover, 2001.

Bergström, Iias, and Alan F. Blackwell. "The Practices of Programming." Paper presented at the IEEE Visual Languages and Human-Centric Computing conference, Cambridge, UK, September 2016. https://www.researchgate.net/publication/308540044_The_Practices_of_Programming.

Berry, David M. *The Philosophy of Software: Code and Mediation in the Digital Age*. London: Palgrave Macmillan, 2011.

Bertin, Jacques. *Semiology of Graphics: Diagrams, Networks, Maps*. 1968. Reprint, Redlands, CA: ESRI Press, 2010.

Bjørn, Pernille, Anne-Marie Søderberg, and S. Krishna. "Translocality in Global Software Development: The Dark Side of Global Agile." *Human-Computer Interaction* 34, no. 2 (2019): 174–203.

Blackwell, Alan, F. "Artificial Intelligence and the Abstraction of Cognitive Labour." In *Marx200: The Significance of Marxism in the 21st Century*, edited by Mary Davis, 59–68. London: Praxis Press, 2019.

Blackwell, Alan F. "The Dark Side of Metaphor: Fetish in User Interfaces." Paper presented at the Conference on Human Factors in Computing Systems, April 10–15, 2010, Atlanta, GA. https://www.cl.cam.ac.uk/events/experiencingcriticaltheory/Blackwell-DarkSide.pdf.

Blackwell, Alan F. "Metaphors We Program By: Space, Action and Society in Java." In *Proceedings of the 18th Annual Workshop of the Psychology of Programming Interest Group*. Brighton, UK: University of Sussex, 2006.

Blackwell, Alan F. "Objective Functions: (In) Humanity and Inequity in Artificial Intelligence." *HAU: Journal of Ethnographic Theory* 9, no. 1 (2019): 137–146.

Blackwell, Alan F. "Patterns of User Experience in Performance Programming." In *Proceedings of the First International Conference on Live Coding (ICLC)*, University of Leeds, UK, July 13–15, 2015. Geneva, Switzerland: Zenodo/CERN. http://doi.org/10.5281/zenodo.19315.

Blackwell, Alan F., Mark Blythe, and Jofish Kaye. "Undisciplined Disciples: Everything You Always Wanted to Know about Ethnomethodology but Were Afraid to Ask Yoda." *Personal and Ubiquitous Computing* 21, no. 3 (2017): 571–592.

Blackwell, Alan F., Luke Church, and Thomas Green. "The Abstract Is 'an Enemy': Alternative Perspectives to Computational Thinking." In *Proceedings PPIG'08, 20th Annual Workshop of the Psychology of Programming Interest Group*, 34–43. Lancaster, UK: Lancaster University, 2008.

Blackwell, Alan F., Geoff Cox, and Sang Won Lee. "Live Writing the Live Coding Book." Paper presented at the International Conference on Live Coding, McMaster University, Hamilton, Canada, October 12–15, 2016. http://iclc.toplap.org/2016/papers.html.

Blackwell, Alan F., and Sally Fincher. "PUX: Patterns of User Experience." *Interactions* 17 (2010): 27–31.

Blackwell, Alan F., George Fitzmaurice, Lars Erik Holmquist, Hiroshi Ishii, and Brygg Ullmer. "Tangible user interfaces in context and theory". In CHI '07 Extended Abstracts on Human Factors in Computing Systems (CHI EA '07), 2817–2820. New York: Association for Computing Machinery, 2007. https://doi.org/10.1145/1240866.1241085.

Blackwell, Alan F., and Thomas R. G. Green. "A Cognitive Dimensions Questionnaire Optimised for Users." In *Proceedings of the Twelfth Annual Meeting of the Psychology of Programming Interest Group*, 137–152, Cosenza, Italy: Edizioni Memoria, 2000.

Blackwell, Alan F., Thomas R. G. Green, and Douglas J. E. Nunn. "Cognitive Dimensions and Musical Notation Systems." Paper presented at *International Computer Music Conference Workshop on Notation and Music Information Retrieval in the Computer Age*, Berlin, Germany, August 27–September 1, 2000. https://www.cl.cam.ac.uk/~afb21/publications/icmc.pdf.

Blackwell, Alan F., Alex McLean, James Noble, and Julian Rohrhuber, edited in cooperation with Jochen Arne Otto. "Collaboration and Learning through Live Coding." In *Dagstuhl Reports*. Dagstuhl Seminar 13382. Dagstuhl: Schloss Dagstuhl—Leibniz-Zentrum fuer Informatik, 2014.

Blackwell, Alan F., Marian Petre, and Luke Church. "Fifty Years of the Psychology of Programming." *International Journal of Human-Computer Studies* 131 (2019): 52–63.

Borgdorff, Henk. *The Conflict of the Faculties: Perspectives on Artistic Research and Academia*. Leiden, the Netherlands: Leiden University Press, 2012.

Borgdorff, Henk, Peter Peters, and Trevor Pinch, eds. *Dialogues between Artistic Research and Science and Technology Studies*. Routledge Advances in Art and Visual Studies. London: Routledge, 2019.

Borgdorff, Henk, and Michael Schwab, eds. *The Exposition of Artistic Research: Publishing in Academia*. Leiden, the Netherlands: Leiden University Press, 2014.

Boria, Simone, Tim Boykett, Andreas Dekrout, Heather Kelly, Marta Peirano, Robert Rotenberg, and Elisabeth Schimana, eds. *On Turtles and Dragons and the Dangerous Quest for a Media Art Notation System*. Linz: Times Up Press, 2012.

Born, Georgina, and Kyle Devine. "Gender, Creativity and Education in Digital Musics and Sound Art." *Contemporary Music Review* 35, no. 1 (2016): 1–20. https://doi.org/10.1080/07494467.2016.1177255.

Born, Georgina, and Kyle Devine. "Music Technology, Gender, and Class: Digitization, Educational and Social Change in Britain." *Twentieth-Century Music* 12, no. 2 (August 2015): 135–172. https://doi.org/10.1017/s1478572215000018.

Boulous Walker, Michelle. *Slow Philosophy: Reading against the Institution*. London: Bloomsbury, 2017.

Bowker, Geoffrey C., and Susan Leigh Star. *Sorting Things Out: Classification and Its Consequences*. Cambridge, MA: MIT Press, 1999.

Brandstetter, Gabriele. *Notationen und Choreographisches Denken*. Freiburg, Germany: Rombach, 2010.

Brecht, George, John Cage, and La Monte Young. *An Anthology of Chance Operations, Concept Art, Anti-art, Indeterminancy, Improvisation, Meaningless Work, Natural Disasters*. Munich: Heiner Friedrich, 1970.

Brook, Peter. *The Empty Stage*. London: Penguin, 1972.

Brown, Steven D., and Rose Capdevila. "Perpetuum Mobile: Substance, Fame and the Sociology of Translation." In *Actor Network Theory and After*, edited by John Law and John Hassard, 26–50. Oxford: Blackwell, 1999.

Brüderlin, Markus. Foreword to Han, *Art of Deceleration*, 8–12. Berlin: Hatje Cantz, 2012.

Burg, Brian, Adrian Kuhn, and Chris Parnin. "1st International Workshop on Live Programming (LIVE 2013)." In *35th International Conference on Software Engineering*, 1529–1530. Piscataway, NJ: Institute of Electrical and Electronics Engineers, 2013.

Burnham, Jack. "Real Time Systems." *Artforum* 8, no. 1 (September 1969): 49–55.

Burnham, Jack. "Systems Esthetics." *Artforum* 7, no. 1 (September 1968): 30–35.

Butler, Judith. *Excitable Speech: A Politics of the Performative*. London: Routledge, 1997.

Butler, Mark J. *Playing with Something That Runs: Technology, Improvisation and Composition in DJ and Laptop Performance*. Oxford: Oxford University Press, 2014.

Cage, John. "Art and Technology." In *John Cage: Writer*. New York: Cooper Square Press, 1969.

Caillois, Roger. *Man, Play and Culture*. Translated by Meyer Barash. 1958. Reprint, Champaign: University of Illinois Press, 2001.

Cardoso Llach, Daniel. "Software Comes to Matter: Toward a Material History of Computational Design." *Design Issues* 31 (2015): 41–54.

Carroll, John M. *Minimalism beyond the Nurnberg Funnel*. Cambridge, MA: MIT Press, 1990.

Cascone, Kim. "The Aesthetics of Failure: Post-Digital Tendencies in Contemporary Computer Music." *Computer Music Journal* 24, no. 4 (December 2000): 12–18.

Çelik Alexander, Zeynep. *Kinaesthetic Knowing*. Chicago: University of Chicago Press, 2017.

Chomsky, Noam. *Syntactic Structures*. The Hague: Mouton, 1957.

Chun, Wendy Hui Kyong. *Programmed Visions: Software and Memory*. Cambridge, MA: MIT Press, 2011.

Church, Luke, Nick Rothwell, Marc Downie, Scott deLahunta, and Alan F. Blackwell. "Sketching by Programming in the Choreographic Language Agent." In *Proceedings of the Psychology of Programming Interest Group Annual Conference*. London, UK: London Metropolitan University, 2012, 163–174.

Clark, Andy, and David J. Chalmers. "The Extended Mind: A Dynamical Systems Perspective." *Analysis* 58 (1998): 7–19.

Clayton, Martin. *Time in Indian Music: Rhythm, Metre, and Form in North Indian Rāg Performance*. Oxford: Oxford University Press, 2000.

Clément, Catherine. *Syncope: The Philosophy of Rapture*. Translated by Sally O'Driscoll and Deirdre M Mahoney. Minneapolis: University of Minnesota Press, 1994.

Cocker, Emma. "Live Notation: Reflections on a Kairotic Practice." *Performance Research* 18, no. 5 (2013): 69–76.

Cocker, Emma. "Performing Thinking in Action: The Meletē of Live Coding." *International Journal of Performance Arts and Digital Media* 12, no. 2 (2016): 102–116.

Cocker, Emma. "Tactics for Not Knowing: Preparing for the Unexpected." In *On Not Knowing: How Artists Think*, edited by Rebecca Fortnum and Elizabeth Fisher, 126–135. London: Black Dog, 2013.

Cocker, Emma. "Weaving Codes/Coding Weaves: Penelopean Mêtis and the Weaver-Coder's Kairos." *Textile: The Journal of Cloth and Culture* 15, no. 2 (2017): 124–141.

Cocker, Emma. "What Now, What Next—Kairotic Coding and the Unfolding Future Seized." In "Improvisational Creativity," special issue, ed. Jon McCormack, Toby Gifford, and Shelly Knotts, *Digital Creativity* 29, no. 1 (2018): 82–95.

Collinge, Douglas J. "MOXIE: A Language for Computer Music Performance." In *Proceedings of the International Conference on Computer Music*, Institut de Recherche et Coordination Acoustique/Musique (IRCAM) Paris, France, October 19–23, 1984, 217–220. San Francisco, CA: International Computer Music Association, 1984. https://quod.lib.umich.edu/cgi/p/pod/dod-idx/moxie-a-language-for-computer-music-performance.pdf?c=icmc;idno=bbp2372.1984.030;format=pdf.

Collins, Nick, Alex McLean, Julian Rohrhuber, and Adrian Ward. "Live Coding Techniques for Laptop Performance." *Organised Sound* 8, no. 3 (2003): 321–330.

Collins, Nick. "Infinite Length Pieces: A Users' Guide." In *Proceedings of MAXIS*, Sheffield, UK: Sheffield Hallam University, April 12–14, 2002. http://composerprogrammer.com/research/infinite.pdf.

Coole, Diana, and Samantha Frost, eds. *New Materialisms: Ontology, Agency, and Politics*. Durham, NC: Duke University Press, 2010.

Cooper-Albright, Ann, and David Gere, eds. *Taken by Surprise: A Dance Improvisation Reader*. Middletown, CT: Wesleyan University Press, 2003.

Couldry, Nick. "Liveness, Reality, and the Mediated Habitus from Television to the Mobile Phone." *Communication Review* 7 (2004): 353–361.

Cox, Geoff. "Means-End of Software." In *Interface Criticism: Aesthetics beyond Buttons,* edited by Christian Ulrik Andersen and Søren Bro Pold, 145–161. Aarhus, Denmark: Aarhus University Press, 2011.

Cox, Geoff. "What Does Live Coding Know?" In *Proceedings of the First International Conference on Live Coding (ICLC).* University of Leeds, UK, July 13–15, 2015, 170–178. Geneva, Switzerland: Zenodo/CERN, 2015. https://doi.org/10.5281/zenodo.19329.

Cox, Geoff, and Jacob Lund. *The Contemporary Condition: Introductory Thoughts on Contemporaneity and Contemporary Art.* Berlin: Sternberg Press, 2016.

Cox, Geoff, and Alex McLean. *Speaking Code: Coding as Aesthetic and Political Expression.* Cambridge, MA: MIT Press, 2013.

Cox, Geoff, Ryan Nolan, and Andrew Prior. "The Crackle of Contemporaneity." In *Futures of the Contemporary: Contemporaneity, Untimeliness, and Artistic Research*, edited by Paulo de Assis and Michael Schwab, 97–114. Leuven, Belgium: Orpheus Institute Series—Leuven University Press, 2019.

Cox, Geoff, and Morten Riis. "(Micro) Politics of Algorithmic Music: Towards a Tactical Media Archaeology." In *The Oxford Handbook on Algorithmic Music*, edited by Alex McLean and Roger Dean, 603–626. Oxford: Oxford University Press, 2018.

Cramer, Florian. "Concepts, Notations, Software, Art." Netzliteratur. March 23, 2002. https://www.netzliteratur.net/cramer/concepts_notations_software_art.html.

Cramer, Florian. "What Is Post-Digital?" *APRJA* 3, no. 1 (2014). https://doi.org/10.7146/aprja.v3i1.116068.

Crary, Jonathan. *24/7: Late Capitalism and the Ends of Sleep.* London: Verso, 2013.

Crawford, Kate. *Atlas of AI: Power, Politics, and the Planetary Costs of Artificial Intelligence.* New Haven, CT: Yale University Press, 2021.

Crawford, Kate, and Vladan Joler. "Anatomy of an AI System: The Amazon Echo as an Anatomical Map of Human Labor, Data and Planetary Resources." AI Now Institute and Share Lab. September 7, 2018. https://anatomyof.ai.

Csíkszentmihályi, Mihaly. *Flow: The Classic Work on How to Achieve Happiness.* London: Rider, 2002.

Cusumano, Michael A. "The Software Factory: A Historical Interpretation." *IEEE Software* 6, no. 2 (1989): 23–30. https://doi.org/10.1109/MS.1989.10017.

Dannenberg, Roger B. "Software Design for Interactive Multimedia Performance." *Interface—Journal of New Music Research* 22, no. 3 (August 1993): 213–228.

Davis, Martin, Ron Sigal, and Elaine J. Weyuker. *Computability, Complexity, and Languages: Fundamentals of Theoretical Computer Science.* London: Elsevier, 1994.

deLahunta, Scott, and Norah Zuniga Shaw. "Constructing Memories: Creation of the Choreographic Resource." *Performance Research* 11, no. 4 (2006): 53–62.

deLaHunta, Scott, Kim Vincs, and Sarah Whatley, eds. "On An/Notations." *Performance Research* 20, no. 6 (2015): 1–2.

Deleuze, Gilles. *Difference and Repetition*. Translated by Paul Patton. New York: Columbia University Press, 1994.

Deleuze, Gilles. *The Fold*. London: Continuum, 2006.

Deleuze, Gilles. *The Logic of Sense*. Translated by Mark Lester. London: Continuum, 2004.

Deleuze, Gilles. "Postscript on Control Societies." In *Negotiations*, 177–182. New York: Columbia University Press, 1995.

Deleuze, Gilles, and Félix Guattari. *A Thousand Plateaus: Capitalism and Schizophrenia*. Translated by Brian Massumi. London: Continuum, 1987.

Denning, Peter J., Matti Tedre, and Pat Yongpradit. "Misconceptions about Computer Science." *Communications of the ACM* 60 (2017): 31–33.

Derrida, Jacques. *Of Grammatology*. Baltimore: Johns Hopkins University Press, 1998.

Derrida, Jacques. *Spectres of Marx: The State of the Debt, the Work of Mourning and the New International*. Translated by Peggy Kamuf. New York: Routledge, 1994.

Dijkstra, Edsger W. "Programming: From Craft to Scientific Discipline." In *Proceedings of the International Computing Symposium*, 23–30, Liege, Belgium, April 4–7, 1977. Amsterdam; New York: North-Holland, 1977.

Doctorow, Cory. "Algoraves: Dancing to Algorithms." Boingboing. May 11, 2013. http://boingboing.net/2013/05/11/algoraves-dancing-to-algorith.html.

Dourish, Paul. "Algorithms and Their Others: Algorithmic Culture in Context." *Big Data and Society* 3, no. 2 (August 2016). https://journals.sagepub.com/doi/full/10.1177/2053951716665128.

Dourish, Paul. *Where the Action Is: The Foundations of Embodied Interaction*. Cambridge, MA: MIT Press, 2004.

Dudas, Richard. "Comprovisation: The Various Facets of Composed Improvisation within Interactive Performance Systems." *Leonardo Music Journal* 20 (2010): 29–31. https://openmusiclibrary.org/article/4662/.

Duignan, Matthew, James Noble, and Robert Biddle. "Abstraction and Activity in Computer-Mediated Music Production." *Computer Music Journal* 34, no. 4 (2010): 22–33.

Eacott, John. "Instant Music? Just Add Water." *AI and Society* 27, no. 2 (May 2012): 287–288. https://doi.org/10.1007/s00146-011-0350-6.

Eco, Umberto. *The Open Work*. Translated by Anna Cancogni. 1962. Reprint, Cambridge, MA: Harvard University Press, 1989.

Engelbart, Douglas. "The Mother of All Demos." Paper presented at the Association for Computing Machinery/Institute of Electrical and Electronics Engineers (ACM/IEEE) Computer Society's Fall Joint Computer Conference, San Francisco, 1968.

Enns, Anthony. "Foreword: Media History versus Media Archeology: German Media Theory and Wolfgang Ernst's Chronopoetics." In *Chronopoetics: The Temporal Being and Operativity of Technological Media*, by Wolfgang Ernst. London: Rowman and Littlefield, 2016.

Erdogmus, Hakan, Nenad Medvidović, and Frances Paulisch. "50 Years of Software Engineering." *IEEE Software* 35, no. 5 (2018): 20–24.

Ernst, Wolfgang. *Chronopoetics: The Temporal Being and Operativity of Technological Media*. London: Rowman and Littlefield International, 2016.

Ernst, Wolfgang. *Delayed Present: Media-Induced Tempor(e)alities and Techno-Traumatic Irritations of "the Contemporary."* Edited by Geoff Cox and Jacob Lund. Berlin: Sternberg Press, 2017.

Ernst, Wolfgang. *Digital Memory and the Archive*. Edited by Jussi Parikka. Electronic Mediations no. 39. Minneapolis: University of Minnesota Press, 2011.

Ernst, Wolfgang. "'. . . Else Loop Forever': The Untimeliness of Media." Paper presented at the conference Il Senso della Fine, Università degli Studi di Urbino, Centro Internazionale di Semiotica e Linguistica, September 10–12, 2009. https://www.musikundmedien.hu-berlin.de/de/medienwissenschaft/medientheorien/ernst-in-english/pdfs/medzeit-urbin-eng-ready.pdf.

Ernst, Wolfgang. "Media Archaeography: Method and Machine versus History and Narrative of Media." In *Media Archaeology: Approaches, Applications and Implications*, edited by Erkki Huhtamo and Jussi Parikka, 239–255. Berkeley: University of California Press, 2011.

Ernst, Wolfgang. "Toward a Media Archaeology of Sonic Articulations." In *Digital Memory and the Archive*, edited by Jussi Parikka, 172–183. Electronic Mediations 39. Minneapolis: University of Minnesota Press, 2013.

Fazi, M. Beatrice. *Contingent Computation: Abstraction, Experience, and Indeterminacy in Computational Aesthetics*. Lanham, MD: Rowman and Littlefield, 2018.

Fell, Mark. "Collateral Damage." *Wire*, January 2013. https://www.thewire.co.uk/in-writing/essays/collateral-damage-mark-fell.

Fell, Mark, and Rian Treanor. "The Musical Score Is the Worst Thing in the History of Music." *Wire*, January 2021. https://www.thewire.co.uk/in-writing/interviews/the-musical-score-is-the-worst-thing-that-ever-happened-in-the-history-of-music-mark-fell-.

Feminist Software Foundation. "C-Plus-Equality." 2016. Accessed April 13, 2018. https://github.com/ErisBlastar/cplusequality/blob/master/README.md.

Fiadeiro, João. "If You Don't Know, Why Do You Ask? An Introduction to the Method of Real-Time Composition." In *Knowledge in Motion: Perspectives of Artistic and Scientific Research in Dance*, edited by Sabine Gehm, Pirkko Husemann, and Katharina von Wilcke, 101–110. Bielefeld, Germany: Transcript, 2007.

Fischer-Lichte, Erika. *The Transformative Power of Performance: A New Aesthetics*. London: Routledge, 2008.

Fisher, Elizabeth, and Rebecca Fortnum, eds. *On Not Knowing: How Artists Think*. London: Black Dog, 2013.

Fisher, Mark. *K-punk: The Collected and Unpublished Writings of Mark Fisher (2004–2016)*, edited by Darren Ambrose. London: Repeater, 2018.

Fisher, Mark. "The Metaphysics of Crackle: Afrofuturism and Hauntology." *Dancecult: Journal of Electronic Dance Music Culture* 5, no. 2 (2013): 42–55.

Foucault, Michel. *Archaeology of Knowledge*. 1969. Reprint, London: Routledge, 2002.

Foucault, Michel. *The Archaeology of Knowledge and the Discourse of Language*. New York: Pantheon Books, 1972.

Foucault, Michel. *Discipline and Punish: The Birth of the Prison*. New York: Vintage Books, 1995.

Foucault, Michel. *Power/Knowledge: Selected Interviews and Other Writings, 1972–1977*. Edited by Colin Gordon and translated by Colin Gordon, Leo Marshal, John Mepham, and Kate Sober. New York: Pantheon, 1980.

Franklin, Ursula. *The Real World of Technology*. 2nd ed. Toronto: House of Anansi Press, 1999.

Freeman, Jason, and Akito Van Troyer. "Collaborative Textual Improvisation in a Laptop Ensemble." *Computer Music Journal* 35, no. 2 (Summer 2011): 8–21.

Free Software Foundation (website). Accessed March 12, 2022. https://www.fsf.org.

Freire, Paulo. *Pedagogy of the Oppressed*. New York: Seabury Press, 1968.

Fukuyama, Francis. *The End of History and the Last Man*. New York: Free Press, 1992.

Fuller, Matthew. *How to Be a Geek: Essays on the Culture of Software*. Cambridge: Polity Press, 2017.

Fuller, Matthew, and Andrew Goffey. *Evil Media*. Cambridge, MA: MIT Press, 2012.

Fuller, Matthew, and Eyal Weizman. *Investigative Aesthetics: Conflicts and Commons in the Politics of Truth*. London: Verso, 2021.

Gadir, Tami. "Resistance or Reiteration? Rethinking Gender in DJ Cultures." *Contemporary Music Review* 35, no. 1 (2016): 115–129. http://dx.doi.org/10.1080/07494467.2016.1176767.

Galloway, Alexander R. "Language Wants to Be Overlooked: On Software and Ideology." *Journal of Visual Culture* 5, no. 3 (2006): 315–331.

Gardner, Howard. *Frames of Mind: The Theory of Multiple Intelligences*. New York: Basic Books, 1983.

Gell, Alfred. *Art and Agency: An Anthropological Theory*. Oxford: Oxford University Press, 1998.

Ghosh, Rishab A., ed. *Code: Collaborative Ownership and the Digital Economy*. Cambridge, MA: MIT Press, 2006.

Gibson, James J. *The Senses Considered as Perceptual Systems*. Boston: Houghton Mifflin, 1966.

GNU. "GNU Emacs." Last modified March 25, 2021. https://www.gnu.org/software/emacs/.

Goffey, Andrew. "Algorithm." In *Software Studies: A Lexicon*, edited by Matthew Fuller, 21–30. Cambridge, MA: MIT Press, 2008.

Goffman, Erving. *The Presentation of Self in Everyday Life*. Woodstock, NY: Overlook, 1973.

Goldsmith, Kenneth. *Uncreative Writing*. New York: Columbia University Press, 2011.

Goldstine, Herman Heine, and John von Neumann. "Planning and Coding of Problems for an Electronic Computing Instrument." In *Report on the Mathematical and Logical Aspects of an Electronic Computing Instrument*, Part II, Vols. 1–3. Princeton, NJ: Institute for Advanced Study, 1947.

Goodman, Nelson. *Languages of Art: An Approach to a Theory of Symbols*. 1968. Reprint, Indianapolis: Hackett, 1976.

Graeber, David. *The Utopia of Rules: On Technology, Stupidity, and the Secret Joys of Bureaucracy*. Brooklyn, NY: Melville House, 2015.

Grant, Stuart, Jodie McNeilly, and Maeva Veerapen, eds. *Performance and Temporalisation: Time Happens*. London: Palgrave Macmillan, 2014.

Green, Thomas R. G. "Cognitive Dimensions of Notations." *People and Computers* 5 (1989): 443–460.

Griffiths, David. "Computation Is Woven." January 28, 2021. Zenodo. https://doi.org/10.5281/zenodo.4476811.

Griffiths, David, and Alex McLean. "Textility of Code: A Catalogue of Errors." In "Weaving Codes, Coding Weaves," special issue, *Textile: Journal of Cloth and Culture* 15, no. 2 (2017): 198–214.

Groff Hennigh-Palermo, Sarah (website). "Seven Points for a Computer Critical Computer Art." Accessed March 11, 2022. http://art.sarahghp.com/seven-points.

Groom, Amelia, ed. *Time*. Documents of Contemporary Art. London: Whitechapel; Cambridge, MA: MIT Press, 2013.

Gross, Shad, Jeffrey Bardzell, and Shaowen Bardzell. "Structures, Forms, and Stuff: The Materiality and Medium of Interaction." *Personal and Ubiquitous Computing* 18, no. 3 (2014): 637–649.

Grosz, Elizabeth, ed. *Becomings: Exploration in Time, Memory and Futures*. Ithaca, NY: Cornell University Press, 1999.

Grosz, Elizabeth. *The Nick of Time: Politics, Evolution and the Untimely*. Durham, NC: Duke University Press, 2004.

Guest, Ann Hutchinson. *Choreographics: A Comparison of Dance Notation Systems from the Fifteenth Century to the Present*. London: Routledge, 2014.

Gygax, Raphael, and Heike Munder, eds. *Between Zones: On the Representation of the Performative and the Notation of Movement*. Zurich: JRP-Ringier, 2010.

Hall, John. *13 Ways of Talking about Performance Writing*. Plymouth, UK: Plymouth College of Art Press, 2007.

Hall, Tom. "Towards a Slow Code Manifesto." Ludions. April 2007. http://www.ludions.com/texts/2007a/.

Hall, Tom, and Alan F. Blackwell. "Sharing Digital Performance Notation with the Audience." In *Proceedings of the 9th Conference on Interdisciplinary Musicology*. Berlin: Staatliches Institut für Musikforschung, 2014.

Han, Byung-Chul. *The Burnout Society*. Palo Alto, CA: Stanford University Press, 2015.

Han, Byung-Chul. *The Scent of Time*. Cambridge: Polity Press, 2017.

Han, Byung-Chul. "Time without Fragrance or the Obscenity of Time." In *The Art of Deceleration: Motion and Rest in Art to Caspar David Friedrich to Ai Weiwei*, 23–26. Berlin: Hatje Cantz, 2012.

Hansen, Nicolai Brodersen, Rikke Toft Nørgård, and Kim Halskov. "Crafting Code at the Demo-Scene." In *Proceedings of the ACM Conference on Designing Interactive Systems*, 35–38. New York: Association for Computing Machinery, 2014.

Hardt, Michael, and Antonio Negri. *Empire*. Cambridge, MA: Harvard University Press, 2000.

Harlizius-Klück, Ellen, in collaboration with Alex McLean, eds. "Weaving Codes, Coding Weaves." Special issue, *Textile: Journal of Cloth and Culture* 15, no. 2 (2017).

Haraway, Donna J. "Anthropocene, Capitalocene, Plantationocene, Chthulucene: Making Kin." *Environmental Humanities* 6, no. 1 (2015): 159–165.

Haraway, Donna J. "Situated Knowledges: The Science Question in Feminism and the Privilege of Partial Perspective." *Feminist Studies* 14 (1988): 575–599.

Haraway, Donna J. *Staying with the Trouble: Making Kin in the Chthulucene*. Experimental Futures. Durham, NC: Duke University Press, 2016.

Harlizius-Klück, Ellen, and Alex McLean. "The PENELOPE Project: A Case Study in Computational Thinking." In *Algorithmic and Aesthetic Literacy Matter: Approaches for a Transformative Network Society*. Leverkusen, Germany: Verlag Barbara Budrich, 2020.

Harman, Graham. *Immaterialism: Objects and Social Theory*. Cambridge: Polity, 2016.

Harman, Graham. *Object-Oriented Ontology: A New Theory of Everything*. London: Pelican, 2018.

Harman, Graham. *Speculative Realism: An Introduction*. Cambridge: Polity, 2018.

Harper, Richard, ed. *Inside the Smart Home*. Berlin: Springer, 2006.

Hartog, François. *Regimes of Historicity: Presentism and Experiences of Time*. New York: Columbia University Press, 2015.

Hawhee, Debra. *Bodily Arts: Rhetoric and Athletics in Ancient Greece*. Austin: University of Texas Press, 2004.

Haworth, Christopher. "Algorithmic Music and the Social." In *The Oxford Handbook of Algorithmic Music*, edited by Alex McLean and Roger Dean, 557–581. Oxford: Oxford University Press, 2018.

Hayles, N. Katherine. *How We Became Posthuman: Virtual Bodies in Cybernetics, Literature and Informatics*. Chicago: University of Chicago Press, 2010.

Hayles, N. Katherine. *My Mother Was a Computer*. Chicago: University of Chicago Press, 2005.

Hayles, N. Katherine. *Unthought: The Power of the Cognitive Nonconscious*. Chicago: University of Chicago Press, 2017.

Hayles, N. Katherine. *Writing Machines*. Cambridge, MA: MIT Press, 2002.

Heathfield, Adrian. *Out of Time: The Lifeworks of Tehching Hseih*. Cambridge, MA: MIT Press, 2009.

Heidegger, Martin. *Being and Time*. 1953. Reprint, Albany: State University of New York Press, 2010.

Hickinbotham, Simon, and Susan Stepney. "Augmenting Live Coding with Evolved Patterns." In *Evolutionary and Biologically Inspired Music, Sound, Art and Design*, edited by Colin Johnson, Vic Ciesielski, João Correia, and Penousal Machado, 31–46. Lecture Notes in Computer Science. Cham, Switzerland: Springer International, 2016. https://doi.org/10.1007/978-3-319-31008-4_3.

Hoare, C. A. R. (Tony). "An Axiomatic Basis for Computer Programming." *Communications of the ACM* 12, no. 1 (1969): 576–580.

Hofstadter, Douglas. *Gödel, Escher, Bach: An Eternal Golden Braid*. 1979. Reprint, New York: Basic Books, 2000.

Hofstadter, Douglas. *I Am a Strange Loop*. New York: Basic Books, 2007.

Hountondji, Paulin J. "Scientific Dependence in Africa Today." *Research in African Literatures* 21, no. 3 (1990): 5–15.

Howse, Martin. Earthcodes Project, September 17, 2014, http://www.1010.co.uk/org/earthcode.html.

Howse, Martin. "The Dark Interpreter." The Dark Interpreter. September 6, 2015. http://www.1010.co.uk/org/darkint.html.

Hugill, Andrew. *Shifting Meanings: The Fate of Words in Transdisciplinary Academia* (blog). January 2020. https://andrewhugill.com/writings/Shifting%20meanings.html.

Humphrey, Watts S. *Characterizing the Software Process: A Maturity Framework*. CMU/SEI-87-TR-11. Pittsburgh: Carnegie Mellon University, Software Engineering Institute, 1987.

Ingold, Tim. *Being Alive: Essays on Movement, Knowledge and Description*. London: Routledge, 2011.

Ingold, Tim. *Lines: A Brief History*. London: Routledge, 2016.

Ingold, Tim. *Making: Anthropology, Archaeology, Art and Architecture*. London: Routledge, 2013.

Ingold, Tim. "Materials against Materiality." *Archaeological Dialogues* 14, no. 1 (June 2007): 1–16.

Ingold, Tim. "The Textility of Making." *Cambridge Journal of Economics* 34, no. 1 (January 2010): 91–102.

Irani, Lilly, Janet Vertesi, Paul Dourish, Kavita Philip, and Rebecca E. Grinter. "Postcolonial Computing: A Lens on Design and Development." In *Proceedings of the SIGCHI Conference on Human Factors in Computing Systems (CHI)*, Atlanta, Georgia, April 10-15, 2010, 1311–1320. New York: Association for Computing Machinery, 2010.

Jack, Olivia. "Hydra: Live Coding Networked Visuals." In *Proceedings of the Fourth International Conference on Live Coding*, 353–354, Medialab Prado / Madrid Destino, Madrid, Spain, January 16–18, 2019. Geneva, Switzerland: Zenodo/CERN. https://doi.org/10.5281/zenodo.3946269.

Jacobs, Jessica. "Intersections in Design Thinking and Art Thinking: Towards Interdisciplinary Innovation." *Creativity: Theories, Research, Applications* 5, no. 1 (2018): 4–25.

Jameson, Fredric. *The Prison-House of Language: A Critical Account of Structuralism and Russian Formalism*. Princeton, NJ: Princeton University Press, 1974.

Jeffries, Janice. "Textiles: What Can She Know?" In *Feminist Visual Culture*, edited by Fiona Carson and Claire Pajaczkowska, 189–207. New York: Routledge, 2001.

Johnson, Tom. *Failing: A Very Difficult Piece for String Bass*. Paris: Editions 75, 1975.

Kay, Alan C. "The Early History of Smalltalk." New York: Association for Computing Machinery, 1993. http://gagne.homedns.org/~tgagne/contrib/EarlyHistoryST.html.

Kay, Alan C. "A Personal Computer for Children of All Ages." In *Proceedings of the ACM Annual Conference 1*. New York: Association for Computing Machinery, 1972.

Kelly, Kevin. *What Technology Wants*. New York: Viking Press, 2010.

Kelty, Christopher M. "Culture's Open Sources: Software, Copyright, and Cultural Critique." *Anthropological Quarterly* 77, no. 3, (2004): 499–506.

Kelty, Christopher M. *Two Bits: The Cultural Significance of Free Software*. Durham, NC: Duke University Press, 2008.

Kiefer, Chris, and Thor Magnusson. "Live Coding Machine Learning and Machine Listening: A Survey on the Design of Languages and Environments for Live Coding." In *Proceedings of the Fourth International Conference on Live Coding*, 353. Madrid: Medialab Prado/Madrid Destino, 2019. https://doi.org/10.5281/zenodo.3946188.

Kirkbride, Ryan. "Troop: A Collaborative Tool for Live Coding." Paper presented at the 14th Sound and Music Computing Conference, Espoo, Finland, July 5–8, 2017. https://doi.org/10.5281/zenodo.1401895.

Klee, Paul. *Pedagogical Sketchbook*. New York: Frederick A. Praeger, 1953.

Knotts, Michelle. "Social Systems for Improvisation in Live Computer Music." PhD diss., Durham University, UK, 2018.

Korzybski, Alfred. *Science and Sanity: An Introduction to Non-Aristotelian Systems and General Semantics*. Lancaster, PA: International Non-Aristotelian Library, 1933.

Kubelka, Juraj, Romain Robbes, and Alexandre Bergel. "The Road to Live Programming: Insights from the Practice." In *2018 IEEE/ACM 40th International Conference on Software Engineering*, 1090–1101. Piscataway, NJ: Institute of Electrical and Electronics Engineers.

Kwon, Miwon. *One Place after Another: Site-Specific Art and Locational Identity*. Cambridge, MA: MIT Press, 2004.

Latour, Bruno. *Reassembling the Social: An Introduction to Actor-Network-Theory*. Oxford: Oxford University Press, 2005.

Lee, Pamela. *Chronophobia: On Time in the Art of the 1960s*. Cambridge, MA: MIT Press, 2004.

Lee, San Wong, and Georg Essl. "Live Writing: Asynchronous Playback of Live Coding and Writing." July 13, 2015. Zenodo. https://doi.org/10.5281/zenodo.19322.

Leman, Marc. *Embodied Music Cognition and Mediation Technology*. Cambridge, MA: MIT Press, 2007.

Leman, Marc. *The Expressive Moment: How Interaction (with Music) Shapes Human Empowerment*. Cambridge, MA: MIT Press, 2016.

Leonard, Dorothy, and Sylvia Sensiper. "The Role of Tacit Knowledge in Group Innovation." *California Management Review* 40 (1998): 112–132.

Lepecki, André, ed. *Dance*. Documents of Contemporary Art. London: Whitechapel; Cambridge, MA: MIT Press, 2012.

Leuf, Bo, and Ward Cunningham. *The Wiki Way: Quick Collaboration on the Web*. Boston: Addison-Wesley, 2001.

LeWitt, Sol. "Paragraphs on Conceptual Art." *Artforum* 5, no. 10 (1967): 79–83.

Lialina, Olia. "Turing Complete User." Contemporary Home Computing. 2012. Accessed March 11, 2022. http://contemporary-home-computing.org/turing-complete-user/.

Licklider, Joseph Carl Robnett. "Man-Computer Symbiosis." *IRE Transactions on Human Factors in Electronics* 1 (1960): 4–11.

Lindell, Rikard. "Crafting Interaction: The Epistemology of Modern Programming." *Personal and Ubiquitous Computing* 18 (2014): 613–624.

LIVE: First International Workshop on Live Programming, in conjunction with 35th International Conference on Software Engineering (ICSE). May 19, 2013. http://liveprogramming.github.io/2013/.

Live Notation Unit. 2012. Accessed March 15, 2022. http://livenotation.lurk.org/.

Louppe, Laurence. *Traces of Dance: Drawings and Notations of Choreographers*. Paris: Editions Dis Voir, 1994.

Mackay, Robin, and Armen Avanessian, eds. *#Accelerate# The Accelerationist Reader*. Falmouth, UK: Urbanomic, in association with Merve, 2014.

Mackenzie, Adrian. *Cutting Code: Software and Sociality*. New York: Peter Lang, 2006.

Mackenzie, Adrian. *Machine Learners: Archaeology of a Data Practice*. Cambridge, MA: MIT Press, 2017.

Mackenzie, Adrian. "The Production of Prediction: What Does Machine Learning Want?" *European Journal of Cultural Studies* 18, no. 4–5 (2015): 429–445.

MacKenzie, Donald. *Mechanizing Proof: Computing, Risk, and Trust*. Cambridge, MA: MIT Press, 2001.

Magnusson, Thor. "Epistemic Tools: The Phenomenology of Digital Musical Instruments." PhD diss., University of Sussex, 2009. http://sro.sussex.ac.uk/id/eprint/83540/.

Magnusson, Thor. "Herding Cats: Observing Live Coding in the Wild." *Computer Music Journal* 38, no. 1 (2014): 8–16.

Magnusson, Thor. "Ixi Lang: A SuperCollider Parasite for Live Coding." In *Proceedings of the International Computer Music Conference*, 503–506, Huddersfield, UK, July 31–August 5, 2011. Ann Arbor, MI: Michigan Publishing, 2011.

Magnusson, Thor. *Sonic Writing: Technologies of Material, Symbolic and Signal Inscriptions*. London: Bloomsbury, 2019.

Magnusson, Thor. "The Threnoscope: A Musical Work for Live Coding Performance." Paper presented at the First International Workshop on Live Programming, in conjunction with International Conference on Software Engineering (ICSE) 2013, May 18–26, 2013, San Francisco.

Magnusson, Thor, and Alex McLean. "Performing with Patterns of Time." In *Oxford Handbook of Algorithmic Music*, edited by Roger T. Dean and Alex McLean, 245–266. Oxford: Oxford University Press, 2018. https://doi.org/10.5281/zenodo.1193251.

Maharaj, Sarat. "Know-How and No-How: Stopgap Notes on 'Method' in Visual Art as Knowledge Production." *Art and Research* 2, no. 2 (2009). http://www.artandresearch.org.uk/v2n2/maharaj.html.

Maharaj, Sarat. "What the Thunder Said: Toward a Scouting Report on 'Art as a Thinking Process.'" In *Art as a Thinking Process*, edited by Mara Ambrožič and Angela Vettese, 154–160. Berlin: Sternberg Press, 2013.

Making History. "Samuel, Professor Raphael Elkan." Accessed March 12, 2022. https://archives.history.ac.uk/makinghistory/historians/samuel_raphael.html.

Manning, Erin. *Always More Than One: Individuation's Dance*. Durham, NC: Duke University Press, 2013.

Manning, Erin. *Relationscapes: Movement, Art, Philosophy*. Cambridge, MA: MIT Press, 2009.

Manning, Erin, and Brian Massumi. *Thought in the Act: Passages in the Ecology of Experience*. Minneapolis: University of Minnesota Press, 2014.

Manovich, Lev (website). "Avant-garde as Software." 1999. http://manovich.net/index.php/projects/avant-garde-as-software.

Markoff, John. *What the Dormouse Said: How the 60s Counterculture Shaped the Personal Computer Industry*. London: Penguin, 2005.

Martinon, Jean-Paul. *On Futurity, Malabou, Nancy and Derrida*. New York: Palgrave Macmillan, 2007.

Maturana, Humberto, and Francisco Varela. *Autopoiesis and Cognition: The Realization of the Living*. Dordrecht: Reidel, 1980.

May, Jon, and Nigel Thrift, eds. *Timespace: Geographies of Temporality*. London: Routledge, 2007.

Mestre, Lilia, and Elke Van Campenhout, eds. *Writing Scores in Process*. Brussels: a.pass, 2015.

McCallum, Louis, and Davy Smith, dirs. *Show Us Your Screens*. Film. 2011. https://vimeo.com/20241649.

McCartney, James. "Rethinking the Computer Music Language: SuperCollider." *Computer Music Journal* 26, no. 4 (2002): 61–68.

McCullough, Malcolm. *Abstracting Craft: The Practiced Digital Hand*. Cambridge, MA: MIT Press, 1998.

McLean, Alex. "Algorithmic Pattern." In *Proceedings of the 20th Conference on New Interfaces for Musical Expression*, Birmingham, UK, 2020. Geneva, Switzerland: Zenodo/CERN. https://zenodo.org/record/4299661.

McLean, Alex. "Artist-Programmers and Programming Languages for the Arts." PhD diss., Goldsmiths College, University of London, 2011.

McLean, Alex. "Forkbomb.pl." July 4, 2001. https://slab.org/forkbomb-pl/.

McLean, Alex. "Improvising with Synthesised Vocables, with Analysis towards Computational Creativity." Master's thesis, Goldsmiths College, University of London, 2007.

McLean, Alex. "Making Programming Languages to Dance to: Live Coding with Tidal." In *Proceedings of the 2nd ACM SIGPLAN International Workshop on Functional Art, Music, Modeling and Design*. New York: Association for Computing Machinery, 2014. https://doi.org/10.1145/2633638.2633647.

McLean, Alex, Giovanni Fanfani, and Ellen Harlizius-Klück. "Cyclic Patterns of Movement across Weaving, Epiplokē and Live Coding." *Dancecult: Journal of Electronic Dance Music Culture* 10, no. 1 (2018): 5–30. http://dx.doi.org/ 10.12801/1947-5403.2018.10.01.01.

McLean, Alex, Dave Griffiths, Nick Collins, and Geraint Wiggins. "Visualisation of Live Code." In *Proceedings of Electronic Visualisation and the Arts London*, 26–30. Swindon, UK: British Computer Society, 2010.

Bibliography

McLean, Alex, Ellen Harlizius-Klück, and Janis Jefferies. "Introduction: Weaving Codes, Coding Weaves." In "Weaving Codes, Coding Weaves," special issue, *Textile: Journal of Cloth and Culture* 15, no. 2 (2017): 118–123.

McLean, Alex, and Hester Reeve. "Live Notation: Acoustic Resonance?" Paper presented at the International Computer Music Conference (ICMC), Ljubljana, Slovenia, September 9–14, 2012.

McNeilly, Jodie. "Temporalising Digital Performance." In *Performance and Temporalisation: Time Happens*, edited by Stuart Grant, Jodie McNeilly, and Maeva Veerapen, 153–167. Basingstoke, UK: Palgrave Macmillan, 2014.

Menkman, Rosa. *The Glitch Moment(um)*. Amsterdam: Institute of Network Cultures, 2011.

Mersch, Dieter. "Aesthetic Thinking: Art as Theōria." In *Aesthetic Theory*, edited by Dieter Mersch, Sylvia Sasse, and Sandro Zanetti and translated by Brian Alkire, 219–236. Zurich: Think Art Diaphanes, 2019.

Mersch, Dieter. *Epistemologies of Aesthetics*. Zurich: Think Art Diapanes, 2015.

Mignolo, Walter. "Foreword: On Pluriversality and Multipolarity." In *Constructing the Pluriverse: The Geopolitics of Knowledge*, edited by Bernd Reiter, ix–xvi. Durham, NC: Duke University Press, 2018.

Mitchell, W. J. T. "What Do Pictures 'Really' Want?" *October* 77 (Summer 1996): 71–82.

Miyazaki, Shintaro. "Algorhythmics: Understanding Micro-Temporality in Computational Cultures." *Computational Culture* 2 (2012). http://computationalculture.net/article/algorhythmics-understanding-micro-temporality-in-computational-cultures.

Molander, Bengt. *The Practice of Knowing and Knowing in Practices*. Frankfurt: Peter Lang, 2015.

Monoskop. "ReadMe." Last modified April 11, 2017. https://monoskop.org/Readme.

Motte, Warren F., ed. *OuLiPo: A Primer of Potential Literature*. Translated by Warren F. Motte. Elmwood Park, IL: Dalkey Archive Press, 1998.

Nafus, Dawn, James Leach, and Bernhard Krieger. "Gender: Integrated Report of Findings." *FLOSSPOLS, Deliverable D* 16 (March 2006). https://www.researchgate.net/publication/264799720_FLOSSPOLS_Deliverable_D_16_Gender_Integrated_Report_of_Findings.

Nash, Chris. "Supporting Virtuosity and Flow in Computer Music." PhD diss., University of Cambridge, 2012. https://doi.org/10.17863/CAM.16375.

Nash, Chris, and Alan F. Blackwell. "Flow of Creative Interaction with Digital Music Notations." In *The Oxford Handbook of Interactive Audio*, edited by K. Collins, B. Kapralos, and H. Tessler, 387–404. New York: Oxford University Press, 2014.

Negri, Antonio. *Negri on Negri: Antonio Negri in Conversation with Anne Dufourmantelle*. Translated by M. B. DeBevoise. London: Routledge, 2004.

Negri, Antonio. *Time for Revolution*. London: Continuum, 2003.

Nelson, Robin. *Practice as Research in the Arts: Principles, Protocols, Pedagogies, Resistances*. New York: Palgrave Macmillan, 2013.

Noble, Safiya Umoja. *Algorithms of Oppression: How Search Engines Reinforce Racism*. New York: New York University Press, 2018.

Noë, Alva. *Action in Perception*. Cambridge, MA: MIT Press, 2004.

Noë, Alva. *Varieties of Presence*. Cambridge, MA: Harvard University Press, 2012.

O'Hara, Kenton, Richard Harper, Helena Mentis, Abigail Sellen, and Alex Taylor. "On the Naturalness of Touchless: Putting the 'Interaction' Back into NUI." *ACM Transactions on Computer-Human Interaction* 20, no. 1 (April 2013): 1–25.

Osborne, Peter. *Anywhere or Not At All: Philosophy of Contemporary Art*. London: Verso, 2013.

O'Sullivan, Simon. *Art Encounters: Deleuze and Guattari, Thought beyond Representation*. Basingstoke, UK: Palgrave, 2006.

Pair, C. "Programming, Programming Languages and Programming Methods." In *Psychology of Programming*, edited by J.-M. Hoc, T. R. G. Green, R. Samurçay, and D. J. Gilmore. Cambridge, MA: Academic Press, 1990.

Papert, Seymour. *Mindstorms: Computers, Children, and Powerful Ideas*. New York: Basic Books, 1980.

Pasquinelli, Matteo. "Google's PageRank Algorithm: A Diagram of Cognitive Capitalism and the Rentier of the Common Intellect." In *Deep Search*, edited by Konrad Becker and Felix Stalder, 152–162. London: Transaction, 2009.

Penny, Simon. *Making Sense: Cognition, Computing, Art and Embodiment*. Cambridge, MA: MIT Press, 2017.

Perec, Georges. *Life: A User's Manual*. Translated by David Bellos. London: Harvill Press, 1996.

Phelan, Peggy. *Unmarked: The Politics of Performance*. London: Routledge, 1993.

Philip, Kavita, Lilly Irani, and Paul Dourish. "Postcolonial Computing: A Tactical Survey." *Science, Technology and Human Values* 37, no. 1 (2012): 3–29.

Pickering, Andrew. *The Mangle of Practice: Time, Agency and Science*. Chicago: University of Chicago Press, 1995.

Pinch, Trevor, and Frank Trocco. *Analog Days: The Invention and Impact of the Moog Synthesizer*. Cambridge, MA: Harvard University Press, 2004.

PiratePad. (website), originally located at http://www.piratepad.net/. Note that this interactive web service is no longer operational. See archived review, October 3, 2017, at https://webapps.softpedia.com/app/PiratePad/.

Plant, Sadie. "The Future Looms: Weaving Women and Cybernetics." *Body and Society* 1, no. 3–4 (1995): 45–64.

Polyani, Michael. "Tacit Knowing: Its Bearing on Some Problems of Philosophy." *Review of Modern Physics* 34 (1962): 601–616.

Polyani, Michael. *The Tacit Dimension*. 1966; repr., Gloucester, MA: Peter Smith, 1983.

Radcliffe, Caroline, and Sarah Angliss. "Revolution: Challenging the Automaton: Repetitive Labour and Dance in the Industrial Workspace." *Performance Research* 17, no. 6 (December 2012): 40–47. https://doi.org/10.1080/13528165.2013.775758.

Ramsay, Stephen, dir. *Algorithms Are Thoughts, Chainsaws Are Tools*. 2016. Video. https://vimeo.com/699880166.

Raymond, Eric. "The Cathedral and the Bazaar." *Knowledge, Technology and Policy* 12 (1999): 23–49.

Reason, Matthew, and Anja Mølle Lindelof, eds. *Experiencing Liveness in Contemporary Performance: Interdisciplinary Perspectives*. Routledge Advances in Theatre and Performance Studies. London: Routledge, 2017.

Reynolds, Jack. "Time Out of Joint." In *Performance and Temporalisation: Time Happens*, edited by Stuart Grant, Jodie McNeilly, and Maeva Veerapen, 101–113. Basingstoke, UK: Palgrave Macmillan, 2014.

Reynolds, Simon. *Energy Flash*. London: Faber and Faber, 2013.

Roberts, Charles, Matthew Wright, and JoAnn Kuchera-Morin. "Beyond Editing: Extended Interaction with Textual Code Fragments." In *Proceedings of the International Conference on New Interfaces for Musical Expression*, 126–131. Baton Rouge: School of Music and the Center for Computation and Technology, Louisiana State University, 2015.

Rogoff, Irit. "From Criticism to Critique to Criticality." *Transversal*, January 2003. https://transversal.at/transversal/0806/rogoff1/en.

Rogoff, Irit. "We: Collectivities, Mutualities, Participations." In *I Promise It's Political: Performativität in der Kunst*, edited by Dorothea Von Hantelmann and Marjorie Jongbloed, 126–133. Cologne: Museum Ludwig, 2002.

Rohrhuber, Julian. "Algorithmic Complementarity, or the Impossibility of 'Live' Coding." *Collaboration and Learning through Live Coding* (Dagstuhl Seminar 13382) 3, no. 9 (2014): 140–142. http://dx.doi.org/10.4230/DagRep.3.9.130.

Rohrhuber, Julian. "Algorithmic Music and the Philosophy of Time." In *The Oxford Handbook of Algorithmic Music*, edited by Alex McLean and Roger T. Dean. Oxford: Oxford University Press, 2018. https://zenodo.org/record/2596675#.YBFtRpP7QW4.

Rohrhuber, Julian. "Live Coding and the Self Alienation of Time." Keynote lecture at the First International Conference on Live Coding, University of Leeds, Leeds, 2015.

Rohrhuber, Julian, and David Griffiths. "Coding with Knots." In "Weaving Codes, Coding Weaves," special issue, *Textile: Journal of Cloth and Culture* 15, no. 2 (2017): 142–157.

Rousseau, Jean-Jacques. "Syncope." In *A Complete Dictionary of Music*, translated by William Waring, 390–391. 1779. Reprint, New York: AMS Press, 1975.

Rushkoff, Douglas. *Program or Be Programmed: Ten Commands for a Digital Age*. Berkeley, CA: Soft Skull Press, 2011.

Russolo, Luigi. *The Art of Noise (Futurist Manifesto, 1913)*. A Great Bear Pamphlet. Translated by Robert Filliou. New York: Something Else Press, 1967. http://www.artype.de/Sammlung/pdf/russolo_noise.pdf.

Rutz, Hanns Holger, and David Pirrò. "Continuous Exposition." Research Catalogue. https://www.researchcatalogue.net/view/381565/381566.

Ryle, Gilbert. *The Concept of the Mind*. 1949. Reprint, Harmondsworth, UK: Penguin 1973.

Ryle, Gilbert. "Knowing How and Knowing That: The Presidential Address." *Proceedings of the Aristotelian Society* 46 (1945–1946): 1–16.

Satchell, Christine, and Paul Dourish. "Beyond the User: Use and Non-use in HCI." In *OZCHI '09—Proceedings of the 21st Annual Conference of the Australian Computer-Human Interaction Special Interest Group: Design: Open 24/7*, edited by J. Paay, S. Viller, and J. Kjeldskov, 9–16. New York: Association for Computing Machinery.

Sauer, Theresa. *Notations 21*. New York: Mark Batty, 2009.

Schaffer, Simon. "Babbage's Intelligence: Calculating Engines and the Factory System." *Critical Inquiry* 21, no. 1 (1994): 203–227.

Scherzinger, Martin. "The Political Economy of Streaming." In *The Cambridge Companion to Music in Digital Culture*, edited by Nicholas Cook, Monique M. Ingalls, and David Trippett, 274–297. Cambridge: Cambridge University Press, 2019.

Schön, Donald A. *The Reflective Practitioner—How Professionals Think in Action*. New York: Basic Books, 1983.

Schutz, Alfred. "Making Music Together: A Study in Social Relationship." In Vol. 2, *Schutz, Collected Papers*, 159–178. The Hague: Martinus Nijhoff, 1976.

Schwab, Michael, and Henk Borgdorff. *The Exposition of Artistic Research: Publishing Art in Academia*. Leiden, the Netherlands: Leiden University Press, 2014.

Schwitters, Kurt. *Ursonate* (performance score). 1932. Originally published in Merzhefte, Merz 24 (Hannover). Republished in 1976 by Peter Lang Gmbh, Internationaler Verlag Der Wissenschaften. Multiple sound recordings of performances of *Ursonate* are available at: https://www.poetryfoundation.org/harriet-books/2007/03/9-versions-of-kurt-schwitters-ursonate.

Sennett, Richard. *The Craftsman*. New Haven, CT: Yale University Press, 2008.

Sheets-Johnson, Maxine. *The Corporeal Turn: An Interdisciplinary Reader*. Exeter, UK: Imprint Academic, 2009.

Sheets-Johnson, Maxine. *The Primacy of Movement*. Amsterdam: John Benjamins, 1999.

Shimojima, Atsushi. "The Graphic-Linguistic Distinction: Exploring Alternatives." *Artificial Intelligence Review* 13, no. 4 (1999): 313–335.

Shklovsky, Viktor. "Art as Device." In *Theory of Prose*. 1925. Reprint, Elmwood Park, IL: Dalkey Archive Press, 1990.

Shneiderman, Ben. "Direct Manipulation: A Step beyond Programming Languages." *Computer* 8 (1983): 57–69.

Sicchio, Kate, and Thor Magnusson, eds. "Writing with Shaky Hands." *International Journal of Performance Art and Digital Media* 12, no. 2 (2016): 99–101. https://toplap.org/special-issue-on-live-coding-in-ijpadm/.

Sicchio, Kate, Zeshan Wang, and Marissa Forbes. "Live Coding Tools for Choreography: Creating Terpsicode." In *Proceedings of the 2020 International Conference on Live Coding*, 87–94. Limerick, Ireland: University of Limerick. https://doi.org/10.5281/zenodo.3939135.

Smith, David C. *Pygmalion: A Computer Program to Model and Stimulate Creative Thought*. Basel, Switzerland: Birkhauser, 1977.

Smith, Douglas K., and Robert C. Alexander. *Fumbling the Future: How Xerox Invented, Then Ignored, the First Personal Computer*. New York: William Morrow, 1988.

Smith, Linda Tuhiwai. *Decolonizing Methodologies: Research and Indigenous Peoples*. London: Zed Books, 2012.

Snow, A. P. *The Two Cultures and the Scientific Revolution*. Cambridge: Cambridge University Press, 1959.

Software Carpentry. Home page. Accessed March 11, 2022. https://software-carpentry.org.

Software Craftsmanship. "Software Craftsmanship Manifesto." 2009. http://manifesto.softwarecraftsmanship.org.

Soon, Winnie. "Executing Liveness: An Examination of the Live Dimension of Code Inter-actions in Software (Art) Practice." PhD diss., Aarhus University, Denmark, 2016.

Soon, Winnie, and Geoff Cox. *Aesthetic Programming: A Handbook of Software Studies*. London: Open Humanities Press, 2020.

Sorensen, Andrew, and Henry J. Gardner. "Programming with Time: Cyber-Physical Programming with Impromptu." In *Proceedings of the 25th Annual ACM SIGPLAN Conference on Object-Oriented Programming, Systems, Languages, and Applications (OOPSLA)*, 822–834, Reno/Tahoe, Nevada, October 17–21, 2010. New York: Association for Computing Machinery, 2010.

Spatz, Ben. *What a Body Can Do: Technique as Knowledge, Practice as Research*. London: Routledge, 2015.

Spiegel, Laurie. "Manipulations of Musical Patterns." In *Proceedings of the Symposium on Small Computers and the Arts*, 19–22. Los Alamitos: IEEE Computer Society Press 1981.

Stanyek, Jason, and Benjamin Piekut. "Deadness, Technologies of the Intermundane." *Drama Review* 54, no.1 (2010): 14–28.

Stein, Danielle, and Craig Valters. "Understanding Theory of Change in International Development." JSRP Paper 1. London: London School of Economics, 2012. http://eprints.lse.ac.uk/id/eprint/56359.

Stern, Daniel. *Forms of Vitality: Exploring Dynamic Experience in Psychology, the Arts, Psychotherapy, and Development*. Oxford: Oxford University Press, 2010.

Stern, Daniel. *The Present Moment in Psychotherapy and Everyday Life*. New York: W. W. Norton, 2004.

Stewart, Ian. *Fearful Symmetry: Is God a Geometer?* Mineola, NY: Dover, 2010.

Stewart, Jeremy, Shawn Lawson, Mike Hodnick, and Ben Gold. "Cibo v2: Realtime Livecoding A.I. Agent." In *Proceedings of the 2020 International Conference on Live Coding*, 20–31. Limerick, Ireland: University of Limerick. Zenodo. https://doi.org/10.5281/zenodo.3939174.

Stiegler, Bernard. *La technique et le temps*. Vols. 1–3. Paris: Éditions Galilée, 1994–2001.

Streitz, Norbert, and Paddy Nixon. "The Disappearing Computer—Introduction." In "The Disappearing Computer," special issue, *Communications of the ACM: The Disappearing Computer* 48, no. 3 (2005): 32–35.

Suchman, Lucy. *Human-Machine Reconfigurations: Plans and Situated Actions*. Cambridge: Cambridge University Press, 2007.

Tanimoto, Steven. "A Perspective on the Evolution of Live Programming." In *Proceedings of the 1st International Workshop on Live Programming*, 31–34. Los Alamitos: IEEE Computer Society, 2013. https://liveprogramming.github.io/2013/papers/liveness.pdf.

Tanimoto, Steven. "VIVA: A Visual Language for Image Processing." *Journal of Visual Languages and Computing* 1, no. 2 (1990): 127–139.

Taylor, Alex. "Data, (Bio)sensing and (Other-)Worldly Stories from the Cycle Routes of London." In *Quantified: Biosensing in Everyday Life*, edited by Dawn Nafus, , 189–210. Cambridge, MA: MIT Press, 2016.

Todorov, Tzvetan. *Littérature et signification*. Paris: Larousse, 1967.

TOPLAP. "About." Accessed March 11, 2022. https://toplap.org/about/.

TOPLAP. "ManifestoDraft." Last modified September 3, 2020. https://toplap.org/wiki/ManifestoDraft.

Toussaint, Godfried. "The Euclidean Algorithm Generates Traditional Musical Rhythms." In *Proceedings of BRIDGES: Mathematical Connections in Art, Music and Science*, 47–56. Banff, Alberta: Banff Centre, 2005. http://citeseerx.ist.psu.edu/viewdoc/summary?doi=10.1.1.62.231.

Tuck, Eve, and K. Wayne Yang. "Decolonization Is Not a Metaphor." *Decolonization: Indigeneity, Education and Society* 1, no. 1 (2012): 1–40.

Bibliography

Turing, Alan M. "On Computable Numbers, with an Application to the Entscheidungs Problem." *Proceedings of the London Mathematical Society* 42 (1936/1937): 230–265.

Turner, Victor. *From Ritual to Theatre: The Human Seriousness of Play*. New York: PAJ, 1982.

Ullman, Ellen. *Close to the Machine: Technophilia and Its Discontents*. 1997. Reprint, London: Picador, 2012.

University of Aberdeen. "Knowing from the Inside: Anthropology, Art, Architecture and Design." Accessed March 12, 2022. https://www.abdn.ac.uk/research/kfi/.

University of Leeds, School of Music. "Weaving Codes, Coding Weaves." Accessed March 12, 2022. https://ahc.leeds.ac.uk/music/dir-record/research-projects/592/weaving-codes-coding-weaves.

Van Gennep, Arnold. *The Rites of Passage*. 1960. Reprint, London: Routledge, 2004.

Varela, Francisco J., Evan Thompson, and Eleanor Rosch. *The Embodied Mind: Cognitive Science and Human Experience*. Cambridge, MA: MIT Press, 1991.

Veel, Kristen. "Latency." In *Uncertain Archives: Critical Keywords for Big Data*, edited by Nanna Bonde Thylstrup, Daniela Agostinho, Annie Ring, Catherine D'Ignazio, and Kristin Veel, 313–319. Cambridge, MA: MIT Press, 2021.

Victor, Bret. "Future of Programming." July 2013. Video. https://vimeo.com/71278954.

Villaseñor de Cortina, Diego, and Alejandro Franco Briones. "Nanc-in-a-Can Canon Generator. SuperCollider Code Capable of Generating and Visualizing Temporal Canons Critically and Algorithmically." In *Proceedings of the Fourth International Conference on Live Coding*, 253. Madrid: Medialab Prado/Madrid Destino, 2019. Zenodo. https://doi.org/10.5281/zenodo.3946192.

Virno, Paolo. *A Grammar of the Multitude: For an Analysis of Contemporary Forms of Life*. South Pasadena, CA: Semiotext(e), 2004.

Virno, Paolo. *When the Word Becomes Flesh: Language and Human Nature*. South Pasadena, CA: Semiotext(e), 2015.

Vitores, Anna, and Adriana Gil-Juárez. "The Trouble with 'Women in Computing': A Critical Examination of the Deployment of Research on the Gender Gap in Computer Science." *Journal of Gender Studies* 25, no. 6 (2015): 1–15. http://dx.doi.org/10.1080/09589236.2015.1087309.

von Engelhardt, Jörg. "The Language of Graphics: A Framework for the Analysis of Syntax and Meaning in Maps, Charts and Diagrams." PhD diss., University of Amsterdam, 2002.

Walker, Michelle Boulous. *Slow Philosophy: Reading against the Institution*. London: Bloomsbury, 2017.

Wang, Ge, and Perry R. Cook. "On the Fly Programming: Using Code as an Expressive Musical Instrument." In *Proceedings of New Interfaces for Musical Expression*, Hamamatsu Shizuoka, Japan June 3–5, 2004, 138–143. Singapore: National University of Singapore, 2004.

Ward, Adrian, Julian Rohrhuber, Fredrik Olofsson, Alex McLean, Dave Griffiths, Nick Collins, and Amy Alexander. "Live Algorithm Programming and a Temporary Organisation for Its

Promotion." In *Read_me—Software Art and Cultures*, edited by Olga Goriunova and Alexei Shulgin, 243–261. Aarhus, Denmark: Digital Aesthetics Research Centre, 2004.

Ward, David J., Alan F. Blackwell, and David J. C. MacKay. "Dasher: A Gesture-Driven Data Entry Interface for Mobile Computing." *Human-Computer Interaction* 17 (2002): 199–228.

White, Eric Charles. *Kaironomia: On the Will to Invent*. Ithaca, NY: Cornell University Press, 1987.

Wiberg, Mikael. "Methodology for Materiality: Interaction Design Research through a Material Lens." *Personal and Ubiquitous Computing* 18 (2013): 1–12.

Wilson, Scott, David Cottle, and Nick Collins, eds. *The SuperCollider Book*. Cambridge, MA: MIT Press, 2011.

Wing, Jeannette, M. "Computational Thinking." *Communications of the ACM* 49 (2006): 33–35.

Winnicott, Donald W. *Playing and Reality*. Abingdon, UK: Taylor and Francis, 2005.

Winskel, Glynn. *The Formal Semantics of Programming Languages: An Introduction*. Cambridge, MA: MIT Press, 1993.

Wolf, Rebecca. *Spielen und bedienen: Das selbstspielende Klavier als virtuose Maschine. Spiel (mit) der Maschine: Musikalische Medienpraxis in der Frühzeit von Phonographie, Selbstspielklavier, Film und Radio*. Bielefeld, Germany: Transcript Verlag, 2016.

Wood, Catherine. *Yvonne Rainer: The Mind Is a Muscle*. London: Afterall, 2007.

Yuill, Simon. "All Problems of Notation Will Be Solved by the Masses." *Mute*, May 2008. https://www.metamute.org/editorial/articles/all-problems-notation-will-be-solved-masses.

Zuboff, Shoshana. *The Age of Surveillance Capitalism: The Fight for a Human Future at the New Frontier of Power*. New York: PublicAffairs, 2019.

Index

3Play (ensemble), 19

aa_cell (ensemble), 25
Aaron, Sam, 27, 184. *See also* Sonic Pi
Abreu, Iván, 67
Access Space (venue), 26
Activism, 20, 29–31, 63, 238–240
Adorno, Theodor, 155, 246
Aesthetics, 43, 117, 173, 174, 183, 206
Agamben, Giorgio, 173, 182, 196
 What is the Contemporary?, 182
Agawu, Kofi, 143
Agency, 11–12, 132–133, 153, 160, 167, 169–170, 172, 175, 200, 215–216, 229
Agile development, 210, 217
Agre, Philip E., 11, 206, 237. *See also* Critical technical practice
Aji, Rangga, 41, 161
Albornoz, Alejandro, 43
Alexander, Amy, 20, 29
Alexander, Christopher, 154, 210
(Algo|Afro) Futures, 31
ALGOBABEZ, 29, 45, 161
ALGOL, 184
Algomech Festival, 43, 61
Algorave, 9, 30, 35–38, 45, 51, 53, 71, 85, 87, 104, 113, 138, 189, 230
 algorave guidelines, 30, 36
Algorhythmics, 203
Algorhythms, 230

Algorithm, 21–22, 32, 65, 117, 130, 134, 156, 160, 184, 201, 213, 229–237
Algorithmic, 121
 composition, 27, 63, 73, 83, 165
 dance, 230
 governance, 121, 155, 188, 213, 231–232
 music, 14, 150, 195, 201
 pattern, 35, 127, 136–138, 235
 poetics, 119
 procedures, 43, 133
 thinking, 164, 225–226
 time, 189–190, 199
Al-Jazari, 183. *See also* Griffiths, Dave
Allographic work, 149–150, 152–153
Alsleben, Kurd, 16, 21
Anderson, Dave, 23
Andrade, Rafaele, 47
Annotation, 106–107, 148, 220
Arendt, Hannah, 157
d'Arezzo, Guido, 129
Aristotle, 157
Armitage, Jack, 49
Armitage, Joanne, 45, 61, 63, 138. *See also* ALGOBABEZ
Artificial intelligence (AI), 11, 53, 103, 121, 123, 139, 202, 206, 211, 225, 230–237, 239, 243. *See also* Machine learning
Artistic research, 218, 221, 225
Attali, Jacques, 232

Audience, 3, 6, 15, 20, 22, 26–27, 36, 57, 73, 83, 113, 117, 124, 163–164, 168, 174–176, 178, 193
Auslander, Philip, 159, 162–164
Austin, J. L., 171–172, 174
Authenticity, 133, 148–149, 159
Authorship, 18, 129, 148, 150, 234
Autographic, 149–150, 152
Autographic work, 149, 150, 152
AutoIllustrator, 17
Automation, 29, 153, 191, 229, 230, 232, 234, 237
Autopoiesis, 174–175
AutoShop, 17

Babbage, Charles, 32–33, 216
Bainbridge, Lisanne, 237
Baker, Camille, 165
Ballweg, Holger. See Benoît and the Mandelbrots
Barad, Karen, 175, 226–228
Barcelona. See Spain
Barthes, Roland, 146
Baudrillard, Jean, 162
Bauman, Zygmunt, 188
Bautista, Lina, 53
Becoming, 190, 198, 199, 223, 226
Bell, Renick, 55, 95, 121
Benoît and the Mandelbrots, 26–27, 95, 161
Bergson, Henri, 190–192, 196, 199
Bernardo, Francisco, 123, 139
Bertin, Jacques, 152
Black Lives Matter, 31, 243
Blank slate. See From scratch
Blum(e), Ashlae, 57
Body, 8, 29, 63, 75, 113, 126, 151, 164–167, 224, 227–228
Bol Processor, 137, 195
Borgeat, Patrick. See Benoît and the Mandelbrots
Boulous Walker, Michelle, 241
Bowker, Geoffrey C., and Susan Leigh Star, 239

Brass. See Instrument (musical)
Braxton, Anthony, 133
Brazil, 51
Brown, Andrew, 16
Buber, Martin, 176
Buenos Aires, 75
Bureaucracy, 207, 209, 213
Burnham, Jack, 183

Cage, John, 132–133, 150
de Campo, Alberto, 21, 123, 249n3
Canada, 99, 101, 109, 119
Capitalism, 61, 221
 anticapitalism, 31
 global capitalism, 182, 222
 surveillance capitalism, 233, 234
Cardenas, Alexandra, 13, 59
Cardew, Cornelius, 155, 157
Causality, 185, 201, 228
CCRMA, Stanford, 26
Cello. See Instrument (musical)
Centro Multimedia, Centro Nacional de las Artes, 26
Chainsaws, 22, 213
Changing Grammars (symposium), 21, 24, 38, 160
Cheesman, Lucy, 61
Chicau, Joana, 63, 103, 117, 165
Chile, 43
Choreography, 27, 63, 113, 133–135, 139, 144, 151, 165
ChucK (language), 16, 21, 26, 134
Chun, Wendy Hui Kyong, 172–173
Cinema, 67
Clayton, Martin, 195
Clément, Catherine, 196
CLIC. See Colectivo de Live Coders
Clock, 181, 186, 187, 190–192, 200, 202
CodeKlavier, 117
Code poetry. See Poetry
Codie, 77, 91, 113
Colectivo de Live Coders, 34, 75, 111, 240

Index

Collaboration, collaborative, 7–8, 11, 45, 61, 63, 77, 101, 107, 123, 138, 160, 168, 170–171, 175, 176–177, 186, 235, 242
Collinge, Doug, 23–24
Collins, Nick, 20, 26, 65, 97, 123, 133, 249n6. *See also* 3Play
Colonialism, 231, 237–239, 242. *See also* Postcolonialism
Community, community of practice, 27, 220–221
Composition, 5, 10, 41, 81, 97, 119, 129, 135–136, 150, 153, 166, 189
 real-time composition, 3, 59, 140–141, 160, 168
 algorithmic composition, 27, 63, 73, 83, 165
 acousmatic composition, 43
Comprovisation, 161
Conductive (live coding environment), 55, 121
Contemporaneity, con-temporaneity, 162, 182
Conversational practice, 160, 176
Conversational programming, 2, 4, 135, 235
Cook, Perry, 16, 18
Copyleft. *See* GNU: General Public License
Cortes, Malitzin, 67
Couldry, Nick, 163
COVID-19/coronavirus pandemic, 43, 123, 232, 242
Craft, 205–208, 212–217
Cramer, Florian, 20
Crawford, Kate, 239
Creative commons, 141, 178, 231, 234
Critical technical practice, 11, 182, 203, 206–207, 237, 242
Critical-technical user, 241
Csíkszentmihályi, Mihály, 167–168
CSound, 3, 14, 26, 55
Cuba, Larry, 15, 16, 281n9
Cybernetic, 135, 232
Cybernetic Orchestra, 27, 101

Dagstuhl, Schloss, 34
Dance, 103. *See also* Choreography

Dance culture, 49, 230
Dannenberg, Roger, 23
Data structures, 139, 231, 232
DAW (Digital Audio Workstation), 43, 73, 81, 93, 115, 145, 154
Declarative (programming language paradigm), 23, 140, 183, 184
Defamiliarization, 3
Definitions. *See* Live coding, definitions of
Deleuze, Gilles, 273
 and Guattari, Felix, 198, 216
Democracy, 208
Demoscene, 215, 221
Dencker, Helmut, 16
Derrida, Jacques, 173, 190, 260
Diarra, Mamady, 69
Disjunction, 168, 181–183, 188, 193, 195, 198
Diversity, 14, 28–32, 81, 85, 111, 119, 123
Donaggio, Claudio, 71
Dorkbot, 20
Drum machine. *See* Instrument (musical)
Drummond, Bill, 19
Duration, 111, 191–193, 195–197, 199, 202
DynamicLand, 209

Eacott, Greta, 130
Eacott, John, 19, 26
Earsketch, 73
Earth to Abigael. *See* Marie, Mynah
Education, 15, 26–30, 41, 73, 85, 91, 123, 184
Elasticity, 181, 186, 190–192, 195
Emacs editor, 211
Ending, 200–202
Engelhardt, Yuri, 152
Engineering, 3, 5, 11, 24, 27–28, 32, 34, 38, 103, 153–154, 181, 184, 205–207, 216
Epistemology, 205, 218, 225, 228
Ernst, Wolfgang, 200–202
Errors. *See* Failure; Trial and error
Eske, Antje, 21
Estuary (live coding environment), 41, 101

Experimentation, experimentality, 3, 24, 61, 77, 148, 208, 219–220, 222, 242
Extempore, 107, 134, 135, 184, 185, 202.
 See also Sorensen, Andrew

Failure, 30, 170, 221, 231
 embracing error, 61, 111
Feedback loop, 113, 131, 174–177, 179, 225
Feminism, feminist, 31, 45, 47, 63, 123, 138, 175, 190, 196
Fischer-Lichte, Erika, 174–176
Fisher, Mark, 141, 222
Flok (live coding editor), 41, 111
F/L/OSS (free/libre open-source Software).
 See Open-source software
Flow, flow state, 83, 167–171, 193, 195
Fluxus (art collective), 132–133
Fluxus (live coding environment), 83, 119, 148, 183
Forkbomb.pl, 17
Forth (language), 23, 211
Foucault, Michel, 190, 226–227, 248, 278, 289
Foundry, The (venue), 19–20
Foxdot, 41, 51, 57, 61, 134
Francesca, Rosa, 31
Franklin, Ursula, 144
Freeman, Jason, 73
Free software, 4, 61, 101, 111, 156, 211, 238.
 See also Open-source software
Freire, Paulo, 176
From scratch, 41, 43, 53, 95, 140, 161, 161
de Fuego, Flor, 75
Fuller, Matthew, 20
Functional (programming language paradigm), 117, 121, 185
Future (of live coding), 2, 29, 31, 49, 57, 83, 85, 97, 101, 115, 123, 224, 229, 243

Galloway, Alexander R., 172
Geeks, 16, 103, 208
Gender, 28–31, 45, 63, 215
Generative, 9, 16, 17–20, 25, 33, 41, 55, 59, 67, 85, 97, 101, 113, 119, 129, 133, 137

Generative Manifesto, 11, 17–18, 20, 22
Gesture, 4, 28
Gibber, 106, 107, 134, 148
Gibson, James, 165
Ginkgo (ensemble), 28
GNU (GNU's Not Unix) project
 GNU Emacs (*see* Emacs editor)
 GNU/Linux (*see* Linux)
 GNU General Public License, 156, 172, 178
Goffey, Andrew, 232
Goodman, Nelson, 149, 152
Goriunova, Olga, 20
Graeber, David, 232–233
Graham, Jonathan. *See* Meta-eX
Griffiths, Dave, 13, 127, 137, 148, 194
 Fluxus, 83, 119, 148
 Scheme Bricks, 134, 194
Groom, Amelia, 188
Grosz, Elizabeth, 190–192, 198
GUI (Graphical User Interface), 55, 95, 103, 148, 151, 153, 209
Guitar. *See* Instrument (musical)
Gutenberg press, 129

Hamilton, Margaret, 32
Hangar Barcelona, 26
Haraway, Donna J., 13, 175
Harlizius-Klück, Ellen, 127. *See also* Weaving Codes/Coding Weaves
Haskell (programming language), 55, 121.
 See also Functional
HAUS++, 79
Hayashi, Yosuke, 79
Hayles, N. Katherine, 167
Heidegger, Martin, 190–192, 202
Hennigh-Palermo, Sarah Groff, 3, 77, 91, 113
Herrmann, Max, 174
Hierarchy, 10, 33, 38, 111, 179, 219
Hiller, Lejaren, and Leonard Isaacson, 14
Hodnick, Mike, 13, 81
Hoogland, Timo, 83, 117
Hopper, Grace, 32
Howse, Martin, 176

Index

Human-computer interaction, 4
Human-machine
　relations, 10, 230–231, 237
　entanglement, 160
Hurtado, Enrike, 19, 26
Husserl, Edmund, 191–192
Hydra, 26, 41, 57, 75, 91, 110, 111, 134, 178, 186, 233. *See also* Jack, Olivia; Video synthesis; VJing

ICA (Institute of Contemporary Arts, London), 17
ICLC (International Conference on Live Coding)
ICMC (International Computer Music Conference)
ILLIAC Suite, 14
Imperative (programming language paradigm), 140, 184
Improvisation, 2, 5, 27, 41, 63, 65, 79, 99, 113, 140, 149, 156, 159–161, 166–168, 169–170, 197, 221
Improviz, 34, 134
Inafuku, Takanobu, 79
Indeterminacy, 11, 79, 132, 188, 196, 199, 206, 221, 224–226, 228. *See also* Causality
India, 87
Indian music/conceptions of time, 195.
　See also Bol Processor
Indigenous knowledge, 33, 238
Indonesia, 41
Industry, 36, 85, 111, 151, 207–208, 212–213, 234, 238–239
Ingold, Tim, 143, 167, 215–217
Instituting moment, 9, 33–36, 243
Instrument (musical)
　bass, 123, 268n60
　brass, 16
　cello, 47, 109
　drum machine, 16, 43
　guitar, 16, 22, 43, 119, 123
　percussion, 16, 59, 81, 83, 91
　piano, 16, 117

player piano/pianola, 131
saxophone, 16
synthesizer, 14, 24, 26, 43, 55, 91, 119, 186
tabla, 153
trumpet, 16
turntable, 5, 91
violin, 153, 236
vocals/voice, 43, 91, 95, 99, 109, 239
Interdisciplinarity, 3, 6, 7, 8, 11, 37, 125, 128, 160, 165, 167, 179, 205–206, 219
Internet performance. *See* Network music
Intersectional, 31, 231
Intra-actions, 11, 175, 226, 228
Irani, Lilly, 239
IRCAM, 14
Irigaray, Luce, 190
Irony, 22, 36–37, 45, 237
Israel, 93
Italy, 71
Ixi instruments, 19, 26
Ixi lang, 29, 43, 61, 107, 123, 138, 148, 153, 170, 178, 194
Izhar, Siraj, 19

Jack, Olivia, 75, 186. *See also* Hydra
Jacquard loom, 32
Just-in-time, 2, 159, 183, 186, 188, 199, 241
Just-In-Time library, 20, 185
Jutland Academy of Fine Arts, 20

Kaat, Miri, 85
Kairos, kairòs, 126, 197–199, 201, 256
Kairotic, 126, 166, 171, 197–198, 219, 223
Kandinsky, Wassily, 132
Kaulmann, Thomax, 20
Kay, Alan, 24, 135, 208–209. *See also* Smalltalk
Kelty, Christopher, 177, 178, 238
Keyboard (computer), 67, 79, 214
Keyboard (piano). *See* Instrument (musical): piano
Khipu, 33
Khoparzi, Abhinay, 41, 87
Kiefer, Chris, 123, 139

Klee, Paul, 132, 144, 216
Klossowski, Pierre, 190
Knotts, Shelly, 13, 45, 61, 63, 95, 123, 161, 253
Know-how, 11, 164, 205, 207, 218, 221, 224, 228, 231
Kubota, Akihiro, 79
Kuivila, Ron, 23–24
Kwon, Miwon, 177

Laban dance notation, 151
Lansky, Paul, 16
Laptops Meet Musicians, 28
Latham, William, 16
Latin America, 31, 87, 240
Lawson, Shawn, 89, 138
Lawsoon, Rex, 131
Lee, Sang Won, 141
LeWitt, Sol, 133
Lialina, Olia, 4–5, 241
Liminality, 196, 197, 206
Linux, 172, 211–212. *See also* GNU
Lisp (programming language), 211–212. *See also* Functional
Live coding, definitions of, 2, 4, 12, 71, 97, 121
Live Coding Research Network
Live notation, 125–126, 139, 166
London, 17, 20, 25, 97
Lopez-Lezcano, Fernando, 26
Lovelace, Ada, 32
Loveless, Melody, 77, 91, 113, 146
Lua (programming language), 89, 135
Luddites, 234
l'ull cec (venue), 26, 123
Luque, Sergio, 26

Machine learning, 113, 123, 134, 138–139, 152, 169, 228–238. *See also* Artificial intelligence
Mackenzie, Adrian, 172, 230–231, 238
Magnusson, Thor, 13, 19, 26, 34, 130, 139. *See also* Ixi lang; Threnoscope

Manifesto. *See* Generative Manifesto; Neokhipukamayoq Manifesto; TOPLAP Manifesto
Manning, Erin, 166–167, 223
Marie, Mynah, 93
Marx, Karl, 157, 176
Material
 code as, 212–215
 thinking through, 223
 materialism, 227–228 (*see also* New materialism)
 materiality, 227, 231
Mathews, Max, 14, 24, 249n8
Max/MSP, 3, 14, 24–26, 59, 83, 85, 107, 148, 249n8
McCartney, James, 14, 23–24
McLean, Alex, 17–22, 34, 43, 55, 61, 63, 97, 113, 127, 138. *See also* Slub; TidalCycles
McNeilly, Jodie, 189, 192
Mediality, 173–174, 223
Mercury (live coding environment), 83
Merleau-Ponty, Maurice, 190
Mersch, Dieter, 173, 219, 222–223
Meta-eX (ensemble). *See* Aaron, Sam
Mexico, 25, 26, 31, 67, 95, 109, 119
MicoRex, 95
MIDI (Musical Instruments Digital Interface), 43, 45, 81, 89, 107, 119, 133
MIMIC (research project), 139, 235
Minimalism, 91, 137
Miyazaki, Shintaro, 203
Mogini, Fabrice, 19, 24–25, 97
Mølle Lindelof, Anja, 163, 176
More-than-human, 10, 181, 195, 203, 206
Morpheus CD-ROM, 24
Moxc / Moxie (language), 23
MP3, 150
Mulenga, Emily, 31
Musical instrument. *See* Instrument (musical)
MUSIC-N, 14, 24
Muxy (software), 233

Nancarrow, Conlon, 131
Negri, Antonio, 198

Index

Neokhipukamayoq Manifesto. *See* Khipu
Netherlands/Netherlands Coding Live (collective), 47, 63, 83, 103
Networked Imagination Laboratory, McMaster University, 34
Network music, 25, 41, 45, 87, 111. *See also* Estuary; Flok; Troop
New materialism, 175, 226, 228
New York City, 77, 91
Nietzsche, Friedrich, 190
Nonhuman, 159, 164, 165, 175–179, 189, 191, 199, 200, 226–229, 231, 241
Noriega, Felipe Ignacio, 117
Northern Sound Collective, 29
Notation, 2, 8–10, 16, 27, 49, 63, 125, 127–157, 159, 164–166, 189, 195, 207, 217, 223–224, 231, 236, 241
Not knowing, 206, 219–221, 227
Núñez del Prado, Paola Torres, 33

Object-oriented (programming language paradigm), 154, 202
Oduro, Kofi, 99
OFFAL (ensemble), 29, 45, 123
Off<>zz, 117
Ogborn, David, 2, 13, 101
Olofsson, Fredrik, 20, 26, 95, 97
On-the-fly, 2, 21, 35, 67, 109, 188, 199, 221
Open-source software, 177, 212, 215, 237–238
Open work, 4, 63, 153
Oral culture, 125, 130, 133, 140–41, 150
Orca (live coding language), 34, 61, 67, 119, 147–148, 153, 184
Osborne, Peter, 182
O'Sullivan, Simon, 198, 199
OuLiPo, 6, 7, 132

Panda Zooicide, 117
Pasquinelli, Matteo, 234
Pattern language, 154, 210, 217
PENELOPE project, 224
Percussion. *See* Instrument (musical)
Perec, Georges, 6, 7, 240

Performative, performativity, 8, 10, 32, 63, 161, 165, 171–179, 218
Perl (language), 17, 25, 55
Peruvian textile practices
Phelan, Peggy, 162
Piano, pianola. *See* Instrument (musical)
Pietro Bapthysthe (live coding band), 51
Play, 222
Poetry, 27, 75, 99, 109, 119, 223
Pop music, 19, 35, 49, 57
Postcolonialism, 31. *See also* Colonialism
Posthumanism, 167, 175, 241
Powerbooks_UnPlugged, 21, 25, 249n3
Pre-gramming, 135, 140, 160, 264
Presentism, 199
Programming language, 3, 6, 14, 23–24, 26, 32, 63, 93, 117, 126, 130, 134–135, 138–139, 146–148, 151, 160, 169–170, 172, 193, 202, 209, 217, 243
Public, 49, 53, 63, 177
 thinking in, 2, 4, 19
 writing in, 20, 142, 155
Public Life (venue), 19–20, 27
Puckette, Miller, 14, 249n9
Pure Data, 3, 14, 26, 67, 148, 249n9
Python (programming language), 51, 57, 73, 135

Quipu. *See* Khipu

Racism, 240. *See also* Diversity
Ramírez, Jorge, 95
Ramsay, Stephen, 178
Rap, 117. *See also* Poetry
Raspberry Pi, 208
Rave scene, 36, 230
Read_me/Runme, 20
Real-time, 3, 14, 18, 23, 97, 107, 160, 168–171, 182–183, 186, 198–200
Reason, Matthew, 163, 176
Recursion, 126, 177, 184–185, 200–202, 211, 225
Red plenty, 141, 222

Reflexivity, 2, 8, 220
REPL (Read-Eval-Print-Loop), 25, 211
Reus, Jonathan, 103
Reyes, Juan, 16
Roberts, Antonio, 31, 61, 105
Roberts, Charlie, 107, 148
Robinson, Martin, 16
Rodriguez, Jessica A., 109
Rogoff, Irit, 183
Rohrhuber, Julian, 20, 21, 24–25, 123, 185, 200–201
Romero, Ernesto ("Tito"), 25, 95
Romero, Juan A. *See* Benoît and the Mandelbrots
Russolo, Luigi, 132
Ruviaro, Bruno, 26

Saladino, Iris, 111, 177
Saunders, Samiir, 31
Schneiderbanger, Matthias. *See* Benoît and the Mandelbrots
Schultz, Pit, 20
Schutz, Alfred, 193
Score, (musical/performance), 5, 10–12, 14, 23, 113, 121, 126–133, 149–157, 160, 165–166, 172, 197
Scratch (software), 148, 184
Scratch Orchestra, 155, 156
Sema, 123, 139, 235
Sheffield (UK), 43, 61, 77
Shklovsky, Viktor, 3
Show us your screens, 3, 4, 174, 20, 123, 220, 226
Shulgin, Alexei, 20
Sicchio, Kate, 13, 63, 77, 91, 113, 132, 134, 165, 233. *See also* Terpsicode
Signifikantelstadl, 28
Simula (language), 24
Singing. *See* Instrument (musical): vocals
Slow, 212, 241
 slowness, 199, 242
 slow coding, 184
Slub (ensemble), 17–22, 97

Smalltalk (language), 24, 135, 151, 202, 209–212
Software engineering. *See* Engineering
Sonic Pi (language), 26, 34, 41, 51, 71, 83, 93, 134, 146, 178, 184, 239
Sorensen, Andrew, 25, 71, 178, 184, 202. *See also* Extempore
Spain, 26, 35, 53, 123
Spanish language, 31, 37
Stallman, Richard, 211–212. *See also* GNU
STEIM, 23
Steiner, Hans Christoph, 26
Stern, Daniel, 166, 192, 197
Stravinsky, Igor, 131
Stubnitz, MS, 28, 36
Subotnik, Morton, 16
SuperCollider, 3, 14, 19, 20, 23–25, 28, 29, 45, 55, 57, 59, 61, 67, 83, 85, 97, 103, 111, 123, 135–137, 178, 185, 200
Sykes, Bobbi, 239
Synthesizer. *See* Instrument (musical)

Takeda, Hirozumi, 79
Tangible user interfaces, 214
Tawallah, Jae, 31
Teaching. *See* Education
Technē, 205, 219
Terpsicode, 113, 134, 233. *See also* Sicchio, Kate
Textile, 7, 8, 33, 128, 136, 137, 167, 236
th4, 115
Thinking-in-action, 160, 165, 167, 170, 223
Thinking in public. *See* Public: thinking in
Threnoscope, 134, 184, 194. *See also* Magnusson, Thor
TidalCycles, 26, 34, 41, 43, 55, 57, 61, 67, 69, 81, 85, 89, 107, 109, 111, 115, 119, 121, 137–139, 143, 185, 194–195
Timeliness, 197, 199
Timing, 126, 127
Tokyo, 55, 79
TOPLAP, 20–23, 35, 37, 43, 53, 59, 67, 71, 93, 111

Index

TOPLAP Manifesto, 21, 34, 113, 213, 217, 238
Trial and error, 127, 219–220. *See also* Failure
Troop (live coding environment), 41, 51, 141
TSpawn, 24
Tuckman stages of group formation, 36–37
Tuhiwai Smith, Linda, 238
Turing, Alan, 65, 130, 201, 202, 225
 Theory of computability, 225
 Turing machine, 181, 201
 Turing test, 207
Turner, Victor, 196

Uncertainty, 206, 208, 220, 221, 224, 225–228, 231
Undeadness, 161, 173, 179
Untimeliness, 182, 196, 201
User, 1, 4–5, 134, 151–152, 210–211, 214–215, 233–237, 240–241
User's manual, 1, 6, 240

Veinberg, Anne, 117
Velasco, Rodrigo, 113, 119, 233
Video synthesis, 91, 185. *See also* Hydra; VJing
Virno, Paolo, 157, 173, 222
Virtuosity, 4, 30, 73, 157, 161, 170, 176, 179, 215
Visibility, making visible. *See* "Show us your screens"
Visualist. *See* Video synthesis; VJing
Visualization, 107, 136, 147–148, 184, 261n68
VJing, 15, 77, 89, 105, 250n11. *See also* Hydra; Video synthesis

Wang, Ge, 27. *See also* ChucK
Ward, Adrian, 17–22
Weaving, 32–33, 127–128, 136–137, 223–224, 234–235
Weaving Codes/Coding Weaves, 32–35, 127, 167, 223–224
Werktreue, 133
White, Eric Charles, 197
Wieser, Renate, 21, 252n36, 277n77
Wiki (software), 210

Wilson, Elizabeth, 121, 171
Wilson, Scott, 16
Wood, Catherine, 179

Xambó, Anna, 123
Xerox PARC, 208–209

Yecto. *See* Velasco, Rodrigo
Yes Men, the, 20
Yorkshire Sound Women Network, 29
Young, La Monte, 133, 216
Yuill, Simon, 155–157, 178, 179